FERRIES OF SYDNEY

Graeme Andrews

OXFORD UNIVERSITY PRESS
SYDNEY UNIVERSITY PRESS

SYDNEY UNIVERSITY PRESS
in association with
OXFORD UNIVERSITY PRESS AUSTRALIA

National Library of Australia
Cataloguing-in-Publication data:

Andrews, Graeme.
 Ferries of Sydney.

 3rd ed.
 Bibliography.
 Includes index.
 ISBN 0 424 00202 7.

 1. Ferries - New South Wales - Sydney - History.
 I. Title.

386.6099441

Edited by Bette Moore
Printed in Australia by McPherson's Printing Group
Published by Sydney University Press in association
with Oxford University Press,
253 Normanby Road, South Melbourne, Australia

CONTENTS

For Gillian and Carina

PREFACE

For most of the 150-year lifespan of the 'Sydney Ferry', the good citizens of Sydney noted it only when it was missing, late or closing down. 'The ferry' was part of life's background. They were rarely photographed, except as a part of something more notable or interesting, and little was published about them.

In the first half of this century, however, some notable articles, recounting experiences and anecdotes were written by Norrie, Deanne, Portus and others. They were mainly published in the *Journal of the Royal Australian Historical Society* (or *Australian Historical Society*).

Interest in Sydney's ferry services seems to have increased since World War II. Perhaps as ferry services declined and as Australians became more interested in their past, Sydney's ferries became objects of historical interest.

In 1969, the first small edition of *Ferries of Sydney* was published. This was the first book on Sydney's ferries and was published at a time when it was unusual to find anything about Australia in most bookshops.

The second edition in 1975 placed more emphasis on the memories of those still living and upon the 'feel' of ferries. There was an ill-defined 'something' about the steam ferries of Sydney that brought forth feelings akin to love in the breast of those who knew them well. I am lucky enough to be one of them. In 1980, a simpler version was published called *A Pictorial History of Ferries*.

Since 1969, other writers have focused on particular aspects of Sydney's ferries. Notable among these writers are John Gunter and A.M. Prescott. John Gunter researched the colour schemes of a time when colour photography was not available and when few paintings were made of ferries. A.M. Prescott's studies of Manly ferries broke new ground. His work on the ferry fleets of Sydney provides an excellent database. L.A. Clark's study of the transport services of the North Shore placed the ferries within context for that area, while

Tom Mead's more recent work did the same thing for the Manly Ferry. Jann Davies, daughter of Eric Nicholson, provided an invaluable insight into the Nicholson ferry family in her unpublished family history. This history provided a major part of the information on the Nicholson ferry services.

A particular interest of mine has long been the identification of ferries from old photos. If a given vessel can be identified it can often be used to date a photograph.

After speaking on Ian McNamara's ABC programme, 'That's Australia All Over', in August 1990, I received more than 90 phone calls and letters, many containing rare photographs, from people across Australia. Over 200 handwritten pages of anecdotes and family ferry memories came from people ranging in age from around 20 years to over 90. These people are all identified elsewhere in this work.

I travelled to school on the Sydney steam ferries — *Kookooburra*, *Kulgoa*, *Kirrule*, *Kirawa* — and spent my hours after school on the small motor ferries, *Promote*, *Provide* and, sometimes even, the magnificent *Proclaim* or Rosman's new *Radar*. I came to love the quiet easy thump of the triple-expansion steam engine — such as is now preserved on the harbour in working order in the museum ship *Lady Hopetoun* (1901), or in the equally old compound-steam tug *Waratah*. The heart-beat-rate thump of the steamers is still with me. Yet I know that the time will come when some other young person will grow to adulthood with similar warm memories of the ferries of today.

As a schoolboy, I took part in unofficial competitions to name the ferries that approached us. Every ferry on the harbour had something distinctive about it — even sister ships. What a pity that it is so hard to identify at a distance differences between vessels of the Freshwater or the First Fleet catamaran classes. Perhaps, as years go by, alterations through the classes will make each vessel more recognisable from its fellows.

I hope this edition of *Ferries of Sydney* will sustain and encourage interest in the ferries of the past and of the future and will act as a source work for future ferry fans.

To all those who have gone out of their way to help with my studies, I offer my grateful thanks. Errors, omissions and misinterpretations are, of course, my responsibility.

GRAEME K. ANDREWS

INTRODUCTION

The ferry is the oldest form of organised water transport. Since prehistoric times, humans have used a log or an inflated sheep stomach to cross streams or rivers. Such basic equipment is still used in some areas of the world and that is the origin of the river crossing or 'ferry'. Despite improvements made by bridges and other forms of competing transport, ferries still survive in most areas where people need to cross water.

It is just over 200 years since the First Fleet came to anchor in Sydney Cove. In that period Sydney's harbour, the birthplace of Australia, developed into Australia's finest commercial port. But it is now in decline as a port. Rising land values, pushed up by tourism and various political decisions, have forced most of Sydney's commercial marine businesses to close or move away. Wharfage has been removed or alienated, and the new harbour tunnel will ensure that the harbour may never again be deepened to cater for the bigger ships of the next century. The finest harbour in Australia is gradually being handed over to those who believe that recreational sailing and boating is more important to the nation than a major port infrastructure. Nowhere is this better illustrated than the closure of the dockyard on Cockatoo Island for private development. Australia has only five substantial graving docks for shipping; two of these national assets will be lost if Cockatoo is redeveloped as an enclave for the wealthy.

For almost 100 years, the steam ferry reigned supreme on Port Jackson. Sydneysiders used ferries to get to and from work and, in the weekends, the same ferries took them to picnic grounds or to inspect the latest maritime wonder as it entered the Heads. The ferry was used to entice land-buyers to inaccessible areas. It became an unofficial symbol of Sydney in the days before the Harbour Bridge, Opera House or contrived enticements like Darling Harbour.

Then came the Bridge — Erasmus Darwin's 'Great Arch'. The inner harbour ferry service withered almost overnight with much of the fleet becoming redundant. However, World War II with its fuel shortages and other transport restrictions, extended the life of the ferry services — even old, laid-up ferries could be used, and some of the bigger ones became substitute warships for the duration of the war.

The takeover of the inner harbour services by the State Government in 1951, and the Manly run in 1974, brought the harbour's transport largely under the control of the Government. It remains so to date, and is an example of government efficiency when private enterprise either could not or would not do the job.

Ferry services are not unique to Sydney. Hobart in Tasmania had a smaller but similar service to Sydney, but allowed its ferries to die away and then found itself physically divided when the bridge fell down. Ferries came from everywhere to fill the void, but it was difficult for them to earn a living after the bridge was repaired. Auckland in New Zealand still uses two double-ended ferries. One is very, very old; the other is brand-new and space age in concept, but both carry out the ferry's traditional role.

New ferries have come to Sydney harbour and they are generally effective, even if some of the lessons of the past had to be relearnt by a new generation of designers and managers. The variety of cruise and charter vessels has been fascinating, although the economic downturn of the early 1990s is also causing pain around the harbour, as it has elsewhere.

SHIP'S BOATS, 'THE LUMP' AND EARLY PASSAGE BOATS

A cursory glance at the list of stores provided for the First Fleet might suggest that Captain Arthur Phillip had everything needed to establish a settlement in a new land. However, among things not provided were wheeled transport and boats for the settlers. Certainly wheeled transport would not be important for many years, but the lack of substantial boats showed little understanding of the need for water craft, either for Botany Bay or for Phillip's preferred waterway, Port Jackson, a little to the north.

The coming to anchor in Sydney Cove of the fleet's eleven vessels meant there were as many as 25–30 ship's boats available for duty. Of various sizes, these boats were pressed into service as ferries, fishing boats and cargo lighters. They were also used to explore the area. Their number dwindled as the convict transports and store ships left, making the need for local craft obvious. Two small boats had been brought from England in knocked-down form and, by October 1788, they were nearing completion. Phillip's instructions included orders not to allow any boat to be built with a keel length of more than 4. 3m so as to discourage the convicts from unauthorised voyages to 'China'.

By April 1789, the need for more capable water transport had become obvious. The river to Rose Hill (Parramatta) was in use as a regular river road and the early farms in that area and along the river were becoming productive. Robinson Reed, ship's carpenter for *HMS Supply*, began building a 'hoy' which was launched on 5 October 1789. Judge Advocate, David Collins, made an acerbic comment on this first triumph of local shipbuilding:

> From the quantity of wood used in her construction she appeared to be a mere bed of timber and when launched, was named by the convicts … the 'Rose Hill Packet' and was generally known as 'the Lump'.[1]

William Bradley, in his journal, also described the new craft:

> Monday 5th October, a vessel of 12 tons was launched, which was the first built in this colony; her construction was that of the lighter [and] of an easy draught for the purpose of carrying stores and provisions over the flats to Rose Hill.[2]

Combining descriptions from Collins and Bradley, we may visualise a beamy, stable, shallow-draught vessel with a capacity of 10–12 tonnes. Sail would be provided; probably a loose-footed single lug sail, able to be lowered quickly against unfavourable river gusts. A normal sailing keel would be unlikely, so lee-boards were probably fitted. Long poles for pushing through shallows, and oars, would have been used as often as the sail, and working the winds and tides would have been important. 'The Lump' would have spent many hours at anchor awaiting the turn of a tide or a wind change: stories of her taking a week for the round trip to Rose Hill are quite credible. Travelling along the river to Rose Hill on 'The Lump', or on the ship's boats that preceded her, or indeed the Passage Boats that followed her, was not for the faint–hearted, although more pleasant than using the bush track that joined the two settlements. Escaped convicts and local Aborigines added to the risks of the track; the major discomfort along the river was exposure and mosquitoes.[3]

The Lump's primary duty seems to have been carrying produce and stores. Passengers would have been carried if room allowed and fitted in where they could. There is no known description of the vessel and apart from the descriptions given by Collins and Bradley, information is sparce.

Rose Hill Packet is often described as a 'hoy', but this may have been for lack of an identifiable term. Contemporary English hoys were rated at about 60 tonnes capacity and carried cargo and passengers on estuarine and coastal waters. They were also known as 'sloops' or 'smacks'.[4] Whatever her faults and limitations, the *Rose Hill Packet* was an effective tool for her time and may well justify her general acceptance as Australia's first ferry. Bradley also states that the Governor went to Rose Hill just two days after she was launched — perhaps her first official passenger was Governor Arthur Phillip.

As the colony spread along the river banks and as fisheries and ship moorings expanded away from Sydney Cove, there arose a need for water transport more reliable than that provided by whatever ship's boat was available. As convicts reached the end of their sentences and gained ticket-of-leave they gradually moved from the public stores list where they were fed and clothed at the colony's expense and were expected to pay their own way. One such way produced the Waterman and the Passage Boat. The Passage Boat was available for hire to take passengers and goods wherever required in the port. The early boats were often of very rough build; having been paid for by alcoholic spirits and their crew often expected payment in spirits, some of which may have been drunk while awaiting the next passenger. The result was a

rough and ready transport system which was not generally admired by its cus-
tomers. While no identified illustrations of Passage Boats have survived, craft
that may well have been Passage Boats may be found in many contemporary
works.[5]

General orders for the Colony included specific instructions for Passage
Boats:

> Passage Boats — Not to convey any person, unless a settler, without a pass;
> penalty, confiscation. The boats to be kept tight; carry four oars, one mast
> and sail; boatmen to treat passengers civilly; to give notice half an hour
> before they depart, by bell-ringing; not to stop more than ten minutes by the
> way, not to go alongside a vessel without acquainting the wharfinger; and the
> proprietors to keep entry-books, under the penalty of forefeiting the bond
> and recognizances entered to at the time their licence was granted.[6]

TRAVELLING THE RIVER BY HORSE AND STEAM POWER

Travellers and traders wishing to cross the harbour or river towards the Field
of Mars 'Soldier Settlements' near Ryde or towards the Hawkesbury River and
between, were long forced to take the bush track to Parramatta if they could
not find a small boat.

The first attempt at providing a permanent river crossing seems to have
been at about the position of the present-day Ryde road bridge. Stephenson
says that a pulling boat possibly was installed here and suggests this may have
been as early as 1800.[7] This service survived as a vehicular punt until the open-
ing of the Ryde road bridge in 1935. The *Sydney Herald* of 16 January 1832
refers to:

> Mr. Busby, the mineral surveyor, has received orders from His Excellency to
> clear away if possible, the obstructions to navigation in the Parramatta River,
> so as to enable vessels of moderate draught to pass at any time of tide. When
> this is done and the punt intended for the ferry at Kissing Point, set to work,
> the land in the neighbourhood will rise considerably in value ...

Another early, and at the time, more important cable ferry and pulling boat
service was from Bedlam Point to Abbottsford, joining the Great North Road.
Here the river narrows to about 300m. A permanent cable punt was estab-
lished here in about 1830–32[8] with a ferryman in residence. Charges were
given as one shilling and sixpence for four-wheeled wagons and one half
penny per animal. The fare was doubled on Sundays. The first Bedlam ferry-
man was a Mr Bateman who lived in a rough hut on the northern approach to
the punt. Power initially came from the Bateman muscles aided by anyone else
who would help him. The rope was often cut or caught by passing vessels until
a chain was used. In a talk to the Royal Australian Historical Society on 27

May 1919, W.S. Campbell said that the ferryman was: ' ... taking his sleep whenever he could ... for he was sometimes engaged both day and night, hauling the heavy punt or pulling a [rowing] boat across the river'.[9]

The Bedlam ferryman was also required to service passing ferries and river traders, transferring goods and people to and from the shore as the ferry laid-to. After 15 years or so, a combination of passenger complaints and lack of maintenance, together with competition from bigger and better river ferries, wharves and other crossings, caused this ferry to fall into disfavour. However, it did struggle on until the opening of the first Gladesville Bridge in 1884.

Other cable ferries to cross the river or the harbour existed at Iron Cove and at the site of the present Glebe Island Bridge. Another punt crossed the river near the site of the Gladesville Bridge.

STEAM GOES AFLOAT

The use of steam for marine propulsion in Australia came well before its use for road and rail, but some years after the introduction of steam for mills and mines. About 15 years passed between the first use in a grain mill and the first local marine use. Almost 24 years later came the first steam railway train. During that period the commercial steamboat had already showed a fuming funnel to many waterways.

Most works on early Australian steamships have accepted that Australia's first 'home-grown' steamer, *Surprise*, was afloat but unfinished when paddle steamer *Sophia Jane* arrived under sail on 13 May 1831. Although unfinished, and no doubt spurred on by the newcomer, *Surprise*'s builder, Robert Millard, and her owners, the Smith brothers, carried out steaming trials just five days after the arrival of the bigger ship and three days after *Sophia Jane*'s Master, Captain Biddulph, had displayed an advertisement in the *Sydney Herald* asking the public to keep away during the work to prepare the ship for steaming. The advertisement of 16 May 1831 said:

> Captain Biddulph informs his friends and the public that in consequence of the engineer and crew of the Sophia Jane being engaged with the engine, and putting the vessel in order after the voyage, he cannot at present, admit visitors; but as soon as these objects are accomplished, he will be glad to see on board, such gentlemen and ladies as will favour him with their company.

Surprise had been launched in Neutral Bay on 31 March 1831. She was 58ft. long by 9ft. 8in. with a hull depth of 4ft. 9in. (17.6 by 2.97 by 1.45m). From the *Sydney Herald* of 6 June 1831:

> The first trip of the first steam boat in New South Wales, took place on Wednesday last [1 June 1831] to Parramatta. The *Surprise*, belonging to Messers. Smith Brothers, started from the Cove at half-past eleven and con-tinued her course 'till half-past two, when she was off Red Bank, where she

grounded, owing to the tide having been ebbing two hours; during her detention there, a large concourse of persons saluted her with continued cheers, and many visited the novel little vessel. She refloated again at 10pm and arrived at Parramatta soon after. A number of persons had been expecting her all day and were much disappointed, but next day the whole of the residents of Parramatta gratified their curiosity by flocking to the banks of the river and numbers went aboard to inspect this beautiful invention. She started from Parramatta on Thursday at one o'clock and arrived in the Cove about half-past four.

Richards has her doing her steam trials on 19 and 25 May under Captain Winbolt.

On 13 June 1831 the *Sydney Herald* ran another item from Captain Biddulph, promising that on Friday [17 June 1831] *Sophia Jane* would run a pleasure cruise to Middle Harbour, starting at 10.00 a.m. and returning at 3.00 p.m. Fares would be 7/6d. for adults with children under 12 years, half price. Allowing for most of a week of steam trials, *Sophia Jane* probably steamed in the first week of June.

There seems to be no identified illustration of *Surprise*, nor any accurate contemporary illustration of *Sophia Jane*. However, there is a rough lino-cut of *Sophia Jane*, apparently done at the time of her first visit to Wollongong.[10] The generally accepted illustration is that shown in C. Dickson Gregory's *Australian Steamships*, published in London in 1928. It is possible that Dickson Gregory had access to an earlier illustration no longer available as he could not have seen *Sophia Jane*.

Surprise went into regular service on 8 August 1831. The previous day while ' … on a party of pleasure … ' she had towed the 367-ton barque *Duckenfield* down harbour. This feat was reported in the ever-observant *Sydney Herald* of 15 August 1831. *Surprise* offered her patrons six round trips from Sydney to Parramatta each week, one of which stayed overnight up-river, leaving Parramatta on the Wednesday morning.

Some sources have suggested that *Surprise* was a failure. Perhaps she was in a commercial sense, but not in a technical sense — otherwise she would not so quickly have found a buyer. In Hobart, Dr Alexander Thompson had been waiting for some time for a small steamer to arrive in parts from England. She was long-delayed and his offer of £4000 for *Surprise* was accepted. Rigged as a sailing ship, *Surprise* arrived in the Derwent under Captain Moffatt on 1 February 1832. She was soon in service as a steamer on the Hobart-Kangaroo Point run and, no doubt, worked as a 'tug of opportunity' as needed.

Surprise had various owners during the next few years and was owned by Philip McArdel in 1842 when her boiler exploded after the safety valve had jammed. The fireman was killed. She was then converted to sail as the schooner *Ann Jane* and seems to have been broken up in about 1845. So passed Australia's first steam ship!

THE 'HORSE BOAT' — AN *EXPERIMENT* THAT FAILED

The next 'powered' ferry to serve the port truly depended upon 'horsepower'. The paddle ferry, *Experiment*, was certainly well-named as her motive power was, variously, two or four horses. These were expected to turn a capstan which turned the paddles. Built for Benjamin Singleton by Marshall and Lowe on the Williams River near Newcastle, *Experiment* cost £1200. The 24.5m by 3.67m vessel had a loaded draft of just 0.6m when carrying 20 tonnes. No technical description of *Experiment* seems to have survived but it is possible that she was twin-hulled, a catamaran. This system was used in several other very early Australian paddlers.

Experiment was not the only horse boat in use. Similar craft existed in Brooklyn, USA, and at Halifax in Nova Scotia from 1816. It is likely that some Australians knew of these ferries. The contemporary Halifax ferry, *Sherbrooke*, was a multi-hull and is illustrated and described in detail in Payzant.[11]

Experiment arrived off Port Jackson under sail on 9 September 1832, but had trouble making the port and was towed to Darling Harbour by the steamer *William the Fourth*.[12] She was soon in service and, almost as soon, out of service. A couple of months after beginning her scheduled run she was sold at auction for just £400; a great loss and an indication of how poorly she was locally regarded. Singleton's bold and expensive attempt to by-pass the high local machinery prices had failed, although A.B. Portus, giving a talk to the Australian Historical Society on 30 June 1904, showed there had been some early encouragement:

> ... her first trip to Parramatta was made on October 5, 1832. Some difficulty was experienced in getting the horses to work but they were quiet before reaching Parramatta and made the vessel work at a rate of six miles per hour. Next day the trip to Sydney was made and took only three hours.[13]

The *Sydney Herald* of 4 October 1832 had been very optimistic:

> SAFE AND EXPEDITIOUS CONVEYANCE TO
> AND FROM PARRAMATTA.
>
> The Public are respectively apprized that the Horse Boat *Experiment* of about 60 tons burthen, and capable of carrying at least 100 passengers, and about 20 tons of goods or merchandise, will be ready to ply from the wharf of Mr. Cains of the Albion Inn, near to the Market Wharf, between Sydney and Parramatta, next Friday, the 5th instant, when she will start for the first time at 8 o'clock in the morning and return to Sydney in the evening after the races.
>
> The rates of Passage to or from will be as follows: In the after cabin 2s. each passenger. Steerage 1s. ditto. Children under 10 years of age, Half Price.
>
> The Charges for Freight of Goods ... will be
> For DEADWEIGHT 6d. per ton

Grain	2d. per bushel
Timber	9d. per 100 feet sup.
....Tea	6d. per chest
...small packages	3d. each

The public are further respectfully informed that this boat combines expedition with safety; but as her management or navigation may not be fully or generally understood, it may well be to add that she is propelled by the rotary movement of four horses over paddle wheels, that she draws only 24 inches of water when fully laden, and consequently can hardly be exposed to accident or detention by any bank or other impediment in the navigation of the river.

Mr. B. Singleton, the proprietor, and in case of illness, his son will constantly navigate the vessel to and from and conduct in person, the business of receiving and delivering goods.

Every facility will be procured at Parramatta for the reception and delivery of Goods on the right bank or Town side of the River, at a scite [sic] which will be hereafter more particularly made known: — On the left bank of the River or that which is near to the Windsor Road, on the land in the occupation of Mr. Gregson as Tenant thereof, and ascent to and from the river, every facility and convenience will at once be afforded for the landing and shipping of Merchandise, Grain, &c.

REFRESHMENTS (including Liquors, as soon as the necessary sanction may be obtained from the Authorities) may always be had on board.

Experiment was eventually fitted with a steam engine by Captain Biddulph of *Sophia Jane* fame and the *Sydney Gazette* of 31 May 1834 reported that she had carried out steaming trials. With the steam engine operational, *Experiment* returned to the Parramatta River. Under the ownership of pioneer sea-trader and ship-owner, Edye Manning, she ran a joint service with the newer *PS Australia*, owned by the Australian Steam Conveyance Company. Formed on 4 April 1835, this organisation is said to have been the first joint stock steamship company in Australia and was capitalised at £2000 in £5 shares. The company paid 35 per cent in its first dividend, but internal dissension soon broke up the company. After litigation, *Australia* was sold to meet the costs of a judgement.

According to the *Sydney Morning Herald* of 20 April 1844, *PS Experiment* was just one of ten steamers laid up in Sydney for lack of work. It may have been that too many steamers were chasing too little business, but *Experiment* was back on the Parramatta River run in October of that year. After nearly twelve years afloat she had to compete with newer and larger vessels and, in 1846, was sent to Brisbane to become that town's first steam ferry. She was used on the tortuous and shallow Brisbane-Ipswich run for a couple of years, but her tired hull must have found the strenuous work too much. On 21 January 1848 she sank at her wharf in Brisbane, possibly another victim of the ravenous teredo sea-worms of the South Pacific. Her engine was fitted into a new stern-wheeler, *PS Hawk*, built in Brisbane in 1849.[14]

While it has long been fashionable for many writers, including myself, to consider the *Rose Hill Packet* to be the 'first' Sydney ferry, it may well be that the *Surprise* could better claim that title. Her owners announced and attempted to maintain a published schedule. This was the first schedule in the port.[15] There were many more to follow as the geographical layout of Port Jackson encouraged water transport.

The topography of Port Jackson is that of a flooded valley with many points, spurs and headlands dividing alluvial flats now long submerged. The headwaters of these bays and flats encouraged early agriculture west of the town and the easiest method of moving goods and people was by water. Where other cities may have developed along bush tracks, roads and rail, Sydney spread along the water routes. In many cases, the existence of a ferry service was sufficient enough to make land saleable. In other cases, ferry services were started in order to encourage land developments such as Mosmans Bay, Watsons Bay, Manly and Hunters Hill.

The launch of the steam vehicular punt *Princess* in 1841 was intended to provide a mobile 'bridge' from Sydney to the northern shore.

March 25, 1841:

> Sydney Ferry Company — the shareholders of this company are informed that their first steam ferry, the *Princess* will be launched on THURSDAY next, the 25th instant at 10 o'clock a.m. from Mr. Buddivant's yard, Balmain.
>
> By order of the Committee of Work,
> B. Mansfield, Secretary.

Launched she duly was, but completion proceeded very slowly and the *Princess* was not ready for almost two years.

Meanwhile the *Sydney Morning Herald* of 10 March 1842 attempted to create interest in the north shore. Waxing enthusiastic, the *Herald* claimed:

> Few undertakings have promised so many advantages to the town of Sydney as that of connecting it with the North Shore by means of steam ferry boat.
>
> Health, pleasure, convenience and economy will all be promoted by this useful arrangement. In the brief space of five or ten minutes, passengers, horses and carriages, livestock and goods will be transported from shore to shore; and as the boat will be plying between sunrise and sunset, this facility of conveyance will be available at all hours of the day throughout the year. The horseman need not dismount from his saddle, nor the driver alight from his gig or phaeton, but retaining his seat, he may cross the water with as little interruption as in passing over a stone bridge ...
>
> Hence it is clear that the immediate and prospective resources upon which the Company are to depend for employment, promise to equal their most sanguine wishes. This indeed, is shown by the fact that there are, even

now, no fewer than six passage boats constantly at work between Sydney and the North Shore and that their passengers do not average less than … one hundred a day. This yields a revenue of nearly one thousand pounds per annum and when we consider the certain increase of passengers that will be caused by the comfort of the steam bridge and the large extra revenue from the conveyance of goods, produce etc … we may confidently assume that the Company's income will be at least 2000 pounds per annum … the rate of profit should be about thirty per cent per annum … [16]

Optimistic as the *Herald*'s hyperbole was, the well-to-do were apparently quite satisfied with life on the Sydney side, and the *Princess* went broke. Like so many of the early steamers, *Princess* seems not to have left any illustrations. Yet she was another local 'first' — the first powered vehicular ferry in Australia. She may have also been the first single-role ferry, designed for one use only and unable to deviate from her job to offer a tow to a passing sailing ship as could other steamers. It was this lack of flexibility that probably caused the doom of *Princess*.

Princess was launched as advertised in 1841, but was not completed for nearly two years, possibly because the price of machinery was too high. She may well have been used as a dumb punt or barge during this time. On 16 January 1843, tenders were called by the Sydney Ferry Company, owners of *Princess*, as follows:

> *Tender 1.* To work the boat, finding engineer and all hands except the Master, plus running expenses including fuel and oil for six months. OR
> *Tender 2.* To rent the boat from the company for six or twelve months, paying all running expenses except for 'fair wear and tear', full security to the value of the vessel required.

By 28 February 1843, paddle punt *Princess* was on duty. The *Herald* of that day announced:

> Ferry punt Princess now in operation. Master George Lavender. Fares Foot pass. 3d. children half price. 4 wheeled carriage 2/6d. dray 2/-. gig or cart 1/6d. horses and cattle 6d. each, goats and pigs 2d. geese and turkeys 1d. each fowls, ducks 1d. per pair.

Princess worked regularly for the next 15 months or so.

George Lavender was one of the early notables of the port. One-time bosun of the prison hulk moored in what was to become Lavender Bay (after George), he ran a Passage Boat ferry service to Billy Blues Point after 1837, having married Billy Blue's daughter Sarah in 1834.[17] The *Rapid* (1838) relieved *Princess* at least once and probably more often, as the *Herald* informed its readers: 'Steam punt lain up to have salt removed from her boilers, temporarily replaced by PS Rapid'. Towing a punt, presumably.

The *Sydney Morning Herald* of 20 April 1844 listed ten laid-up steamers, and *Princess* was among them — so their earlier enthusiastic prognostications had been to no avail. *Princess* went to the auctioneer's block:

To be auctioned at Mr. Blackman's mart, George St. the steam ferry punt Princess built under the supervision of Colonel Barnes, R. E. at a cost of 1300 pounds (hull) and 1800 pounds (engine).

The auction was successful but not for the ship's owners. The *Sydney Morning Herald* of 11 June 1844 reported the sale of the hull for [just] £60 and the engine for £365 to a Mr Smith of Newcastle for use in a flour mill at East Maitland. That *Princess'* hull brought so little suggests she may well have suffered worm damage, perhaps as a result of her long layup period before completion. The engines worked in that mill until at least the mid-1930s.[18]

Two other very early harbour ferries deserve mention here — *PS Australia* (1834) and *PS Kangaroo* (1840). *Australia* is sometimes referred to as *Australian*, an aquatint in the Rex Nan Kivell Collection in the National Library, spelling her name thus is dated 25 October 1838. There appears to have been no other steamer with either name at this time, so this illustration may well be the earliest identified contemporary illustration of a local steamer.

Australia was built on the Williams River by John Russell and was rated at 45 tons on a length of 25m. At the request of Governor Sir Richard Bourke, she was named *Australia* by her owners.[19] She ran on the Parramatta River for the Australian Steam Conveyance Company and later for J. Wilson, one of the more notorious early businessmen. Her master then was J. Morris. She was soon to become part of the Edye Manning fleet, being used as a trial horse for the newer *PS Kangaroo*. After this, she was more often on the shorter distance harbour runs, and after modifications, in September 1844, she

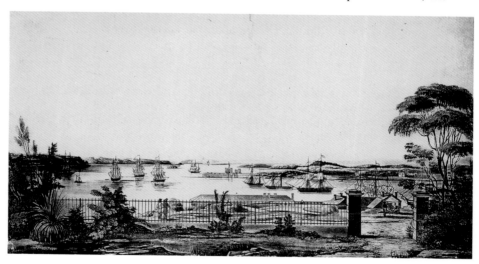

The steam boat *Australia(n)* escorting the brig *Camden* to sea on 25 October 1838. *Australia* worked mainly as a ferry on Port Jackson.
[Rex Nan Kivell Collection, Australian National Library]

became a vehicular ferry on the North Shore run. She was advertised for horses and carts, for drays, and for produce and passengers, leaving the Watermens inner steps near Campbells Wharf for Milsons Wharf on the North Shore. Manning announced that a new vessel would be built for the run if the trade demanded.

How the narrow-gutted *Australia* coped with such deck loads on its narrow beam of just over three metres and a deck length of about 15m is not stated. Perhaps she towed punts abeam for extra load and stability? But not for long. She hit a submerged rock near Milsons Point and the *Sydney Morning Herald* of 8 October 1844 reported her as sinking despite all efforts. *Australia* then became a sailing vessel and was wrecked in Queensland in 1863.

Kangaroo had a much longer and more varied career; she was built by J. Korff of Raymond Terrace for Edye Manning in 1840. At 82 tons she was longer and wider than *Australia*. She was more powerful too, but her deeper draught had her stuck in the Parramatta River at least twice — in March and in June 1841. At times she worked as a tug and after two years or so was sent to Hobart in a particularly rough voyage to compete with the Derwent steamers. This venture failed, and she returned to Sydney in just 91 hours steaming time — a very creditable seven knots sea speed average. *Kangaroo* went back on the river running with the new double-ender *Emu* (1841), offering departures from Parramatta at 7, 8, 11.00a.m. and 3.00p.m. From Sydney, times were 9 and 11.00a.m. and 5.00p.m.

Generally, steamers may be considered as the most important public transport in Sydney in the period 1831–1860. Rail was still to come or newly-arrived, and effective tramways were in the future. The many shallow harbour inlets and bays and the width restriction of the Parramatta River created problems for single-ended steamers. The result was the port's first double-ended paddle ferry, introducing a style that has typified the 'Sydney' ferry for more than 150 years.

P. G. Collyer, in a manuscript *Ferries of Port of Sydney* of about 1939, described the steamer *Rapid* as being an iron double-ender. *Rapid* arrived in Australia in the hold of the sailing ship *John*, to the order of one John Lord, on 19 June 1837. She was re-assembled by R. Dawson's Australian Foundry and equipped with a copper boiler and an engine of 20 indicated horsepower.

Rapid was 24.5m long with a beam of 4.35m. She soon impressed locals with her ability to make the passage from Sydney to Parramatta in just 90 minutes. However, the long run at sustained speed may have been beyond the capacity of her boiler, and she was sold to Edye Manning within three years. However *Rapid* did not impress everyone. In 1844, Tasmanian novelist, Louisa Anne Meredith, who lived along the river in Homebush House wrote:

> We then embarked in a steam boat named the Rapid or the Velocity or some
> such promising title on the Parramatta River (alias Port Jackson) and moved
> from the wharf at a most funereal pace, which I for some time accounted for

by supposing that other passengers were expected alongside; but at length found to my dismay that it was the best speed with which this renowned vessel could travel without fear of explosion.[20]

After working around the port for some 14 years, *Rapid* was run ashore at Glebe Point. Stripped and abandoned, she became the home for a ferryman named Suggate. The hulk was eventually absorbed into a sea-wall. *Rapid* was just one of a growing fleet owned by Manning and sundry partners, including sometimes, W.J. and J. Byrnes. The Manning group became the largest fleet owners on the river with rarely fewer than six ferries in service at any time between 1840 and 1875.

By the end of the 1850s, 25 steamers had worked in or from Port Jackson; of these, seven or eight could be classified as 'ferries'. Although most of the steamers had worked the excursion trade at some time, starting with *Sophia Jane*, most had changed owners more than once or, in some cases, had gone to other States to make a living. No doubt the high initial costs of hull and engine, combined with the considerable running costs, made them less economically successful than the still-effective wind and oar-powered ferries in all but the coal trade and on longer hauls. Subsistence boat operators, where the owner was probably skipper, still had a major role to play around the port and waters nearby. Not everybody wanted the speed and costs of steam.

NOTES

1 Collins, David 1975, *An Account Of The English Colony In New South Wales*, Vol. 1, ed. Brian H. Fletcher, Sydney, p. 67.

2 Bradley, William 1969, *A Voyage To New South Wales*, 1786–1792, facsimile, Sydney, p. 178.

3 See also research on early Sydney working craft: Hardie, Daniel 1989; *The Rosehill Packet*, Sydney, and 1990, *Forgotten Fleets*, Sydney.

4 Kemp, Peter, ed. 1979, *The Oxford Companion To Ships And The Sea*, London, p. 404.

5 McCormick, Tim 1987, *First Views Of Australia 1788–1825*, Sydney, pp. 114–115, 242.

6 Mann, D.D. 1979, *The Present Picture Of New South Wales*, 1811 Reprint, Sydney, pp. 24–25.

7 Stephenson, P.R. 1980, *The History And Description Of Sydney Harbour*, second ed. amended by Brian Kennedy, Sydney, p. 249.

8 Levy, M.C.I. 1947, *Wallumetta*, Sydney, p. 12.

9 Cole, Joyce 1983, *Parramatta River Notebook*, Sydney, p. 15.

10 Andrews, Graeme 1983, *South Coast Steamers*, Sydney, opp. p. 4.

11 Payzant., Jean and Lewis 1979, *Like A Weaver's Shuttle*, Nova Scotia, pp. 11–17.

12 Nicholson, I.H. 1977, *Shipping Arrivals And Departures, 1826–1840*, Canberra, p. 88.

13 Portus, A.B., 'Early Australian Steamers', *Journal and Proceedings, Australian Historical Society*, 30 June 1904, pp. 188–189.

14 Torrance, William 1831, *Steamers On The River*, Brisbane, p. 7.

15 *Sydney Herald*, 8 August 1831.

16 *Sydney Morning Herald.*, 10 March 1842, quoted in Birch, Alan, and Macmillan, David.S. 1962, *The Sydney Scene, 1788–1960*, Sydney, p. 106.

17 Pollen, Frances 1988, *The Book Of Sydney Suburbs*, Sydney, p. 150.

18 Collyer, P.E. c1939, *Ferries of Port of Sydney*, unpublished manuscript. Copy in author's possession.

19 Richards, Mike 1987, *Workhorses In Australian Waters*, Sydney, p. 17.

20 Meredith, Louisa Anne 1844, *Notes And Sketches Of New South Wales 1844*, London, facsimile 1973, Sydney, p. 125.

CHAPTER 2

WATERMEN AND THE
SCHEDULED FERRY

After visiting Sydney with the French Nicolas Baudin expedition, historian Francois Peron noted that by 1793 a Packet Boat service was running along the Parramatta River. Charges applying were one shilling a person or one hundredweight (c.50kg).[1] Commercial small boat use was inevitable — the difficulty of land travel, the interdependence of Parramatta and Sydney, and the preference for the 'river road' over the bush track encouraged the use of the waters. This, combined with the increasing number of immigrants and ticket-of-leave convicts seeking to make a private living, made adherence to Phillip's instructions to restrict small boats impossible to obey.

By 1803, Governor King had licensed a number of watermen and one woman, Ann Mash, to ply the port and the river.[2] By 1816 West Indian, Billy Blue, was petitioning Governor Macquarie '… gracious permission to estab-lish a ferry boat … to Lane Cove … '. Approval was given but by 1823 Blue was applying for exclusive operation as competition arose. Mr. Wollstoncroft proposed a service and ran it in opposition to Blue whose reputation for rudeness and eccentricity had grown apace.[3]

The Passage and Packet Boats were early placed under colonial govern-ment control. Complaints about dirty and ill-found boats matched reports of rudeness, drunkenness and incivility from Passage Boat operators. All opera-tors were required to post a good behaviour bond and fines were often used to support orphans.[4]

By 1830, Billy Blue (then 82 years old) had established a regular Passage Boat service between Blue's and Dawes Points. His sons, William and Robert,

helped in the ferry and were later joined by Blue's son-in-law, George Lavender. Lavender maintained the service after Blue's death in 1834 until he received a better offer, to be master of *PS Princess*. The end was in sight for the regular scheduled watermen services across the harbour.[5]

But the Passage Boats survived *Princess* as they had the early steamers, by adapting their role to new circumstances. Although the omens were obvious, there was still much for the small boats to do. The watermen themselves investigated the new technology by forming a company and building their own steamer, appropriately named *PS Waterman* (1844).

The clash of interests and handling characteristics between pulling/sailing boats and steamers was tragically illustrated by the *Sydney Morning Herald* of 17 June 1841:

> A melancholy accident took place on Tuesday evening, through the swamping of a boat by the William the Fourth steamer on her coming up the harbour from Brisbane Water. It appears that a ferry boat belonging to the Balmain watermen, was taken by a small party, consisting of two men and one woman, they proceeded down the harbour and were met by the steamer which was stopped, on observing a boat ahead; they were told to keep out of the way, and instead of pulling off to one side they came just under the bows of the steamer; when it was thought she had got quite clear, the steam was put on, and the boat unfortunately run down, and although every effort was made to save them, one man could not be found.

PS Waterman was introduced to serve the Balmain area which had come under development after land auctions in 1836. She would have provided a much quicker way to town from Balmain than either by track or small boat and would have markedly encouraged speculation and growth of the area she served. *Waterman* was soon to be sold to other ferrymen to become part of larger organisations, but the small boat watermen kept working. (See also Chapter Three.)

From the 1840s, two quite distinct strands of marine commerce developed on the harbour. The more obvious was, and is still, the scheduled ferry run. Such services, originally with both passengers and cargo, divided into dedicated passenger and specialised cargo services. The last cargo service died out in the 1920s. From the passenger services developed the excursion trade and purpose-built excursion vessels. *Sophia Jane*, with Captain Biddulph showing his ship to the gentlefolk of Sydney, can well claim to have carried the first local excursion passengers.

The second, and less well-documented strand involved the hardy watermen and their boats. As steam ferry services spread around the port, the watermen survived by servicing areas too sparsely settled to justify a steamer. Watermen took travellers to far flung outposts such as Manly. They also provided a crew service to ships at anchor in the port. From these services came such variations as 'Press' and 'Butcher' boats. Crews of these boats would range far out to sea

to be the first to board an incoming ship to get the latest 'intelligence' or an order from a meat-starved crew.[6]

From these boatmen developed the Picnic Launch. The arrival of the small and relatively cheap steam engine was soon followed by the small, compact internal combustion engine. Boatmen and women now had a flexibility of operation for the first time. Sydney's watermen now had the use of new technology and a city with people numerous enough to enjoy group harbour picnics at chosen holiday sites. In the 1880s much of Sydney's waterways were still distant from the inhabited areas. Picnic grounds flourished along Middle Harbour and the Lane Cove and Parramatta Rivers. The launchmen flourished with them:

BOATMEN'S FARES, BOATS AND STEAM LAUNCHES

Boatmen's fares. — To and from any vessel in Sydney Cove, 6d.
To any vessel in the stream, 1s.6d.
To any vessel between Fort Denison and Millers Pt. 1s.6d.
To any vessel between Fort Denison and Bradleys Head, 2s.6d.
To any vessel between Bradleys Head and Watsons Bay, 4s.6d.
To Mossmans Bay, 4s.
To Dawes Point, 6d.
To any place between North and South Heads, 7s.
To Quarantine Ground, 8s.
To Manly Beach, 8s.6d.

LICENSED WATERMENS STAIRS WITHIN THE CITY

The Princes Stairs, Circular Quay, Queens Wharf, Circular Quay, Next A.S.N. Co's Wharf, Circular Quay.
Fort Macquarie.
Dawes Point.
Erskine Street.
Market Street and Margaret Place.

Boats may be hired with or without watermen from 3s. to 4s. per half–day, in Woolloomooloo Bay (Ireland), (Yates),

Dawes Point, next Mercantile Rowing Club (Ward); next Gaslight Co.'s Wharf (Miller), (Buckley); and at Double Bay from Stannard.

Steam launches may be obtained at from five pounds per day from Parramatta Steam Co.[7]

Guide books to Sydney from the 1870s onwards show many such launchmen and picnic launch companies, two of which carried names still well known around the Sydney waterways: Stannards and Messengers.

The first period of the Port Jackson watermen and women may be considered to have ended about the mid 1880s. By this time, scheduled steam ferry services were available to most of the shoreline from Manly to Parramatta along both shores. Population densities meant the low speed and small capacity of the waterman's launch, when the high fare asked was considered, could

not compete with Sydney's developing aquatic mass transport system. Even for short or narrow crossings, cable punts and bridges existed. Steam vehicular ferries also provided another dimension in heavy-lift commuting across the gap that would one day be filled by

> There the proud arch, Colossus-like, bestride Yon glittering streams, and bound the chafing tide … [8]

The Sydney Harbour Bridge did come. It may have affected the scheduled steam (and motor) ferries much more than it did the watermen or launchmen. Picnics were still popular, ships still came to anchor, and the harbour's sailing races were more popular than ever.

SCHEDULED RIVER STEAMERS SERVICES

Discontent in the Hunters Hill and Lane Cove River area with the services to Sydney provided by Edye Manning's ferries was general and constant. As with so many other areas, the locals wanted a better service and lower fares and were vocal about the drawbacks of the Parramatta River ferry service.

Several meetings were held to discuss what might be done — the options ranging from bridging the Parramatta River to improving the cable punt service to connect with better roads. The idea of running an opposition steam ferry to run in conjunction with a horse-drawn omnibus also appealed. The matter came to a head when the Hunters Hill ferry service was reduced to one each way every day after one boat was withdrawn from the run. Even this 'service' was at an inconvenient time as part of the Sydney-Parramatta run. The locals were forced back to using their own small boats, and much was made of ' … with an annual outlay of £7500, Edye Manning was earning from the river community a profit of £6500 pounds'.[9]

In the early 1860s, Jules Joubert, tired of lengthy delays to and from the city, chartered steam yacht *Ysabel* (*Isabel*) from P.N. Russel and Co. and commenced a five round trip a day service from the Lime Street Wharf (city) to Hunters Hill and Tarban Creek (Villa Maria). He said that the 'Parramatta River trade was a monopoly. Steamers called at unsuitable hours … at exhorbitant rates. P.N. Russel & Co. had a suitable screw vessel … to sell.[10] Instead of the usual rate of 2s. and 6d. each way, Joubert asked just 1s. return from residents of the Hunters Hill area. Manning reduced prices, but even the nickname 'Jezebel' and rumours concerning her safety did not deter *Ysabel* and her operator. The interlopers held their ground and although *Ysabel* was not a good cargo carrier she earned Joubert enough in a few months to pay her way as well as some local wharf repairs. Suitably encouraged, the population of Hunters Hill looked for even better things.

At a meeting at Cowls Inn, Ryde, in September 1865, an operating company was formed to take over *Ysabel*'s charter for six months with an option for purchase of £1250. Shares to the value of £5000 at £5 each were to be offered.

Jules Joubert was to be Chairman of the company, and Charles Jeanneret the manager. Phillip Geeves suggests the founders were Joubert, Jeanneret, Campbell, James Farnell, James Devlin, Spurway and John Russel, as representative of *Ysabel*'s owners. The two leading figures in the new company were Jules Francois de Sales Joubert, born in France (1824–1907) and Charles Edward Jeanneret, born in Sydney (1834–1898). Joubert emigrated to Australia in 1839, first settling in Lane Cove in 1843 and then returning to Lane Cove in 1855.[11]

Just one year after facing and convincing a Parliamentary sub-committee of the prospects for the new Parramatta River service, Joubert was declared insolvent. A mercurial character, he had many ups and downs in a long life of which ferry services were only a small but important part. His brother, Didier, and nephew, Numa, played a greater ferry role, but to Jules goes the honour of being the first ferryman for his area.

Jeanneret married in 1857 and bought land on the Hunters Hill peninsular as had the Joubert brothers, Jules and Didier. His long interest in and involvement with ferries and the waterfront may have been inspired both by the Jouberts and by his new landholdings. In later years, Jeanneret would be wharf-owner, alderman, politician and magistrate.

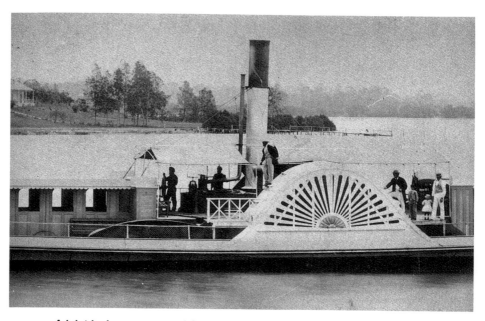

Adelaide, later renamed *Swan*, was considered the best style of river ferry in the 1870s. In this photo can be seen engine valves, steering wheel, passenger clothing details and a small ship's boat stowed on its side to the left of the paddlebox. [Graeme Andrews Collection]

The new river service quickly had an effect on the established company. The removal of the well-populated Hunters Hill area from the Manning 'catchment area' caused Edye Manning to suggest some form of cooperation. This was rejected. By October 1865, the horse omnibus 'Yankee' was running connecting services for passengers from Ryde to Hunters Hill ferry wharf. The system was working so well that services were extended to Pennant Hills and Ryde, using the new wharf built at Ryde in 1863. The first vessels in use by the company appear to have been *Ysabel*, then *Platypus* (1867) and the fast double-ended paddler, *Adelaide* (1866).

A move to amalgamate the old and new companies was made in 1866 with the older organisation's shares being valued at £7000 and those of the newer at £6000. A new share issue of £15000 was agreed, and joining of the two companies was achieved in May 1867.[12]

Jules Joubert, perhaps with problems more pressing than ferries, seems to have taken less interest from about 1866–7, while Jeanneret moved the company ahead, building up its strength. By 1873 he was running the Hunters Hill Steam Ferry Company. In 1884, he used his excess ferry capacity on the Mossman's Bay and Neutral Bay Ferry Co. service (1882–85). Captain Amore was the manager. By 1881, Jeanneret had built a steam tramway service from the western side of Parramatta to the confluence of Duck Creek and the Parramatta River wharf site. The *Tramway Act (Vic.45)* was passed in August 1881, and steam trams were soon meeting the steamers *Cygnet* (1866), *Gannet* (1883), *Halcyon* (1884), and later, *Pheasant* (1889).

By 1888, Jeanneret had sold the whole system to Phillip Walker for £57000, although there is some doubt that Jeanneret received the whole sum. Walker ran the company until 1893 when it was recapitalised as a limited liability company under the name 'Parramatta River Steamers and Tramway Company, Ltd'. Jeanneret retained a marginal marine interest for another few years and was the proprietor of the Gosford and Parramatta Steamers Wharf in Darling Harbour in 1890.

With the Hunters Hill, Ryde and Parramatta River services apparently in good hands, the Joubert family ran a subsidiary Lane Cove River ferry service from 1871. Didier was manager until his death in 1881 when his son Numa Auguste Joubert (1840–1926) took over. The Hunters Hill and Lane Cove Steam Ferry Company ran the paddler *Kirribilli* (1860) on the Lane Cove River in the period 1871–1874, together with *Womerah* (1871), and from 1877 the screw steamer, *Aegeria*. Numa ran the company with success and flair, introducing many new ferries, all named after flowers or women, and became something of a local character:

> Monsieur N.A. Joubert lived in Fig Tree House — a chateau-like place built almost on the water's edge ... a giant Moreton Bay fig tree grew in front of the square tower, overshadowing the house and casting its reflections on the water that rippled and lapped against the stone retaining wall in the wake of the passing ferries. Ladies looking down from the windows would see the

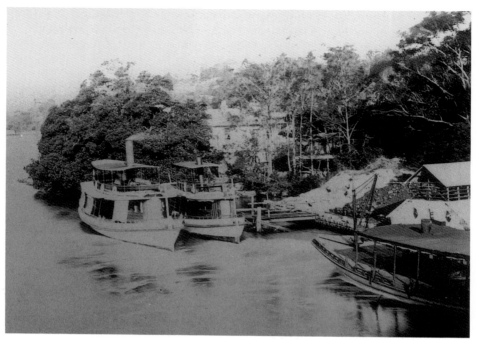

Early Joubert ferries near Figtree House. In the foreground is the cargo ferry *Iris*. *Pearl (2)* is outboard of (probably) *Rose (1)*. [Lane Cove Library]

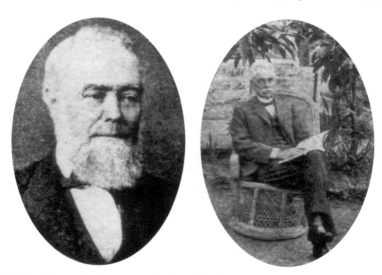

Didier Numa Joubert consolidated the Lane Cove ferry service after brother Jules moved on. Son Numa Auguste Joubert took the service to its greatest strength. [Graeme Andrews Collection]

Pearl, Daphne or the Lobelia plying from Fig Tree Wharf to Erskine Street; or the Iris cargo boat, puffing and fighting its way up the river, once daily, making more noise than the whole fleet put together — to which was later added the Rose and the Shamrock, giant boats that filled the river residents with pride.

Monsieur was a little, dark, highly-polished man. He wore a gold pince-nez, and always dressed in black — the black that parsons wear — ... clasping his hands in front as he bent graciously to inquire if they were enjoying the trip ... then upstairs to the wheelhouse to talk to the captain, or down to the engineer, who sat, fat and sweating amidst the thudding steel and signal bells, in view of the boarding passengers, who passed the time of the day with him. For the engineer and the captain had quite a standing on the ferries ... for Mons was proud of his fleet and the gentry of Lane Cove saw to it that social prestige was observed on board. The six and seven o'clock boats carried the workers; the eight and nine, bank managers and professionals; the ten and eleven, the ladies of leisure stepping daintily aboard in high-heeled shoes, disdaining to hasten, or to lower their bright silk umbrellas until well onto the plank, their men-folk standing back until all the ladies of class had passed on, then stepping briskly on in front of any women of the lower orders.

The gentry sat upstairs. The older ladies of that class went to the ladies cabin down-stairs, the men to the smoking cabin in the forepart if they desired to indulge, for no man would think of smoking upstairs near the ladies. The lower orders sat around the engine-room.

Any girl not of the genteel class who travelled on a boat later than eight o'clock was at once under suspicion of having a job that at least meant her boss must have a doubtful reputation ...

The ticket collector travelled between Erskine Street Wharf and Greenwich Point where the old Sobraon ... lay opposite; here he would wait for the incoming ferry to resume collecting fares. Any intermediate passengers paid their fares to the plank-boy ... [13]

While Numa Auguste Joubert was generally considered to be a civic-minded and a fair ferryman, not everyone was always satisfied with the service on offer. A dispute between Joubert and some ferry regulars resulted in the formation of an opposition service. The Lane Cove Co-Operative Ferry Co. lasted just one month before collapsing.[14] The real crunch came when the 'unfaithful' passengers re-applied for their usual monthly tickets. These were not available to them and they were required to pay daily full-rate fares. There was a great fuss and threats of legal action were made. Private boats began making the long haul to Sydney, but this activity soon palled and after a few weeks the uproar died away and monthly tickets became generally available again.

Not long after this dispute, Joubert added a new, larger *Rose* (2) (1898) and the even larger *Shamrock* (1901) to his fleet. *Shamrock* was Joubert's biggest ferry and could carry 400 passengers at 11 knots. Both vessels had the top passenger deck partly enclosed and were similar to and slightly larger than the Sydney excursion ferry *Mulgi* (1926).

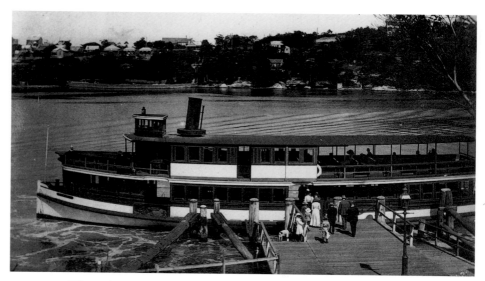

The pride of the Lane Cove fleet was *Shamrock*, shown loading passengers at Longueville about 1910. [Neg. 181, Lane Cove Library]

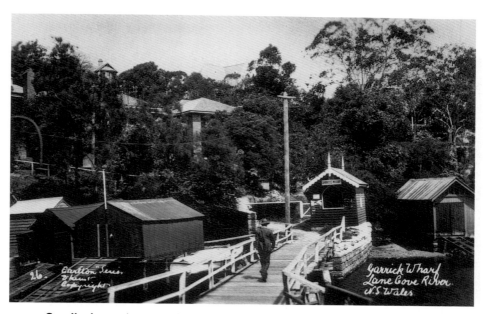

Small, almost 'personal' wharves, tucked in between private boatsheds allowed for an almost 'door-to-door' ferry service on the Lane Cove River. Garrick's Wharf is shown on this old postcard. [Lane Cove Library]

During an operating period of more than 35 years, the Joubert family's Lane Cove river services seem to have been the most successful family ferry company on Port Jackson. Working from a small but generally affluent area, the Joubert fleet worked to wharves sometimes only a short walk apart, and the relative lack of serious competition suggests the service was generally well run and popular. Apart from the competing company previously mentioned, local identity, A. Garrick, bought the old *Womerah* and *Aegeria* from the Jouberts in 1881 and to them added the *Rose* (1) (1881). *Rose* was soon sold to the Jouberts and the other ferries were sold away from the area.

Numa Joubert sold the ferry service to the Balmain New Ferry Company (BNFC) in 1906. Fred Jules went to the new company as traffic manager. At the time of sale, Joubert had a comparatively modern fleet of single-ended ferries, ranging from *Pearl* (3) (1884) to the *Shamrock*. The new owners gradually replaced them with the double-ended 'Lady' class. Some of this type were remarkably long-lived, carrying Sydney's commuters into the 1980s. Two existed intact in 1990.[15] By 1901 the Lane Cove ferry run was nearing its peak. Trams were already collecting from part of the ferry catchment area. The Gladesville Bridge allowed trams and later, motor cars, to cross the Parramatta River, heading for Sydney via the Iron Cove Bridge. The Fig Tree Bridge of 1885 crossing the Lane Cove River near Numa's home formed part of a road traffic route which boded no good for Joubert's ferries. The electric tramway was extended to Burns Bay Road, Lane Cove, in 1909.

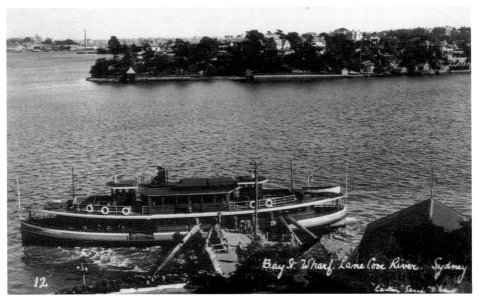

Double-ender *Lady Chelmsford* at Bay Street Wharf with Onions Point in the background. [Postcard, Lane Cove Library]

Although the Balmain New Ferry Company built modern double-ended ferries, the service went into gradual decline and was absorbed by the burgeoning Sydney Ferries Ltd. in 1917. This Company ran a gradually declining passenger service along the Lane Cove River until restricting it to peak hours only after 1946. At this time, the small ferry *Lithgow* (1927) tried a three month trial service from Longueville to Circular Quay. Lack of custom ended this attempt on 17 December 1946. Lithgow's operator was G.H. Newman, a local bus operator. When Sydney Ferries Ltd. closed down the river run completely in November 1950, private buses ran from Northwood and Longueville Wharves to Circular Quay. From 1950, ferries run by Charles Rosman, using mainly *Radar* (1947), provided peak hour services morning and night, calling at Alexandra Street, Longueville and Northwood. In 1992, the Rosman ferries were owned by Steven Matthews' Brystand Pty. Ltd., although still trading as Rosman Ferries. The fleet consisted of *Radar, Royale* (1974) and *Regal II* (1981)[16].

THE PARRAMATTA RIVER RUN

Paddlers, *Surprise, Experiment* and *Australia* were all intended to provide a regular, if not really scheduled service along the river to Parramatta. To run and sustain any such service, there must not only be enough capacity to provide a regular service, but there also needs to be enough vessels to allow for repairs, surveys and accidents. The formation of the Australian Steam Conveyance Company showed that the demand existed, but the one-ship company was not able to capitalise on this demand.

The place of the Australian Steam Conveyance Company was taken by a succession of ferrymen with Edye Manning, also interested in sea-going vessels, soon becoming pre-eminent along the river. The river service improved after the failure of the original company. In partnership with various people, including W. and T. Byrnes, Manning provided regular and efficient river services for the next 20 or so years. The Manning group was active into the 1870s, running, at various times, about 15 vessels, notably *Experiment, Kangaroo, Australia* and *Rapid, Emu* (1841), *Native* (1844), *Star* (1852), *Pelican* (1854), *Black Swan* (1854), *Pearl* (1) (1856), *Nautilus* (1856), *Peri* (1856), *Courier* (1) (1865) and *Cygnet* (1866). Some of these ferries were taken over from competitors or from failed services. *Star* came from J. Entwistle and partners who ran it in 1852-3. Some Manning ferries went to other groups or companies and there seems to have been a fair amount of wheeling and dealing of ferries as there is today.

W.S. Campbell in 1919 told of life along the river as far back as 1848 — the hey-day of the Manning group:

> Most of the country in the vicinity of the river was in its primeval condition, or nearly so, and in 1848 and for about five years afterwards was exceedingly beautiful.

The unidentified steamer in the background may well represent the first photograph of an Australian steamship. The view was taken (near Clontarf?) by John Smith on 23 November 1852.
[Historic Photograph Collection, Mackay Library]

The only wharves where steamers went alongside between the lower Parramatta Wharf, known as Redbank [near the junction of Duck Creek and the Parramatta River], and Sydney, were Pennant Hills Wharf and Kissing Point Wharf. At Bedlam Ferry and elsewhere, the steamers stopped mid-stream and passengers were transferred by local boatmen who charged what the trade would bear. Such an arrangement for landing was as awkward as it was disagreeable.

The time the last steamer in the afternoon left the old Phoenix Wharf for the Parramatta River was 4pm and it was not until 1857 that an additional boat was put on to leave at 6pm for Ryde.

Campbell explained the physical restriction of the tide on river traffic:

Along the water frontage of Elizabeth Farm were two wharves, one at Redbank and the other opposite Subiaco (Subeacca, as it was often termed). Here the steamers stopped according to the tide. If favourable, the steamer could ascend to the George Street Wharf, but, if not, passengers had to land at one of the others.[17]

In 1840, Edye Manning placed an order with the London shipbuilders, Ditchburn and Mare, to build a fast new shallow draught steamer for the Parramatta run. *Emu* was an iron double-ender which would have made the master's job easier in the narrow reaches of the headwaters of the Parramatta River. She was re-assembled by John Struth in Sydney and was launched in January 1842. Her shallow draught of just over one metre full load made *Emu* the successful progenitor of many of Sydney's future ferries. She would work the port for more than 20 years, with Manning using her layout for the later *Pelican* and *Black Swan*. Double-ended ferries, able to reverse direction without losing time turning around, have been an integral part of the Sydney ferry trade since that time.

In 1839, those wishing to travel by steamer to Parramatta had two services each way every day. Ferries left each end at 9.00a.m. and 4.00p.m.[18] At this time, the *Experiment*, *Australia* and *Rapid* seem to have had the steamer trade along the river to themselves.

Forty years later, the situation was much improved with the river ferries approaching their zenith. Gibbs, Shallard and Co's 1882 guide to Sydney illustrates their activity:

PARRAMATTA RIVER

The Parramatta steamer starts from the wharf at the end of King Street to Hunters Hill and Gladesville — 7, 9, 10, 11am; 12.30, 1, 3, 3.45, 4.15, 5.05, 6.15, 7pm. To Cockatoo, Hunters Hill and Villa Maria — 7, 9, 10, 11am; 12.30, 1, 3, 3.45, 4.15, 5.05, 6.15, 7.45, 9.30, 11.15pm.

Fares, 1s., return 1s.6d.

The points touched at along the way are Biloela, Fitzroy Dock [both sides of Cockatoo Island], Hunters Hill, Five Dock, Asfield, Burwood, Gladesville, Ryde, Ermington, Newington, Subiaco and Parramatta.[19]

At this time the Sydney to Parramatta River service was dominated by Charles Jeanneret. During the period 1873–1890, he had control of as many as 20 vessels, having 14 or 15 at his disposal most of the time. The requirements of refits, repairs, survey and breakdowns meant that the Company could probably call on about ten ferries at any given time. Between 1882 and 1885, Jeanneret also provided a service to Mosman and Neutral Bay, perhaps to employ excess ferry capacity and test that market. His attempts to maintain an efficient river service became more difficult as trains, trams and horse bus routes extended. Transit time from Parramatta to Sydney by train was less than by ferry, and the trains ran more often and were not affected by weather conditions. Increasingly, the ferries drew upon passengers who could either walk or use a short bus or vehicle ride to the wharf. Removal of the Parramatta terminal to Redbank reduced the ferry steaming time but increased total travel time as the steam tram had an add-on effect. There were now many wharves along the river and each presented its own berthing or

passenger problem. The master had to cope (as they do today) with the ever-changing problems of tide, wind, current and load distribution.

A booklet, *The Water-Way to Parramatta*, published in 1896, provides a good description of the trip along the river late in the last century:

> To the left the tall chimneys of Morts Dock works in Waterview Bay divide the attention with Goat Island on the other side ... We are now fast to the wharf at Cockatoo an island known to history as not one of the pleasantest memories of the old penal system ... From Cockatoo, and on the way across to Pulpit Point, on the opposite side of the river, we pass Spectacle Island, the Imperial magazine and depot for the stores of war ...
>
> Pulpit Point is the goal for Fern Bay excursionists, being the popular place of amusement owned by Messrs Lane Brothers, who have established a reputation as first-class entertainers of holiday throngs ...
>
> From Drummoyne we hark back to the north bank to the wharf at Hunters Hill. A first glance at 'The Hill' suggests to the stranger that it is a high-toned locality and the home of moral rectitude and inquiry confirms the suspicion... Near Chiswick is also the handsome family residence of the late Dr. Fortesque and at Blandville, that of Mr. Forsythe, but, before reaching Blandville we pass within a short distance, on the right hand side, the broken column erected on a rock in the river to the memory of Searle, the champion and unbeaten sculler of the world.
>
> This is the locality known as 'The Brothers', a familiar spot to countless thousands of people as the finish of the champion aquatic racecourse ...
>
> On one side of the Abbottsford landing are the traces of the old punt that once carried traffic across the river at this point before the Gladesville Bridge was built ...
>
> The tram from Sydney runs to Abbottsford now, and as a natural consequence some of the sylvan beauties of the neighbourhood have been broken into by the jerry builder and the jangle of the time-payment piano has taken the place of the matin song of the birds and the strident challenge of the early rooster ...
>
> Leaving Gladesville ... to Cabarita which is also the landing for Correys Gardens ... it is on record that on the last Eight Hour Day, the two Parramatta River Steamship Company's boats Pheasant and Aleathea delivered somewhere about three thousand excursionists, almost equally divided between those grounds and those already mentioned at Fern Bay ...
>
> Ryde, as seen from the river, is a decidedly pretty spot with a peaceful, contented, old fashioned sort of air about it that speaks of solid, even slow, progress, and life in some of the secluded and picturesque cottages that adorn the water frontages would seem as though it ought to be a dream of bliss, which perhaps it is ...
>
> From Newington we cross the left-hand branch of the Parramatta River, known as Duck River, and on which was erected the first windmill in the colony in the year 1797, and in a few minutes time are landed at the Tramway Reserve at the junction of the two rivers. The trip by water is now over.

We have covered about 13 miles, and including all stoppages, have only been a trifle over an hour and a quarter about it in the fast and comfortable Pheasant, the latest addition to the Company's fleet. Between the last landing place and our destination there is yet a distance of three miles to travel, and this is comfortably done in the steam tram, which is also run by the Company.

Jeanneret's eventual sale of the business to his friend Phillip B. Walker in 1888, according to Jeanneret, appears not to have been all he would have wished. The sale price of £57000, to be paid in cash upon delivery, seems to have been somewhat diluted. There was apparently a delay and Jeanneret claimed to have eventually gained the agreed sum less Walker's claimed £5000 commission. Walker soon sold the transport company to the Sydney and Parramatta Wharves, Steamers and Tramway Co. Ltd. registered in London, for an impressive £125000. No wonder Jeanneret was aggrieved, claiming to have lost about one-third of the value of a business which he claimed had been earning him a clear profit of £8000 a year.[20] Jeanneret died of cancer at Wyrallah, New South Wales, on 24 August 1898 and was interred in the family vault at Ryde.[21]

The Parramatta ferry service between 1893 and the takeover by Sydney Ferries Ltd. in 1917 provided perhaps the peak of the service. The company's biggest ferry, *Bronzewing*, went into use in 1899. She could carry about 500 passengers and could bring them down-river at better than 12 knots in peak hour trips. Walker's main passenger vessels of the time were *Bronzewing* (1899), *Pheasant* (1889), *Halcyon* (1884) and *Aleathea* (1881). Development of Sydney Ferries Ltd. from its genesis on the North Shore is discussed in Chapter 3.

EXCURSIONS, REGATTAS AND PICNICS

Numa Joubert was quoted by Henry Gerdes as saying: 'Regular passengers were only an excuse to put into the Quay; it was the tourists that made the service pay'.[22]

With those words, Joubert may well have summed up the reasons for the overall success of the Sydney ferryboat. While most Sydney ferry services developed because of a perceived need or as a back-up for real estate speculation, commuter services tended to be passenger-weighted at either end of the working day with little loading at weekends. Encouragement of 'tripping' and 'tourist trips' started very early on the harbour. The excursion steamer is contemporary with the passenger ferry in Sydney, but it was only in the period after the 1960s that the two types separated into two distinct design types.

Ferries such as those of Joubert's Lane Cove River fleet served a number of established picnic grounds in the days before the houses of Sydney's wealthy forced other interests away from the foreshores. Rowing and sailing regattas were generally popular from as early as the 1850s and group picnics were

common and popular. Sydney's excursion vessels have served many millions of Sydneysiders attracted to the exhilarating waters of the port.

Three years after James Milson of Milsons Point fame bought Robertsons Point in 1853, he leased a large area to Messrs. Woolcott and Clarke who established an early colonial copy of London's Cremorne Gardens. The name has remained for the suburb. The gardens offered an Italian Walk, an Avenue, a Serpentine maze, supper rooms, and park furniture. Secluded walks led to secluded seats. Regular dances, firework displays and other attractions were advertised. However, by the 1870s, the site had become infamous for bad behaviour and families turned to other picnic grounds. The ferry fleet took the crowds to Cabarita, Clontarf, Balmoral, Manly and even Fairyland up the shallow Lane Cove River. Fairyland was still in business in the 1950s.

In addition to rowing and sailing regattas, there were three notable events which illustrate the capacity of Sydney's ferryboats to cater for the crowds: in 1877, 21 ferries carried full loads to Middle Harbour to see tightrope artist Harry L'Estrange. He was to walk 340ft. (104m) above the water from Long Bay and Cammeray, a distance 1400ft. (427m). Observers suggested that there were about 8000 people there on the day. It is said that Mr. L'Estrange had thoughtfully chartered all the ferries well before the day of his performance.

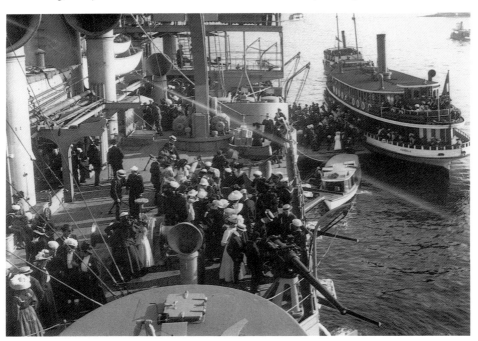

Dwarfed by the battleship *USS Connecticut* is Sydney Ferries' *Kareela* as she brings another load of Sydneysiders, avid to inspect the Great White Fleet. [Graeme Andrews Collection]

In 1908, the American Navy's Great White Fleet had Sydney all agog. Naval historians trace the birth of the Royal Australian Navy to the public interest in naval defence generated by the sight of the battlefleet in Port Jackson. Sydney Ferries Ltd. later claimed to have carried more than one million Sydneysiders on trips on the harbour to see the fleet — in one week!

From about 1914, the Balmain New Ferry Company and later, Sydney Ferries Ltd., ran the steamer *Lady Rawson* as a concert boat. She may have been the first 'permanent' cruise ferry. *Lady Rawson* carried a piano and often carried musical groups. Typical of her cruises was the afternoon run from Sydney Cove to Fig Tree. She left the Quay at 3.00p.m., arriving at Fig Tree about 20 minutes later. Passengers would patronise the Fig Tree Tea Rooms or Mrs. Waller's Tea Rooms (Mrs. Waller was said to be sister to one-time Premier of New South Wales, Jack Lang). Some people would take the short walk across the opening bridge and then scurry back to return to Sydney when the *Lady Rawson* left at 4.00p.m. Courting couples might explore some of the more secluded paths, intending to go home on the 8.00p.m. boat, but care had to be taken to avoid those paths which led to the many two-up schools whose lookouts (cockatoos) would warn of anyone approaching.[23]

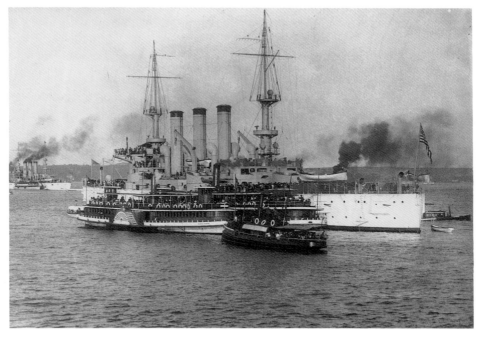

Battleship *USS Kansas* attracts a gaggle of ferries — paddler *Bunya Bunya* is outboard of one of the newer ferries, possibly *Kulgoa*, while a small river passenger–cargo steamer awaits its turn.
[Graeme Andrews Collection]

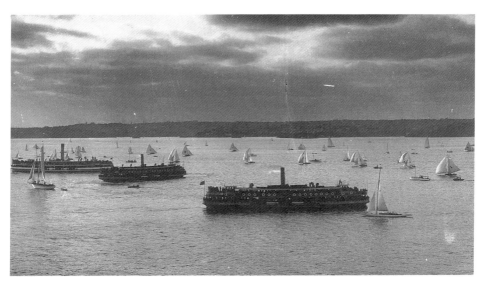

**Three of Sydney Ferries' biggest follow the races. From left:
Kuttabul, Kai Kai and *Kulgoa*. All three have extended controls above
one wheelhouse to allow the master to see over the crowd.**
[Humphrey Collection, Australian National Library]

While special happenings on the harbour have always attracted Sydney
families, a steady, non-commuter income was always welcome. Sailing races,
particularly the '18' and '16' footers, together with other class racing, was the
answer for much of the period between the World Wars. Some idea of the vol-
ume of interest may be gathered from this magazine advertisement:

> DON'T MISS NEXT SATURDAY'S OPENING RACE
> The Sydney Flying Squadron's 18 footers Mark Foy Handicap.
> The Sydney Ferries Ltd. large steamers follow the race.
> Steamers leave as follows, wet or fine, every Saturday:-

Lavender Bay and McMahons Point at	1.45pm
John St. Pyrmont	1.45pm
Stephen St. Balmain	1.50pm
Darling St. Balmain	2.10pm
No.2 Jetty, Circular Quay	2.10 and 2.40pm
Woolloomooloo Bay	2.35pm
Rushcutters Bay	2.35pm
Double Bay	2.50pm[24]

A panoramic composite photo of about this period, shows eight large fer-
ries, including *Kuttabul* (1922) and *Koompartoo* (1922) (rigged as an excur-
sion steamer) with *Karingal* (1913), recently converted to diesel power.

In the period between the two World Wars, audience involvement in the
sailing races went well beyond mere barracking and cheering. Race organisers

had gained permission in 1917 to run organised gambling 'sweeps' on the races, but this was not enough for many patrons. The sail crews were often a rough and ready lot, with as many as 18 in a boat rated as an 'eighteen footer'. Fisticuffs and disagreements over right o'way were common. The onlookers were just as vigorous, and gambling on the races was widespread and well organised. The Government of New South Wales tried to restrict gambling aboard the ferries with amendments to the *Gambling and Betting Act*, assented to on 4 October 1938. The police quickly used their new powers. On 16 October, police raided *Koompartoo* and *Kuttabul* and arrested 13 men. The charge was: 'That they had been found in a street, to whit, a vessel used in navigation on the harbour of Port Jackson, for the purposes of betting'.[25]

The New South Wales Sailing League was furious. Its President claimed that banning sweeps and betting would cause the League to lose so much money that fewer ferries would be chartered, employees would lose their jobs, and race prize monies would become minimal. He had a point. On the day of the raid, perhaps with rumours abroad, only 1863 adults, instead of a more usual 8000, went afloat to watch the racing.[26]

State laws and police raids never really succeeded in doing away with activities said to be illegal on the ferries on race days. In the late 1980s, two police officers had to resist being thrown overboard from a small ferry following the races — old traditions die hard.

The introduction of purpose-built Showboats, the Manly Excursion Steamers, and the cruise and excursion boat boom of the Vietnam War and post-Vietnam War era, are described in Chapter 7.

NOTES

1 Alan Birch and David S. Macmillan 1982, *The Sydney Scene, 1788–1960*, Sydney, p. 9.

2 Isadore Brodsky, 'Serenade Of Sydney', *Saturday Journal*, n.d.

3 Eric Russell 1970, *A Lane Cove History 1788–1970*, Sydney, p. 104.

4 R.J.B. Knight and Alan Frost eds. 1983, *The Journal of Daniel Payne, 1794–1970*, Sydney, p. XXVII.

5 See also note 15, Chapter 1.

6 An excellent description of the use of the Butcher Boat may be found in an article by Bert Paul, 'Butcher Boats of 20 years ago', *Australian Motor Boat and Yachting Monthly*, July 1929, p. 38.

7 Gibbs, Shallard & Co. 1981, *An Illustrated Guide to Sydney, 1882*, facsimile edition, Sydney, p. 134.

8 From Erasmus Darwin 1982, 'Visit of Hope to Sydney Cove', *The Voyage of Governor Phillip to Botany Bay*, facsimile edition, Melbourne, p. v.

9 M.C.I. Levy 1947, *Wallumetta*, Sydney, pp. 102–3.

10 Jules Joubert 1890, *Shavings and Scrapes*, Hobart, p. 77. It is interesting to note that Joubert spelt the vessel's name *Isabel*, against *Ysabel* in other sources.

11 D. Pike, ed. 1966–1974, *Australian Dictionary of Biography*, 5 vols, Melbourne University Press.

12 Philip Geeves 1970, *A Place of Pioneers*, Sydney, p. 94.

13 Rose Lindsay 1964, *Ma and Pa*, Sydney, pp. 40–2.

14 Notice 1894, *Government Gazette*, Vol. VI.

15 In 1990, *Lady Chelmsford* (1910)was operational as a cruise boat on the Yarra Yarra River, Melbourne, after many years in a similar role in Port Adelaide. *Lady Denman* (1912) has been established as a relic ashore at Huskisson on the NSW South Coast.

16 Russel, pp. 104–108, 152–159.

17 W.S. Campbell 1919, 'The Parramatta River and its vicinity, 1848–1861'. *Journal of the Royal Australian Historical Society*, Vol. V, Pt. VII, pp. 251–283.

18 James Maclehose 1977, *Picture of Sydney and Stranger's Guide to NSW for 1839*. Facsimile edition, Sydney, p. 181.

19 Gibbs, Shallard & Co. 1882, Sydney, p. 97.

20 Geeves, p. 123.

21 *Daily Telegraph*, 25 August 1898.

22 Brodsky 1957, *Sydney Looks Back*, Sydney, p. 219.

23 Memories attributed to the late Joe Howard, maintenance man and general factotum at Fig Tree Wharf from about 1900.

24 *The Open Boat*, 21 September 1935.

25 *The International Power Boat and Aquatic Monthly*, 10 November 1938, p. 12.

26 *Ibid.*

For additional reading on the Parramatta River and Lane Cove River services see:

Harold Norrie 1935, 'Sydney's Ferry Boats', *RAHS*, Vol. XXI, Part 1.

Margaret Swann 1935, 'Early Ferry Services of Parramatta', *Journal of Parramatta and District Historical Society*, Vol. IV.

M.E. Deane 1937, 'Reminiscences of Parramatta and Lane Cove Steamers', *Royal Australian Historical Society*, Vol. 23, Part 3.

A.M. Ward, 'Parramatta River Ferries', *Port of Sydney Journal*, Maritime Services Board. 1967–1970.

'The Water Way to Parramatta 1896', reprinted in the *Western Suburbs Courier*, 19 and 22 January 1986.

CHAPTER 3

INNER HARBOUR SERVICES

DARLING HARBOUR, JOHNSTONES BAY, ANNANDALE, BALMAIN, MORTS DOCK.

The technological advantages of the early Parramatta River steam ferry services justified the relatively high fares charged. Alternate means of going to and from Parramatta did not excite admiration.

Ferry services in what can be loosely described as 'Inner Harbour-South Shore', had similar advantages early on but lost them more quickly as the increasing population filled in the open spaces around the edge of the city. Initially the ferries servicing the Parramatta run called at Balmain and Long Nose Point as these were on the direct ferry route along the river. As the population grew and as industries developed there was a need for more than watermen and spasmodic river ferry visits.

PS Australia was the first steamer to attempt a regular ferry run around the Cockle-Bay (Darling Harbour) area. Displaced from the Parramatta River by newer vessels, she moved to the short haul — almost direct routes to this area from the city. She would have caused some concern among those doughty watermen who had been using muscle and sail power to serve the area. Their reaction was prompt but not too effective. In 1844, the Waterman's Company was formed to operate the new paddle steamer *Waterman* (1844) on the short haul routes. She was about 15m long, had an engine of about eight nominal horsepower, and was soon hard at work. She became notorious for not being able to maintain steam pressure and her passengers are said to have described this as 'Stopping to get her breath'.[1]

An advertisement from the Balmain Ferry Company in the *Sydney*

Looking from near Jones Bay towards the Balmain Peninsular, H.Gritten recorded this scene in 1854. Ferries identified are *Ferry Queen* and *Waterman* (far right). At least one of the houses can still be seen.
[Marian Michell, Perdriau Family Archives]

Morning Herald of 29 October 1844 shows how the budget-priced steamboat (£175) must have drained the resources of those independent watermen who had built her:

> The Balmain Steam Boat Waterman, having undergone a thorough repair, with new paddle shafts and wheels, by Rogers, Buller & McVeigh, Engineers and Millwrights, will again resume plying on Wednesday, the 30th instant, from the Gas Company's Wharf to Balmain Ferry, every quarter of an hour from light until dusk for the accommodation of the public.

Any ferry run that takes just 15 minutes for a round trip, including loading and unloading, is short indeed. *Waterman*'s run at this time was usually from the Gas Company Wharf to the small bay to the south of St. Mary's Church, Balmain.

Henry Carter Perdriau was born in England on 5 November 1817 of an aristocratic family whose parents left him orphaned by the age of seven. He went to sea and made several voyages to Australia before 1831. He settled in Sydney during the 1830s, possibly sailing on local trading craft and made at least one voyage back to England. His activities around Sydney were then mainly maritime. He married in 1844 and in that year was one of the group that started the Balmain ferry. This group included Mr. Fennimore. One source has them running *Waterman* on the Darling Street Balmain to

Henry Carter Perdriau (1817–92)
[Perdriau Family Archives]

Gasworks and Grafton Wharves; probably she ran to a number of sites around Balmain.[2]

In 1847, J. Entwistle (also spelt Entwhistle) and Marshall put the *Gypsy Queen* (1845) on the run around Balmain in competition with *Waterman*, then owned by Henry Carter Perdriau. *Gypsy Queen* ran from the Burnbank Hotel Bay, near the mouth of Johnstones Bay, to Sydney. Entwistle and Marshall added the small ferry *Pet* to their service at about the same time.

Perdriau sold his interest in Waterman for £300 and went to the goldfields, returning in 1853, presumably successful in his digging. In partnership with Buckham and Hunt, he bought *Waterman* and the Entwistle and Marshall fleet and then had the new ferry *Alma* (1855) built by J. Booth of Glassop Street Balmain. Booth was a life-long friend of Perdriau and became the first Mayor of the Municipality of Balmain.[3] With the arrival of *Alma*, the Johnstones Bay service was extended to Bald Rock at the head of Johnstones Bay. The Bald Rock Wharf was also served by the small ferry *Kirribilli* (1860) which ran to Adolphus Street Balmain soon after completion.

The Perdriau service faced competition in about 1856 from Melbourne businessman, Samuel Crook, who imported, in knocked-down form, three paddle steamers for use around Balmain. *Nautilus*, *Peri* and *Pearl* (1856) were sisterships, capable of carrying about 60 passengers on the Adolphus Street, Erskine Street, Sydney run. This challenge disappeared when Perdriau took over the Crook fleet in about 1858. Ten years later, William Bates ran *Gomea* (1868) and *Galatea* (1868) in opposition, but failed to dent the established company. A second try by Bates from 1870 with *Warrah* (1869) and *Womerah* (1871) also failed. In 1871, Perdriau was sole owner and the ferry company was valued at £6220.

Notable ferry masters in the Perdriau service of the 1870s were Captain A. Begwell who later worked for the North Shore Ferries in 1876, and Captain Murden who left the company in about 1881, about the same time that Henry Carter Perdriau began to develop other interests. His son, Henry, explained in an article in the *Sun* of 26 May 1929:

In the late seventies, my father who was now in complete control of the company, sold the Johnstones Bay ferries to Mr. John Watson. My brother Stephen and myself now bought my father out and in 1881 we sold the Morts Dock ferries to a syndicate which included Mr. John Woods and Mr. Forsythe. This syndicate later became the Balmain Ferries Ltd.

Henry Carter Perdriau served as Balmain's second Mayor during 1868–1875 and died on 22 January 1892.

The Balmain peninsula's ferry services expanded when Thomas Sutcliffe Mort and Captain Rowntree began their shipping and engineering business in Waterview (Mort) Bay. The influx of workers and the population increase resulted in new ferry services on both the north and south shores of the peninsular. Sites of some of these wharves are now covered by landfill or modern shipping wharves. The present Balmain coal-loader has 'evened-up' the shoreline. The Bald Rock Wharf was near Roberts Street and there were wharves at Stephen and Gordon Streets nearby. A look at Sydney street directories of the 1990s shows many 'Ferry' and 'Wharf' streets, some in places now well away from the water.

Several ferry routes crossed Darling Harbour to the inner suburbs south of the Parramatta River and along its south bank. At one time a ferry ran as far as the southern end of Hen and Chicken Bay (defunct about 1905). Nearer to the city, one of the shortest ferry runs may well have been from Lime Street, just a few hundred metres across Darling Harbour to John Byrnes Wharf, Pyrmont.[4]

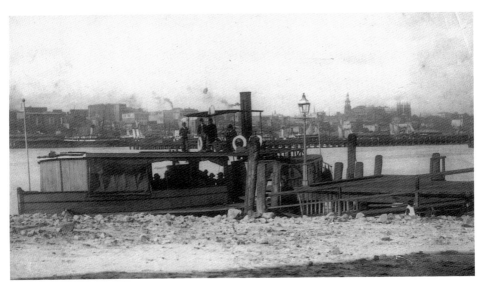

Typical of Perdriau's Balmain ferries was *Leipoa* (1872). The enclosed, women's saloon is at right. Canvas covers suffice for the higher-sited men's/general seating and there are open-air seats above the saloon and around the funnel. [Mitchell Library]

The Annandale ferry route called at Pyrmont Wharf (at the north end of Harris Street) or, alternatively, at the end of wharf Number 20, Pyrmont, then passing under the Glebe Island Bridge to Glebe Point (Glebe Point Road) and Johnston Street in Rozelle Bay. On the northern end of the peninsular, ferries called at Darling Street, Balmain; Yeend Street; Thames Street; and probably on demand, the wharf at the south-west end of Goat Island.

The formation of the Balmain Steam Ferry Company in 1882 spelt the end of the Perdriau family as a ferry force although they continued to run ferries as general charter and excursion vessels. The Balmain Steam Ferry Company was the first serious attempt at providing a small area-based public ferry company, as different to family services operating in much larger areas, around Balmain. Among the directors were Thomas Hesleton (also involved with the Manly service), J. Casey, John Woods, and A.W. Gilles. In 1882, this company offered services from Erskine Street to Darling Street and Dry Dock (Morts) starting from 5.35a.m., 5.50, 6.20, 7.05, 8.05a.m. and every 15 minutes to 12.00p.m. Saturdays had more frequent services, and on Sundays boats ran every half an hour from 9.00a.m. to 9.30p.m. Another service ran from Erskine Street to Stephen Street and Bald Rock almost as often along the south side of the peninsular. Fares were 3d. In 1884, S. Briggs was the manager and C.E. Moreton the company secretary.[5]

Bigger and better ferries matched the competing omnibuses and later trams. The Balmain Steam Ferry Company was handling up to 400 passengers, with steamers double-ended to save terminus turn-around time. For the first five years or so, the Balmain Steam Ferry Company competed with the Watson group's ferry fleet until it bought out the competition. Thomas Henley's Drummoyne, Leichhardt and West Balmain service competed from 1899 to 1906, and the Annandale Co-operative Ferry Company Ltd. worked for seven years from 1897. Competition and the depression of the 1890s left the Balmain Steam Ferry Company too weak to compete when another new company entered the ferry fray.

Local people often consider that fares are too high and that they are being used as a 'milk cow' by avaricious private transport operators. Often they are prompted to start their own competing ferry service in retaliation, but these services quickly dissolve due to the economic realities of operating ships. Jeanneret on the Parramatta, and the Balmain New Ferry Company around Balmain, were notable early exceptions. The formation of the Balmain New Ferry Company as an opposition service in 1892 forced the Balmain Steam Ferry Company to amalgamate with the newcomer by 1900. The newcomer's fare cuts were the trump card.

This was boom and development time for all of Sydney's ferries. The private motor vehicle was still just a stuttering blue cloud on the horizon and housing and worker densities around the shores of the port allowed ferries to maintain loadings despite the inroads of tram, train and horse-drawn transport. As the population grew, so too did all forms of public transport. As the

Balmain New Ferry Company expanded on the inner harbour to the west, so too did the services to the North Shore and to Manly. The North Shore service would ultimately control all inner harbour services and, eventually, through the State Government, the Manly service.

Max Solling of the Glebe Society, in the Royal Australian Historical Society newsletter in August 1976, told how the Balmain Steam Ferry Company offered discount fares of seven trip tickets for just one shilling in an effort to outbid the lower-priced and more vigorous Balmain New Ferry Company. It was to no avail. Although the Balmain Steam Ferry Company had maintained technological equivalence with its contemporaries, the Balmain New Ferry Company looked to new ideas and much of the results of their innovations have lasted well into the twentieth century when the company is just a memory.

The late Isadore Brodsky, in *Sydney Looks Back*, described the role of the Roderick family in the new company during this boom period. Oswald Roderick, the last of the family involved with Port Jackson, retired from the New South Wales Maritime Services Board in 1988 and in 1992 was living near Ballina, New South Wales. He quotes Roderick saying:

> The Ladies, in order of seniority are [in 1957] *Lady Chelmsford*, *Lady Denman*, *Lady Edeline*, *Lady Ferguson* and *Lady Scott*. *Lady Chelmsford* began as a river boat in 1910.
>
> There were Lady boats before them, many of them designed by Walter Reeks, each to be remembered for some distinguishing feature.
>
> *Napier* and *Manning* were the oldest of the line and were waterborne in 1892[6]; *Mary* which with *Edeline* shared in bearing Christian names, where the others bore dignitaries surnames; *Hampden* with an eccentric funnel, an

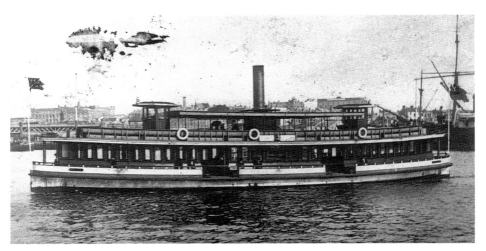

An expanded version of *Lady Mary* was *Lady Napier*. She worked from 1892 until 1928 and was broken up in 1934. [Duffy Collection]

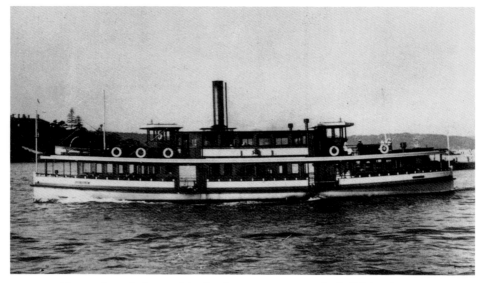

Shown here in her original guise as a steamer, *Lady Edeline* lasted from 1913 until October 1984, the last working wooden 'Lady' ferry.
[Duffy Collection]

open top deck and a siren which functioned with a preliminary drawn-out shriek; *Carrington*, fastest of the coke-burners; *Northcote*, nearly the counterpart of *Carrington*, smaller and with thinner smokestacks; and *Rawson*, broad in the beam, two-funnelled, queen of the concert boats and flagship of the fleet.

'Ossie' Roderick's grandfather, Anthony, was one of the founders and first chairman of the Balmain New Ferry Company; he was born in 1854 and had earlier worked as a hard-hat diver.

The *Lady Scott*, whose hull became the modern-looking cruising restaurant *John Cadman*, was christened at Jervis Bay by Daisy Roderick who explained to Brodsky the origins of the *Lady Mary*'s and *Lady Edeline*'s names. *Lady Mary* was named for a Mary Lygon and *Lady Edeline* after Edeline Strickland. *Lady Edeline* was to be launched at the foot of Waterview Street, Balmain, but she didn't want to go. The ropes were cut and the ways got more soft soap, and all and sundry pushed until she let go and took off down the ways. *Lady Edeline* became the last working 'original' Lady boat on Port Jackson, being retired in October 1984. She started life with the recovered steam engines of the recently-salvaged ferry *Birkenhead*.

Henry Gerdes started work as a deckhand in 1900 and worked on Sydney's ferries until he retired in 1953 as ferry master. He told Brodsky that all the Ladies handled differently, and said that *Rawson* was his favourite. The four Gerdes brothers followed their father, Herman Gerrard Anton Gerdes, to

work on the water. Herman had jumped ship in Sydney and, according to Brodsky, was crew on the 1845 *Ferry Queen*. Frederick Gerdes became a tug master with the Adelaide Steamship Company; Alfred worked on Newcastle's ferries; Herman Gerdes (Jnr) worked as a waterman on Port Jackson (his License No. 4, was issued on 24 August 1875); George Gerdes was relieved as master of the ill-fated ferry *Greycliffe*, just one trip before she was sunk. Henry Charles Gerdes received his Harbour and River Master's Certificate on 24 July 1906 from the New South Wales Department of Navigation. Nearly five years later, he was honoured by the Royal Shipwreck Relief & Humane Society of New South Wales for 'jumping fully dressed from the ferry steamer *Drummoyne*, near Elliott St. Balmain … and saving the life of a little boy who had fallen into the water'.[7]

Herman Gerard Anton Gerdes was contemporary with the Jouberts, and Brodsky comments on how closely the harbour's ferry people were intermingled. In the Balmain New Ferry Company at one time there was a Roderick, a Joubert and a Gerdes — all of them with origins in other ferry services. Anthony Roderick ran the business, Fred Joubert was traffic manager, and Henry Gerdes was a ferry master.[8]

The Balmain New Ferry Company consolidated its grip on the western side inner harbour ferry services. It absorbed the Balmain Steam Ferry Company in 1900 and Joubert's Lane Cove services and Henley's Annandale service in 1906. However, the Balmain New Ferry Company had only a few years to enjoy a near area monopoly. By 1917, it was facing declining patronage. How much of that came from the effects of improved tram services and how much was caused by the departure of many local men to the Great War, invites further study. In 1917, the Balmain New Ferry Company became part of the rapidly-increasing Sydney Ferries Ltd., the child of the Milsons Point North Shore service and a ferry colossus, of which more later.

THE RISE AND FALL OF THE 'HORSE PUNT'

Two kinds of vehicular ferries have crossed the harbour's waters — one pulled by rope or cable, the other self-propelled using propellers or paddle wheels.

The need for such a facility was early recognised: the first attempt to provide for wheeled traffic to the North Shore by paddle punt *Princess* was discussed in Chapter One. The *Illustrated Sydney News* of 12 August 1854 was almost as excited by the possibility of a vehicular ferry as had been the *Sydney Morning Herald* of almost a decade earlier:

> The union of the North Shore, Balmain and Pyrmont within the City of Sydney by means of steam bridges is the project to which we invite attention
> …
> It is with much satisfaction therefore that we find ourselves enabled to place before our readers accurate representations of a floating steam bridge.[9]

This particular, grandiose 'floating' or 'steam' bridge did not progress beyond the fulsome pages of a periodical, but the press has nevertheless continued to faithfully report the dreams and designs for new ferries ever since. Port Jackson would, eventually, be served by just 13 purpose-built paddle and propeller-driven vehicular ferries, aided and abetted in the early days by a few vessels converted from other duties or towing flat punts alongside.

The first such craft, *Princess* (1842), was ahead of her time. Whether she had side wheels or a centre wheel between two hulls as had Hobart's *PS Kangaroo*, just about a decade later,[10] is not known. She may have had a ramp at one end only, but there seems to be no contemporary illustration of *Princess*. There is, however, a fairly clear picture of a vehicular ferry of the 1860s and 1870s. A photo of sailing ships in Sydney Cove, dated 1870, shows at least one small obvious vehicular ferry tucked away under the bowsprit of a large sailer on the east side of Sydney Cove. The next vehicular ferry built after *Princess* was *PS Transit* (1866), subject of a much-copied and blurry photograph. Another seven years passed until the arrival of the next vehicular ferry, *Bungaree* (1873). It is reasonable to assume that these two photos show both craft, as all other later vehicular ferries have photos which show their names.

Earlier writers on Sydney's ferries had little interest in the vehicular punts or cable ferries. Norrie's standard paper on the ferries mentions only *Transit* and *Princess*.[11] Even though the Sydney Harbour Bridge was a wonder of the day and there were big, powerful punts laid-up, Norrie mentioned them not, although he did say that much had to be omitted from his paper for lack of time and space. A.B. Portus, in his two-part series, mentioned *Princess* but his paper ended before *Transit* arrived.[12]

James Milson, 'laird' of Milsons Point, may reasonably be considered as the founder of the present-day Sydney ferry system and certainly of the vehicular service prior to the bridge. In 1838 he attempted to promote a steam punt but lacked enough local support. A public meeting was called in 1840, involving Milson, to try to form a company to run a punt but nothing came of this. A few years later, *Princess* tried and failed. Attempts at towing punts alongside conventional steamers, including *PS Australia*, were made from time to time.

James and John Milson, Harry Jones, and William Milson Shairp ran a small ferry service to the North Shore from 1860, becoming the North Shore Ferry Co. in 1861. This organisation developed enough trade to justify two vehicular punts. The *Transit*, probably the first effective paddle punt in the port — her hull lasted until about 1900 and *Bungaree* (1878–1890). Then, at regular intervals as traffic increased, came *Warrane* (1883–1921), *Benelon* (1886–1932), *Barangaroo* (1890–1932), *Kamilaroi* (1901–1930), *Killara* (1909–1932 sold), *Kedumba* (1914–1932 sold), *Koorongabba* (1924–1932), *Koondooloo* (1924–1950 sold), *Kalang* (1926–1972) and *Kara Kara* (1926–1941 RAN).

This magnified small section of an 1870s view of Sydney Cove clearly shows a vehicular ferry. It seems to have loading space at one end only and is probably *Bungaree* (1873). [Graeme Andrews Collection]

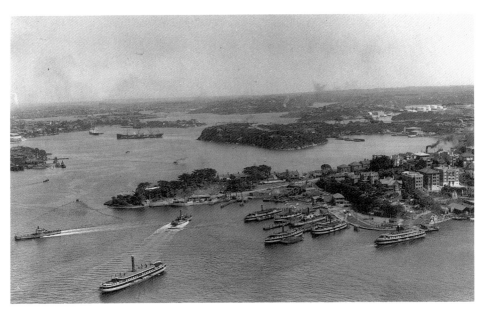

Sydney Ferries' base in its new location at 'Gibralter' between Blues and McMahons Points. In this early 1930s view can be seen punts *Benelon* and *Barangaroo* leaving and approaching the vehicle ramp while other ferries are laid up, awaiting the peak hour.
[Graeme Andrews Collection]

The early horse punts ran from Dawes Point to Milsons Point, landing very near to the site recently occupied by the relic bow of the World War I light cruiser, *HMAS Sydney*. Upon the introduction of *Warrane*, the main route across the harbour was from the western side of Fort Macquarie to Milsons Point, at a position more into the small bay than was the exposed earlier berth. Three paddlers, *Warrane*, *Benelon* and *Barangaroo*, worked this run until the turn of the century. Reformation of the (then) North Shore Steam Ferry Company to become Sydney Ferries Ltd. roughly coincided with the opening of a new, secondary vehicular ferry route from Dawes Point to Blues Point on the western side of Lavender Bay. This allowed two punt routes across the harbour. One wonders how long it would have taken to build the bridge if a suggested vehicular ferry crossing from Cremorne point to the Woolloomooloo area had developed.

About this time, the odd-looking vehicular ferry *Kamilaroi* became the first propeller-driven punt. She is said to have been given the derogatory nick-name of the 'Agricultural farm/Show'. This title may have come about from the cluttered and clumsy layout of her upper-works[13] or because she is said to have ferried the bigger animals across the harbour to the site of the new zoo at Athol, Taronga Zoo Park.[14] *Kamilaroi* had her wheelhouses on one side and passenger accommodation on the other with a centreline vehicle road. She had overhead stiffening wires and gantries and one of her better-known masters was Captain Leonard-Jonsson-Enmark whose home in Naremburn on the North Shore was named 'Kamilaroi.' According to an old, undated newspaper cutting, Captain Jonsson-Enmark died at Blues Point ferry base of a heart attack just after reporting for duty on the ferry.[15]

The vehicular ferry berths or slips were fitted with tapered timber guide-ways to assist the incoming ferry to berth across possible wind and tide. The open end 'bow' with its cable-operated link-span was above the matching shore-link. The shore-link was manually adjusted according to the state of the tide. One dock was provided at Dawes Point and another at Blues Point on the other shore (traces of the stonework exists at both sites). Double berths were provided at Fort Macquarie (Bennelong Point, site of the Opera House) and at Milsons point. The Milsons Point docks were moved eastward to the foot of Jeffrey street in 1926 as construction of the bridge required the area. In 1992 the Hegarty ferry service regularly serviced a wharf at this site. The biggest punts were used on the high-volume Fort Macquarie run. The smaller-capacity punts usually worked the Dawes Point ramp. *Killara*, *Kedumba*, *Benelon*, *Barangaroo* and *Kamilaroi* could be found on the Dawes Point-Blues Point route, but the *Kamilaroi* could sometimes use the other run as well.

Kedumba was sold to A.K.T. Sambell of Cowes, Victoria, following the bridge opening. The ferry slip that suited her was also sold and was shipped to Victoria for re-erection at Cowes and Stony Point on Westernport. The tug, *St. Olaves*, left for Victoria with *Kedumba* in tow in January 1933. In rough seas, near Montague Island, the unmanned *Kedumba* sank. Back to Sydney

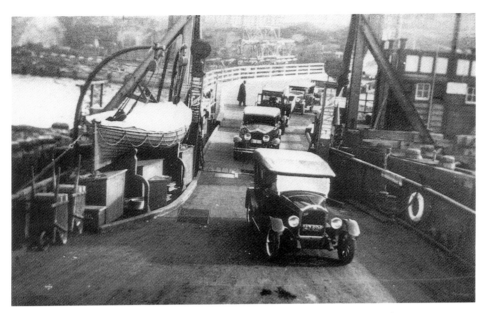

**One of the four large vehicular ferries takes on cars at the
Jeffrey St. ramp.** [Graeme Andrews Collection]

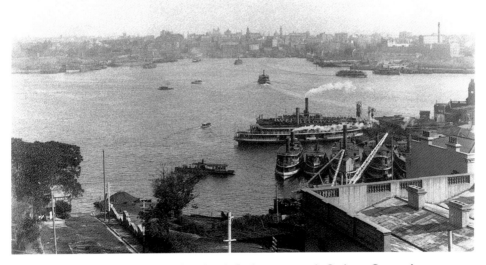

**Looking from Jeffrey St. North Sydney towards Sydney Cove: the
Milsons Point ferry base is soon to be moved to allow construction of
the Bridge. From left: *Lady Carrington* and *Lady Mary*, a *Kubu* class
and two smaller Ks. Side-on, *Kiandra* lies near a loading car ferry.**
[Graeme Andrews Collection]

came Mr. Sambell and bought *Kedumba*'s slightly older sistership *Killara*. *Killara* had been in use only as a spare ferry for some time and was not in as good condition as had been *Kedumba*.

Killara was refitted in Sydney and her accommodation was extended for her new role. She sailed under her own steam for Victoria on 13 March 1933 and, despite heavy weather, reached Westernport on 22 March. In Sydney she had been rated at 33 vehicles and 49 passengers, now she was rated at 35 vehicles and up to 1000 passengers — often carrying rather more. She could also carry around 1000 sheep on special runs. When the bridge joining Phillip Island and San Remo was completed in 1940, *Killara* soon became a barge and seems to have been broken up in Tasmania in about 1961.[16]

Vehicular punt services on Newcastle's Port Hunter were under similar pressure in the 1930s to those on Port Jackson and no bridge was planned. The solution was the ex Hobart punt, *Lurgerena* (1925) and the locally-built *Kooroongabba* (1921) which was soon sold to the Main Roads Board, initially for use at Peats ferry on the Hawkesbury River, but actually for use in Newcastle. Both big punts worked in Newcastle until 1971 when the Stockton Bridge was opened. They then joined *Kalang* in the abortive tow towards the Phillipines.

The three biggest Sydney 'horse punts' had interesting and varied careers after the bridge was built. Originally they sailed from the United Kingdom and subsequently all of them spent some time back at sea. *Koondooloo* was

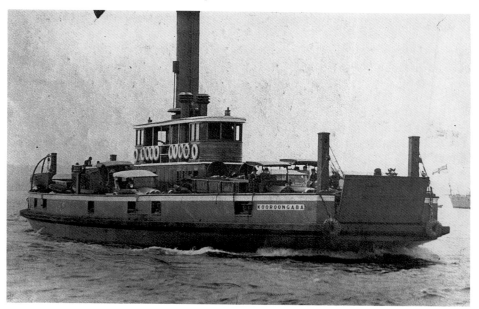

Kooroongabba had a long and successful career in Sydney and Newcastle before she sank at sea. [Graeme Andrews Collection]

It's 1991 and the beached hulk of *Koondooloo* has allowed the dunes
and beach grasses to extend the beach into the sea. [Author]

Unknown to most Sydneysiders and tourists, a cable ferry carries
cars and pedestrians across the Parramatta River at Putney. [Author]

converted into the prototype Sydney Showboat. She was given one almost full length enclosed deck and an open top promenade deck. She was rated at about 1700 passengers in this role. Following the conversion of her sistership, *Kalang,* into a showboat with two full-length enclosed decks with an open upper deck, *Koondooloo* also received a second enclosed deck, but did not have it long as she was requisitioned by the Commonwealth Government as an Army vessel from 1942 to 1946. She was converted back to her original car-ferry design in Newcastle by 1951 for use in that city. *Koondooloo* ended her career on the beach at Trial Bay.[17] Showboat *Kalang* was also soon part of the Australian war effort and her story can be found in Chapter 7 which discusses ferries at war.

After some time laid-up *Kara Kara* was sold to the Royal Australian Navy in 1941. She was used mainly as a boom-gate ship in Darwin and was damaged by Japanese air-attacks in 1942.[18] *Kara Kara* was retained by the Royal Australian Navy as a base ship after the war, spending many years laid-up in the Ships in Reserve group at Athol Bight mooring dolphins. She was sunk as a naval target in 1973, her triple-expansion engine having been sent to the Goulburn Steam Museum and from there to the National Maritime Museum.

So ended the vehicular ferries of Sydney — horse punts, car ferries, call them what you will, truly their like will not be seen in Sydney again. In 1992 just one vehicular ferry works the port and that is a cable ferry — vessel working in chains — joining Putney and Mortlake across the Parramatta River. This service began after the Ryde bridge was opened in 1935, using (then) the punt that had worked from Ryde to Rhodes. The punt is run by the Road Traffic Authority (ex Department of Main Roads). The Greiner Coalition Government applied a toll-fee on it in, presumably, an effort to reduce custom to the level where removal could be justified. This certainly worked, but a local outcry and some press publicity caused a rethink and the toll was removed. The trip across the river, complete with car, is a tourist 'gem' that too few know of.

SOUTH SHORE FERRY SERVICES — EASTWARD

Of the various segments that made up the totality of Sydney's ferries, those that served the eastern suburbs along the southern shore were always the weakest in both passenger numbers and in resistance to alternative means of transport. The eastern suburbs remained less densely populated than other areas to the west, while the incomes of the locals were perhaps higher on average, producing a rather greater ability to provide private transport. An excellent tramway service which reached Watsons Bay in about 1909 provided almost unbeatable competition.

In view of the early construction of a military road to Watsons Bay in '10 weeks from 25 March 1811'[19] by 21 soldiers of the 73rd Regiment, it is perhaps surprising that any ferry service began at all. The only ferry route offered few populated headlands of the type that forced long road/tram detours in other ferry areas.

Watsons Bay was originally considered by its inhabitants to be a fishing village, built around the needs of defence, signal and pilot stations. Third generation local, Vince Marinato, insists it is still a 'village.' It was, and is, a good place for a picnic with views back along the harbour and up the hill from the infamous Gap and nearby South Head. In March 1854, Edye Manning's steamer *Victoria* (1851) ran to Watsons Bay for the Sydney and Melbourne Steam Packet Company, leaving Campbells Wharf on Sundays and public holidays. Fares were half a crown saloon and 1s.6d. forecabin. *Victoria* left Sydney at 9.00a.m. and 3.00p.m. and Watsons Bay at 10.00a.m. and 6.00p.m.

The *Fairy Queen* ran for Waterhouse, carrying about 30 passengers in a spasmodic commuter service about 1872. This may have been *Ferry Queen* (1844) as there does seem to have been some published confusion in the spelling and with the owners of this craft.[20] She would leave Watsons Bay at 10.00a.m. and Sydney at 5.00p.m. — sometimes. At other times, passengers were left to find their own way home with, no doubt, few kind words for the ferry 'service'.

In 1876, William I. Harmer began the first serious ferry service on the route. He offered a regular scheduled service using the 12 tonne, 58 passenger *Golden Rose* (1872) under command of Captain Lawrence. According to the *Daily Telegraph*, Harmer then ran the *Cowper* (possibly a press misprint of the *Coombra*) and then *Phantom*.[21] The registers of the period suggest that

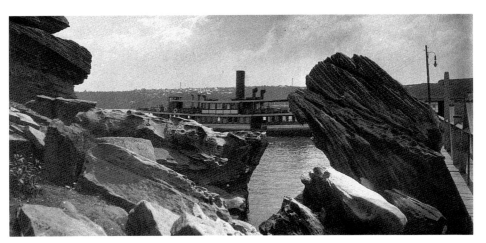

'Vaucky', *Vaucluse*, the fastest ferry on the harbour, near the Nielson Park Wharf. [Graeme Andrews Collection]

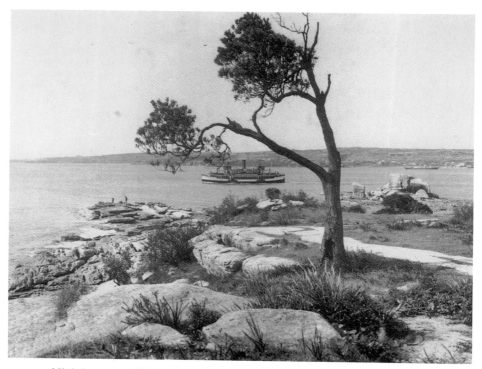

High bows and high wheelhouses gave *Woollahra* the look of a small Manly ferry but she spent most of her time on the Watsons Bay — Sydney run. [Graeme Andrews Collection]

Harmer had *Golden Rose*, then *Swansea* (1877) and *Coombra* (1872) with *Jenny Lind* (1883) advertised for weekend trips. In a later advertisement, Harmer described his service as 'Harmer's Watsons Bay Regular Steam Ferry Company', using *Elaine*, *Cruiser* and *Mascotte*. The first two may have been chartered from the Perdriau family and the other from Mr. Shipley. None seem to have been in Harmer's use for long. This probably represented Harmer's last try, as Sir John Robertson, member of the New South Wales Legislative Council who lived in the village, set up a ferry service in 1881. Robertson offered return fares of 1s. and monthly tickets of 15s. He ran ten trips a day, but sometimes departures at either end depended upon Sir John's convenience if he was late completing breakfast or had stopped for a tipple between Parliament and the ferry. On weekends, Harmer, Halstead and Matthew Byrne all competed for the tripper trade with touts ranging up the streets near the Quay, all extolling the virtues of their particular charge. Harmer's wife continued his business for some time after his death.[22]

Robertson's service was reconstituted in 1887 as the Watsons Bay and South Shore Steam Ferry Co. Ltd. The name was soon simplified to Watsons

Bay and South Shore Ferry Co. Ltd. in 1912 and stayed as that until Sydney Ferries Ltd. took over in 1920. The finest vessels in the company before the takeover were four double-enders, *King Edward* (1902), *Vaucluse* (2) 1905, *Greycliffe* (1911) and *Woollahra* (1913). *Woollahra* had the style of a small Manly ferry and was intended for a proposed Watsons Bay-Manly run which did not happen. *Vaucluse* was long considered to be the fastest ferry on the harbour, easily able to overtake and pass the larger Manly ferries. *Greycliffe* was a victim in the harbour's worst disaster when she was cut in two by SS *Tahiti* in 1927. The story is told in Chapter 7.

Sydney Ferries Ltd. gave up competing with trams, buses and private cars in 1933 and abandoned the Watsons Bay–Sydney run. Since that time, several attempts have been made to run either peak hour services or weekend tourist trips. These and the various Garden Island services are discussed in the relevant sections on Rosmans, Messengers, Stannards and Government PTC/ UTA/STA services.

TRAMS, TRAINS, BUSES AND FERRIES — UNEASY RELATIONS

In the developmental phase of Sydney, ferries and walking were the major means of mass transport. Horses and wheeled traffic were few and expensive and still later came rail — trams and trains. Although trains connected Sydney and Parramatta from 1855, trams made the first notable incursions into ferry patronage. Effects of the early trains on the ferry trade between the two centres of population — Sydney and Parramatta — was partly compensated for by the natural increase in the riverside population.

From the 1880s, the trams really began to damage ferry trade. The slow cable tram gave way to the electric and the steam tram. The electric tram soon took the lion's share of the eastern suburbs trade. Trams ran along the ridges, feeding directly into the city, although some trams did feed to ferry wharves, notably at Balmain, Erskine Street Sydney, and on the North Shore.

As late as the 1950s, State Government tram and bus services attracted criticism for not providing coordinated tickets for tram, bus and ferry routes. Of necessity, pre-bridge trams served some ferry wharves, but after 1932 backloading along the lines to the wharves contributed to the drop-off in ferry passenger numbers. In this period, passenger numbers continued to decrease while tram passengers crossing the bridge slowly increased. Absorption of the Port Jackson and Manly Steamship Company into the State Government transport system has allowed gradual development of combined public road and water transport, but it has taken a long time.

In April 1973, a major study on harbour ferries recommended to the then Minister for Transport, the Hon. Milton Morris, MLA, that joint ticketing and pricing of bus and ferry services be studied.[23] The report complained

that 'Transport authorities in the past regarded bus and ferry operations as two distinct systems instead of being integral components of a transport complex'.[24]

In the 20 years since that report, some efforts have been made to comply. However, problems of wharf ownership and maintenance continue to plague ferry services.[25] Provision of parking areas is generally insufficient. Those who can afford to live near a ferry wharf do not want the cars of those who can't afford such a position choking their area. Generally, it is easier to get to a ferry than it was 20 years ago, but not as easy as it was in the days when trams fed the ferries. These feeder tramways could have provided the base of a coordinated ferry and road interchange system.

FERRIES TO THE NORTH SHORE

James Milson Snr. (1783–1872) was one of the first settlers on the North Shore. He arrived in Sydney in 1806 and was granted land opposite Sydney Cove. In addition to farming and quarrying, Milson provided fresh produce to shipping in Sydney and this required boats to carry the produce as well as ship's crews. He also speculated in land, buying Robertsons Point from James Robertson in about 1853. Early attempts at promoting vehicular ferries were made by Milson without result. In 1845, *PS Ferry Queen* was run by Thomas and Joseph Gerrard on the cross-harbour run. She could also haul one or two flat-top punts alongside from Windmill Street, Millers Point, to Blues Point. Road traffic from Sydney to the North Shore normally had to go via Bedlam Point or Kissing Point or even as far as Parramatta. Vehicular ferry travel directly across the harbour was needed.

In 1847, the double-ended paddler, *Brothers*, was on the run for the Gerrards, and she was joined by *Agenoria* in about 1850. Mr. Hall's *Herald* (1855) also worked the route, but was well-known for her owner's interest in supplementing her income with casual towage of shipping. No doubt, her would-be passengers fumed as much as did *Herald*'s funnel! Other competitors joined the ferry fray from time to time, but James Milson Snr. and partners began running the 60 passenger *Kirribilli* (1860) from the newly-constructed Semi-Circular Quay to Milsons Point. The original ferry wharf at the point was on the eastern side and was difficult to use when the southerlies roared across the harbour. The early steamers were double-ended and steering was by means of a tiller at each end. The tiller moved the rudder at that end while the disused 'bow' rudder was locked tight by a pin. This principle was used on Port Jackson until the departure of the Manly ferry *North Head* and the preservation of the last inner harbour ferry, *Kanangra*.

The story is told how school boys, William Milson Bligh and Jack Brindley, thought it might be interesting to see what happened when the bow rudder pin was removed as the ferry neared the Quay. Out of control, the ferry

smashed into the wharf, causing pandemonium. The ferry master was not amused. Nor were the boys after the master had discussed the matter with them.[26]

Public attention was drawn to 'the commodious ferry steamer *Kirribilli*, fare 3d. dawn to 7pm, 6d. 7pm to 11pm'. Weekly tickets were 2/6d. and family monthlies 12/6d.[27]

The North Shore Ferry Co. was formed in 1861 from James Milson Senior's service with James Milson Jnr, Charles Frith, Francis Lord, Thomas Laurie and William Tucker. From 1861, they had *Kirribilli*, then *Alexandra* (1864) of 75 passengers and the vehicular ferry, *Transit*. Another vehicular punt, *Bungaree* (1872), and three other passenger ferries coped with the trade until 1878.

Considerable passenger traffic also developed to the north end of Lavender Bay, probably because of the proximity of the wharf to North Sydney for pedestrians. With the advent of the cable tram after 1886, running along the ridge from Milsons Point to Ridge Street, main commuter traffic moved back to the Milsons Point wharf. Within a few years, the North Shore Ferry Company was running the additional ferries *Florence* and *Coombra* of 1872, vehicular ferry *Bungaree* and *Darra* of 1875.

The North Shore Ferry Company was sold for £20 100 on 5 March 1878 to become the North Shore Steam Ferry Co. Ltd. In 1875, the population of the area comprised no more than 600 families and the new ferry company was obviously looking well ahead. Captain Thomas Summerbell was appointed traffic manager, and fares were reduced to 2d. each way. The new company started with nine ferries — *Transit, Gomea, Galatea, Florence, Coombra, Darra* and *Nell* and *Telephone*.

Before 1886, North Shore travellers to Milsons Point terminal had only a line of horse omnibuses or private transport to get to the ferry. On 22 May 1886, the cable trams started. Commuters now had a relatively quick means of transport to serve the ferry. This was one case where a road service was intend-ed to complement a ferry. The railway line from Milsons Point to Hornsby was opened on 1 May 1893 and electric trams connected with steamers to Mosman on 1 March 1897.

One of the most important Sydney ferries was *Wallaby*. Designed by Norman Selfe to the order of Thomas Summerbell, she was the first double-ended screw steamer in Australia. Several vessels of broadly similar principles had preceded her in Britain.[28]

Wallaby was well described by Harold Norrie:

> She was a peculiar model, having no outside seats on the bottom deck, the walls of the cabins fore and aft being flush with the 'skin' of the ship, while the main deck was extended beyond this line in the form of a wide sponson. She was the first and for many years, the only ferry to have both cabins fitted with glazed windows. All the other boats were glazed only in the after or ladies cabin, the for'ard or smoking cabin being fitted with large open 'ports' which sometimes were covered in wet weather by canvas curtains.[29]

The Milsons Point ferry terminal was an example of an early transport interchange. Vehicular ferries berthed at left. Passenger ferries unloaded into the covered waiting area directly to trams under cover while train passengers went to the right. [Roger Benjamin]

Unusual, successful and for many years unique in Sydney — *Wallaby* of 1879 was the first double-ended screw steamer in Australia.
[Graeme Andrews Collection]

A similar mechanical design was adopted for the *Aleathea* (1881) of the Parramatta River ferries. She was not an initial success, making just 6.5 knots with both propellers working. After one fell off she went faster and she was rebuilt as a single-ender. Because of *Aleathea*'s early failure, no more double-screwed ferries were built until the North Shore Steam Ferry Company's *Kangaroo* of 1890.

Wallaby soldiered on with newer and bigger paddle-steamers as running mates — *St. Leonards* (1881), *Victoria* (1883), *Waratah* (2) and *Bunya Bunya* (1885). These were the 'heavy lift' ships of their time and *Wallaby* saw them come — and go.

By the time the North Shore Steam Ferry Company was once more reorganised into Sydney Ferries Ltd., in December 1899, it had become an awakening transport giant. From the six steamers of 190 tons total, carrying about 500 passengers, it now had five double-decked screw ferries, three vehicular ferries, and four large passenger paddlers — a total of 18 vessels.[30]

The original six ferries were no doubt, enough for the needs of the community. Statistical returns of the time for the North Shore, excluding the railway line stations from Roseville to Hornsby, show how Sydney Ferries Ltd. had to keep up with the rise in population:

	1871	1881	1891	1901	1903[1]
pop.	3619	3500	30 517	35 658	41 660

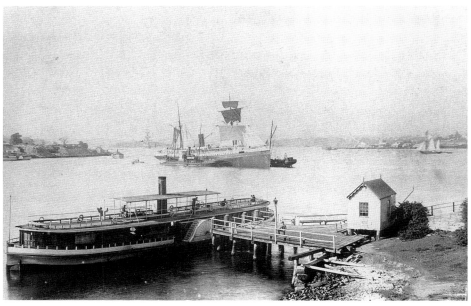

A Large paddler, *Bunya Bunya* or *Waratah* (2) loads at McMahons Point as American passenger liner Alameda takes on coals.
[Historic Photograph Collection, Mackay Library]

In the 1860s, Mosman Bay had subsided somewhat from its early industrial/ whaling/ship repair role.[32] Local resident and businessman, Richard Hayes Harnett, decided to revitalise the area by means of day trippers. In the 1860s, he bought the old Mosman Estate with the intention of building a pleasure and picnic ground. A fine painting 'Mossmans Bay' by S.T. Gill of about 1860, shows a steamer leaving the stone quay at the site of the present Mosman Wharf. The vessel may be the *Peri*. Sturrock suggests she may also be *Black Swan*, but records show *Black Swan* to have been double-ended.[33]

As there were many other picnic grounds — Cremorne Point, Athol, Balmoral, Clifton Gardens, Chinamans Beach, and Pearl Bay in the area around Mosman, Harnett's venture failed. He sold the land for £3500 and rebought it in 1871 for £1500.[34] Harnett then began to promote the area as an up-market residential site but to do this a ferry service was essential. In 1871, Harnett subsidised the *Herald* to provide a regular service. The *Herald* was also used as a tug and oftimes failed to appear when expected. When she did run, she offered minimal shelter from rain and wind. The late Jack Carroll claimed she was even used to carry horses and carts at times, the equipage being separated with one item at either end. Studying a photo of *Herald* gives no clue as to how this was done.[35]

In 1873, the Milsons Point Ferry Company advertised *Florence* (1872) for the Quay — Mosman Bay via Manns Wharf, Neutral Bay — a round trip of about every two hours at 6d. a head each way. *Florence* would call at the wharf, now Royal Sydney Yacht Club, for Mr. Peake. She would then head towards a rock in front of 'Holbrook' to embark the 'genial' Mr. Pitt. Because of his great weight, it was necessary to have the other passengers move to trim the ship.[36] References to balancing early ferries abound in reports of the time.

Harnett hired a variety of steamers to serve Mosman Bay and erected some small, lightly-built wharves in front of homes and laneways, to give easy access to the ferries. Among vessels thought to have worked for him were *Abeona*, *Golden Rose* (1872), *Zeus* (1878) and *Speedwell*. After 1878, Shipley and Chapman attempted a regular run to the area with a subsidy of one pound a day, using *Katie* (1879) and *Pacific* (1881). Charles Jeanneret also used some of his spare ferries on the run in opposition. *Eclipse* (1873) and *Osprey* (1879) are mentioned and, no doubt, others filled in.

None of these attempts at providing passengers with a regular ferry service seem to have pleased Harnett. The rapidly-expanding North Shore Steam Ferry Company after 1884 began running to Mosman and Neutral Bays. Harnett partly sponsored the service, and for a year or so there was intense and often physical confrontation. This included Harnett barring access across his land to the ferry wharf for people not using his company's ferry. A gate was erected and blown up and for some time travel by ferry became exciting. Jeanneret eventually left the field. Among the ferries used by the North Shore Steam Ferry Company in the area at this time were *Nell*, *Wallaby* and *Victoria*. In Neutral Bay, the company also met and defeated the local compe-

tition. In 1885, local developer, Patrick Hayes, used chartered steamers *Florrie* (1879) and *Gannet* (1884) but within a year found the competition too tough.

Two ferries were initial regulars on the North Shore Steam Ferry Company's Neutral Bay run. They were *Lily* (1882) and *Lotus* (1886) — both formerly Joubert Lane Cove River ferries. They were replaced by more modern and bigger double-enders in the 1890s. There is some confusion about the fate of *Florrie*. After an earlier edition of *The Ferries of Sydney*, I was taken to task for suggesting that *Florrie* ended her career on the Clarence River. I was quoting Norrie who stated that the 'Neutral Bay' sign could still be seen on Florrie when in service on the northern New South Wales river.[37] In fact, two Florries of similar dimensions were built within a year of each other.[38]

After 1900, Sydney Ferries Ltd. controlled services along the North Shore east of Lavender Bay. The company went on to absorb the Parramatta River Steamers and Tramway Co. Ltd in 1901, the Balmain New Ferry Co. in 1906, and the Watsons Bay and South Shore Ferry Co. in 1920.

NOTES

1 Mike Richards 1987, *Workhorses in Australian Waters*, Sydney, p.23.
2 Obituary, Mrs. Henry Perdriau, *Balmain Observer*, 1 March 1918.
3 *Balmain Observer*, 5 March 1922.
4 Michael R. Matthews 1982, *Pyrmont & Ultimo, a History*, Sydney, map, p.85
5 *Sands Directory*, 1884.
6 *Lady Manning* was 1894.
7 Family documents, courtesy Norman Gerdes, son of Henry Charles Gerdes.
8 Isadore Brodsky 1957, *Sydney Looks Back*, Sydney, pp.217–219.
9 Alan Sharpe 1979, *Colonial NSW 1853–1894*, facsimile, Sydney, p.41.
10 *PS Kangaroo*, 1855.
11 Harold Norrie 1935, 'Sydney's Ferry Boats', *Journal of the Royal Australian Historical Society*, Vol. 21, part 1, pp1–36.
12 A.B. Portus 1904, 'Early Australian Steamers, period 1831–1856', *Journal of the Australian Historical Society*, Vol. 2, parts 8–9, pp.178–196/197–226.
13 Brodsky 1963, *North Sydney 1788–1962*, Sydney, p.78.
14 Gil Hayman c1972, letter.
15 John H.Webster, letter, 11 June 1985.
16 A.E. Woodley 1973, *Westernport Ferries*, Melbourne, pp.81–82.
17 A.M. Prescott 1984, *Sydney Ferry Fleets*, Magill, suggests some of the punts were used as cargo vessels.
18 An existing Sydney ferry (1992), *Seeka Star*, was a naval craft in the Darwin area at that time.
19 Monument at Watsons Bay, Sydney.
20 *Daily Telegraph.*, 'Harbour Transportation' (series), starting 28 August 1906.
21 *Ibid.*
22 Vince Marinato, family memories, Watsons Bay, Sydney.
23 *Report of the Committee on Sydney Harbour Ferry and Ancillary Services*, April, 1973.
24 *Ibid.*

25 Ferry wharves may have a range of owners, including MSB, local councils and private operators. In 1990, the MSB indicated it would no longer take responsibility for ferry wharves.

26 Roy H. Goddard 1955, *The Life and Times of James Milson*, Melbourne, pp.104, 120.

27 *Ibid.*

28 Ferry No.3 (1869), and others, Duckworth and Longmuir 1972, *Clyde River and Other Steamers*, Glasgow, p.226.

29 Norrie 1935, *Journal of the Royal Australian Historical Society*, Vol.21, part 1, p.15.

30 *Daily Telegraph*, 20 August 1906.

31 *Ibid.*

32 Edward A. Ancher 1976, *The Romance of an Old Whaling Station*, Sydney.

33 Rob Sturrock 1983, *A Pictorial History of Mosman*, Sydney, p.36.

34 *Ibid.*

35 *Ibid.*

36 L.F. Mann 1932, 'Early Neutral Bay', *Journal of the Royal Australian Historical Society*, Vol. 18, p.183.

37 Norrie, p.20.

38 Prescott has Florrie going to South Australia, p.68.

TUG BOATS TO JET BOATS —

Seven miles from Sydney

Getting to Manly in the days before roads and bridges was not easy. A distance of seven nautical miles by water became about 60 land miles, or about 95 kilometres by track through the bush. Technically, Manly is on the north shore of Port Jackson but early land traffic had to skirt Middle Harbour, an almost fiord-like inlet of about five nautical miles in length.

One early attempt to shorten the land route involved a hand-punt which crossed Middle Harbour at its narrowest point, The Spit. A Mr. Peter Ellery is said to have worked here in about 1850. A charge of one shilling and sixpence applied for wheeled vehicles and 6d. for pedestrians. This punt was taken over by the colonial government in 1888 and replaced by a steam punt in the following year. The service was steam-powered until it was withdrawn in 1924 following completion of the first Spit Bridge.[1]

There is some evidence to suggest that one Barney Kearns (possibly Kerrins) ran a ferry from the Balmoral area to North Harbour or Manly in about 1830. A second service also is suggested between Folly Point in Long Bay, Middle Harbour, to the other side, probably near The Spit where access is over a beach. Both these ferries were probably sail and oar-powered 'Passage Boats'.[2]

Customers for Kearns' service were few and far between with perhaps 50 families living between Manly and the Palm Beach area. Those travelling to Sydney had to walk or ride a horse to Manly or North Harbour, travel with Kearns to Balmoral, walk to Milsons Point opposite Sydney Cove, then cross the harbour by whatever means could be found.

In 1848, the situation improved somewhat when the Gerrard brothers, John and Joseph, began spasmodic runs to Manly using the paddlesteamer *Brothers* (1847) whose 50-passenger capacity was well able to cope with whatever trade and custom was on offer. In 1853 Henry Gilbert Smith, who had been involved in building Australia's first working steamship, *Surprise*, bought land and leased other land between Manly harbour beach and the ocean front. The intention was to develop Manly as another, better, harbour 'attraction' along the lines of England's Brighton. Smith even used that name for the area.

Captain James Matthew Hutton brought the very narrow *Phantom* from Melbourne to Sydney. [Jenny King]

As no regular transport service ran to Manly, Smith had to subsidise or charter steamers to support his venture. Edye Manning began excursion trips to Manly on Boxing Day 1854, using *Nora Creina* (1849). Having tested the waters, Manning began a regular weekend service and then, later, twice and thrice weekly services, using *Black Swan* (1854), *Pelican* (1854) and *Emu* (1841). Smith provided the wharf and his hotel as an inducement to visitors. Manning's steamers had exclusive vessel use of the wharf. Recreational trade increased so well that daily services were started in about 1856, but disagreement arose between Manning and Smith as Smith wanted people to settle in the area, while Manning was more interested in the tripper trade.

Smith tried to encourage public financial interest in a dedicated local ferry service with little result, and then formed the Brighton, Manly Beach Steam Company himself. In 1859, he bought a half share in the new double-ended Melbourne paddle steamer, *Phantom* (1858). The other share was held by owner Samuel Bourne Skinner. *Phantom* was brought to Sydney under the command of Captain James Hutton [3] Hutton was, no doubt, well pleased to hand over his charge as *Phantom* was very long and narrow (119ft. by a mere 13ft.) and was a poor sea-boat. He then went on to a long and respected career in the New South Wales Marine Board and in the New South Wales naval forces. *Phantom* didn't last quite so long. She arrived in Sydney on 19 May 1859, and commenced her Manly service two days later. When trade was slack, she was used on other runs such as that to Watsons Bay.

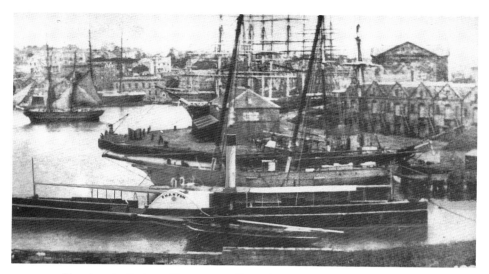

Phantom in Sydney Cove, near Campbell's Wharf about 1880. She became the first 'traditional' Manly ferry. [Graeme Andrews Collection]

Phantom may reasonably be described as the first of the 'typical' Manly ferries. She was double-ended and her tall white funnel with its black cap set a style which was used on all Manly ferries until 1974. Tales of *Phantom* have gone into the folk-lore of the harbour. Several times big seas flooded her boiler room and required her crew to hoist sail to complete the journey. She was delayed so often that the Hot Potato Club is said to have been formed by Robert Grant — so named because passengers brought potatoes which they roasted in the fire box to stave off the pangs of hunger. *Phantom*'s ability to blow perfect smoke rings in calm weather earned her the name, 'Puffing Billy'.[4]

Smith kept control of the ferry trade to Manly by allowing only *Phantom*'s operators — Skinner and his new partner, Captain S.H. Wilson — to use his wharf. *PS Breadalbane* (1853) was added to the run in 1862. She came out from Govan, Scotland to work in Brisbane before being bought for Sydney use. *Breadalbane* was somewhat bigger and bulkier than *Phantom* and was of tug layout. During the week she carried general cargo and provided harbour tugging as needed. On weekends she carried trippers to Manly.[5] The death of both Skinner and Wilson in 1867 allowed the service to come under the control of first, T.J. Parker and later, Captain Thomas Hesselton. The Brighton and Manly Steam Ferry Company was advertising for trade in 1868 and, under Hesselton, the size of the fleet increased. Early in 1875, Hesselton sold out to John Randal Carey who combined with John Woods and J.B. Watson to bring extra capital into the business. Hesselton continued on as manager. By 1876, trade was sufficient for the Port Jackson Steam Boat Co. to be formed on 23

January 1877. Progressively, this became the Port Jackson Steamship Co. in 1881, and the Port Jackson and Manly Steamship Co. Ltd. in 1907. Along the way, it faced and beat competition from two interlopers, encouraged by constant complaints about fare prices from Manly's citizens. These worthies applied pressure both for better ferries and lower fares — and for some time, they got both.

Table 1 *Port Jackson and Manly Steamship Co. Fleet list — 1916.*

vessel	built	tons gross	length ft.*	type
Balgowlah	1912	499	210	pass.
Barrenjoey	1913	500	210	pass.
Bellubera	1910	499	210	pass.
Ben Bolt	1907	83	92	cargo
Binngarra	1905	442	190	pass.
Brighton	1883	417	220	ps. spare.
Burra Bra	1908	458	195	pass.
Kuring–Gai	1901	497	171	pass.
Manly (II)	1896	229	147	pass.
Narrabeen	1886	214	160	ps. cargo.

Total: 8 plus 2 cargo (one ex pass. p.s.) * *Lengths in feet, rounded off to nearest whole.*
Total passenger capacity: c.10434.

Table 2 *Port Jackson and Manly Steamship Co. Fleet List — 1937*

vessel	built	tons gross	length ft.	type
Balgowlah				Pass.
Baragoola	1922	498	199	Pass.
Barrenjoey				Pass.
Bellubera				Pass. *
Burra–Bra				Spare.
Curl Curl	1928	799	220	Pass.
Dee Why	1928	799	220	Pass.

Total: 7 ferries. * *M.V., rebuilding after fire.*
Total passenger capacity: c.10511.

Table 3 *Port Jackson and Manly Steamship Co. Fleet List — 1951*

vessel	built	tons gross	length ft.	type
Balgowlah				Spare.*
Baragoola				Pass.
Barrenjoey				Pass.
Bellubera				mv.Pass.
Curl Curl				Pass.
Dee Why				Pass.
South Steyne	1938	1203	217	Pass.

Total: 7 ferries. * *delete Balgowlah for 1955 Manly fleet list.*
Total passenger capacity: c.10 844

In 1888, J. Murray ran the chartered steamer *Admiral* (1883) to Manly for some months. This lone venture did not unduly bother the established company, but competition from J. Brown's Manly Co-Operative Steam Ferry in 1893 did. Manly Council had enjoyed a 'love-hate' relationship with the ferry company for some time and quickly encouraged the newcomer. The new venture started with five chartered steamers, including *Admiral*. The previous debates about ferry fares had abated since the early 1880s when fares were reduced from 1/6d. return to 1/-. The rise to their old levels in May 1892 caused uproar which created the opposition fleet. The new company offered a fare of 6d. return, using tug-type ferries. The old company matched it, and Manly was quiet no longer. Those locals who had wanted better ferry services and lower fares got what they wanted. However, they also got crowds of holiday-makers and gangs of loud louts who could all now afford the fare to Manly. Working class families who had been unable to afford a day out at Manly now could, and they came in their thousands. This 'lowered the tone' of the place as a picnic at Manly was now within reach of all. Manly has generally retained the holiday destination 'feel' ever since.

During the 'Great Ferry War', ferries raced each other for wharves. Weekend crowds threw stones at other crowds across the water. They barracked for their ferry as it raced neck and neck with another. Safety was not a great issue and neither was over-loading. Ferries pulled into the wharf, loaded, and left — schedules were abandoned on weekends and holidays. It was great fun for the passengers, but not for the ferrymen who were all losing money. The new company ordered its first new ferry from the board of naval architect Wal Reeks. She was to be a radical, very fast, double-ended propeller ship, able to beat the opposition. The new *Manly* (2) (1896) was well able to do that, but by the time she was ready for use her owners had failed. In November 1895, the old company turned the screws up tight. The return fare was reduced to 3d! It was the end of the war. On 15 May 1896, the two companies amalgamated as the Port Jackson Co-Operative Steamship Company, soon to be renamed, the Port Jackson and Manly Steamship Co. Ltd.

Manly (2) has been quoted by many, including myself, as having made the run to Manly in the remarkable time of just 22 minutes. In retrospect I now doubt this. *Manly*'s design speed is generally given as 14 knots to give a journey time of about 31–32 minutes as serves in 1992. To do about seven nautical miles in such a short time would need a speed of about 19 knots average, which, allowing for stopping and starting, would increase to nearly 21 knots. Perhaps!

Before the 'war' ended, plans were drawn up by Wal Reeks for a bigger version of *Manly* (2) to the order of the established company. After amalgamation this new ship was not rushed to completion. Instead, *Kuring-Gai* (1901) was built of steel by Morts Dock and Engineering, one of many Manly ferries to come from that long-established group. She was big and powerful, and carried more than 1200 passengers to *Manly*'s 800. She set the style and standard

for Manly ferries until 1928. She was the forerunner of the durable and hand-some 'B' class ferries, and was the first Manly ferry to exceed the capacity of the magnificent paddlesteamer, *Brighton* of 1884. She cost £23 789.

The after-effects of the battle of the ferries probably altered the growth pat-terns of Manly and those suburbs to the north. Many people were now acquainted with the area who might never have known of the place. Passenger numbers continued to grow and fares stayed at a modest rate because of this.

The 1900s saw the fortunes of the company grow steadily until almost the middle of the century. New ferries came at regular intervals, and commuter numbers increased as suburbs formed north of Manly with trams and buses but no bridge connection to Sydney feeding the ferries. The company was no longer dependant upon the weekend trade to survive. After 1924, the ferry passenger catchment area was reduced somewhat when the Spit Bridge allowed direct road connection with that area across the harbour from Sydney. Direct road access to Sydney, via the vehicular punts, was now avail-able, and those living well away from Manly and who had an automobile now drifted away from the Manly ferry.

During the period 1870s–1880s, a fine fleet of double-ended paddle steam-ers served the Manly run. A larger and equally-impressive fleet of passenger paddle tugs backed up the passenger ferries. The passenger ferries were *Emu* (1865) renamed *Brightside* (1887), *Fairlight* (1) (1878), *Brighton* (1884 with two funnels — to become the last Manly paddle passenger ferry by 1916), and *Narrabeen* (1) (1886). *Fairlight* and *Brighton* came from Britain under sail and power, *Emu* was imported in pieces and re-assembled, and *Narrabeen*

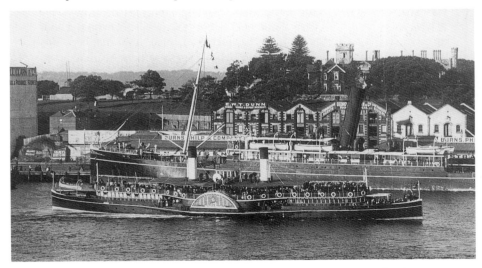

Biggest and finest paddler ever to work Port Jackson was *Brighton* (1883–1916). She is shown here bringing a large load into Sydney Cove. [Graeme Andrews Collection]

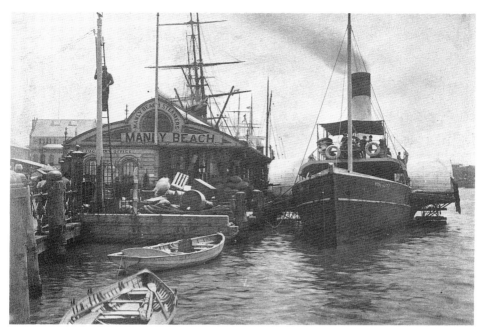

***Royal Alfred* (1868–93) berthed on the western side of Sydney Cove, takes aboard passengers and cargo for Manly.** [Graeme Andrews Collection]

was built by Morts Dock in Sydney. Passenger tugs of the time were *Breadalbane, Goolwa* (1870), *Royal Alfred* (1873), *Mystery* (1874), *Manly* (1) (1874), *Commodore* (1878), *Glenelg* (1874), *Port Jackson* (1883) and *Irresistible* of 1883.

By 1900 screw steamers were becoming general and the Manly fleet began to change. Competition from dedicated towing companies cut into the ferry company's tugging trade. The tugs were gradually sold, with J and A. Brown taking the last three from the ferry company. Henceforth, the service would have passenger ferries and some cargo-carriers, mainly converted from obsolete passenger ferries. In 1921, the designated cargo-ferry *Narrabeen* (2) was built, but soon became redundant when the Spit Bridge was opened.

Replacing the handsome paddle-ferries were the *Manly* (2), the *Kuring-Gai* and the long-lived 'B' class double-ended screw ferries. An indication of passenger growth may be gained from their capacities. *Manly* (2) — 800, *Kuring-Gai* — 1228, *Binngarra* (1905) — 1372, *Balgowlah* (1912) — 1528, *Baragoola* (1922) — 1523. By 1928, two new-style Scottish-built ferries — *Dee Why* (1) and *Curl Curl* (1) could carry 1587 passengers each. The *South Steyne* of 1938 could carry a massive 1781 passengers (compared with the 1100 of the 1980s Freshwater class). In the 1920s, the Manly fleet could lift more than 10 000 passengers (in theory) in one load.

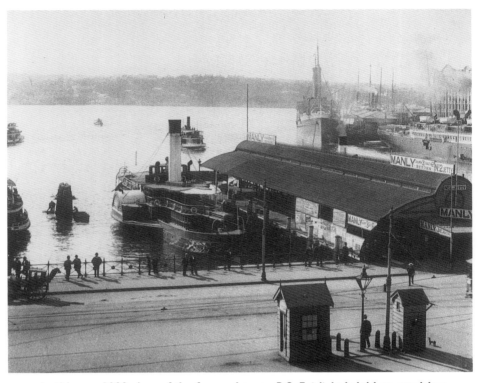

In this pre-1908 view of the ferry wharves *P.S. Fairlight* is laid-up awaiting the evening peak while a smaller ferry shows a funnel top on the other side of the wharf. The fare is 6d. return. [Graeme Andrews Collection]

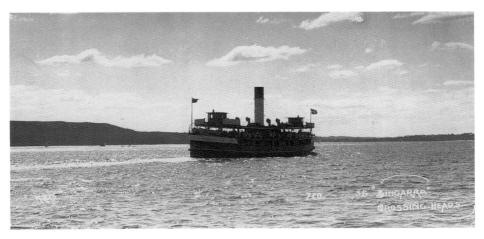

On a quiet afternoon *Binngarra* crosses the Heads towards Manly.
[Tyrell Collection]

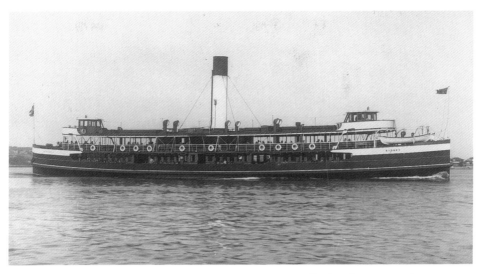

Baragoola shows her original style with small wheelhouses and fully-airconditioned upper deck. [Duffy Collection]

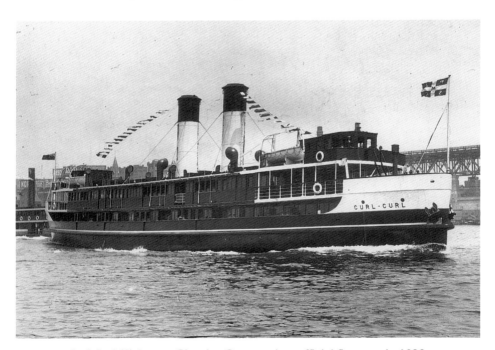

Curl Curl (1) leaves Circular Quay on her official first run in 1928. Compare her appearance with sistership *Dee Why* in almost the same place nearly 40 years later. [Graeme Andrews Collection]

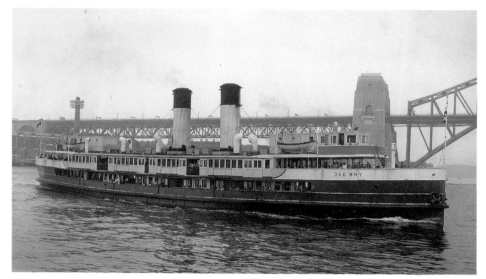

Dee Why (1) shows her final appearance in the early 1960s.
Compare with sistership *Curl Curl*'s original layout.
[Port Jackson & Manly Steamship Co.]

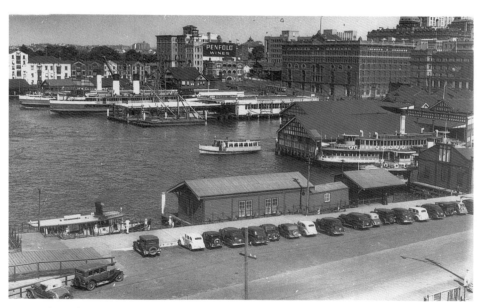

Late in the 1930s a 'B' class Manly ferry leaves for Manly as Hegarty's
small ferry *Aster* heads for the near North Shore. The two-funnelled
Curl Curl(1) and the *Kareela* (at right) wait for passengers.
[Graeme Andrews Collection]

The six 'B' class ferries and *Kuring-Gai* were symmetrical and efficient craft with the newer ferries able to maintain a service speed of 14 knots. A proposal to build a railway to the northern beach suburbs created concern among the company's management. The answer was two new big fast ferries which were ordered so as to be ahead of the competition, if it came. It did not, but the arrival of the two new ferries brought new standards of excellence to the run. Capable of almost 18 knots and a 25-minute service time if pressed, the new twins had enclosed upper decks, a cafeteria and a new colour scheme, featuring the dark green hull which many people still consider to be the 'only' colour for the Manly ferries. They were, truly, the 'poor man's passenger liner' and their tall twin-funnelled silhouette spoke of power and style. Passengers flocked to them, but the big ferries did not need their speed to compete with the trains that never came — and probably never will. The next Manly steamer, *South Steyne* of 1938, was not quite as fast as the 'twins' but of greater capacity. Her lines and looks, high bows and graceful sheerline and luxurious fitout were not to be equalled by the austere new ferries of the Freshwater class that eventually replaced her. *South Steyne* cost £141 526 delivered to Sydney, almost half the capital of the company. The chance of a sistership was remote.[6]

While arranging for *South Steyne*, the company investigated up-grading the 'B' class ferries. Diesel-electric propulsion was new and seemed to offer benefits of power and economy as needed. *Bellubera* was re-engined as the prototype, but was not entirely reliable early in her new guise. A tragic and fatal fire

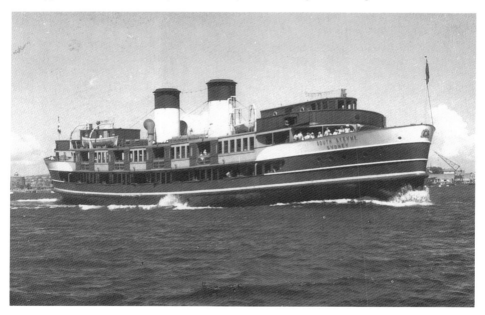

***South Steyne* at her peak in 1951. The four gangway ports on the upper deck are open.** [Fred Saxon]

HENRY ROBB, J.P.
SHIPBUILDER
CHAIRMAN OF LEITH CHAMBER OF COMMERCE

From the Clyde he came
To make his name
In the Yards by the shores of Forth.
He scoured the earth
To fill the berth
With orders for ships of worth.
In grim days of wars
He repairs their scars,
E'en a battleship sublime!
And you bet your bob
If it's Henry Robb
The work will be done on time!

Cartoon of builder of *South Steyne* holding model of ship from 'Modern Athenians 1944'.

happened soon after her reintroduction to service. After World War II, tenders were called to convert *Barrenjoey* to *Bellubera*'s pattern after surveys showed that two new ferries to replace *Balgowlah* and *Barrenjoey* could not be funded. The only avenue was to upgrade as much as possible and hope trade improved. The company began to diversify its activities. During the next few years it dabbled in real estate, started a new ferry service on the Hawkesbury River and, later, involved itself in the oil-industry support role.

Converting *Barrenjoey* into a small look-alike for *South Steyne*, took two years and about £260 000. It almost finished the company. When *Baragoola* was converted somewhat later, she was given the minimum conversion. Except for a shorter funnel, her external appearance was almost unchanged.

The opening of the Sydney Harbour Bridge decimated the inner harbour ferry services. There was no obvious effect on the Manly service but, eventually, the bridge would have its effect there too. The great arch allowed motorists from well away from the Manly wharf to bypass the ferry to town. There was little encouragement to use public transport — quite the opposite. The Cahill Labor Government removed the extensive and capable tramway service against both public and council opposition, encouraged no doubt by the various oil companies at a time when Australia had no available indigenous oil supplies. Pollution was not a factor and the idea of parking spaces near wharves was not seriously considered.

The story of the Manly service from the early 1950s is one of slow decline, of genteel and almost unseen poverty, with maintenance slipping gradually

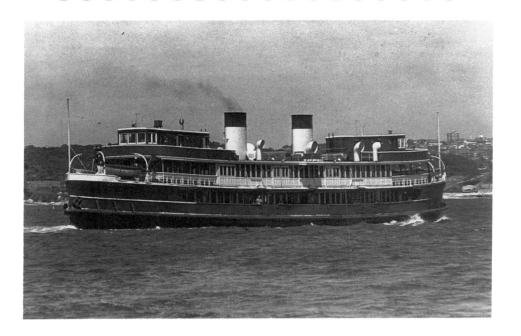

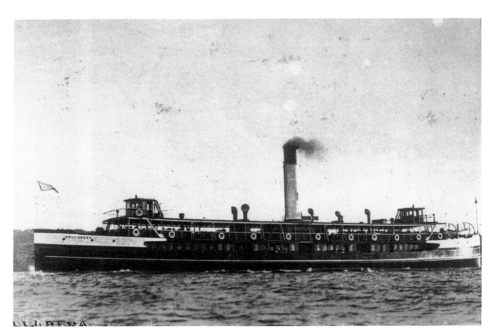

Bellubera as a steamer and in her later shape as a motor vessel. The 'Pretty Lady' served from 1910 until 1973. [Graeme Andrews Collection]

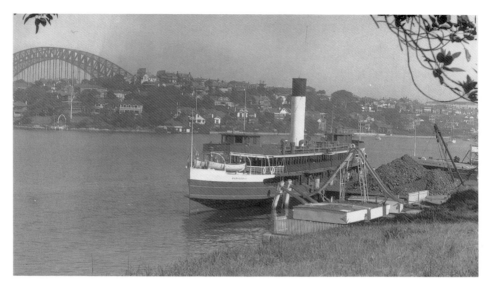

Steamer *Baragoola* coaling at the Port Jackson and Manly Steamship Company's Kurraba Point base.
[Humphrey Collection, Australian National Library]

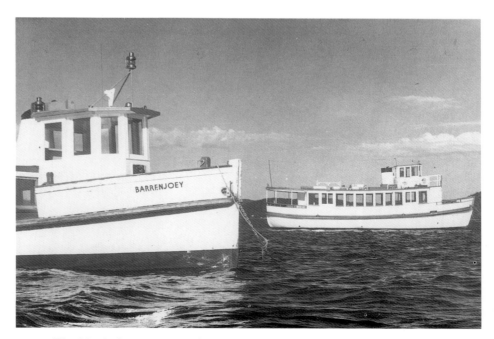

The Manly ferry company's out-ferries *Barrenjoey* and *West Head* sport the white funnel and black cap of the true Manly ferry. [Author]

away beneath the polished brass and touched-up paintwork. Despite diversifying into other fields, the Port Jackson and Manly Steamship Co. was still cash-short. Government did not want to know about it, the more so when it was forced to take over the collapsing Sydney Ferries Ltd. The State Government paid the Manly company a few thousand pounds a year to run the remains of Sydney Ferries Ltd's inner harbour services through a subsidiary, Sydney Harbour Ferries Pty. Ltd.

The late John C. Needham, managing director of the company from 1964 until the Government take-over in 1974, investigated new large ferries during the early 1970s. The idea was to have large, displacement hull double-ended catamarans.[7] A side elevation drawing was given in the *Manly Daily* of 9 September 1975, with expected costs of $6 million, to carry 1200 passengers at 18 knots. It would have been very interesting from a technical and mechanical viewpoint, but like so many other ferry 'plans' it came to nought. During Needham's stewardship, the first Manly hydrofoil, *Manly* (3) came into use and was soon followed by much bigger versions. They attracted customers, but whether they were new customers or transfers from the tired and unreliable old ferries is hard to decide. The hydrofoils were tried on harbour cruises and on a commuter service to Gladesville, but their noise and damaging wash in the narrow river soon restricted them to the more open Manly run.

Sydney's first commercial hydrofoil was *Manly* (3), shown here stopped with failed gearbox. It's November 1968 and *Manly* was towed back to Circular Quay by the author's naval workboat. [Author]

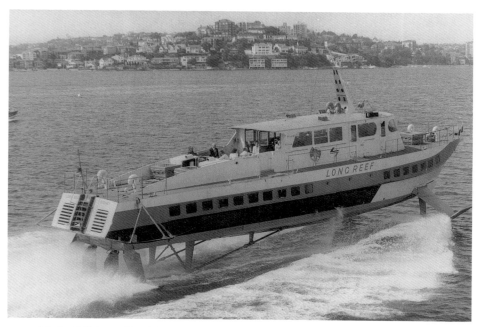

Hydrofoil *Long Reef* shows her long legs as she races in November 1979.
[Author]

In 1972, Brambles Industries made a second offer to buy the company for just over $2.1 million. It was accepted. It was surprising that the hard decision to give up had not been taken sooner. Perhaps there was a strong sense of obligation to staff and to those passengers who were rejecting the service.

Brambles quickly made it obvious that sentiment had no place in [their] ferry management. The sale had come when the fleet was so run down that even politicians were noticing. Press and public had become vocal. Senior Brambles management were interviewed on television to solemnly assure viewers of 'improvements that would be made to the service'. This was proven to be a sham. In quick succession, *Bellubera* was retired; it was announced that *Barragoola* would be retired, and *South Steyne* ceased her coastal cruises and was laid up at weekends. The hydrofoils were sold to a finance company and leased back, something the State Government seems not to have known until after it bought the ferry service. How Brambles were to run an improved service in this manner was not announced.

During this period, the State Government installed express city buses from Curl Curl to the city, with the effect of further reducing ferry patronage. The Askin Liberal Government's own Government Transport Committee warned of the total closure of the Manly service to no avail. Politicians still didn't want to know about ferries.[8]

Lady Northcott rolls across the Heads towards Sydney in March 1980. Note funnel logo. [Author]

The only bright spot in this dismal picture was the acceptance of a recommendation that two large new inner harbour ferries be modified while under construction to allow them to use the Manly Wharf if they were needed as relief ferries. These two ferries — *Lady Wakehurst* (1974) and *Lady Northcott* (1975) were to become vital on the Manly run.

In May 1973, Brambles increased fares by 10 per cent for daily trips and 33 per cent for weeklies, while discontinuing annual and monthly tickets. An announcement was made that Saturday services in the future would be run only by the fare-intensive hydrofoils. This created the outcry that, perhaps, Brambles had anticipated. Unions, commuters and the press attacked them over this policy.

Demands that the Government take over the ferries came from all sides. The newspapers of the day, particularly the vociferous *Manly Daily*, make interesting reading. A 'Save the Ferries' committee was formed, serving mainly as a platform from which aspiring Labor politicians could berate the Government.

Brambles chairman, R.A. Dickson was quoted as saying that the company would consider a Government takeover. That came as no surprise to observers of the company's actions. *Baragoola* was to battle on pending such a decision. On 26 February 1974, State Premier, Sir Robert Askin, announced a tempo-

rary subsidy pending a Government decision. Some months later, Transport Minister, Milton Morris MP, announced that the Government would buy only two large Manly ferries — but did not say which two. Morris was advised that two ferries and the hydrofoils could handle the passengers on offer. What was to happen during refits, breakdowns, survey periods, and accidents was not stated. It was not hard to guess which two ferries would be chosen. The two smaller and older ferries were diesel-fuelled. The larger, crew-intensive *South Steyne*, used mainly imported furnace fuel-oil which was very expensive. The Government, through its Transport Commissioner, Mr. Phillip Shirley, had been very active in retiring steam railway locomotives; steam was obsolete! The option to buy *South Steyne* would expire on 28 August 1974. The headlines of 26 August 1974 need no comment:

Biggest ferry burns, solving Government selection problem.[9]

Transport Minister Morris' belief that two ships could handle the passenger load of peak periods was given the lie when the *Manly Daily* of 7 September 1974 published a series of photos showing passengers packed like sardines. It seemed the Government's advisers had 'forgotten' about the 700 season ticket holders when calculating maximum passenger numbers.

On 1 December 1974, the Government took over the remnants of the Manly ferry service, to be operated by the Public Transport Commission. Of the two newly-built inner harbour ferries, *Lady Wakehurst* was soon desperately needed on the Manly run as *Baragoola* had been undergoing a major refit since October. There was a big difference between *Baragoola*'s 1300 capacity and the 700 odd of *Lady Wakehurst*, but at least Manly HAD a ferry.

Meanwhile *South Steyne* was becoming a media star. The press hammered the Government. Preservation groups came and went, some doing more harm to the ship than had the fire. Labor politicians, safely in opposition, expended hot air on the subject, and the first of many 'South Steyne will steam again' type headlines appeared.[10]

Then Hobart's Tasman Bridge fell down after the *Lake Illawarra* gave it a mighty clout. Tasmanians in Hobart had ignored their once-virile ferry service and allowed it to wither, but without their bridge, the citizens on the bank of the river opposite Hobart were in trouble. *Lady Wakehurst* was one of several Sydney ferries towed to Hobart to help cope with the loads. On the day she arrived in Hobart, her sister, *Lady Northcott*, started on the Manly run — 18 January 1975. These 'Ladies' were too small and too slow for the run. They did a fine job as fill-ins, but their trial speeds of just over 13 knots (and planned service speeds of 12 knots) meant flat-out running on the 14 knot Manly run — and mechanical troubles as a result. Manly needed the new Lady class, but Hobart needed *Lady Wakehurst* even more. For the first three months, she was on loan for free and then cost her users $3000 per week — she was a bargain! After 18 months, she was towed back to Sydney with a heavily-dented stem, the result of bad berthing in Hobart. That scar was

repaired in 1990. Her arrival, once more, was fortuitous. Her sister had made a bad berthing in the Quay and was out of service. *North Head* was plodding on alone and passenger demand was rising.

The Arab 'Oil Weapon' increased world oil prices in the early 1970s and that, plus road congestion and ecological considerations, turned the public eye towards public transport. The nadir had been reached for the Manly ferries and the curve was to be upward until the massive fare rises of 1989.

New conventional Manly ferries were first mentioned by Coalition Transport Minister, Mr. Wal Fife MP, not long before the Labor party won office.[11] The new Transport Minister, Mr. Peter Cox MP, soon released plans for a super-fast large ferry to replace *Baragoola*. Once more the magic figure of 18 knots was announced with a service time of just 25 minutes. Consideration of the much greater density of recreational traffic (from 1928) and the size of the wash at such a speed seem not to have been considered.[12]

In August 1976, *North Head* caught fire and passengers had to be evacuated. Three years later, on 4 August 1979, she lost her rudder en route to Manly. Off Bradleys Head, her master merely changed ends and completed the run, but *North Head* was then a lame duck. She could do just one peak hour run each way as the time taken to turn her around could not be fitted into a schedule.

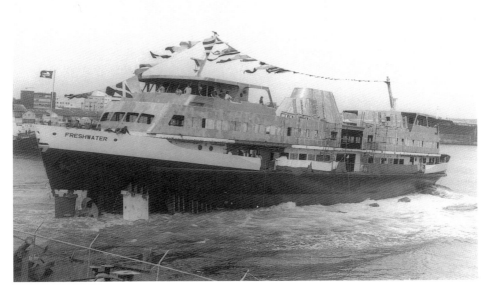

A new generation of Manly ferries begins. *Freshwater* is launched at State Dockyard, Newcastle. Note the lack of sponsons on the bow.
[Author]

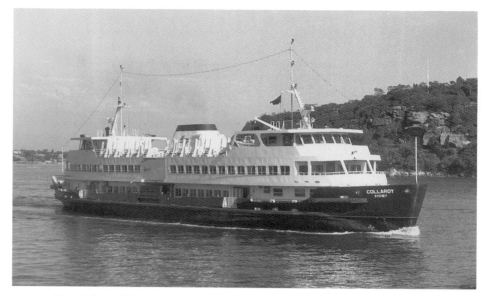

Manly ferry *Collaroy* shows off her modified accommodation to allow passengers better vision and fresh air. [Author]

This may have been the lever that moved the Government into action on the Manly ferries. *Freshwater* was laid down in Newcastle on 19 December 1980. She would be the first of four, and was intended to carry up to 1200 passengers at speeds of up to 17 knots. Many of the design lessons learned over more than 100 years of Manly ferries were ignored in the new craft and this was to become obvious. *Freshwater* entered service on 18 December 1982. Comfortable and roomy, the new ferry was immediately popular with passengers although the interior was somewhat 'clinical' in appearance. *Freshwater* soon became notorious for mechanical and 'computer' malfunctions. Her most notable exploit was to park herself on the Manly harbour beach, in the full glare of all the various media.[13] She broke down and drifted and somehow dropped an anchor while under way, but it was early days, and *Freshwater* eventually came good. Her most dramatic incident gained considerable acclaim for her master at the time. Late in the evening Captain Dave Stimson was heading for Manly when he was confronted on his bridge by an apparently armed man who demanded he head out to sea. Stimson was able to broadcast a radio message that soon brought the water police who quickly terminated the unauthorised ocean excursion.[14]

Design problems with the new ferries included insufficient fendering on the hull sponsons, which necessitated the fitting of a high-level 'eyebrow' sponson on *Freshwater* after launching. Until the use of a single hull colour with the introduction of *Collaroy*, there were regular changes of hull colour

arrangements as attempts were made cosmetically to provide an artificial sheerline. The broad, low bows of this class make them very wet inboard and they are very lively in a seaway. Their jerky roll could be compared with the even, almost stately motion of the *North Head* when the old and the new passed while crossing the Heads. A lack of open seating on the top deck caused much comment. This was remedied with *Collaroy*, but the cut-out design sections do not blend with the rest of the superstructure and are an obvious afterthought.

Freshwater (1982), *Queenscliff* (1983), *Narrabeen* (1984) and *Collaroy* (1988) have provided Manly with an effective and modern large ferry service which should be relatively unchanged until the next century. While they are effective ferries, they do not run at the service speeds originally touted. They were given two engines to allow a service speed of up to 17 knots. Fuel costs at that speed, and the resultant wave formation (in the author's experience as potent as that of *South Steyne* at the same speed), make such a speed uneconomical. As a result, these ferries usually run on one engine and have the other as a spare which should ensure reliability.

Collaroy was modified for use as an offshore day cruise vessel. In 1989 and 1990 she carried out cruises from Sydney to Broken Bay and the Hawkesbury River to the north, and from Sydney to Botany Bay to the south in shorter cruises, twice a day. She also ran a series of similar cruises from Newcastle to Port Stephens, as did the ex Manly ferry *Kuring-Gai* in the 1920s. These cruises were in abeyance after the middle of 1990 after ferry officers requested to be paid the same 'Spew' allowance received by the deckhands for cleaning up after passengers following sea cruises.

The introduction of hydrofoils from 1964 produced an alternative form of Manly transport that has always caused controversy. I believe that the short — seven nautical mile — run to Manly was too short to show hydrofoils at their best. Turn around time is relatively long as a proportion of total voyage time, while the engine loadings and fuel consumption of becoming airborne every few minutes was uneconomical and demanding upon the power plants.[15]

Introduction of the larger RH160 'Manly' class did not solve the problem. Their arrival roughly coincided with the demise of the last of the old, mainly wooden, inner harbour ferries. This may be a coincidence, but Balmain ferry staff have long suggested that the true running cost of the hydrofoils was disguised by 'creative accounting' which saw some of the actual costs apportioned to the older ferries. Be that as it may, the cost of running the hydrofoils became a public issue soon after the old ferries were retired. Plans for a new type of super, fast ferry were announced.

One result of the Hobart Bridge disaster was the construction of a fleet of Hobart-built displacement ferries. These were built and run by Bob Clifford, who, realising that a rebuilt bridge would again kill Hobart's ferries, looked for innovation in ferry design. In conjunction with naval architect, Phil Hercus, a prototype fast ferry was built. *MV Jeremiah Ryan* (1977) was fast and effective

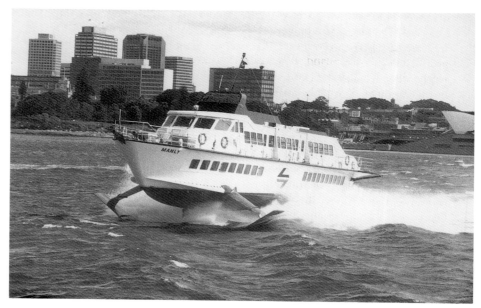

'Super' hydrofoil *Manly* (4). [Author]

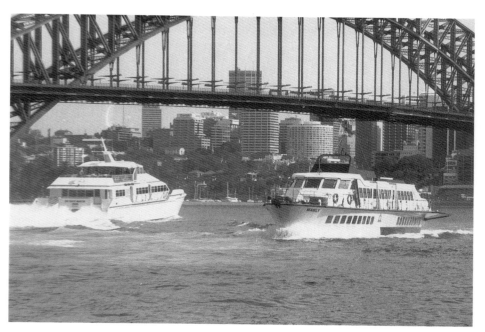

Jet Catamaran *Sir David Martin* heads out from the Quay as hydrofoil *Manly* comes into the Quay. [Author]

and would evolve into the world-renowned International Catamaran (Intercat) designs, revolutionising ferry and commuter services worldwide. The first of this type to work on Port Jackson was *Blue Fin*, a Jet Cat, built in Cairns, North Queensland. *Blue Fin* went into service in Sydney on 16 July 1990, some months after being officially named by Premier Greiner at Manly on 29 April 1990. During her extensive familiarisation trials, she had one main engine replaced and attracted unfavourable comment about the severity of her wave pattern.[16]

Late in 1991, the Manly ferry fleet consisted of *Freshwater*, *Queenscliff*, *Narrabeen* and *Collaroy*, with large hydrofoils *Manly* and *Sydney*, smaller hydrofoils, *Long Reef* and *Curl Curl* laid up, and the new *Blue Fin*, *Sir David Martin* and *Sea Eagle*. The three new additions caused some concern over fuel costs which were greater than the big hydrofoils and their reliability not obviously better than the politically-derided hydrofoils.

Since World War II, a large number of Manly ferries have been retired. Many of these craft spent long periods lying in harbour backwaters; others went on to new careers, and others refused to leave quietly.

First to leave the run was *Balgowlah*. It had been intended to refit and modernise her in a similar manner to *North Head* (formerly *Barrenjoey*). *Balgowlah* was the last coal-burner on the Manly run and was a spare ferry. She was withdrawn on 27 February 1951 and, after two years being laid up, she was sold to

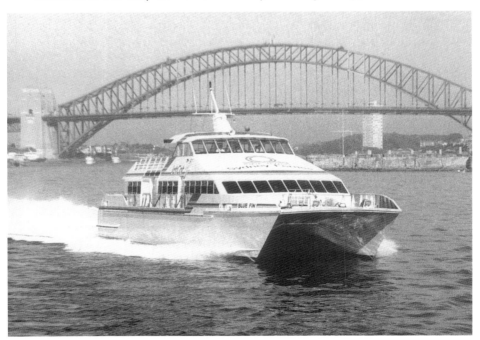

The prototype Jet Cat *Blue Fin* passes Fort Denison. [Author]

J. Stride, shipbreaker of Rozelle Bay. Machinery bought in 1949 for her conversion was kept in store until the company was able to convert *Baragoola* to diesel electric power. *Baragoola*'s austere rebuild began on 1 December 1958 and she entered service again on 9 January 1961. The return of *Baragoola* meant the end for the steamer *Curl Curl*. She ran her last service from Manly on 25 October 1960 and was then laid-up in Neutral Bay. *Curl Curl* was eventually sold to Stride Bros. shipbreakers and towed to Rozelle Bay on 3 July 1963. There she was gradually stripped with sister ship *Dee Why* eventually meeting the same fate alongside her. *Curl Curl* was towed to sea and scuttled on 13 August 1969.

Dee Why was withdrawn on 8 April 1968 and was then berthed alongside her partly-stripped sister awaiting the hammer. After considerable material was removed, including her wheelhouse intact for display in the Warringah Mall, she was consigned to the artificial fish reef off Long Reef, north of Sydney. She was towed to sea by the tug *Fern Bay* on 25 May 1976.

The demise of the twin sisters left *South Steyne* as the last steam ferry in the port. Next to go was *Bellubera*. Despite the massive fire which gutted her superstructure and distorted her hull in 1936, she'd had a long and successful second career. *Bellubera* ran her last trip on 29 November 1973 and then spent some time laid up at various wharves around the harbour, including the Balls Head coal loader and Simmons Point. She was sold to Pacifica Enterprises who stripped from her many mechanical parts, some of which were later sold to the Public Transport Commission as spares for *Baragoola* and *North Head*. During this time, various plans for her were announced including the almost-obligatory suggestion for old ferries of a floating restaurant. The most interesting was a plan to use her to run supplies from Darwin into Timor for the Fretelin guerillas fighting the Indonesians. What the Indonesian Navy would have made of a Manly ferry heading into Dili can best be left to the imagination! Some of *Bellubera*'s remaining machinery was moved to the former Royal Australian Navy minesweeper, *Gull*, in 1980. *Bellubera* joined the fish reef on 1 August 1980.

South Steyne was the next Manly ferry to be withdrawn, but this was one ferry that would not be ignored! The takeover of the Port Jackson company by Brambles in 1972 meant the end for the big ferry. Routine maintenance was cutback and the ocean cruises ran their last voyages on 20 May 1973. On Sunday, 25 August 1974, while tied up over the weekend following her Friday run, *South Steyne* caught fire near the engine room. This unexplained fire signified the start of an almost 20-year battle by a variety of people to not allow the graceful ferry to die. Many proposals for her re-use were made, and it is obvious now that she could have been quickly returned to use if there had been the political will to so do.

The first Manly hydrofoil was the 72-seat PT20 class *Manly* (3) which entered service in January 1965. As well as peak hour services, she ran tourist trips and was sent to Port Phillip, Victoria, in February 1967 to run tourist

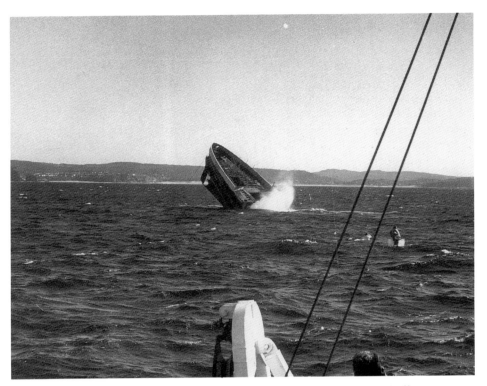

**Manly ferry Dee Why (1) goes to the bottom as a fish reef off
Long Reef, north of Sydney.** [Author]

trips on the bay. She was laid up in 1978 and sold in 1979 for use in
Queensland on the Rosslyn Bay-Keppel Island service under the name
Enterprise. She was for disposal in 1989. Other hydrofoils to be withdrawn
were *Fairlight* (2), *Dee Why* (2) and *Palm Beach*, all late in 1985 or early 1986.
They were broken up in Homebush Bay, Sydney, and their aluminium was
said to have been exported. In 1991 the remaining hydrofoils, *Long Reef*, *Curl
Curl*, *Sydney* and *Manly* (4) were retired and then sold overseas. They left
Sydney aboard the motor ship *Regine* on 7 February 1992.

Baragoola's last run was under Captain Ron Hart on 1 January 1983. She
was replaced by *Freshwater* and was soon reported sold for $100 000 to a syn-
dicate of businessmen who intended to use her as a floating restaurant along-
side Manly wharf. What diners would have thought of the sudden surges when
big swells hammer the wharf is open to estimation. The sale fell through.
Baragoola was then sold to the Eureka Foundation which intended to use her
as a mobile floating unofficial university. She was to cruise the harbour, pick-
ing up students from various wharves, and returning them later.[17] How the

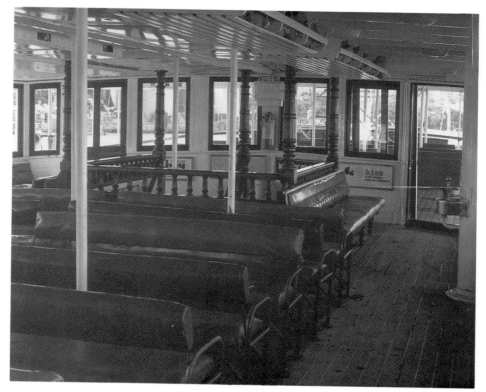

Leather seats and varnish set off *Baragoola*'s upper deck accommodation in 1980. [Author]

ship could be manned, paid for, or maintained, seems not to have been understood by this group of optimists. The ignorance of the sea and ships displayed was awe-inspiring in its scope. *Baragoola* spent several years afloat in Rozelle Bay, Sydney, under control of this group, before being resold. After some hull repairs in the Garden Island floating dock, she was still afloat under new owners at the same site in 1990.

More successful was the retirement of the *North Head*, formerly *Barrenjoey* (1913), the 'last' working traditional Manly ferry. She was withdrawn without fanfare (after earlier plans for a farewell were postponed) on 12 December 1985. For several years prior to this, the Geelong Maritime Society had planned to take her to Port Phillip to recreate the great cruise boats that lived there in the years before World War II. They were further inspired by *North Head*'s 1964, 1965 and 1967 visits to Melbourne during the Moomba Festival. Their efforts came to nought, but *North Head* did head further south. She was sold to North Head Pty. Ltd in March 1987 and arrived in Hobart on 29 March 1987 where she has since been running as a private vessel.

NOTES

1 Charles E. McDonald and Capt. C.W. Henderson 1975, *The Manly Warringah Story*, Sydney, p.27.

2 Harold Norrie 1935, 'Sydney Ferry Boats', *Journal of the Royal Australian Historical Society*, Vol. 21, part 1, p.4.

3 Jenny King, descendant of Captain Hutton, letter and family archives.

4 Tom Mead 1988, *Manly Ferries*, Sydney, p.15.

5 Details of her early career in Scotland may be found in Duckworth and Longmuir 1972, *Clyde River and Other Steamers*, Glasgow, p.39.

6 For details of the purchase and delivery of 'South Steyne', see A.M. Prescott and R.K. Willson, 'South Steyne', *The Log*, August-November 1983.

7 Conversation with John C. Needham, c1972. See also *Manly Daily*, 12 September 1975 and B.J. Browne, 'Catamaran to Manly', *The Log*, May 1991, p.53.

8 Mead, p.111.

9 *Sydney Morning Herald*, 26 August 1974.

10 Mead, various.

11 *Manly Daily*, 12 February 1975.

12 *Sydney Morning Herald*, 1 January 1978: Tenders called for new Manly ferry.

13 *Daily Telegraph*, 3 March 1983.

14 Mead, p.133.

15 *High Speed Surface Craft*, July-August 1988, pp.29–32.

16 *Modern Boating*, August 1990.

17 *Sydney Morning Herald*, 8 December 1983. See also 'University takes a nose dive', *Manly Daily*, 7 April 1984.

CHAPTER 5

SYDNEY FERRIES 1900–1951,
GOVERNMENT FERRIES 1951–1992

THE FERRY SCENE TO 1951

The roughly fifty years of Sydney Ferries Ltd. (SFL) represents the period of greatest ferry route and passenger growth in the ferry story. New heights were reached in routes and in vessel numbers and size. The highest point appears to have been in 1928 after which SFL began their slow decline and then steep drop after the Bridge was opened in 1932. This decline flattened out somewhat before World War II, reversed its direction during the war and the period of petrol rationing after the war, and then continued downwards.

Before 1920, Sydney Ferries Ltd. absorbed most of its contemporaries, except for the Manly service. The Parramatta River ferries went to SFL in 1901 and the Balmain ferries (which had taken over the Joubert Lane Cove River ferries in 1906) joined them in 1917. Those running to Watsons Bay came under the SFL aegis in 1920.

Thus, the fleet available to SFL was considerable and some culling of ferries began in the 1920s even while passenger numbers were rising. In this way SFL was able to field a fleet of ferries, many of which had characteristics suitable to a particular service, while maintaining enough dual-purpose ferries to relieve and replace others when needed. In the early 1920s, the fleet ranged from vehicular ferries, to the massive 2000 plus capacity Kuttabul class, to the fast single enders of the Parramatta River run, and the small double ended 'free' ferry *Una* of the Tarban Creek feeder service. Small lighterage tugs, water carriers and cargo ferries backed up the glamour ships.

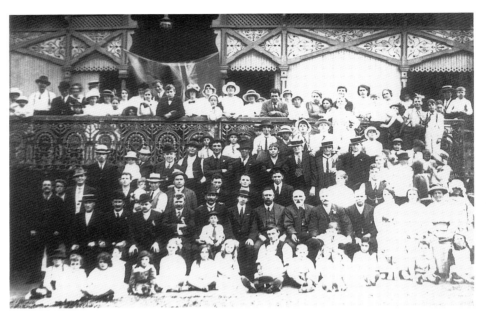

The staff of Sydney Ferries Ltd. gets together for a staff picnic in 1914.
[Meg Donnison]

Berthing this maritime conglomeration took some considerable organisation. Ferries were berthed in Mort Bay at the old Balmain ferry base and others laid up at Blues and McMahons Points. Still others were rafted to moorings in Tarban Creek when not wanted.

This was the major part of the ferry fleet, and it was represented in nearly every photograph of the harbour between 1900 and World War II. The tall-funnelled Manly ferries made up the other indigenous part of the scene, usually shown passing naval pinnaces or moored naval vessels jutting out from Farm Cove. Sailors flocked ashore from the fighting ships, landing at the excursion wharves adjacent to the tram depot that occupied the site of the present Opera House. In Sydney Cove, as many as six or seven ocean liners would line the east and west sides of the cove. They dominated but did not subdue the parade of steam ferries that dodged among the passing parade of lesser ocean ships heading up or down the harbour from berths west of the Quay.

The introduction of the plan for the harbour bridge — 'the Great Arch' — roughly coincided with the slide into the Great Depression, but in the meantime, Sydney Ferries Ltd. had to cater for the demands of an increasing cross-harbour trade. In 1922, two new 'giant' ferries were built in Newcastle for the major commuter run — the peak-hour Quay-Milsons Point service. They were the first new Sydney ferries since 1914 and were similar in size to the Manly ferries but had a much greater passenger capacity. *Kuttabul* and

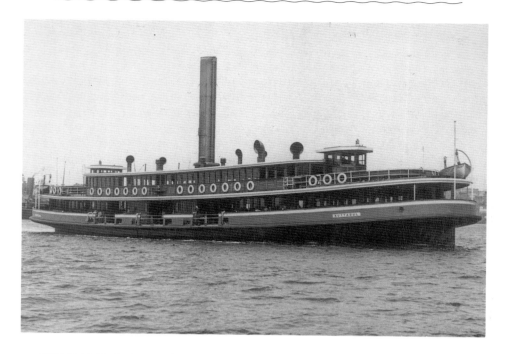

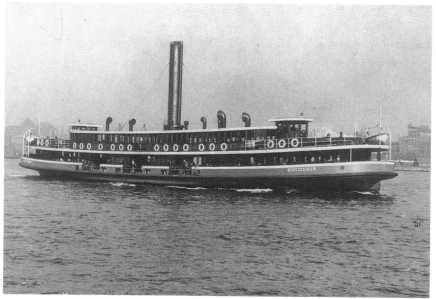

The magnificent *Kuttabul* and *Koompartoo* could each carry more than 2000 passengers on the short run from the Quay to Milsons Point.
[Duffy Collection]

Koompartoo were the largest capacity Sydney ferries built. They were needed because of a population increase on the North Shore that produced, in the decade before the bridge, a passenger demand, wharf size and trip frequency equation that could be solved only by the introduction of very big ferries on a run which reached a peak hour frequency of one departure every SIX minutes. Backing up the giant 'K' boats were usually *Kuramia*, *Kai Kai* or *Kulgoa*.

On their other routes, SFL ran a high/low mix according to the time of the day and had reserve sufficient to cater for breakdowns and unexpected down-time.

During the middle to late 1920s, SFL began a fleet rationalisation program. Towards the end of the decade, the combined effects of urban sprawl, railway, and bus and tramway competition had ended the Parramatta River passenger trade.[1] Although SFL continued to run ferries along the lower Parramatta River and on the Lane Cove River, the company contracted steadily after 1928.

In July 1928, Sydney Ferries Ltd. announced cut-backs to the Balmain ferry services. The *Lady Manning* (1894) and *The Lady Mary* (1892) were soon sold at auction for £100 and £150, respectively, to the Tay Lighterage Co. *The Lady Mary* soon became a ramshackle houseboat.[2]

The old Lady ferries, some dating from the previous century, were tiring. *Lady Rawson* (1903) broke her propeller shaft as she neared Neilson Park.[3] *Lady Hampden* (1894) was usually unreliable. In this period, the record shows a considerable collision rate between ferries and ferries and between ferries and ships. Over the period December 1927 to December 1928 there were seven collisions involving SFL ferries with each succeeding year bringing several more. So regular were these incidents, that little publicity was given them.

The start of constructing the bridge symbolised the ferry's future. The gracious arcade of shops that allowed passengers dry transfer from ferry to tram or train was torn down. The ferries now unloaded on the west side of Milsons Point, alongside the present-day site of the Olympic Pool. The doomed vehicular ferries were moved east to a new ramp at the base of Jeffrey St.

Sydney Ferries Ltd. increased fares from 2d. to 3d. as the bridge grew. This was bitterly contested and cartoonists and others attacked the company.[4] As 'Bridge day' approached and afterwards, SFL gives the impression that it was unable to come to grips with the dimensions of the disaster to its business.

The last of the single-ended river ferries — *Bronzewing* — had gone in 1928. In June 1930 the Sydney City Council voted that Sydney Ferries Ltd. should REDUCE fares — and was ignored. In that year, SFL claimed to have carried 44 757 000 passengers, down from 47 million in 1927.[5] The following year a newspaper report suggested that the Sydney Ferries Ltd. fleet had been offered for sale in London.[6] With the bridge now dominating the port, the suggested sale came to nought and SFL had to cope with the situation.

Earlier that year, as if to remind the car ferry crews of their fate, a cable hanging from the bridge swept over vehicular ferry *Killara*, causing damage, panic and injuries.

The Watsons Bay run was fading away and barely made the middle of 1933 with SFL offering 18 (!) ferries for sale as early as March, 1932. An attempt was made to combine the Zoo and Watsons Bay services, but this was soon abandoned.

Belatedly, as the bridge-effect on the harbour trade became apparent, SFL reduced fares; more than 100 SFL staff had been sacked and the company looked for other ways to reduce running costs. In August 1932, SFL announced experiments with the intention of converting some of the smaller ferries from steam to diesel power.

It was hoped to reduce crews from four or five to three. The vehicular punts were gradually sold or were laid up. Some of the various 'Ks' and all the older 'Ladies' went. *Lady Carrington* (1907), the little *Lady Linda* (1906) and *Lady Napier* (1892) were retired in 1934. *Lady Rawson*, the 'flagship' and picnic boat, was sold, with her broken shaft, to the Australian Motor Yacht Squadron. This group re-named her 'AMY's Clubship' and moored her off Beauty Point, Middle Harbour, as a club house. A launch was provided to carry club members from Lyons Boatshed, near the Spit Bridge, to the old ferry.[7]

Vaucluse (1905) was sold to Newcastle as a dockyard ferry in 1931; *King Edward* (1902) had her engines sold in 1935 and was laid up — perhaps with

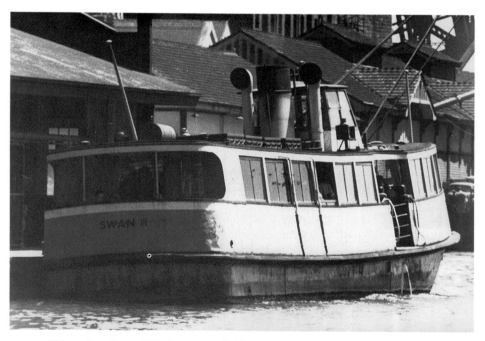

Waterbus *Swan III* leans towards No. 7 wharf as she loads passengers.
[Ross Gillett Collection]

conversion to diesel power in mind? *Kirribilli* (1900), *Koree* (1902), *Kummulla* (1902) and *Kurraba* (1899) all left the fleet in 1934.

In place of these craft, SFL fielded a slimmer fleet, gradually using diesel engines. *Lady Chelmsford* (1910) was the prototype conversion in 1933 and results were said to be very good. Her speed increased from 9.3 knots to 10.5 knots and she needed to be refuelled every three weeks (instead of every few days), running about 18 hours a day. The new engine was a Gardner diesel, of the two-stroke, five cylinder type, giving about 190 brake horse-power.[8]

After two years of trial service, SFL was confident enough to begin converting the rest of the Lady class and some of the smaller 'K' boats. In 1936, ladies *Denman* (1912), *Edeline* (1913) and *Northcote* (1905) were converted to motor ferries. The largest, *Lady Northcote*, seems not to have been a success as she was hulked by 1941. It is possible that she was chosen for conversion as she had push-pull power (screw at one end only) which would be easier to motorise. Ladies *Ferguson* and *Scott* (1914) were converted in 1937. The first of the 'K' boats to receive internal combustion engines, *Karrabee* and *Karingal* (1913) were converted in 1936 and 1937, respectively.

While the conversions were happening, SFL was altering other aspects of its business. *Koompartoo* was modified as a concert boat in 1935. One end of her upper deck seating was fully enclosed. Sistership *Kuttabul* was given a rudimentary 'flying bridge' over each wheelhouse to allow the master to see over the crowds that packed around the wheelhouses on race days. *Kulgoa* and *Kai Kai* received similar extensions to their wheelhouse controls.

Needing to compete with road transport, SFL essayed Sydney's first fast ferries. Built by Morts Dockyard in 1934, they were three fast single-enders of a design new to Sydney. Although they were generally known as 'waterbuses', SFL statements of the time mentioned importing a 'waterbus' from the UK in addition to the three locally-built ferries. The new fast ferries were intended, initially, to run on the Lane Cove River and lower Parramatta River services, and were named after three of the ships of Sir Francis Drake. Capable of about 13 knots, the Crane class were two or three knots faster than the big SFL ferries, and five or six knots faster than small single-ended ferries of the time. Their career was brief. Mechanically, they were troublesome. At speed they developed an impressive wash which was damaging in confined bays and along the river. They worked spasmodically during World War II (interestingly, Australia had coal aplenty for SFL's coal-fired ferries, but had to import liquid fuels) and during the late 1940s, but were all laid up by the early 1950s. (*Swan III* had final survey in September 1942, *Pelican* in 1949, and *Crane II* in August 1949.)

Sydney Ferries Ltd's passenger traffic dropped from the 1927 figure of 47 million to about 15 million in 1933, showing how immediate was the effect of the bridge.[9] The figure rose slowly to about 17 million by 1945, mainly because of war-time petrol rationing, and then fell to just under nine million in 1950. By then, SFL was running only 15 ferries (51 in 1931, 27 in 1933). Effectively,

it was the end for SFL but, perhaps because of a sense of responsibility, the company carried on, the while seeking to inspire a takeover by the Government of New South Wales.

It hadn't been easy. In August 1949, George William Bonsall, SFL manager, announced that there would be more cuts in the company's services.[10] He followed this with the announcement that the ferries would be 'all out for trade'. Mr. Bonsall probably meant it, but the means to arrest the decline of SFL were not available to him. The combination of poorly-maintained, hard-worked old vessels, insufficient capital for improvements or new ferries, the relaxation of petrol rationing, and the resultant increase in car use, all worked against the survival of SFL. Added to this was competition from trams and buses, plus wage rises of up to £1 a week. The Directors and shareholders of Sydney Ferries Ltd. had little to be optimistic about. There seemed to be no commercial way out of the trouble.

In 1951, the company's shareholders were asked to approve the sale of the company to the McGirr Labor State Government if it could be arranged. Chairman of Directors, Colonel A. Spain, intended to offer only the ferry arm of the company while retaining the Showboat and the lighterage wing, Harbour Land and Transport.

Early in 1950, the company approached the State Government, through the Commissioner for Transport, A. Shoebridge and Transport Minister, W. Sheahan MP, for an operating subsidy. This was refused.

For the year ended 30 June 1950, Colonel Spain claimed the lighterage company made a profit of more than £9000 with a similar profit from the Showboat *Kalang*, balancing a loss of more than £17 000 from the passenger ferries.[11]

A.C. Barber of Hegartys Ferries, may have been remembering SFL's earlier inconsistencies regarding the Lavender Bay service when he publicly offered to take over, on a progressive basis, ALL existing SFL services at just 6d. per passenger trip. SFL had recently increased adult fares from 6d. to 9d.

On 15 March 1951, SFL began to force the Government's hand. Colonel Spain announced that SFL would cease passenger ferry services either on 31 March 1951 or on 30 April according to the wishes of the shareholders.

There was an uproar. Reg. Winsor, Director of Transport and Highways, claimed the statement came as a 'bombshell'. Perhaps he hadn't been paying attention? Winsor complained that SFL's many years of profitability should cause the company to continue until such time as alternatives were established. Colonel Spain believed that was just what the company had been doing. Again SFL asked for a State Government subsidy, claiming the company needed to carry 8000 more than the current daily total of 21 000 passengers to pay its way at the current fare rate.[12]

A plan by Mosman's mayor, Alderman G.I. Ferris, that joint ferry and bus and ferry and tram tickets should be issued was rejected by SFL as liable to cost the company even more revenue.

The following day, Transport Minister Sheahan stated that the Government would not buy the unprofitable parts of the company, which indicated that purchase was being considered. Premier McGirr weighed in with a good swipe at private enterprise — interesting in a 1990s context:

> Self-appointed experts have been active … in pointing out what private enterprise can do. I note that private enterprise now suggests that it is going to close up without … consideration for the travelling public.
>
> I wonder if the company has yet called in as consultants the transport experts connected with newspapers and others who are always so eager to tell government how transport services should be run.

McGirr had made his point. Over the next few decades, private enterprise was often to demand the right to run public transport unhindered, until financial problems made 'interference' by the Public Service more desirable than it had earlier seemed.[13]

Sydney Ferries Ltd. hung on, announcing that services would continue to 30 June. Spain and Sheahan were getting nowhere and the shareholders agreed to subdivide the company. One million shares of 2/6d. were issued in Harbour Land and Transport to existing shareholders and the existing capital was reduced by half. Spain pointed out that accumulated ferry losses over four years were more than £70 000 and that almost no dividends had been paid for four years.

Karingal showing her original appearance as a motor ship. She was later given an 'up-turned flower pot' funnel. [Fred Saxon]

Faced with the probability of having to provide hundreds of extra buses and trams, the McGirr Government took over SFL's ferry services at midnight on 30 June 1951. Ferry *Karingal* left on its last run for the night to Mosman as a member of the SFL fleet and returned, after midnight, as a unit of the Sydney Harbour Transport Board (SHTB) fleet.

Director of Transport, Winsor, signed for a flotilla of just 15 ferries for a price of just £26 000, following the passage of the *Sydney Harbour Transport Act* of 1951 which provided for the formation of the Sydney Harbour Transport Board. Winsor took possession of the ferries, the Balmain ferry base, and the staff. Management was to be by the Port Jackson and Manly Steamship Co., through a specially-established subsidiary. It seemed an almost-ideal arrangement while the Manly company ran, but it too was soon looking for help or subsidy. The State Government's 'quick-fix' left it vulnerable without ferry-wise staff when Brambles Transport Industries began to demonstrate its ideas of 'private enterprise' with the Manly company in 1974.

GOVERNMENT FERRIES

The formation of the Sydney Harbour Transport Board (SHTB) and the takeover by the Government of SFL equipment on 1 July 1951, would, eventually, mean total revision and revival of the once-great harbour ferry services.

Sydney Ferries Ltd. had contracted to serving just Mosman Bay, Neutral Bay, the Zoo, and the Cockatoo Island-Huntleys Point route. Under new management, there was an initial flurry of activity as abandoned routes were considered for possible re-use. There were a number of press leads of the 'State May Build Ferries' type.[14]

Later that year, Harbour Land and Transport distanced itself even further from its one time ferry arm, with a name change to Harbour Lighterage and Showboat.

During the next several years, more old ferries went to the breakers. Some, such as *Kamiri*, long laid up, were of little value. Others, such as *Kirawa*, were disposed of long before their time with many years of work still in them (*Kirawa*'s sister ship *Kanangra* worked until the mid-1980s). In the first few years of the 1950s, *Kurra Ba* (formerly *Kanimbla*) was broken up, as was *Kiandra*, *Kirrule* and *Kirawa*, the last needing only a boiler refit or a diesel engine. *Kosciusko* and *Kanangra* were motorised around 1959 with *Kubu* (the last coal-fired ferry on the harbour) dropping out when *Kanangra* returned to service. *Kameruka* was given her internal combustion engine in 1955.

By 1960, the SHTB fleet showed the form it would present for almost a decade. The new small ferry *Kooleen* (1957) was in use, together with the wooden ferries *Karrabee*, *Karingal*, *Kosciusko*, *Kameruka*, and ladies *Scott*, *Chelmsford*, *Edeline* and *Ferguson*. Steel-hulled *Kanangra* was the heavy-lift ship used mainly on the peak-hours Cockatoo Dockyard run. In 1958,

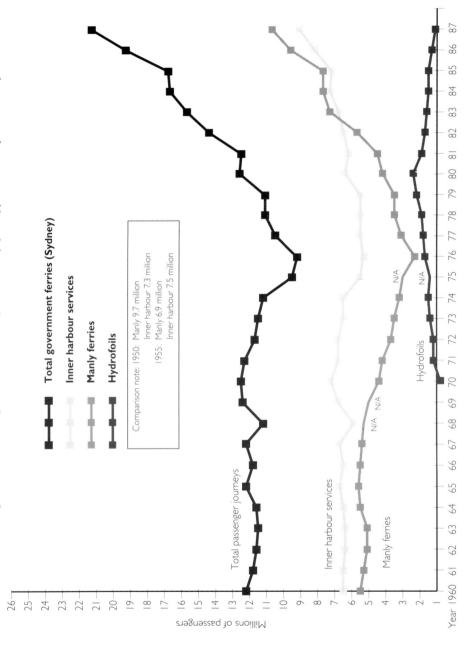

Passengers carried on government ferry services (Sydney) 1960–87 (in millions)

Legend:
- Total government ferries (Sydney)
- Inner harbour services
- Manly ferries
- Hydrofoils

Comparison note: 1950: Manly 9.7 million
Inner harbour 7.3 million
1955: Manly 6.9 million
Inner harbour 7.5 million

Millions of passengers

Year 1960 61 62 63 64 65 66 67 68 69 70 71 72 73 74 75 76 77 78 79 80 81 82 83 84 85 86 87

Graph 1

One of three almost-identical sister ships was *Kiandra*. The others were *Kirrule* and *Kubu*. [Fred Saxon]

Wearing the bow scars of a bad berthing, *Kareela* eases back to call at Musgrave St. wharf. [Fred Saxon]

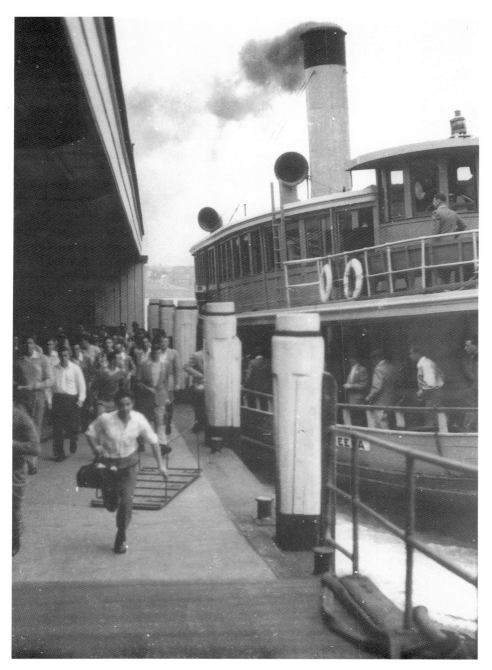

'Over the gunwale and off up the wharf for train or tram . . . '
Kareela's passengers seem keen to get to work [Fred Saxon]

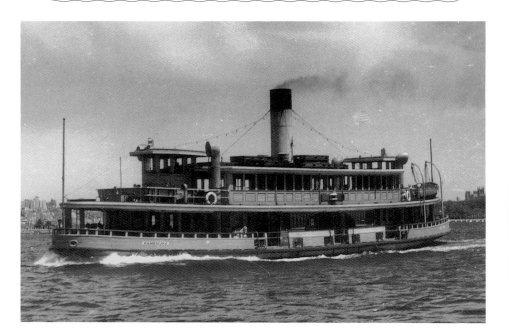

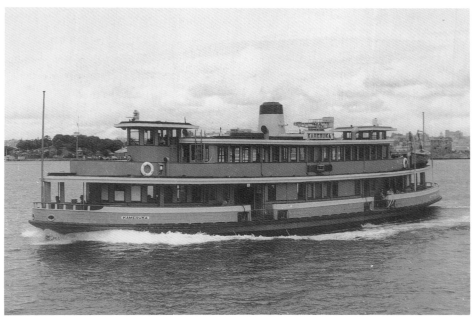

One of the fast Sydney steam ferries, *Kameruka* changed her looks over the years. She is shown as a steamer about 1954 and as a motor vessel in the mid 1960s. [Fred Saxon]

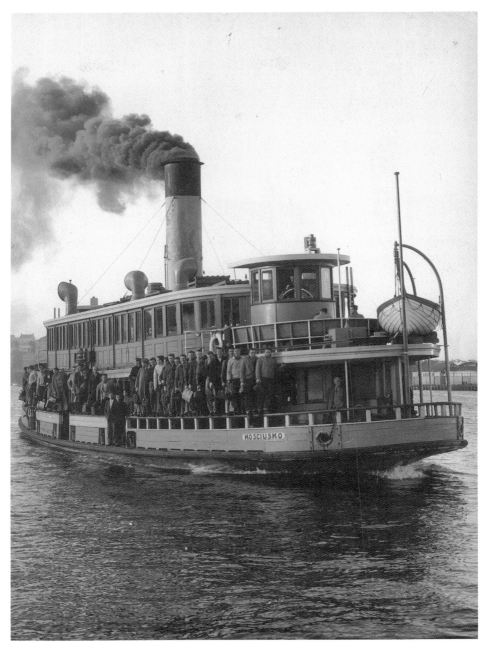

The morning balancing act — a fine judgement had to be made as the gap between *Kosciusko* and wharf narrowed. Being able to swim and duck-dive helped. [Graeme Andrews Collection]

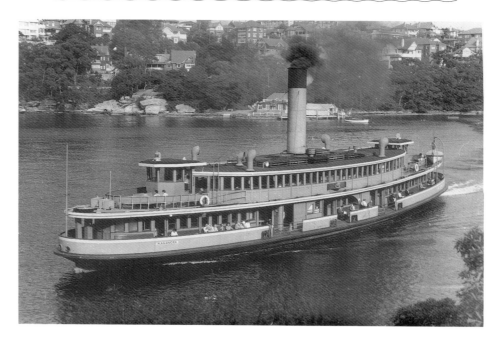

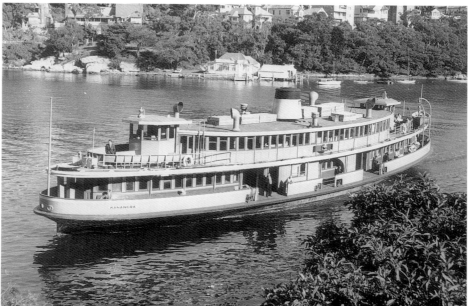

Steamer *Kanangra* nears Musgrave St. wharf on her way to Sydney as
a steam ship, and does it again about 10 years later as a motor vessel.
[Fred Saxon]

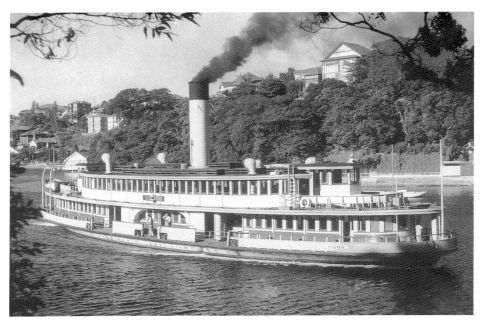

Coal-fired *Kubu* completes the three-minute run from Mosman to Old Cremorne wharves in the mid-fifties. [Fred Saxon]

Harbour Lighterage and Showboat tried to divest itself of the loss-making showboat, but the State Government was not to be led by the nose again. The SHTB had trouble enough without taking on another (see section on excursion vessels Chapter 8).

It seems the Sydney Harbour Transport Board was interested in a new colour scheme prior to the arrival of *Kooleen*. The muted varnish and buff brown superstructure became yellow and cream and the soft hull green became more strident with maroon external seating and bulwark rails. It did not please all passengers, and a Mr. Plomley burst into print so vigorously that the SHTB promised to return to the old colours — it did not.[15]

The order for *Kooleen* was placed with the State Dockyard in Newcastle in 1954. The new vessel was to be a prototype, offering about 300 passengers a fully-enclosed urban ferry. The result looked something like a small, fat submarine with windows. There were no outside seats and the master had all-round vision.[16] On trials on Port Hunter, *Kooleen* had a tendency to poke her nose under water so she was fitted with two bow 'caps' which solved the problem for the rest of her working life.

Kooleen carried out her official VIP cruise on Port Jackson on 11 January 1957 and the VIP list was a Who's Who of the ferrymen of the day: Minister for Transport, A.G. Enticknap MP; Commissioner for Government Transport,

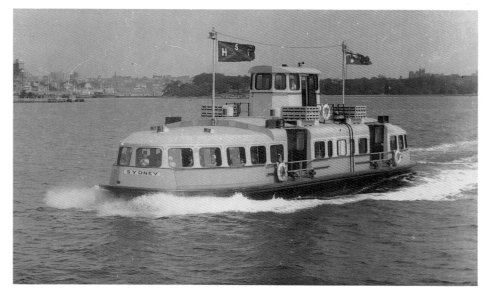

Brand new and wearing the SHTB house-flag *Kooleen* **shoulders the harbour aside on her way to Cremorne Point wharf.** [Fred Saxon]

A.A. Shoebridge: Managing Director of Sydney Harbour Ferries, George Bonsall; and Chief Engineer, F. Hilton. All pronounced themselves well-pleased, but then it was into the courts as the marine unions refused to man the ferry with a crew of two. They claimed that it was too dangerous for the master, remote in his small wheelhouse above the passengers, to be also responsible for the engine. The courts agreed and *Kooleen* worked with three crew.

As a one-time master of *Kooleen* (1980), I cannot imagine how I could have maintained the pumps and associated equipment while under way, nor how I could have restarted her if she failed to restart, when reverse was needed, into a dead-end wharf such as Mosman Bay.

It was intended that there be 15 of the *Kooleen* class but *Kooleen* remained an orphan.[17] She cost £96 000 and began commercial service on 14 March 1957. The passengers did not like her at all and showed it by letters to the Editors of newspapers. Her tram-type seats were too close together and she vibrated so much that print on newspapers blurred. There were no outside seats, and the sliding windows generally didn't slide.

Kooleen stayed an orphan until she was retired in May 1985. Her hull was partly replated early in 1981 and she was sold to J. Crawford in January 1986. As the first of the First Fleet class catamarans came into service, *Kooleen* became a spare boat and then redundant. In 1991, she was in use as a cruising houseboat.

The Sydney Harbour Transport Board tried again with much greater success in 1968. The State Dockyard was again given the order for the new ferry. She was to be a big boat, almost twice as long as *Kooleen* and much heavier. Two decks were provided, with adequate open air seating on both decks. *Lady Cutler* was laid down in March 1968 and was in passenger use by 8 October 1968. In appearance, she was much different to the 'classic' old Sydney ferries, but the style and effect was similar and derivative. She was followed by two almost identical sisterships — *Lady Woodward* and *Lady McKell* — on 19 October 1970. Two bigger sisters, *Lady Wakehurst* (3 October 1974) and *Lady Northcott* (30 January 1975) were built by Carringtons Slipways of Tomago (Newcastle). *Lady Wakehurst* was owned by the SHTB when completed, but *Lady Northcott* was a Public Transport Commission (PTC) vessel from completion as the PTC was formed on 1 December 1974. *Lady Street* and *Lady Herron* (19 June 1979 and 23 August 1979 respectively) came from the State Dockyard as half-sisters to the *Lady Cutler*.

Under the control of Mr. Phillip Shirley, the Public Transport Commission tried to coordinate ferry, train and bus liveries. The idea seemed to suggest that new colours and logos meant new efficiency. The newly-acquired *North Head* and *Baragoola* lost their distinctive dark green hulls — brown upperworks with white trim, topped by black-capped white funnels. They reappeared in pastel blue hulls with cream upperworks and funnel, and with a logo. They looked awful, and the eventual red rust streaks and green seawater

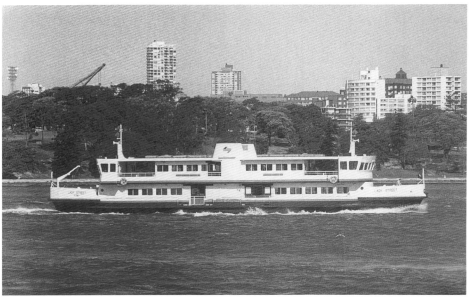

**The new *Lady Street* crosses Farm Cove in October 1979.
Note the two-tone funnel logo.** [Author]

Austere, clinical, vandal-resistant and modern; *Lady Street*'s seating wasn't particularly comfortable. [Author]

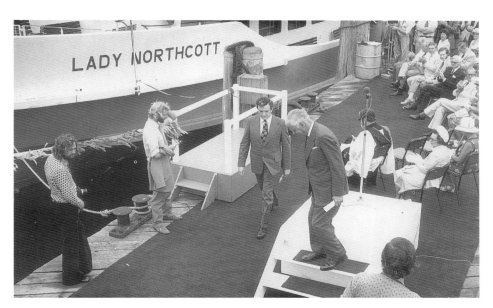

Commissioning Day for *Lady Northcott*. PTC manager Phillip Shirley steps off the dais as NSW Transport Minister Wal Fife approaches. [Author]

slime did little to enhance the effect. Without fanfare, the PTC made gradual modifications to the colour scheme. For a time the ferries had a dark blue and light blue hull with cream superstructures. In 1974, the first of a stylised funnel logo appeared and since then there have been two other versions. Ferry researchers in the future may well be able to date photos of the harbour by considering which of three funnel logos can be identified. By the early 1980s, all ferries had dark blue hulls and cream upperworks with cream bulwarks for and aft. With the arrival of *Collaroy*, the hull became one colour — dark blue — and the rest of the fleet soon followed suit. In this guise, the ferries had reached a serviceable and attractive livery. The formation of the State Transit Authority (STA) meant another change of colour and logo.

The mid-1970s were not a happy time for the Public Transport Commission, but the Coalition Government with Transport Minister, Milton Morris MP, plugged on and, in retrospect, can claim to have set the pattern that was successfully followed by the Wran Labor Government with its first Transport Minister, Peter Cox, MP.

Construction of a small graving dock at the Balmain ferry base, gave the Public Transport Commission greater flexibility of maintenance. It was opened in August 1975.

On 14 June 1979, one of the great harbour ferries made its last run without fanfare. Captain Peter Loosemore took *Lady Denman* off on the Hunters Hill run with just a few rolls of fluttering toilet paper to alert the observant. *Lady*

Interior of *Lady Denman* in the 1970s. Compare with interior of *Lady Street*; note open engine control room. [Author]

Denman was to become a museum ship at Huskisson on the New South Wales South Coast.[18]

Less than six months later, Labor Transport Minister, Peter Cox MP, flew the flag for new harbour ferries. The harbour would get a fleet of 'brightly-painted' mini-ferries to boost tourism and to serve areas not presently served. They would be of 20m length and carry 200 passengers at 17 knots.[19] The following month, these ferries had grown to 25m and 18 knots, carrying 250 passengers. They would cut trip times by one third.[20]

Not everybody was impressed. The operators of the new Birkenhead Shopping Centre announced that they would run their own ferry to Sydney, after a year of asking the Public Transport Commission to provide a Birkenhead-Quay service. Gordon Davey provided the service, initially with the *Birkenhead* (2), formerly *John. H. Walter*, previously on the Newcastle-Stockton run.[21]

In 1980, the Public Transport Commission became the Urban Transit Authority (UTA) — with a new logo — and there was some amusement when it was realised that UTA was also the initials of the French airline also serving Sydney. When the old ferry *Karrabee* sank, the initials suggested to some wags that UTA may have meant 'Underwater Travel Authority'.

The one-time Newcastle ferry *John. H. Walter* became *Birkenhead* (2) in 1980 when the Birkenhead harbourside shopping centre wanted its own shopping service. [Author]

In April 1984, an Urban Transport Authority spokesman was compelled to confess that the UTA ferry situation was 'critical'. The inner harbour fleet was down to eight ferries and this often meant cancelled runs as ferries broke down or were withdrawn for repairs.[22] The industrial situation at the Balmain base didn't ease the problem. The UTA hired private ferries when Government ferries did not run and passengers could disport themselves in the unfamiliar surroundings of *Radar*, *Proclaim*, *Captain Cook II* or *Port Jackson Explorer*.

Four days before the April 1982 Drummoyne State Government by-election, the new fast ferries 'surfaced' again. Tenders would be called (late in 1983!) for nine 250 passenger, 14 knot catamaran ferries.[23] Journalist, Phillip West, writing in the *Sydney Morning Herald*, was caustic about the sudden Government renewed interest in fast ferries just before a by-election.[24] Transport Minister, Peter Cox MP, thought he was being unfair.

Tenders for five medium-speed ferries for the Parramatta and Lane Cove River runs were called in January 1983,[25] but this was a period that the UTA would probably consider to be a 'rough run'. In March 1983, the new Manly ferry, *Freshwater*, instead of gaining kudos for the UTA, was creating harbour havoc (see section on Manly ferries). In January 1984, the old wooden ferry *Karrabee* sank following the running of the Ferryboat Race. As a result of this, the remaining wooden ferries became suspect, with only about half of the new fast cats on duty.

The Bi-Centennial (1988) was approaching, and politicians became conscious of a need to be seen to be historically minded. State Premier, the Hon. Barrie Unsworth MP, announced, in January 1984, that *Kanangra* would be preserved as a 'Bi-Centennial Project'. This was just two months after an Urban Transit Authority spokesman had announced that the old ferry would not be retired, contrary to the State National Trust of New South Wales beliefs. She would run 'for at least another year'.[26] In February 1985, *Kanangra* was retired following a survey and the Government's restoration of the big ferry as an historic cruise vessel was then cancelled by Minister, Ron Mullock MP (May 1986).

While all this was going on, Urban Transit Authority deckhand, Margaret Tinghey, became the focus of the press when, in August 1984, she was given command of the inner harbour ferry, *Lady McKell*. Captain Tinghey was the first female Government ferry master, but not the first female ferry master on the harbour, as was generally suggested.[27]

The new catamaran ferries began running along the Parramatta River to Meadowbank in February 1987. UTA chief, Captain T.F. Gibson, had earlier admitted that only about 750 people could make the peak hour trips (on three ferries), confirming that the ferries could make little real impression on road, train and bus loadings. The following year, it become obvious that the new ferries made much bigger waves than the UTA had anticipated. They were soon restricted to about 12 knots in service. This coincided with rebuilding the

Golden Grove of the First Fleet class, awaits passengers at the new Gladesville wharf in 1986. [Author]

earlier vessels' accommodation to carry around 400 passengers — this made the load potential about 1200.

Considerable effort had been made to design ferry schedules to incorporate the new fast ferries, running at their intended speed. Some time improvements could have been expected on the longer, long-established Zoo and Hunters Hill runs. There was little likelihood of the '30 per cent' reduction in passage times on runs such as Mosman and Neutral Bays where wharves are sometimes less than two minutes apart. The proposed scheduling for the fast ferries included a proposed hovercraft service from The Spit (no information suggested a berthing site in Sydney Cove). The 1977 proposed scheduling envisaged fast ferries (designated 'V') being restricted, largely, to services west of the harbour bridge at an expected service speed of 14 knots. The Lady class and older ferries, designated 'L', would work the other inner harbour runs at about 10 knots. It is interesting to note that rough hand-drawn illustrations in this plan include an obvious large double-ended catamaran Manly ferry (as described to me in the early 1970s by the late John Needham).[28]

Proposed ferry pick-ups along the river to Meadowbank were Quay, Cockatoo Island, Wolseley Street, Gladesville, Chiswick, Abbottsford and

Meadowbank. Actual calling points on weekdays in 1987 were Quay, McMahons Point, Wolseley Street (Drummoyne), Gladesville, Abbottsford and Meadowbank. Services to Hunters Hill called at Cockatoo Island, Long Nose Point and Darling Street, Balmain.

The introduction of the First Fleet class ferries produced an interesting side aspect. The First Fleet of Captain Arthur Phillip of 1788 comprised 11 sailing vessels. The Urban Transit Authority First Fleet has only nine. Those left out were *Prince of Wales* and *Lady Penrhyn*. The reason for this is open to conjecture.

The introduction of a more tourist-oriented ferry-use program saw the UTA introduce two 2.5 hour cruises on each week day. The 10.00a.m. run — the Five Islands Cruise — covered the major part of the inner harbour. The 1.30p.m. cruise ran from Sydney Cove (Quay) to Middle Harbour and back. Fares in January 1989 were $10 for adults, $5 for a child or concession, and $25 for a family. Two commuter and tourist oriented ferry services began in Watsons Bay and Darling Harbour. A night-time Harbour Lights cruise was offered at fares of $7.50 and $4.50.

Early in 1989, the new Manly ferry, *Collaroy*, was offering trips up the coast to Broken Bay and the Hawkesbury River. For $38 and $25, Sydneysiders could see what their local coastline looked like as they had previously been able to do with the magnificent Manly ferry, *South Steyne*. Shorter cruises were also on offer, from Sydney south to Botany Bay to the 1770 landing place of Captain Cook. Some problems developed. Although the Urban Transit Authority professed satisfaction with the cruises, *Collaroy* had a livelier motion in a seaway than did *South Steyne*, and some passengers were sick. Deck crew were paid a 'spew' money allowance for cleaning up after seasickness. When ferry officers asked for the same allowance, the coastal cruises were dropped, and in May 1991 were in abeyance.

After the election of the Greiner Coalition Government in 1988, new administrative arrangements were made. The UTA became the State Transit Authority on 16 January 1989, under the control of naval architect, Owen Eckford, assisted by Manager of Operations, Captain Mick Costello (both former Maritime Services Board senior officers). The STA changed the UTA logo from two half arrows going in opposite directions, to a full circle device, symbolically showing road, rail and waves. Ferry crews referred to it as the 'Racing Snail'.

A new colour scheme followed the formation of the STA. The royal blue hull colour became a mid-green and the superstructure a much lighter cream with deep yellow trim. Vessel names were picked out in either yellow or white. It remains to be seen if this mid-green becomes, eventually, similar to the serviceable dark green that had been the style for the Manly ferries until 1974.

Perhaps mindful of the major fare increases that followed the election of the new Government, the State Transit Authority introduced Family Tickets for the Manly ferry. In 1991, one adult and unlimited family children could go

Table 4 Sydney Ferries Ltd Fleet List — 1916

vessel	built	tons gross	length ft.*	type
Aleathea	1881	120 reg.	109	hulk
Barangaroo	1889	205 gross	119	active
Benelon	1885	204	120	"
Bronzewing	1899	149	102	"
Carabella	1897	129	106	"
Cygnet	1882	74	84	"
Drummoyne	1884	42	72	active BNFC
Ente	1886	55	74	Cargo/Tug
Gannet (t)	1883	48	65	"
Iris	1884	35	60	cargo/tug BNFC
Kai Kai	1907	303	152	"
Kailoa	1902	124	97	"
Kameruka	1913	144	112	"
Kamilaroi	1901	328	128	"
Kamiri	1912	144	112	"
Kanangra	1912	295	149	"
Kangaroo	1890	158	112	"
Kangoola	1910	88	90	cargo
Kanimbla	1909	156	116	"
Karaga	1894	143	108	"
Kareela	1905	186	113	"
Karingal	1913	106	104	"
Karrabee	1913	106	108	"
Kedumba	1913	294	132	"
Kiamala	1896	122	106	"
Kiandra	1911	257	140	"
Killara	1909	309	131	"
Kirawa	1912	295	149	"
Kirribilli	1900	198	133	"
Kirrule	1910	257	140	"
Kookooburra	1907	180	140	"
Koree	1902	276	141	"
Kosciusko	1911	165	116	"
Kubu	1912	258	140	"
Kulgoa	1904	338	140	"
Kummulla	1902	168	119	"
Kuramia	1914	335	156	"
Kurraba	1899	195	134	"

Lady class all carrying prefix 'Lady':

vessel	built	tons gross	length ft.*	type
Carrington	1907	146	130	"BNFC
Chelmsford	1910	98	110	"BNFC
Denman	1912	96	110	"BNFC
Edeline	1914	96	111	"BNFC
Ferguson	1914	95	110	"BNFC
Hampden	1896	135	116	"BNFC
Linda	1906	13	43	"BNFC
Manning	1892	97	109	"BNFC
Napier	1892	89	98	"BNFC
Northcote	1905	128	116	"BNFC

vessel	built	tons gross	length ft.	type
Rawson	1903	172	117	BNFC
Scott	1914	95	110	BNFC
(Ladies completed)				
Lobelia	1886	50	75	BNFC
Lotus	1886	70	74	active
Nautilus	1873	11	46	"
Rose (2)	1898	80	80	"
(The)Lady Mary	1892	79	83	BNFC
Una	1898	44	67	active
Wallaby	1878	164	109	"
Warrane	1882	109	99	"

Total: 57 (including the 18 vessels of BNFC)
Passenger capacity: in excess of 28 000. Some ferry capacities not known.
* Lengths in feet, rounded to nearest whole number.
Lady Linda only motor vessel.

to Manly and back for $7.20, with two adults and children for $10.00. In January 1991, the return adult fare to Manly via Hydrofoil and Jetcat was $8.60.

Satisfactory, apparently, from the State Transit Authority's viewpoint, was the 1989 introduction of a push-button, self-service ticketing system for all ferries. Considered by the STA to be simple, the system required the study and understanding of an 18-page User's Manual. The old system required the passenger to state his or her destination to the token seller and then drop that token into a turnstyle slot. Introduction of the new system resulted in police being called as ferry passengers abused helpless staff over the complexities of the machines.[29]

As a public relations exercise, the introduction of a new ticketing system neglected timing — the new machines' arrival co-incided with major fare increases, to a maximum of 87 per cent. Many people preferred the token machines which took solid, almost ever-lasting metal tokens which could then be sold at whatever was the current price. However, in May 1991, it was still possible to join the queue to buy a ticket from a human being — in a small booth away from most wharves.

Old people, those who don't see well, or those who do not understand English, and those running for a ferry, have not found the new machines to be user-friendly.[30]

A CONFUSION OF INTENTIONS AND BRIGHT IDEAS

The 1970s were probably as confusing for ferry men as they were for passengers. New maritime technology was becoming identified and the press was always quick to contrast what might be with reality. This vaguely defined period began with a 1969 story that a hovercraft was to provide a fast service from

Mascot airport to the city, unloading passengers in the Quay. No mention was made of the technical problems of handling and berthing a large air-cushion vehicle in among a plethora of busy conventional ferries. How passengers would have enjoyed belting into a full southerly gale on the circuitous coastal route to Mascot was not mentioned either, but it did make a good headline.

The hovercraft idea would not go away, 'Cheap hover ferry urged' came from the *Northern District Times* in May 1973, with no apparent understanding of the contradiction in terms given. We were then told that there was a superior type of Manly ferry available in Western Australia. The large single-enders that served Rottnest Island off the coast from Fremantle were 'better and cheaper' for the Manly run than local designs which had been developed over more than 100 years. How such a craft would turn around in Sydney Cove and then make up time was not explained.

At Manly the citizens found a new 'togetherness' in mass commuter rallies, demanding a better, or indeed, *any* ferry service. It must have been just what the accountants at Brambles wanted. 'Cabinet Acts to Save Ferries ... '[31] Just two days later, the press gushed over the 'Unsinkable Sea Bus — *Rotork*' and we were told that a fleet of such 'mini-ferries' were about to descend upon the harbour: 'Water buses by '75'.[32]

'Thousands give up the ferry',[33] and 'Is it curtains for the ferries?' told of trouble in the big ferry services, but small private companies still serviced their niche successfully. Charles Rosman commissioned his new ferry, *Royale*. She was a good sensible working ferry, but *Aeroplane Press* was still demanding 'Hoverferry to Drummoyne'.[34] The *Daily Mirror* kept the pressure on the Government with 'Morris must keep ferries on the Manly run'. *The Telegraph* weighed in to the fray with the discovery of a bureaucratic mess. 'Experts' had calculated that just two Manly ferries could manage the peak hour demand. They apparently didn't consider breakdowns, slippings, refits or the 700 odd passengers who carried season tickets. Photos of over-loaded ferries with passengers sitting on the interior steps and on the deck had political impact when printed over half a page.

Newer, bigger and faster hydrofoils seemed to be the answer for some people: 'Here comes the flying super ferry!'[35] This followed a derisory comment that *Lady Wakehurst* broke down on her first trip to Manly in her role of fill-in ferry.

On the evening of 5 January 1975, *SS Lake Illawarra*, a heavily-loaded bulk carrier heading up the Derwent River, smashed into the Tasman Bridge, Hobart's equivalent of the Sydney Harbour Bridge, and knocked out a large section. About a dozen people from the ship and the bridge were killed and Hobart found itself divided.

Ferries were found from many sources and were of many types, including several hurriedly brought down from Sydney. The first Sydney ferry to Hobart was the brand-new *Lady Wakehurst*. Urgently needed on the Manly

run, she became even more urgently needed in Hobart. *Lady Wakehurst* arrived in Hobart under tow on 22 January 1975, on a three-month initial charter for the peppercorn fee of just one dollar. Over the long term, this became $3000 a week.

The old wooden ferry *Kosciusko* was next to be taken to Hobart, arriving on 4 May 1975. *Kosciusko* provided a fine running mate for *Lady Wakehurst*, but retired in Hobart after the bridge was rebuilt and *Lady Wakehurst* was taken home. A third Sydney ferry, *Lady Ferguson*, was towed to Hobart. The word around the waterfront in Sydney was that she would not be used in Hobart as she was too frail. At great expense she did reach Hobart then failed survey and was never used again as a ferry.

Through 1975 we were told the *South Steyne* would soon be back at work (in 1989 that story line was STILL good for a headline) and told that 'Minister Joins fight for South Steyne'.[36] Phillip Ruddock MP had not previously been well known for an interest in ferries.

'Tenders for new Manly ferry',[37] was quickly followed by 'New ferries to cut run to Manly by 11 minutes'.[38] The big new ferries were to race across the harbour at fuel-hungry high speeds and the wonders of modern design would ensure that they didn't make large waves like the *South Steyne*.

The Great Ferry Boat Race of 1989: *Lady McKell* **carries a full load as she races past Gore Bay** [Gwen Dundon]

At speed, in use, they made waves as big or even bigger than did the older ferries, but they soon settled down to running at economical lower speeds and nothing more was said about saving 11 minutes.

In 1980, we had the first Great Ferry Race, an inspired idea which became a little dated later, and we were told that 'New fast ferries for Parramatta River' were on the way.[39] Maybe so, but by 1981 the Urban Transit Authority (UTA) was often short of ferries and had to charter vessels from Rosmans and Stannards and even Captain Cook Cruises, to carry commuters.[40]

The new catamarans were soon on the harbour. If they were not quite as capable as their publicists had expected, they were modern, reasonably fast, and in numbers sufficient to allow for ferries out of service. When they started on the Parramatta run, they were not quite the fast ferries promised. When they ran at full speed, they pushed up such steep waves that they were soon governed to a more sedate speed. However, it really didn't matter along the river and commuters loved the run.[41]

Not everything was sweetness and light. Press reports on troubles in the Balmain ferry base, prompted by photographs of a dozen ferries laid up awaiting repairs, saw a maritime union going public and blasting the Painters and Dockers Union over delays and lack of cooperation.[42]

In the mid 1960s *Lady Edeline* chugs towards Cremorne Point wharf.
[Fred Saxon]

The Andrews Family settles on board _Lady Edeline_ at the old Zoo wharf in 1979. [Author]

Sydney's skyline from _Lady Edeline_ in 1979 is modest when compared with that of the 1990s. [Author]

Fishburn removes passengers from the disabled ferry Lady Street.
[Author]

Towards the end of the 1980s, the last of the old ferries left the ferry scene. The sinking of *Karrabee* in 1984 quickly led to the withdrawal of the remaining old ferries. *Kanangra* became a static display for the Sydney Maritime Museum. *Karrabee* became a floating restaurant at Gosford, *Lady Edeline* collapsed into the ooze of the Parramatta River, and *Karingal* sank in Bass Strait while trying to make it to Melbourne under her own power. *Kameruka* quietly sank and was broken up by a grab dredge in Pyrmont.

By any consideration, be it press headline or actual events, the period 1970 to 1990 presented an early downward spiral for ferries, bottoming out in 1974 and then heading upwards at a steady angle until 1990. In 1992, the oldest Government ferry was *Lady Cutler* (1968), laid up with hull and engine problems.[43] The fleet consisted of nine medium-fast catamarans, two large inner harbour ferries (able to relieve on the Manly run), five double-ended inner harbour ferries, four modern Manly ferries, three Jetcats and four new low-wash, Rivercats — *Dawn Fraser*, *Betty Cuthbert*, *Shane Gould* and *Marlene Matthews*. Commuters trying to catch a ferry on the harbour in 1974 would have been amazed if one of the optimistic newspaper headlines of the period had suggested those kind of figures–they would not have believed it. Perhaps the ferry score card for the next 20 or so years of Government ferries might be read as having many more pluses than minuses, despite all the false leads and problems.

NOTES

1 *Sydney Morning Herald* (*SMH*), 8 February 1928.

2 *SMH*, 1 August 1928.

3 *Ibid*, 18 January 1932.

4 *Daily Guardian*, 24 August 1923.

5 Peter Spearitt 1978, *Sydney Since the Twenties*, Sydney, p.150.

6 *SMH*, 4 June 1931.

7 *The Powerboat and Aquatic Monthly*, January, 1933.

8 *Ibid*, December, 1933.

9 L.A. Clarke 1976, *North of the Harbour*, Sydney, p.27.

10 *SMH*, 25 August 1949.

11 *Ibid*, 16 February 1951.

12 *Ibid*, 21 February 1951.

13 The Dolphin Ferry service, Sydney Monorail and the proposed Very Fast Train (VFT) projects come to mind.

14 *SMH*, 22 July 1951.

15 *Ibid*, 4 December 1956.

16 R.K. Wilson 1986, 'Sydney Ferries Built at Newcastle', *The Log*, No.84, May.

17 *Shipbuilding*, 30 November 1955 and February 1957.

18 *SMH*, 15 June 1979.

19 *Daily Mirror*, 13 February 1980.

20 *Sunday Telegraph*, 9 March 1980.

21 *Northern District Times*, 1 April 1980.

22 *SMH*, 23 April 1981.

23 *Ibid*, 14 April 1982.

24 West, Phillip, 'Glitter wears off new ferries', *SMH*, 18 April 1982.

25 *Daily Telegraph*, 17 January 1983.

26 *SMH*, 24 July 1984.

27 Jan McLaren, owner/master of *MV Mulgi*, formerly *Prolong*, was rather earlier.

28 *Proposed Inner Harbour Timetables*, 15 June 1977. C. Byrnes Collection.

29 *Daily Mirror*, 12 July 1989.

30 *The Sydney Ferries Ticketing System, User's Manual*, State Transit Authority, 1989.

31 *SMH*, 16 January 1974.

32 *Daily Telegraph*, 17 January 1974

33 *Ibid.*, 15 September 1974.

34 *Aeroplane Press*, 13 November 1974.

35 *Daily Telegraph*, 4 October 1974.

36 *SMH*, 15 April 1975.

37 *Ibid.*, 4 January 1978.

38 *Ibid.*, 8 April 1978.

39 *Sunday Telegraph*, 9 March 1980.

40 *SMH*, 23 April 1981.

41 *Northern District Times*, 18 February 1987.

42 *SMH*, July 1985.

43 The ferry's sponsor, Lady Cutler, died in November, 1990.

CHAPTER 6

ERA OF THE SMALL FERRY

HEGARTY'S FERRY SERVICE

Following the opening of the Sydney Harbour Bridge, Sydney Ferries Ltd. were indecisive as to what routes it could maintain and whether new routes might be of value. The all-night ferry service to Milsons Point ceased, but the SFL announced that it would keep the vehicular punts to the North Shore running.[1]

The Sydney Harbour Trust, responsible for port control, was no doubt glad to see the end of the cross-harbour ferry in the narrow and congested area below the bridge, but would have none of this[2] and the *Sydney Morning Herald* of 30 March 1932 announced that the punt service would cease. Sydney Ferries Ltd. soon sacked a large number of its staff, particularly wharf and support crews.[3]

Senior personnel of the company seem to have been surprised by the resultant large reduction in custom, making some decisions they were later to regret. One such decision was to abandon the Lavender Bay ferry run. This was done with just two days notice when, early in October 1932, Sydney Ferries' *Karaga* took the last service to Lavender Bay.

Two single-ended diesel ferries, belonging to Norman D. Hegarty took over the running. The Hegarty company rapidly expanded its small fleet and was well able to defend itself against Sydney Ferries Ltd. when it once more displayed interest in the Lavender Bay and the new Luna Park/Olympic Pool trade.

Captain Norman D. Hegarty had worked in southern New South Wales and Victoria. In the late 1920s, he was active on Port Jackson, running excursion and picnic ferries, including *Ettalong, Evelyn* (both built by Gordon

Beatty and his brother in Woy Woy in 1922) and the well-decker *Mt. Pleasant*. The fleet grew in 1927 with the arrival of the big *Estelle* (also built by the Beattys). She was towed to Sydney for fitting out at Holmes Boatshed at McMahons Point, Sydney.

Hegarty's first ferries on the run were *Estelle* and *Ettalong*. They were soon joined by the *Eagle* (1936) which the Beattys completed in the front yard of the Hegarty's Drummoyne home, then came the all-enclosed *Evelyn* and the newly-built *Emerald* (1942).

Two small ferries, *Aster* (100 passengers, former Newcastle Ferry Co.) and *Kurnell* (100 passengers, 1913) were soon added to the fleet. As well as running off-peak on the Lavender Bay and associated services, Hegartys ran a passenger service from Erskine Street Wharf to Bald Rock and nearby. *Kurnell* was built by Fisher of La Perouse for the Kurnell run and was originally a well-decker. *Aster* was sold to Peters Ice cream in about 1946, and then taken north for use as a milk boat on the Hastings River. *Kurnell* became a small lighterage tug after having been salvaged at sea when she broke adrift while under tow south when the Hegartys left Sydney in 1949. She was eventually broken up by the Maritime Services Board in their No.2 depot in 1983.[4]

Captain Norman Downard Hegarty with Mrs. Evelyn Hegarty and daughter Estelle, pictured in the yard of his Drummoyne home as a ferry is about to be launched. [Roger Benjamin]

N.D. HEGARTY & SON
MOTOR FERRY BOATS FOR HIRE

EVELYN 150 PAS'G'RS.

ESTELLE 400 PAS'G'RS.

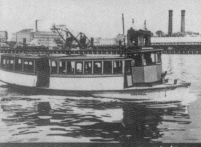

KURNELL 100 PAS'G'RS

ETTALONG 250 PAS'G'RS

ASTER 100 PAS'G'RS

Mᵀ PLEASANT 63 PAS'G'RS

HARBOUR EXCURSIONS & PICNICS A SPECIALITY.
PHONES. B 3173 & Drum. 407

**Promotional leaflet shows the Hegarty ferry fleet of the mid-1930s.
The company was well-placed to replace SFL on the Lavender Bay run.**
[Roger Benjamin]

Hegarty's *Estelle* was the biggest single-ended motor ferry on Port Jackson. She finished life as a tuna fishing boat.
[Graeme Andrews Collection]

'Art Deco ferry': *Eagle Star* was intended to provide a modern look for the Lavender Bay run. She was streamlined and almost totally enclosed.
[Roger Benjamin]

Prior to the outbreak of war, the Hegarty company bought the big single-ended lake steamer *Gippsland* (1909) from the Gippsland Lakes for use as a ferry and cruise-steamer. She arrived in 1937 after a rough ride up the coast, but she was not suitable for the short runs on Port Jackson and was sold to Brisbane for use as a showboat.[5]

The Hegartys persevered with smaller ferries. In the few years before the war, their fleet consisted of *Evelyn, Estelle, Kurnell, Ettalong, Aster* and *Mt.*

Pleasant. Mt. Pleasant was a well-deck picnic launch of 63-passenger capacity and was only used as a back up on ferry runs.

In addition to gaining the lease on the Lavender Bay Wharf, Hegarty provided services along the Kirribilli peninsular. His ferries called at Jeffrey and Beulah Streets to the east and at McMahons Point to the west of the Harbour Bridge.

The redevelopment of the one-time bridge construction site (once a railway station) on the western side of Milsons Point also led to Sydney Ferries Ltd's interest in the area again. The Olympic swimming pool and the fun park — later known as Luna Park — meant that passengers and Sydney Ferries Ltd. submitted to council a new-found willingness to serve Lavender Bay. Although the small steamer, *Karaga* (1894), had been too big for the run, SFL were talking of once more using the giant ferries of the *Kuttabul* type.

Locals were divided. There were those who were happy with Hegarty. Others wanted the big ferries back, and some wanted to play both bidders off. The McMahons Point-Lavender Bay Progress Association wanted SFL back, but looked a trifle silly when Hegarty quoted their own letter to him of the previous year (1933) thanking him for the 'punctual, efficient, courteous and obliging service displayed'. More than 2300 locals petitioned council to keep Hegarty, who, according to one participant, 'had stood by us'. North Sydney Council agreed. SFL's manager, A. Wedderburn, graciously withdrew from the bad publicity, mentioning the new fast ferries on order and stating that: 'We have no desire to crush the little man ...'[6]

The Hegarty family completed *Emerald* (*Star*) on the water's edge of their Drummoyne home in 1942. She had been laid down at Brooklyn, but the builders had given up. Company foreman, Charlie Shannon, and shipwright, Bill Taylor, completed the hull sufficiently at Brooklyn to allow it to be towed to Sydney by *Sunrise Star*.

During World War II, *Evelyn Star* and *Kurnell* worked on the Cockatoo Dockyard run. About 300 workers travelled both ways each day from various wharves around the harbour opposite the now-defunct (1990) dockyard with a weekly worker's ticket costing 2/6d. *Eagle* and *Estelle* helped out and still maintained their peak-hour services. Hegarty's staff at this time included N.D. Hegarty, Leonard Hegarty, George Wallace, Bill and Abby Taylor, Charlie Shannon, Bill Banbury, Bill Phillips and Owen Allen. Estelle and Evelyn Hegarty looked after the turnstile and the office.

Cross-harbour services boomed as petrol rationing cut road traffic. The Hegarty home faced across the harbour towards Cockatoo Island, and it was here that the family fleet was berthed. (In the late 1940s, I remember the fleet with white hulls, and green funnels with black tops.) Joining the company in late 1952 was steamer *Sorrento*, formerly *Rowitta* (1909). She was built in Hobart and more recently used on Port Phillip. The company was still named Hegartys, but the owners were now Mr. and Mrs. A.C. Barber and Miss Jean Porter. Bill Banbury of the company was sent to Melbourne to refit the

Emerald Star's interior shows the typical small ferry lay-out of the
mid 1900s. Lifejackets are stowed under the centre seats and above
side seats. [Author]

Emerald Star heads into Sydney Cove with mid-morning commuters.
[Author]

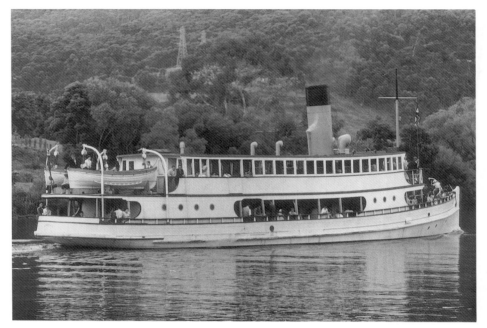

Sorrento, Ex Rowitta, tried her hand on Port Jackson as a cruise boat. She was soon back in Tasmania. Shown here as Rowitta in Tasmania.
[F.Reid]

Sorrento which had been laid up for some years. He was to get her ready to steam to Sydney. After three months battling with the Victorian Marine Board, *Sorrento* was ready. Captain Muir was engaged for the voyage with Banbury as engineer. Bad weather kept the old steamer in Eden for a week.

After arrival in Sydney, many more weeks of modifications were necessary to satisfy the Maritime Services Board's survey needs. It was intended to use *Sorrento* as an excursion steamboat, smaller and more intimate than the massive Sydney showboat *Kalang*. There seems to be no evidence that *Sorrento* did any more than a few trial trips as a showboat. She spent months laid up in the Quay and was used only spasmodically on the Lavender Bay ferry run for which she was too big and unhandy (hard to handle). Single ended ferries were then required to berth in the Quay bows out and turning the over-long *Sorrento* around was risky when other vessels were also trying to berth. After about six months she was sailed back to Hobart and new owners. In 1992, she was afloat at the Flagstaff Hill Maritime Museum, Warrnambool, once more as *Rowitta*.[7]

Initially Hegarty's ferries carried some family names. When the girls were joined by a boy it was decided, rather than give a ferry a male name, that all the fleet should gain the suffix 'Star'.

In the mid-1900s several Sydney ferry companies were family based and owned, often operating from the family home. Along with the Hegartys were Stannards, Nicholsons, Messengers and Rosmans, all of them long-running and well-known around the port. Rosmans, Nicholsons and Hegartys all built ferries in their front yards.

After the Hegartys sold the company, they eventually moved to Eden, having worked *Sunrise Star*, *Estelle Star* and *Eagle Star* on Westernport Bay for some time en route.[8] *Sunrise Star* is still in use on Port Jackson. *Eagle Star* was abandoned after severe collision damage at Cowes in 1978, and *Estelle*, after conversion to a tuna fishing boat, was lost at sea by fire in 1979. Still in the Hegarty fleet is the sturdy *Emerald Star*. She has had many changes over the years. In 1955, she gained commercial publicity by being fitted with an air-cooled diesel engine.[9]

Barber and Porter sold Hegartys to J.C. Needham in 1960. The company was sold again to Stannards in February 1978 and yet again to Captain Cook Cruises, in November 1987.

Norman Downend Hegarty was born in 1876 and died at Cowes in Victoria in 1950 where he is buried. Leonard and Estelle died in 1968. Estelle's daughter, Rosalind, married Gordon Butt and is a partner in the catamaran cruise boat *Cat Balou*, working on Twofold Bay, Eden.

NICHOLSON BROS. HARBOUR TRANSPORT PTY. LTD.

John Nicholson, coppersmith, started Nicholsons in 1909 when he began a rowing boat service across the port using pulling boat, *Ena*. He then built a motor launch, *Nellie II*, named after his daughter. In 1911, he built a 48 passenger motor launch, *Promise*, named after the sailing boat in which he courted his wife. Nicholson had four children. Two of them, Stan (born 1890) and Eric (born 1898) became legends around the harbour as the Nicholson Bros. The 14-passenger *Nellie II* was often used to service the Fairyland Picnic Grounds on the Lane Cove River and *Promise* was even better suited to that role.

After leaving school in 1912, Eric Nicholson joined the business which moved to a waterfront site on Snails Bay in 1913. At about this time, the Nicholson family made the acquaintance of the Abbott family, beginning a family and professional association that lasted from 1910 to 1970. Reg Abbott worked for the Nicholsons from 1917 to 1970. Other members of the family also worked for them for long periods.

After John Nicholson left the business, Stan and Eric formed Nicholson Bros. in 1917, a partnership that lasted well over 50 years. In 1917, the two-decked *Protector* was completed giving the Nicholsons one effective 'ferry' at least. In 1990, *Protector* was still in use as a picnic boat on Kogarah Bay, south of Sydney.

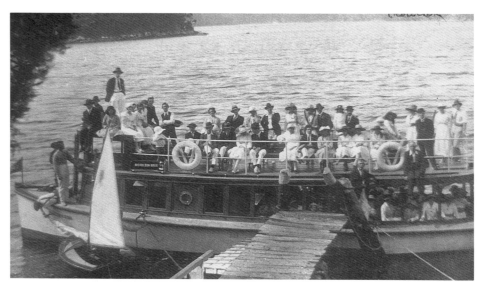

Nicholson's first ferry was *Protector*, shown in the 1920s in Middle Harbour with a goodly load. [Jann Davies]

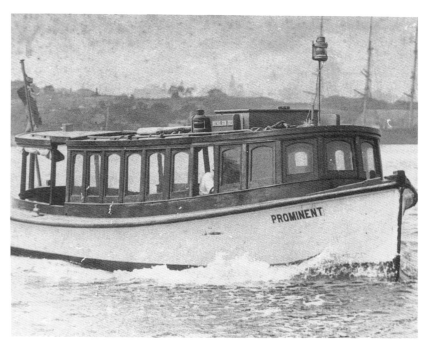

Prominent worked for the Nicholson family for a half a hundred years then moved to a Hawkesbury River ferry run. [Jann Davies]

By the end of World War I, Nicholsons had *Protector*, *Promise*, *Prospect* and *Proceed* (1917). Eight years later, ten passenger vessels were working the port plus a cargo boat and several small line handling launches, whose job it was to duck under the bows and sterns of large ships berthing, and haul the heavy mooring lines across to the wharf.

Sydney Ferries Ltd. (SFL) gave up the Balmain-Erskine Street ferry service in 1937 and Mr. Les Staples tried his hand with *Prominent*, leased from the Nicholsons. Staples gave up, and Nicholsons then took over the run. There was now a real need for roomy, small ferries on the inner harbour wharf areas. The Sydney-built *Wangi Wangi* (1924) was for sale far away in Cairns. Eric Nicholson flew to North Queensland and bought her in 1938. *Wangi Wangi* had worked on Lake Macquarie originally and had then been taken to Cairns for island tours, but had been unsuccessful. *Wangi Wangi* sailed back to Sydney and was rebuilt by Nicholsons as the two-deck, *Provide*, long considered to be Nicholson's best-looking ferry. The next ferry in the fleet was the tubby little *Promote*, built as the milk-boat *Nambucca* in 1917. She could carry 199 people on two-decks on a length of 14.5m!

Provide and *Promote* started on the Balmain ferry service on 1 April 1939, providing up to 30 round trips per day, serving Darling Street, Yeend Street and Thames Street at Mort Dock with the terminus at Erskine Street city. *Ettalong* was chartered from Hegartys in 1939 to cope with the rise in trade. When Hegartys sold out, *Ettalong Star* became Nicholson's *Profound*. In 1990, she was in service on Lake Macquarie as *Wangi Queen*, a spiritual return of the *Wangi Wangi*. *Provide* was sold to Stannards as Nicholsons wound down. Nicholsons then sold her to Gordon Davey's Hawkesbury River ferries as *Kuring-gai II* in 1977.

Nicholson's biggest ferry *Proclaim*, was launched from Morrison and Sinclair's yard, Snails Bay, on 12 December 1939. Just seven weeks later, she was at work and was soon followed by *Project*, formerly *Wangi Queen* (1925), and the long and lanky *Prolong*, formerly *Mulgi*, from the Clarence River. *Prolong* (1926) was very fast and was used by the United States Army for a year from 1942 as a troop carrier on the harbour. In 1969, she provided a fast service along the Parramatta River from Meadowbank to the city. On this run, she reached 13-14 knots with a clean bottom and the old Atlas diesel going 'Pocketa-Pocketa-Pocketa' with spasmodic perfect smoke rings in calm airs. The run didn't last long — perhaps because Stannards had no suitable running mate for *Prolong*. *Prolong* was long known around Sydney's harbour as 'Skinny' while her shorter, fatter and heavier running mate, *Proclaim*, was known as 'Tubby'. *Proclaim* was rather slower on the river run.

After World War II, Nicholsons had a large fleet of small and medium harbour and lighterage tugs, work boats and ferries. Harbour cruises for visiting passengers on P and O liners were a new idea and there were always the weekend sailing races to keep the ferry fleet busy. The delightful double-ender, *Produce*, joined the fleet in 1947, launched from the family's front yard. In

1992, she and *Proclaim* were still working the harbour with their original names.

One of the great strengths of the Nicholsons and their associated companies was their ability to build and repair vessels and machinery. The company also overhauled sea-going ships and even made marine engines.

Messengers sold the ferry *Messenger II* (formerly *Unit 1*, 1932) to Nicholsons in 1954, but the gradual removal of wharf-tram connections and the replacement of trams by unreliable buses, harmed Nicholson's commuter trade. The Balmain ferry run was reduced on 20 August 1956 and in 1964 the historic Erskine Street wharf in Sydney, with its tram loop and ferry and tram connection, was demolished. Perhaps its demise was symbolic of the future for Nicholson Bros? The Balmain-city terminus was moved to Jetty 6B, Quay, starting from 28 January 1964.

Eric Nicholson died on 1 June 1966, after a heart attack. In many ways his death was confirmation of the decline of the company. *Provide* and *Promote* were still running the Balmain run, but passenger trade was bad, and the ser-

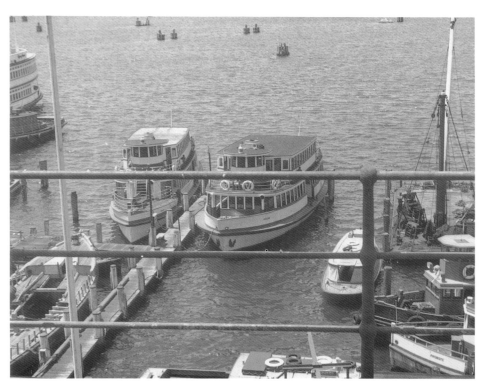

The view from Nicholson's office in 1964. At far left is the laid up *Sydney Queen* (ex *Kalang*), then *Prolong*, ('Skinny'), *Proclaim* ('Tubby'), *Promote* and *Project* (foreground). [Nicholson's]

vice had run at a loss for more than ten years. Nicholsons gave up the run on 29 October 1966. The Sydney Harbour Transport Board tried to run a peak-hours only service and then sub-contracted it to Stannards for peak-hours only.

Stannard Bros. bought out Nicholsons on 2 January 1968. Stan Nicholson was nearly 77 at the time. He died in his sleep on 13 September 1969.

During its existence, Nicholsons operated 41 ferries and over 70 passenger launches. It became so well-known around the waters of Port Jackson that balladeer Bernard Bolan's 1973 song — 'The Rose Bay Ferry' — brought smiles of remembrance to many Sydney-siders. The following lines are selected from various parts of the song (recorded by Bernard Bolan for Larrikin Records):

> 'Every morning at 8.25 down to the Rose Bay wharf I drive,
> 'Park my Humber underneath the tree, skip along the gangplank and then
> I'm free....
> 'Where are we going today Mr. Nicholson, where is it going to be?
> 'Don't turn left, turn right down the harbour and out to the open sea
> 'Monday, Java, Tuesday Spain, Wednesday Tokyo and back again
> 'The only trouble is there isn't any gents
> 'But what can you want for twenty cents?
> 'Our hearts are men of the sea,
> 'So the whole lot be merry on the Rose Bay ferry
> 'For we've finished up at Circular Quay, you see
> 'We've finished up at Circular Quay'.

THE MESSENGER FAMILY

For most of the last century there have been Messengers involved with Port Jackson. Charles Messenger Snr, son of one of the Thames Royal bargemen, came to Melbourne late in the 1800s. He soon moved to Sydney and had five sons who all carried Coxswain and Drivers Certificates: Dally, William, Charlie (Jnr), Wallace and Earnest. The family ran a boatshed in Double Bay, now Double Bay Marina (1990). Here, picnic launches and boats could be hired.

After World War II, Ernest Messenger, using *Messenger II*, ran a service from Circular Quay to Watsons Bay carrying navy men and bringing office workers back from Watsons Bay. This service left at 7.30a.m. and was known to its passengers as travelling by the 'Flying Flea'. It ran from 1950 until 1953 when Ernest Messenger retired because of ill health.

Ernest's son, E. Charles 'Boy' Messenger, has continued to own and work charter boats and to work as a ferry master around the port since that time. Charles A. Messenger Jnr, independently, ran a picnic and scheduled ferry service both before and during the war. Using two small well-deck ferries, *Lady Dudley* and *Lily Braton*, he carried workers to and from Rushcutters Bay to the Garden Island base during World War II before the dockyard was joined to the mainland.

Two stalwarts of Sydney's harbour — 'Boy' Messenger at ease in the old varnish and brass of *Proclaim*'s wheelhouse. [Author]

DOLPHIN FERRIES PTY. LTD.

Managing Director, Mr. B.J. Halvorsen.

The hoverferry, *Blue Dolphin*, a Hovermarine built in 1973 by Hovermarine Transport, Southampton, England, was Australia's first commercial hovercraft. Imported by Dolphin Ferries Pty. Ltd., she was rated at 57 passengers at 32 knots. She was powered by two 640bhp diesels driving underwater propellers and was kept on hover by another smaller diesel engine providing the air pressure. After public harbour trials on 4 December 1973, *Blue Dolphin* started a passenger service from Sydney to Gladesville and Meadowbank on 17 December 1973.

Her master was Captain Ray Blackburn, formerly from the Army, who was later to become master of the New South Wales Government VIP cruiser, *Captain Phillip*. On early runs, Blackburn was often forced to leave passengers at Gladesville on peak hour services. He flew back for them from Sydney, showing how effective a fast ferry service could be.

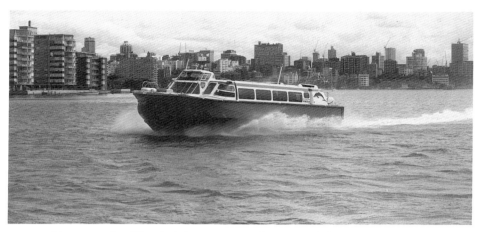

Hovermarine *Blue Dolphin* races tourists around Port Jackson at 30 knots or more. In 1991 she was in Auckland. [Author]

Unfortunately, this promising beginning did not last and patronage fell, helped no doubt, by the problems of running a one-vessel service with no suitable craft capable of filling in at short notice.

Attempts by Dolphin ferries to gain State and Federal government financial help were rejected.[10]

The hoverferry service to Meadowbank ceased in September 1974, just nine months after it started. *Blue Dolphin* was then used for harbour cruises.[11] The *Blue Dolphin* fast river ferry service reminds one of the short-lived PTC hydrofoil service to Gladesville and the Matilda Cruises, River Rocket service of more than ten years later.

ROSMAN FERRIES

Charles Rosman was born in 1898 and worked as a ferry master on Port Jackson from about 1916 until he retired in 1987 — 71 years! It is unlikely that Rosman's record of more than seven decades in charge of harbour ferries will be exceeded.

Charles Rosman's parents, Charles (Snr) and Elizabeth, bought land on the shore of Mosman Bay in about 1908. That property is still home for Charles Rosman. It was also his ferry base for more than 70 years. Charles Rosman (Snr), jeweller and musician, died on 1 August 1914. He had given up his jewellery business at 38 years of age and taken over a public boatshed in payment of a debt. In the former Collies Boatshed he began building launches and pulling boats which he hired out.

After the death of Charles Snr., Elizabeth Rosman continued the business, arranging completion of the 139-passenger picnic ferry *Rex* (1914). *Rex* was a large, clipper-bowed well-decked ferry, somewhat larger than Rosman's first

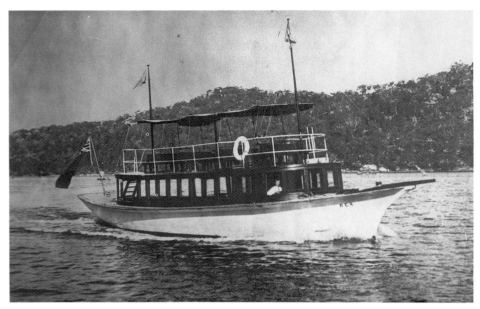

A most unlikely looking ferry — *Rex* was mainly a picnic boat but she made ferry runs when needed. [Charles Rosman]

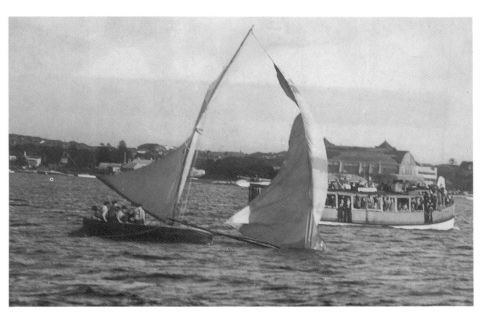

The almost 'unknown' Rosman ferry. *Royal* follows the 18 footers across Rose Bay during the late 1930s. [Seacraft Magazine]

picnic ferry, the 35-passenger *Regal* (1910) A second ferry, *Regina*, could carry 54 passengers. All three of these ferries were busy before World War I as excursion launches.

After the death of Charles Bentham Rosman, the Rosman business was long controlled by Elizabeth Rosman until she was able to divide the Rosman boats among the brothers.

At this time, *Regal* and *Royal* went to Charles and *Rex* and *Regina* to James. There seems to have been little cooperation between the brothers, with James living at Tennyson on the Parramatta River (with his boats on moorings near-by) and Charles based in Mosman Bay.

In 1916, with World War 1 well under way, Charles Rosman began a ferry service between Balmain, North Sydney and Garden Island, carrying dockyard workers to the naval base. This run operated almost unchanged for more than 60 years. The original 30 or so passengers each morning grew to more than 500, morning and night, with Stannard's launches backing-up the Rosman vessels. The service ceased in 1981 when naval sailors moved more into private car use, and passenger loadings dropped away to just 35 a day.

Between World War I and World War II, Rosman's ferries, based in Mosman Bay, worked mainly in the picnic trade with the Garden Island run being the company's only ferry service until World War II. During World War II, Rosmans provided an on-call all-night service from the naval base as required, using *Regalia* (Formerly *Regis/Rodney*), *Royal* and *Rex*.

After the war, with the base now connected to the shore, Rosman con-

Charles and James Rosman (right), two young ferrymen with ferry history to make. [James Rosman Junior]

tinued the Dockyard run, but he also looked into other ferry routes. The withdrawal of Sydney Ferries Ltd. from the Lane Cove River run in November 1950 provided an opportunity to expand onto the Lane Cove River.[12]

Ferries owned by the Rosmans during the 1920s to 1940s period included *Renown*, *Royal* and *Regalia*. *Renown* was originally the well-deck ferry *Loonganna*, in use on Lake Macquarie for Taylors. *Renown* was owned by Charles's brother James, before World War II and was sold to Charles after the war.

Royal was built at Rock Davis's yard at Woy Woy and Charles Rosman (Jnr) travelled up to Woy Woy each weekend by train to work on her. Originally she too was a well-decker with an open top passenger deck, but new stability rules between the wars resulted in her conversion to a flush-decked single-deck ferry.

During a real estate boom around Lake Macquarie, Charles Rosman ran *Royal* around the lake for six months for the developers, servicing new home sites in the area south of Toronto and Rathmines. In this period, there were only very rough bush tracks to Dora Creek. When the roads went through, Rosman brought *Royal* to Sydney. Just before World War II, an early diesel engine was bought for her, but it stayed in storage until after the war to allow time to fit it.

During the visit of Her Majesty the Queen in 1953, Rosman contracted to lease four ferries from the Woy Woy area. All four sailed to Sydney together in rough conditions, arriving intact. Using these ferries and his own, Charles Rosman, in his own words, 'made a killing … ' because of his willingness to pick up parties anywhere. It was a boom period for Rosman Ferries.[13]

The newly-completed double-decker *Radar* (later *La Radar* and then, again, *Radar*), described as the 'streamlined, modern ferry' in 1947,[14] was the best-looking and most impressive 'small' ferry on a harbour full of elderly ferries. *Radar* had an open top deck and a large modern motor ship funnel with

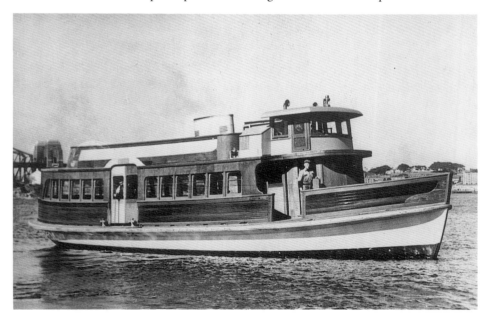

Charles Rosman's *Radar* on her trials. Built in Berrys Bay, she represented an attempt to incorporate 'modern' streamlining with practicality. She has been most successful. [Graeme Andrews Collection]

'R' on it. Her decks were of Indian teak from the veteran Australian light cruiser *HMAS Adelaide* which was being broken up as *Radar* was built. Rosman found it impossible to control passenger numbers on her top deck when following sailing races and, with the growing passenger trade along the Lane Cove River in mind, soon covered over most of the upper deck. For many years, *Radar* carried the prefix 'LA' before her name as another *Radar* was in service when she was launched. As soon as the other vessel lost her name, *La Radar* lost her prefix.

After the war, *Royal* was soon sold to Port Hacking and ended her career as an oyster dredger. She was replaced by *Radar*. *Regalia* was sold to Ian Ford in 1982; *Royale* was built by Peter Braken in 1974, and *Regal II* in 1980. Charles Rosman continued to run his ferry service well into the 1980s, a legend among harbour ferry masters for his ability to maintain schedules regardless of weather.

Charles Rosman retired in 1987 and sold his ferries and the ferry services to Brystand Pty. Ltd., a company under the control of Stephen Matthews who continued to trade under the name Rosman Ferries. Brystand Pty. Ltd. has as principals, Stephen Matthews and his father Frank, together with Ross and Neva Williams, who, in 1992, also owned and jointly operated the former Nicholson ferry, *Proclaim*.

James Devenish Rosman, younger brother of Charles Rosman, was also

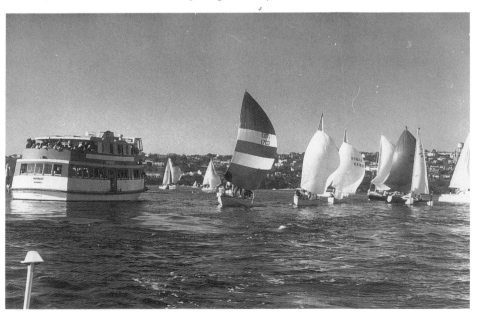

Royale follows a yacht race in Rose Bay. Compare this with the photo of *Royal* taken about 50 years earlier in the same area.
[Author]

involved in ferries. Born in 1904, James ran a ferry and picnic service from the middle 1920s for more than 20 years. He died in 1961.

Apart from picnics, James Rosman ran services from the Quay to Mortlake, calling at Goat Island, Long Nose Point, Greenwich, Woolwich, Drummoyne, Ferry Street, Huntleys Point and Five Dock. Factory ferry services went to Nestles, Abbottsford, Henley Point and Glades Wharf Road, Cabarita, Tennyson and Putney Point. Additional services were run to Nestles, Balm Paints, Lysarts Wire and Meggits Linseed Oils from the Mortlake Gas Works (near the Putney Punt). James Rosman was able to extend several of his river ferry runs as Sydney Ferries Ltd. contracted after the building of the bridge.

Steven Matthews, second owner, and skipper of Rosman Ferries, takes *Royale* up the Lane Cove River on the morning run. [Author]

In 1941, James Rosman took over the Erskine Street-Bald Rock ferry service from Agar Bros, who had used the ferry, *Azile* (1911–1942). Half the Erskine Street (city) wharf was used by Nicholsons and the Morts Dock ferries. The other side was used by James Rosman. From there he ran a 20-minute service to Stephen Street and Bald Rock Wharves, calling at the P & O passenger wharf and the Wheat Wharf.

An interesting and unusual ferry service was James Rosman's 'hospital' run. Patients were carried from the city to the Edith Walker Convalescent Home, opposite Kissing Point. This twice weekly trip ran from the late 1920s until 1949, bringing many families to visit recuperating former servicemen in a voyage which was both relaxing and pleasant.

James Devenish Rosman was unable to continue his ferry service after 1949 and his vessels were sold. His son, James Jnr., later became a tugmaster, working along the Queensland coast, apparently the last Rosman working as a ship's master.[15]

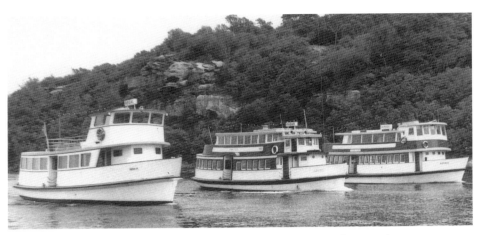

Getting the three busy Rosman ferries in the same place at the same time and in the same direction wasn't accidental. From left: *Regal II, Radar, Royale.* [Author]

THE STANNARD FAMILY

The Stannard family connection with Port Jackson began with William Stannard (Snr.) running a waterman's service and boatshed from Double Bay from around 1863. He died in December 1911. His son, also William Stannard (Jnr.) continued the trade. His waterman's licence number 237, issued in 1881 by the Marine Board of New South Wales still hangs proudly on the wall of the Stannard office. Stannard's boat was probably of the long, easily-pulled clinker style which he often pulled far out to sea to meet incoming ships. His passengers may have been the 'gentlemen of the Press', looking for the latest intelligence from ships perhaps six months out of England, or they may have been traders hoping to make a contact quickly.

As his service prospered, Stannard gained permission to work from Man O War Steps (at the east side of the Opera House site) in about 1880. Here he could service naval vessels and vessels at anchor in the stream, being one of 15-20 watermen based at the site. William Stannard (Snr.) was joined in the trade by his son, William (Jnr.) (1856–1936). A third generation of Stannards, Albert (1894–1987) joined the business in about 1909 and by 1913 was the proud owner of Certificate number 235 from the Sydney Harbour Trust as a driver of a motor boat under 15 tons.

The advent of the motor launch changed the face of the harbour and the waterman's trade. By 1912, the trade for pulling and sailing boats was declining. At about this time, a Dr. Graham loaned the Stannards £200 to buy a boat with an engine. They quickly cornered the market, but unfortunately it sank in about 1913. The boat was quickly replaced. Stannards had four launches working busily by the end of World War One.

William Stannard (l) sits on a waterman's boat at the family boatshed in Double Bay [Alan Stannard]

By the end of 1932, perhaps coinciding with the changes that the Bridge made to the harbour, there were no watermen's boats that were not powered and only three watermen were working from Man O War Steps. Albert Stannard shared the steps with Bill Steerman and his boat *Angler* and another waterman, whose boat was *Alice May*. Albert gradually took over the full service and extended the waterman's shed as an office.

The construction of the Opera House on Bennelong Point from the 1960s caused the Stannards to move their base to what is now known as Campbells Cove, in Sydney Cove. This created some problems as the trams had previously delivered many of the company's customers straight to the wharf. In the new location, Stannards was a little harder to find, but the trade was moving away from launches and more into ferries and work boats. Stannards were required to rebuild an old house on the site as part of their 20-year lease.

In 1937, Albert Stannard bought the Lavender Bay workshops and slipway of W.L. Holmes. These were used as workshop and repair yards until about 1965 when the area was redeveloped. In about 1960, Stannards bought the Berrys Bay land owned by the estate of W.M. Ford, boatbuilders, and then added the other end of the area owned by B. Halvorsen in about 1965 to allow them to move out of Lavender Bay.

In 1968, Stannards bought the Nicholson business and vessels and in 1969 moved the company headquarters to the Nicholson base. After taking over Nicholsons, Stannards began exploring ways of using their expanded ferry fleet on new routes. On 18 March 1969, the company began a peak hour service along the river from Meadowbank to Sydney, using *Proclaim* and the faster *Prolong*. The run began in response to the regular local calls for a ferry service and novelty value provided a reasonable passenger load for some time. However, by 1973, there was not enough business to make the service worthwhile. Inadequate car parking and lack of a connecting bus service as well as too few wharves discouraged any further attempts for some time. Looking towards the other end of the harbour, Stannards began a cross-harbour ferry run on 2 June 1969. This idea had been provoked by a Mosman Council Alderman who was rowed across the harbour to show how much quicker a boat was than a car using the bridge. He was right about the time taken, but

there was no real need for such a service as Stannards found out when they began running it. The service was altered to run from Mosman Bay to meet another new service — the Rose Bay Ferry. Started on 23 March 1970, the Rose Bay Ferry became known as the 'Kiss and Ride' service, inaugurated in the full glare of TV lights as nubile young ladies planted kisses on someone else's husband. The business people bravely set out for the city without the company car, inspiring singer Bernard Bolan's humorous song, 'The Rose Bay ferry'. Oddly enough, he used the Nicholson name in the song and the Nicholsons were no longer involved. The Rose Bay ferry battled on for a few years with three morning and four evening trips, making it the most extensive peak hour ferry service for many years. To be viable, about 400 passengers, morning and evening, were needed, but by the time the numbers were down to about 170 each way it was time to go. The Vaucluse Progress Association made a fuss. If more of its members had used the service there would have been no need to protest against its demise.[16]

William Stannard (2) and Albert Stannard at the Waterman's Steps, Man O War Landing, Sydney
[Alan Stannard]

The withdrawal of Sydney Ferries Ltd. from the Watsons Bay and south-eastern harbour suburban runs, left a small and obvious commercial gap. It was July 1933, and the Great Depression was having its full effect. Judging that there just might be an opening for a small ferry, Albert Stannard tried a small ferry where the big one had not been viable. Using diesel launch, *Picton*, between Vaucluse and Man O War Steps, Stannards initially averaged 50 passengers per trip per day from the day after Sydney Ferries Ltd. ceased running. Stannards charged 5d. per trip, with *Picton* running from Central Wharf, Vaucluse at 8.15 a.m. and reaching the city at 8.45a.m. The return run left Man O War Steps at 5.30p.m. Somewhat encouraged, the company put a second launch on a run from Parsely Bay at 8.10a.m. landing patrons at the Customs Steps on the east side of Sydney Cove.[17]

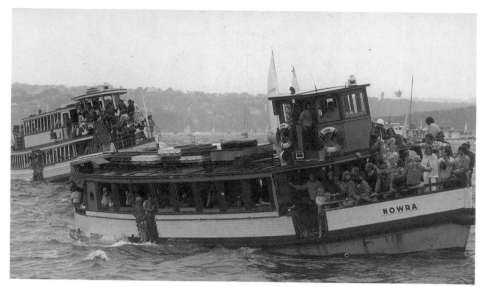

**Stannard's *Nowra* and Nicholson's *Prolong* show why ferrymasters
worry about ferry balance when following yacht races.**
Seacraft Magazine 1972

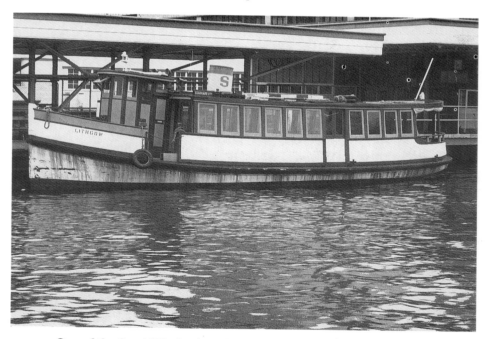

**One of the few 1920s ferries still plying Port Jackson is the Stannard
ferry *Lithgow*. She was built as *Kin Gro* in 1927.** [Author]

Announcing plans for a 130-passenger ferry which would cut the run time from 30 to 20 minutes, Stannards didn't build the new ferry, probably as the initial passenger enthusiasm wore off.[18]

Stannards bought the N.D. Hegarty and Son ferry service from William Needham in February 1978 and continued the Lavender Bay and Kirribilli run. In November 1987, that company and its ferries — *Leura*, *Emerald Star* and *Twin Star* — with leases and rights to wharves, was sold to Captain Cook Cruises Pty. Ltd.

Previously, in February 1970, 50 per cent of Stannards' operations in Sydney and in other ports, had been sold to The Adelaide Steamship Co. with the company working under the name Stannard Brothers Launch Services Pty. Ltd. In April 1980, the other 50 per cent was sold to the Adelaide Steamship Co. and the Stannard family company (in 1990 under the control of Chris Stannard, son of Alan) departed from the ferry and launch business, although retaining a considerable marine business in other fields.

The construction of *Port Jackson Explorer* to the order of Chris Stannard from a design by Phillip Hercus in 1981, gave Port Jackson its first passenger catamaran. Hercus went on to design the world-famous International Catamaran range. In 1992, *Port Jackson Explorer* was part of the Captain Cook Cruises Pty. Ltd. fleet.

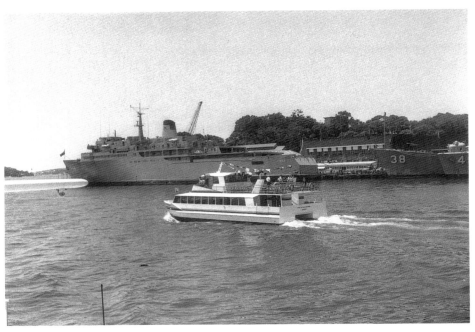

The Stannard family's last ferry was the radical *Port Jackson Explorer*, seen here passing *HMAS Jervis Bay* in 1981. [Author]

THE PART-TIME CHARTER BOAT

While families such as the Stannards, Messengers and Nicholsons were famous around Port Jackson, there were also many small launch operators who made their living around the harbour's commercial fringes. These men ran one or more 'picnic' launches, catering only for the weekend and holiday trade. They were too many in number and, historically, too indistinct to be classified as 'ferries'. Perhaps they may be regarded as one small branch of the last of the watermen.

Typical of these boatmen was Walter Charles Morris Bate. Bate was born on 19 April 1889 and died on 9 September 1976, aged 87. He was a railways blacksmith by trade. From the mid-1920s he ran small party launches, *Lady Betty* and *Lady Betty II*, both named after his wife. In the 1930s, he built a larger version, *Bettina* (1935). She was 24 tons gross and 140-passengers. *Bettina* was one of the largest party boats available and with her and *Lady Betty II* — 40 ft., 44-passengers, Bate and his son Wal could cater for parties large and small.

Bate lived in Tennyson Street Clyde and kept his boat behind his home on a mooring in Duck Creek. His blacksmith work kept him busy during the week and out of hours he ran the launch. When tides were not

Wally Bate poses in Bettina's wheelhouse. [Graeme Andrews Collection]

right in Duck Creek, he would leave the launch at the Brickworks Wharf, Auburn, ready for an early start on the next day.

Chief trade for *Lady Betty*, *Bettina* and other similar craft was following the racing yachts or taking family or social groups from the Parramatta area down the river to the harbour's beauty spots. *Bettina* failed to pass survey in August 1950, but seems to have been back in survey as a ferry when sold in 1962 for use on the Hawkesbury River. Wally Bate was shown in *The Advertiser* of 4 October 1962 preparing to hand his beloved *Bettina* over to her new owner. It seems the new owner couldn't raise the balance of the finance, and *Bettina* became a houseboat in Northbridge, Sydney during the mid–1960s.[19]

Wally Bate and family on *Bettina* in the Bate family drydock in Duck Creek about 1935. [Bate Family]

GOVERNMENT NON-COMMERCIAL FERRIES

Not all of the ferries working on Port Jackson have been commercial. For perhaps 100 years various State and (later) Federal Government agencies have run small craft on regular scheduled runs to provide reliable contact between their base and out-stations or particular jobs.

The Royal Australian Navy and other Navies have long used their ship's boats to transfer personnel to and from naval vessels. In addition, a scheduled ferry from Garden Island to Cockatoo Island has been run from the early 1950s until the present date. In the 1990s, with the reduction of the Royal Australian Navy and the demise of Cockatoo Island as a repair base, the service was downgraded, using mainly ship's boats.

When I worked as a launch-driver from Garden Island in the late 1960s and early 1970s, the Naval ferry run was served by two fine, medium-speed ferries, *Herakles* and *Ulysses*. Of 14m length, with a Gardner diesel that gave them about 11 knots, these pre-war ferries could carry 43 passengers. The normal run was from Garden Island, to Number 2 ferry wharf, Sydney Cove, and from there to Cockatoo Island and return.[20]

Cockatoo Island has long provided its own scheduled and on-call passenger launch services. From 'Codock', these launches service Cove, Elliott and Valentia Street wharves, Greenwich Point, Drummoyne and Spectacle Island as required.

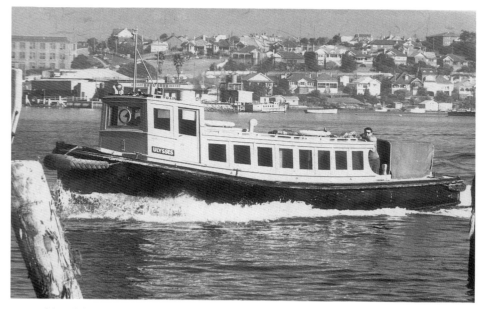

Naval ferry *Ulysses* and sister, *Herakles*, were civilian-manned, providing a regular day-time connection between Garden Island, Circular Quay and Cockatoo Dockyard. [Author]

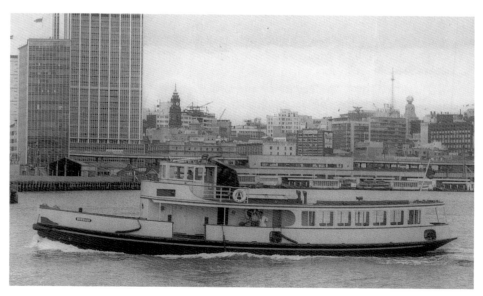

For three decades **MSB** water boat/ferry *Burragi* ferried workers to and from Goat Island. During the day she carried schoolchildren and the under-privileged on harbour tours [Fred Saxon]

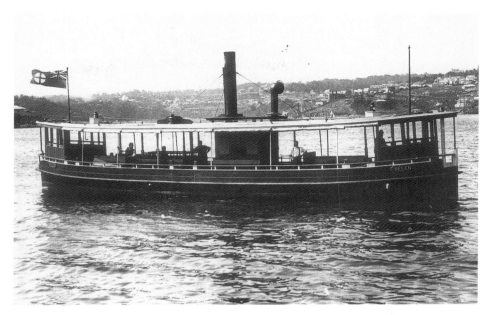

This odd-looking double-ender is *SS Helen*. She served the Sydney Harbour Trust (later MSB) and was a sister of SFL's Tarban Creek ferry *Una*. Details of her career are obscure. [Graeme Andrews Collection]

When Cockatoo Island is handed over to the developers, it is likely that a ferry service will be needed — but probably more pretentious and upmarket vessels than those of the government ferries would no doubt be required.

The Maritime Services Board (MSB) and its forerunners, the Sydney Harbour Trust (SHT), Marine Board, and other maritime agencies, also needed small ferries to carry workers and visitors around the port. The many recent changes of Head Office location and management has seen Maritime Services Board archive access downgraded making it difficult to trace departmental vessel histories.

The Sydney Harbour Trust and Maritime Services Board has used three VIP passenger vessels this century. The 1902-built steam launch, *Lady Hopetoun*, was used as a harbour command vessel and VIP cruiser from 1902 to 1964, when she was replaced by the new *Captain Phillip* later sold out of service in 1989. In 1992, a Steber 52 luxury motor cruiser was purchased for about $1.3m. Known as 'HCV' (Harbour Control Vessel), this expensive, fast craft was outfitted for duties more concerned with VIP tours and the attempt on the Olympic Games bid than for harbour control.

The Maritime Services Board used a varied fleet of 11–12m, 22–25 passenger launches, the names of most of which begin with 'G.' For about 30 years, a service known as the 'Sputnik' run carried passengers and island workers to

Goat Island. The run commenced at Commissioner's Steps, Sydney Cove, and might call at McMahons Point, 10 Walsh Bay and Darling Street Balmain, on the way to stops on either side of Goat Island. The closure of the Goat Island shipyard by the Greiner Government and the rundown and abandonment of most MSB harbour duties brought the launch ferry to an end in 1991.

Other notable ferries used by these Government agencies in ferry runs around Port Jackson have been steam launch, *Scylla* (a smaller version of *Lady Hopetoun*), *Burragi* (formerly *SS Isis*) and various vessels named *Helen*, of which the most interesting was the double-ended steam ferry *Helen*, an apparent identical sistership to Sydney Ferries' *Una* (1898), a 67ft., 150-passenger plus ferry used on the Tarban Creek run.

The last passenger ferry used by the Maritime Services Board was *Burragi*, formerly *Isis*. Built in about 1916 as a steam water tender whose role was carrying water to the steam plant in use around the port, *Isis* was converted to a passenger carrying water boat cum ferry in 1957.[21]

She could carry about 120 passengers on a length of 75ft., at about nine knots. For two decades or more, *Burragi* carried workers to and from Goat Island and, during the day, provided harbour tours for school parties from as far away as Broken Hill, in addition to regularly carrying sightseeing parties of the seriously physically and mentally disadvantaged from time to time. *Burragi* was withdrawn and sold towards the end of the Unsworth Labor Government's term, leaving it necessary to charter a Rosman ferry to carry the Island's workers. This service ceased late in 1991.

NOTES

1 *Sydney Morning Herald* (*SMH*), 17 March 1932.
2 *Ibid.*, 16 March 1932.
3 McDonald, Nesta, letter, August 1990.
4 The author helped haul Kurnell from the water for breaking up at Marine Services Board's Two Depot.
5 Bull, J.C. and Williams, Peter 1966, *Gippsland Shipping*, Melbourne, pp.50–57.
6 *SMH*, 31 July, 14 & 28 August, 1935.
7 Cox, G.W. 1971, *Ships in Tasmanian Waters*, Hobart, pp.49–50.
8 Woodley, A.E. 1973, *Westernport Ferries*, Melbourne, pp.98–100.
9 *Power Boat and Yachting Magazine*, October 1955, p.19.
10 *Aeroplane Press*, 13 November 1974.
11 *Northern District Times*, 20 November 1974.
12 *SMH*, 10 November 1950.
13 Taped conversation Charles Rosman, 1990.
14 *SMH*, 19 July 1946.
15 Letters from James Rosman Jnr. and interview with Charles Rosman (August 1990).
16 *SMH*, 26 January 1977.

17 *Ibid.*, 3 August 1933.
18 *Ibid.*, 8 August 1933.
19 Walsh, Edith 1990, letter, Port Macquarie.
20 Andrews, Graeme 1971, *Australasian Navies*, Sydney, pp.50–51.
21 *Power Boat and Yachting*, January 1958, p.20.

WAR AND OTHER DISASTERS

FERRIES AT WAR

By nature ferries are peaceful vessels, given only to the occasional tangle on the harbour. They were not intended for the cut and thrust of battle. Very rarely does a ferry find itself in a warlike role. The most famous Sydney ferry to become involved in a war was the big inner harbour steamer *Kuttabul*. Built at the Newcastle Government Dockyard in 1922, *Kuttabul* was one of two big sisters, built for the high-volume Milsons Point-Circular Quay service. Her sister ship, *Koompartoo*, was identical, but was to have a long, if not particularly successful, life. *Kuttabul* was not so lucky. After some time as a concert boat (after the harbour bridge made her redundant), *Kuttabul* became an accommodation ship for the Royal Australian Navy, being requisitioned on 7 November 1940. She was commissioned *HMAS Kuttabul* on 26 February 1941, whilst still owned by Sydney Ferries Ltd.

On the night of 31 May 1942, World War II came to an almost unprepared Port Jackson. The attack on the harbour by a force of Imperial Japanese Navy midget submarines caused much sound and fury, but there was little real damage other than to the submarines and to *HMAS Kuttabul*. A torpedo loosed at the heavy cruiser *USS Chicago*, missed, and exploded under *Kuttabul* against the stone-clad shores of the naval base.

The blast ruptured the ferry's thin plates and she settled on the bottom, shattered superstructure and funnel well above the water. Nineteen naval men were killed. To commemorate the tragedy, the base at Garden Island now carries the name, 'HMAS Kuttabul'. The wheelhouse of the old ferry, after decades as a naval police control box, is now on the parade ground of HMAS Kuttabul, together with a photographic display of the raid.[1]

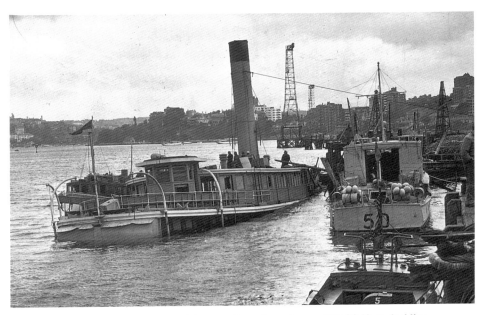

War comes to a peaceful port. One-time ferry, *HMAS Kuttabul* lies awash as workers clear the debris. Main damage was at the end away from the camera. [Graeme Andrews Collection]

SS Kai Kai seems to have been the first ferry taken up for naval use; she was hired several times between 1940 and 1942 as an accommodation ship. She was bought by the Royal Australian Navy on 4 March 1943, and was sold on 2 June 1947 to the breakers.

The redundant big vehicular ferry, *Kara Kara*, was the next ferry to be 'recruited'. She was also the last to be demobilised. She was taken over from Sydney Ferries Ltd. on 27 February 1941 and was bought outright on 7 November that year, having been commissioned on 14 October. As a boom defence ship, *HMAS Kara Kara* (Z221) sailed to Darwin in November 1941 where she served as a boom-gate vessel for the rest of the war. When Japanese aircraft attacked Darwin on 19 February 1942, *HMAS Kara Kara* was a sitting duck, attached to the boom gate and unable to manoeuvre, with just one 12 pounder and several Vickers machine guns as armament. She was attacked and two men were killed, but damage was moderate and she survived that attack and all the others. After World War II she was placed in reserve in Darwin until she was brought to Sydney and placed in the Ships In Reserve Fleet laid up in Athol Bight. *Kara Kara* was sold for stripping in 1972 and after all useful items, including her engines, had been removed, was sunk as a target at sea on 31 January 1973 by HMAS Ships *Teal*, *Perth* and *Yarra* in combination with Skyhawk fighter bombers from the Fleet Air Arm.

This old ferry survived Japanese air attack then spent years mouldering in reserve. Ex *HMAS Kara Kara* is towed to sea.

One time car ferry and showboat, Army ship *Kalang* lies at anchor in Torokina. That pounding, flat-bottomed bow broke eggs, light-bulbs and sailors. [Graeme Andrews Collection]

Kara Kara survived her sisters *Kalang* and *Koondooloo* by only a short while, but she was the last of Port Jackson's large 'Fighting Ferries' although the one-time Hawkesbury River ferry, *George Peat*, survives into the 1990s in Tasmania.

Showboat vehicular ferry, *Kalang* is probably the best-known of the wartime ferries. *Kalang* and sistership, *Koondooloo*, were built in the United Kingdom, as was *Kara Kara*, as vehicular ferries. After service as a showboat, following the opening of the bridge, *Kalang* was requisitioned in October 1942 by the Australian Army as *Kalang (AB97)* — a mobile Army workshop. She was equipped with an extensive workshop built on the one-time vehicular deck and with 30-ton capacity lifting gear. Her intended role was as a general repair ship and maintainance base for Army small craft (and those of the RAN/United States Navy) around the New Guinea area. Being coal-fired, she was unable to match the cruising range of the Hawkesbury River Peat Class diesel-engined vehicular ferries. Her estimated 1600 nautical mile range was, however, sufficient for passage making.[2]

As an Army vessel, *AB Kalang* carried a crew of 82 men, mainly engineers. Her voyage north in 1943 was something of an endurance run as the almost-horizontal under-surface of the flat bow smashed into the wave faces. This required special shock-resistant light bulbs, but little could be done for either crew or eggs.

Kalang called at Brisbane, Rockhampton, Townsville and Cairns before heading across the Coral Sea to Samarai through the China Strait. She was based at Torokina on Bouganville Island, as late as Christmas 1944. While at Torokina, *Kalang*'s engineers made and fitted a shaft bearing for the RAN frigate *HMAS Diamantina* (a museum ship in Brisbane in 1990).

Some reports state *Kalang* was towed back to Sydney, but I believe that she steamed home via Rabaul, Port Moresby, Thursday Island, and the same ports called at on the outward voyage.[3] *Kalang* was demobilised in January 1946 and reconstructed as a showboat at Newcastle, resuming service as Sydney's Showboat on 5 October 1947.

Koondooloo was taken over by the Australian Army as S.181 floating work-shop on 17 September 1942. She was returned to Sydney Ferries Ltd. on 21 August 1946, but was not reconverted as a showboat. Instead, in 1950, she became a vehicular ferry once more — in Newcastle's Port Hunter on the Stockton Ferry route.

Wooden Sydney ferry, *Kuramia*, was taken over for duty as a boom gate vessel for Port Jackson on 20 February 1942. She was commissioned 'HMAS' (FY46) on 30 June 1942 and bought by the government in September 1943. After the war, she was used as an amenities vessel, paying off for disposal on 3 December 1945. She was sunk at sea as a target by aircraft from the aircraft carrier *HMAS Sydney* on 10 October 1953.

Kuttabul's sistership, *Koompartoo*, was requisitioned by the British Ministry of Transport on 17 November 1941 for use in the Middle East. She was con-

verted for her new role by Morts Dock, but war in the Pacific was to keep her in the Australian area. *Koompartoo* went to RAN control on 18 June 1942 and was commissioned on 23 December 1942. As a boom gate vessel (Z256), she served with *HMAS Kara Kara* in Darwin from late January 1943 until 1945 when she went into reserve in Darwin. She was taken to Sydney in 1950 and laid up until sold in 1962. Her hull was towed to Launceston for use as a bauxite barge in 1966.

Manly ferry, *Burra Bra*, had one of the more interesting roles as a war ferry. Built in 1908 as one of the 'B' class Manly ferries, she was the last open top deck Manly ferry. After the arrival of *South Steyne* she was used mainly as a relief ferry. *Burra Bra* was taken over by the RAN on 13 March 1942 and altered for naval duties by Poole and Steele Ltd. Balmain. She was commissioned on 1 February 1943 as an anti-submarine target ship and RAAF target vessel under the command of Lt. R.E. Morley RANR(S). Her 13 knot top speed allowed her also to work as a patrol vessel in the Sydney area at times and she was defensively armed. She was bought outright for the RAN on 25 August 1943 and was later placed in reserve, although often used as a mobile steam power plant for ships in refit after that time. *Burra Bra* was sold by auction in November 1947.[4]

Other Sydney ferries to have minor wartime roles included the retired Manly ferry, *Binngarra*. Already a hulk, she was taken over and used as such in New Guinea. After the war, she was scuttled off Sydney on 11 December

HMAS *Burra Bra* lies alongside a Royal Navy escort carrier at Bennelong Point, Sydney Cove [Ross Gillett Collection]

1946. The inner harbour wooden ferries, *Karabella* (1897), *Karaga* (1894) and *Kiamala* (1897), laid up spasmodically since 1932, went to the US Navy: *Karabella* for £3500 on 30 April 1943, *Karaga* for £1450 on 3 May, and *Kiamala* for £2500 on 7 June 1943. All were taken away by the United States Navy and seem to have become untraceable. Other old ferries to be of naval use were *Lady Hampden* used as a target in 1943, and ex Manly ferry, *Kuring Gai*, used as a barge in New Guinea. She was later abandoned on the river bank at Hexham, upriver from Newcastle, and (in 1990) was visible at low tide.

The Army and Navy list shows other small wartime ferries of which *Seeka* (*Star*) is probably the best known. *Seeka Star* was still in use in 1990, having been variously owned by Hegarty ferries, Gordon Davey, and Captain Cook Cruises. *Seeka* was built for the Hordern family before the war as a ketch-rigged auxiliary motor launch. She was commissioned as HMNAP 536 (His Majesty's Naval Auxiliary Patrol vessel). She sailed to Darwin under her own power and was in action as a rescue vessel when the Japanese attacked in 1942. Her light machine guns and small depth charges were of less value than her ability to rescue downed Australian pilots from the sea.[5]

Shown in the Army list of small craft is *Gunna Matta*, one of the early Cronulla-Bundeena ferries. This 11.5m vessel had a Kelvin diesel which allowed her to carry 3.5 tonnes at six knots. The list does not say where she worked during the war, but she was probably used as an Army ferry.

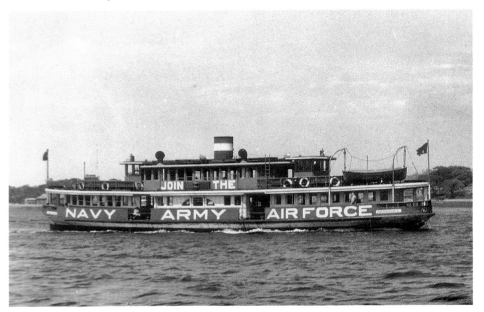

Karrabee became red, white and blue for armed forces recruiting. The Korean War was under way [Fred Saxon]

MAJOR AND MINOR DISASTERS

The ferry services on Port Jackson have been remarkably free from tragedy when one considers the millions of ferry trips and myriads of passengers that have crossed the port. However, unfortunately, there have been some major tragedies and many groundings, minor collisions, and some sinkings. Many of the ferries of Sydney came to grief elsewhere, often with considerable loss of life, but on Port Jackson there have been only two disasters involving deaths of more than one person.

The worst ferry disaster on the harbour happened at about 4.30p.m. on 3 November 1927, when the Watsons Bay ferry, *Greycliffe*, heading for Watsons Bay, was overtaken and run over by the Union Steam Ship Company's *SS Tahiti*.

SS Greycliffe left Sydney Cove for Watsons Bay, via Garden Island, Neilson Park, Vaucluse and Parsely Bay at 4.15p.m. under the command of Captain William T. Barnes.

Barnes was a regular on the run and was relieving Captain G. Gerdes for his day off. Deckhand on the ferry was Frederick 'Curly' Jones, engineer was Jack Barratt, and fireman was Alfred Dean.

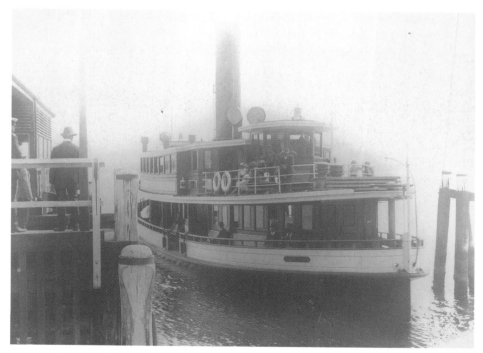

Watsons Bay ferry *Greycliff* was the victim in Sydney's worst marine disaster. Detailed photos of the ship are rare. This glass plate negative has faded at the top but shows fine detail. [Graeme Andrews Collection]

Greycliffe was running the 'school boat run' with a considerable number of homeward-bound school children among her estimated 125 passengers. Many of the children aboard had been to the combined schools athletic meeting at Moore Park and were full of fun and excitement as they compared notes and skylarked. Also aboard were many adults from Sydney and from Garden Island naval base, making up, perhaps, more than half the complement of passengers.

As *Greycliffe* left Sydney Cove, so too did ferry *SS Kummulla*, heading for Taronga Zoo Wharf at Athol. *Greycliffe* picked up naval and civilian employees at Garden Island and headed east as *Kummulla* neared the Zoo Wharf. Coming down-harbour under the command of Captain Aldwell, with pilot, Captain Thomas Carson advising, was the 7898 tons gross passenger liner *SS Tahiti*. The two vessels were on slightly converging courses with *Tahiti* in the overtaking position on the ferry's port quarter. At about 4.30p.m., *Tahiti* cut *Greycliffe* in half, with roughly half of the ferry being sent down either side of the bigger ship.

Kummulla, just leaving the Zoo wharf, was the first vessel on the scene as *Tahiti* came to a stop and dropped anchor. Other vessels quickly at the tragedy were pilot steamer *Captain Cook* (2), ferry *Woollahra* (which had been on *Greycliffe*'s reciprocal course), Manly ferry *Burra Bra*, a police launch, and several small ferries and naval launches.

Dragged ashore on Whiting Beach are the awful remains of *Greycliff*, showing where Tahiti's bow crushed the ferry's sponson and then, severing the steel sponson band, cut through the hull. [Vince Marinato Collection]

The final death toll is usually given as 42 with many injured. Contrary to popular belief, the death toll included relatively few schoolchildren, most of whom appear to have been on the outer decks at the time of the collision. The small fishing 'village' of Watsons Bay and nearby Vaucluse lost many well-known residents.[6]

The court of marine enquiry was told by *Tahiti*'s master and pilot that the ship was doing only six or seven knots and that *Greycliffe* altered course to port across the overtaking ship's bows. Other competent witnesses, including Rupert Nixon, who was on the wheel of Manly ferry *Burra Bra*, travelling at full speed (13.5 knots) — (and only slowly overtaking *Tahiti*), various naval officers and other seamen, stated that *Tahiti* was going much faster than the *Greycliffe* (maximum speed was about nine knots). Captain Barnes of *Greycliffe* flatly denied altering course away from the heading to his next wharf and stated he was doing about 6.5 knots.

Mr. Justice Campbell on 28 January 1928 concluded that *Tahiti* was making about twelve knots and *Greycliffe* between nine and ten knots. He concluded that the main reason for the collision was *Tahiti*'s failure to keep out of the way of the vessel being overtaken as is required by the collision regulations. This conflicted with the earlier Coroner's report which stated that *Greycliffe* was guilty of contributory negligence.

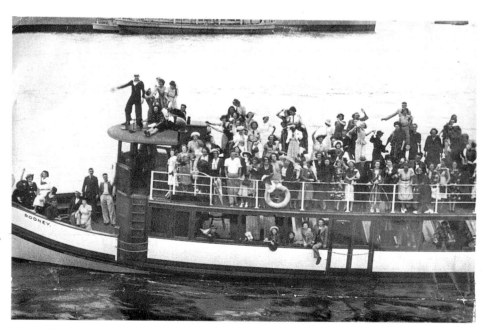

The near-new motor ferry *Rodney* is about to roll over! Too many on the top deck and too few on the bottom and that naval sailor on the wheelhouse roof should have known better [Graeme Andrews Collection]

In 1929, Sydney Ferries Ltd, owners of *Greycliffe*, sued *Tahiti*'s owners for damages. In March 1929, Mr. Justice Halse Rogers found that the greater blame rested on Captain Barnes who had made an 'unexpected and unnecessary turn … '. This judge gave two-fifths of the blame to *Tahiti* and the rest to *Greycliffe*.[7]

In terms of death and injuries, the capsize of the small ferry *MV Rodney* on 13 February 1938, rates second in disasters on Port Jackson.

Rodney was one of a small flotilla of private and excursion craft farewelling the American heavy cruiser *USS Louisville* as it headed for sea after a courtesy visit.

Approximately 104 passengers were aboard *Rodney* as the Rosman ferry circled the big cruiser. The nearly-new ferry was certificated for up to 211 passengers and two crew, but the number of people on board on the open top passenger deck was much too high.

As *Rodney* passed around the stern of the slowly-moving cruiser, passengers on the upper deck rushed from one side to the other to get a better view. This was too much for the stability of the small ferry, and she rolled over and slowly sank. Eyewitnesses stated that the disaster was caused by the ferry turning and being caught by the bigger ship's wash at the same time as passengers on the overcrowded upper deck rushed to the starboard side.[8]

More than 60 people were treated for injuries at Sydney and St. Vincent's Hospitals. The final death toll was considered to be 19; a figure arrived at only after the ferry was refloated and searched.

Photos taken of the *Rodney* moments before the disaster were a major part of the evidence. These photos showed that at least 80 people were on the upper deck just before the overturning, with many of them standing on the backs of their seats and even on top of the wheelhouse. The bottom deck was almost empty with those few people there leaning out of the windows.

Robert Stanley Westhorpe, senior shipwright surveyor for the Maritime Services Board, seemed unable to decide why the vessel capsized and was reluctant to criticise the design, preferring instead to point out the 'idiotic loading'. In his view, it was not that boats were unsafe; the problem lay in the people who were on them who did not act responsibly.[9]

Verdict of 'Accidental Death' was returned by the City Coroner at an enquiry on 30 March 1938 and C.H. Rosman, master of the *Rodney*, was found to be not guilty of criminal negligence. At a later enquiry, the Maritime Services Board suspended his master's certificate for a period.

Rodney was refitted and repaired. Her upper deck seating was removed and, as *MV Regis*, she re-entered harbour use. Some time later, she was renamed *Regalia* and, as such, worked the harbour for almost 50 years. In 1990, she was in use on the Georges River south of Sydney as an excursion vessel, owned by Ian Ford.

Apart from the *Greycliffe* and *Rodney* disasters, ferry travel on Port Jackson has been better known for the large number of minor collisions, groundings,

and the occasional fire, than for serious injury or loss of life. Perhaps Sydney's ferries have a better passenger safety record than do even Australia's commercial airways. Certainly, it is hard to locate reference to serious accidents, other than those included here.

The loss of life of a waterman's passenger in collision with the steamer *William the Fourth* in June 1841 seems to have been the first loss of a passenger involving a steamer on the harbour.

The more interesting of these incidents include the small former Joubert ferry, *Pearl* (1883). She joins the sad list of Sydney ferries whose accidents have caused loss of life. Transferred to Brisbane, *Pearl* collided with the anchored *PS Lucinda* in 1896 while trying to cross the flooded Brisbane River. Although not then a 'Sydney' ferry, she is included because of the death toll of 23 and because of her origins.[10]

One of many collisions involving Sydney's ferries was reported by the *Daily Telegraph* of 2 February 1914:

<div style="text-align:center">

FERRY BOAT SUNK

A PLUCKY FIREMAN

RAKES FIRES TO SAVE PASSENGER'S LIVES

</div>

Fireman Harry Taylor of the Balmain Company's ferry boat *Me Mel*, stood waist deep in water, and raked his fires to prevent the boilers from exploding. The vessel was, at that time, sinking rapidly after a collision with the steamer *Mokau* in Darling Harbour on Saturday.

So was reported the heroism of one of the harbour's ferrymen. *Me Mel* (1888) had about 30 passengers aboard during the 11.40a.m. trip from Darling Street Balmain towards Erskine Street. Just off No.6 Jetty, *SS Mokau* rounded her owner's wharf at the foot of Market Street heading for Pyrmont. *Mokau* hit *Me Mel* near the port paddlebox and pierced the hull. Captain Lawler of *Me Mel* headed for his wharf with *Mokau* still embedded in the hull. Ferries *Lady Napier* and *Lady Rawson* stood by as *Me Mel* reached the wharf. All disembarked safely as *Me Mel* sank.

No doubt, Sydney's television news stars would work themselves into a verbal lather over a similar situation today, but Harry Taylor had his day in print in the *Daily Telegraph* which described his heroic action in detail:

When the passengers and crew were congratulating themselves on their escape, someone clambered onto the steps, dripping wet. It was Fireman Taylor who had made his escape from the engine room almost at the moment the vessel made its last plunge. Taylor was below when the vessel was struck. There was a rush of water and he was swept off his feet. Taking in the situation at a glance and with his thoughts on his boilers, he regained his foothold and raked frantically at the fires. The water gradually rose until it reached his armpits but his job was finished. He felt the vessel tremble. He plunged for the companionway, leapt up the stairs and regained the open, just in time.

Sydney's biggest paddle ferry's career was almost cut short on 7 August 1900. The grand paddler, *PS Brighton* (1884) in the charge of Captain George Setterfield, left the Quay on the last trip of a moonlit night at 10.30p.m. She had about 40 passengers aboard. Near the Sow and Pigs Reef the collier *SS Brunner* ran into the ferry, striking just forward of the paddlebox on the port side. The damage was considerable and the ferry's boats were lowered to save those who had not scrambled on board the collier.

Captain Setterfield then headed at full steam for Chowder Bay beach at Clifton Gardens. He was successful in beaching the big ferry and she was repaired and returned to service for another 15 years. Injuries were minor on the ferry and the collier's bows were severely damaged but the ship was in no danger of foundering.[11]

The *Daily Telegraph* headlines on 15 May 1913 told some of the story: 'WILD WEATHER ... FERRY STEAMER SUNK ... GREAT SEAS ON THE COAST'.

The magnificent Manly paddler *Brighton* leans awkwardly on the beach at Clifton Gardens after a serious collision. She worked another 15 years.

[JA Soloman]

For several days Sydney and the adjacent coast were battered by one of the great storms. Coasting steamers took shelter where they could. Buildings were blown down and the Manly ferry service ceased — most people prudently used the trams instead. Even inner harbour ferries had trouble berthing, and for *SS Birkenhead* (1888), it was the last landing. Under the command of Captain Atkins, she was attempting to berth in the Quay at the Lane Cove ferry wharf. She hit the wharf bow on and opened up the bow. Engineer Young reported that *Birkenhead* was leaking badly, so an attempt was made to get her out of the congested Sydney Cove and over to Blues Point where she could be run aground. She didn't make it. As she neared the vehicular ferry slip at Dawes Point, the foredeck was awash. Captain Atkins placed her alongside the Dawes Point punt wharf and all four crew scrambled ashore as *Birkenhead* disappeared. The Dawes Point ferry ramp was blocked for some days until *Birkenhead* could be raised and removed.[12]

In these days of few very large ships and radar and voice marine radio, it is perhaps difficult to imagine Port Jackson when more than 100 steam ferries worked the port, dodging the dozens of coasters and colliers that came and went about their business. Added to them were the great liners and the smaller tramps that carried Australia's imports and exports. Crossing this traffic almost at right angles were two vehicular ferry routes, both of them very busy.

Benelon (1885) sank after being run down by the North Coast Steam Navigation Company's *SS Burringbar* just before 6p.m. on 17 May 1923. The paddle ferry was carrying only 11 people, including its crew. Master of *Benelon*, Captain C. Webb, was the only person injured and was last off the sinking ferry. The crew comprised engineer G. Hill, fireman B. Wagg, deckhands J. Quite, R. Thomas and J. Martin.

Benelon was heading from Blues Point to Dawes Point when the coaster hit her on the port side forward of the paddle box. Although there were no human injuries, it seems no-one had the time to consider five horses which were harnessed to vehicles. All drowned because no-one cut their traces. *Benelon* was refloated and repaired and in regular use until the opening of the bridge removed the need for the vehicular ferries.[13]

If sinkings of passenger ferries have been few and far between, burnings have not. The most dramatic and tragic ferry burning involved the newly-converted Port Jackson and manly Steamship Company's *Bellubera*, as it lay alongside the company base wharf at Kurraba Point. On 16 November 1936, five men were trapped in the ferry's engine room when it caught fire while work was being done.

The Sydney Harbour Trust's fire float *SS Pluvius* attacked the fire from seaward when it became obvious that land-based firemen could not get enough water. Ferry *Dee Why* pulled her sister, Manly ferry *Curl Curl*, clear before she caught fire. The ferocity of the fire turned the ferry's upperworks into a tangled mass of rubbish, comparing dramatically with the minimal external damage sustained by the Manly ferry *South Steyne*, from a fire in 1974.

Two men died as a result of the *Bellubera* fire. Robert William Duncan Finlay (39) died in the fire, and Sydney Patrick Tight (38) died in hospital of injuries sustained. Lewis S. Maxwell saved his life by keeping his head out of one of *Bellubera*'s portholes as attempts were made to cut into the hull to reach him. Sydney Cronshaw and Frederick Thompson were trapped in the hull.[14]

One ferry that caught fire was completely reborn as a different ferry with a different name and official number. *SS Kaludah* (1909); almost new, caught fire near Gladesville on 22 March 1911 and was gutted. She was used as the base for a new ferry, *Kamiri* (1912) which was finally broken up in 1950. Senior foreman, the late Ted Willoughby of Morrison and Sinclair's shipyard, Balmain, was involved in both jobs as a young man and told me how he had kept tools found in the bottom of *Kamiri*, which were engraved 'Kaludah'.

Two ferries burnt out side by side in Waterview Bay (Mort Bay) on 6 June 1916. The Balmain New Ferry Company vessels, *Leichhardt* (1886) and *Daphne* (1886), were gutted and not rebuilt. *Eagle* (1882) was considered to be an 'unlucky' ferry. A boiler flash killed a fireman in the 1880s and she was rebuilt as *Cygnet* (1899). *Coombra* (1872) was gutted and rebuilt and lasted to 1913, and *Kangaroo* (1891) was burnt out twice and still lasted to 1926. Many other ferries had fires, the most recent being that aboard *MV North Head* (1913 rebuilt 1951) in August 1976. The small ferry, *Leura*, was badly fire-damaged on 27 March 1981.

The problems involved in using faster-than-usual ferries on the harbour were first illustrated when the steel water bus, *MV Crane II* (1934) ran down the fishing launch *Kia-ora* on 14 March 1937. The boat survived the impact as did her passengers.[15]

The courts were generally lenient towards masters of ferries whose collisions had caused no injuries. Captains L.L.B. Schofield of ferry *Kulgoa* and E. Buckridge of ferry *Kurraba* almost lost their certificates after a collision in Sydney Cove on 24 September 1936. They were given a dressing down by the Court which suggested that Captain Schofield should make sure that he knew the meanings of the international sound signals.

Not so lucky was the unidentified Sydney ferry master who was sacked in 1956 after overshooting Musgrave Street wharf and not going back to it, then smashing into Old Cremorne Wharf, narrowly missing a moored yacht in Mosman Bay, and then abusing passengers who complained.

One of the more interesting ferry collisions involved three ferries. *SS Karrabee* approaching Dawes Point, gave right of way to vehicular ferry *PS Barangaroo* (1889). As *Karrabee* went astern, she was run into by vehicular ferry *Benelon*. Damage was minor and there were no injuries. About nine hours later, sisterships *Kanangra* and *Kirawa* had an altercation off Robertsons Point at about 11.30p.m. Again, no-one was hurt and both vessels kept running. It was an interesting day on the ferries![16]

Ferry *Kosciusko* didn't sink after a heavily-loaded RAN steel fuel barge

being towed by steam tug *Wattle* smashed into her hull. That she didn't was only because the barge kept the ferry afloat until naval and Maritime Services Board tugs could get their pumps in action. Fog was the given reason, and once more a wooden ferry survived damage that should have finished her off. *Kosciusko* had other collisions, but survived long enough to provide major help to bridgeless Hobartians when the *Lake Illawarra* knocked the bridge down in 1974.[17]

The Manly ferry steamers have had their fair share of drama. Apart from Brighton's near disaster, already mentioned, there have been other notable incidents and accidents on the seven nautical mile run to Manly.

Because of their greater size and speed and their mostly steel construction, the Manly ferries usually came off best in collisions involving the smaller harbour ferries. The results were usually a wooden ferry with smashed bulwarks and a few dents in the Manly ferry. When they took on bigger ships, the Manly ferries usually came off very second best. Listed below is a representative collection of incidents involving Manly ferries. It is by no means exhaustive as there are more detailed sources available.[18]

Deaths involving collisions with Manly ferries have been rare, but they have happened. *Fairlight* (1) ran down a small sailing vessel near Middle Head a day or so before Christmas 1882, killing a young boy.

More dramatic was the rescue of the small Manly ferry, *Manly* (2), by the bigger paddler *Brighton* in heavy seas and gale force winds on 30 June 1901. Under the command of Captain Percy Davis, *Manly* left the Manly Wharf at 10.15p.m. on her last run for the night. Conditions were very bad. Nearing the Heads in big seas, her engines failed. An anchor was dropped and held her from going ashore near the Old Mans Hat on North Head. *PS Brighton*, heading for Manly under Captain Drewette, responded to *Manly*'s distress flares. After some excellent seamanship, she managed to tow the smaller vessel close to the Manly harbour beach. Here she was re-anchored and left while *Brighton* unloaded passengers. *Manly* was dragged ashore onto the beach, but was unharmed and later refloated. *Manly* was later to collide with the launch *Agnes* on 4 December 1910, leaving two dead.

The 'B' class ferries on the Manly run also had their fair share of crashes and smashes. *Balgowlah* defeated the inner harbour ferry *Kanimbla* (1909) in a sharp engagement on 15 June 1927. Four people were injured on the smaller vessel which nearly sank.

Bellubera did a better job on the small government explosives tug *Kate*. No-one was hurt when *Kate* went to the bottom. It was the second time that a Manly ferry had sunk *Kate*! In 1898, she lost a bout off Garden Island naval base with Manly ferry *Narrabeen*.

Bellubera came second when she took on the cargo ship *Taurus* on 18 October 1950, but she scored a publicity victory twenty years later against the Royal Australian Navy. The Type 12 frigate *HMAS Parramatta* was backing out of Chowder Bay fuelling wharf when *Bellubera* smashed into her. Under

Captain Bruce, *Bellubera* had done more damage to *Parramatta* than she had taken from the bigger ship, and the press and television journalists loved it. The RAN refused to comment.

North Head, formerly *Barrenjoey*, was the last of the 'B' class ferries to hit anything. As the lonely last of her class, and on borrowed time awaiting arrival of another new Freshwater class ferry, *North Head* took a big bite out of the inner harbour steel ferry *Kanangra* on 5 November 1984. It was the end of the commercial line for *Kanangra*. *Kanangra* was soon retired and became a museum ship. *North Head* was soon to sail to Hobart.

The magnificent sisters *Curl Curl* and *Dee Why* seemed to prefer not to hit other vessels, concentrating instead on spectacular groundings and wharf demolitions. After an early smash involving inner harbour ferry *Kiandra* (1911) on 30 April 1930, *Curl Curl* went for better targets. On 24 February 1932, she sailed majestically into the Manly Harbour Pool, causing some comment and discussion among those who were using it.

When the fog lifted on 31 March 1936, there was *Curl Curl*, well aground on the reef off Bradleys Head. No-one was hurt, but there was some damage to the ferry. Her foray into the offices that lined the shore end of Manly ferry wharf on 13 February 1953 was well-publicised.

Sister ship, *Dee Why*, confused the experts by parking on Obelisk Beach during a foggy night on Christmas Day 1946. Compass error was blamed for that one.

The magnificent Manly ferry, *South Steyne*, had her share of incidents of which just a few here. Early in her career, she showed her power and weight by dealing the Manly wharf a heavy blow. A hard hat diver was under the wharf at the time and was lucky to live to talk about it. In May 1944, she again tried to demolish the Manly wharf, and almost succeeded. Plenty of frights, but no injuries.

South Steyne was able to shake mere wharves but she met her match when she took on the outgoing Blue Funnel liner *Jason* on 13 March 1964. Her best-publicised collision came when she tried to avoid some small sailing craft off the end of the Garden Island Naval base. Aircraft carrier, *HMAS Melbourne*, was nearby, quietly moored to a buoy and not expecting to be rudely rammed in the stern by a Manly ferry. The date was 30 September 1970 and I just happened to have my camera at hand as *South Steyne*'s master made the choice between sailing craft whose skippers had little knowledge of seamanship and the solid stern of the warship. *South Steyne*'s softly rounded upper bow crumpled and the *Melbourne* was almost undamaged.

South Steyne's withdrawal is discussed elsewhere in this work, sufficient here to add that in October 1990 she arrived in Newcastle to do duty as a floating restaurant and occasional excursion steamer. Attempts to make her pay in Melbourne had failed after a multi-million dollar overhaul, and the Manly ferry that nobody seems to really want was once more looking for a new role.

During the nadir of the Manly ferries before and following Brambles foray

Manly ferry *South Steyne* smashes into the stern of the moored aircraft carrier *HMAS Melbourne*. [Paul Hopkins]

into ferry ownership, the two smaller inner harbour ferries *Lady Wakehurst* and *Lady Northcott* became Manly ferries. Of about the same size and passenger capacity as the wooden *Manly* (2), they provided an exciting ride in even moderate seas. *Lady Wakehurst* was participant in a tragedy on 11 April 1982. In a collision near Fort Denison, the Sydney-bound ferry's propeller killed John Leslie Ferguson, crewman on the yacht *Soho*. Captain Bernadus Geradus Gevelling of the *Lady Wakehurst* was later committed for trial on a charge of manslaughter. He was acquitted on this charge but his certificate of competency was later revoked by a Court of Marine Inquiry.

An unusual and needless tragedy involved the hydrofoil, *Curl Curl* (2), on 2 October 1981. Several young men, having hired a cruiser for a bucks party, were anchored near Fort Denison in the peak hour period. One young man, Timothy Grahame Wearne (23), was swimming in the harbour when he was run over by the hydrofoil. Hydrofoil master, Captain Gevelin, didn't even know of the tragedy until he reached Manly.

This incident emphasised something that the writer who has been both ferry and tug master on Port Jackson well knows — the lack of knowledge of seamanship of many private boat users on the port — particularly those in racing yachts and those owning big, expensive and fast power boats.

Obtaining brand new and 'hi-tech' Manly ferries did not cure the problems of collisions and crashes on the Manly run. Rather, for a while, it seemed as if things were worse.

The new *Freshwater* had a real genius for getting publicity in her first few seasons. When in use only a month, she broke down off Middle Head. She did it again off Bradleys Head the following month. After several more highly

publicised failures, she parked herself on the Manly Harbour Beach, taking the swimming pool net with her. It seems the computer that handles her controls was not programmed correctly and refused instructions from Captain Kramer. Coloured postcards were soon on sale showing the embarrassed *Freshwater* almost high and dry. It wasn't a good time for the new ferries, their design had been roundly criticised for many things.

On 12 September 1984, the new Manly ferry, *Narrabeen*, parked herself in almost the same spot as had her older sister, *Freshwater*, a year or so before. She dragged herself off, taking the swimming pool net with her.

Gradually the engineers and electricians solved the problems of the new *Freshwater* class, but there are still many older passengers and harbour users who compare, unfavourably, their lively behaviour and tossed spray in a sea-way with the more comfortable motion of the older and smaller Manly ferries, upon whose designs the new boats were said to be an improvement.

The sinking of an elderly wooden ferry in Circular Quay on 22 January 1984 did more than just provide a thrill for her many passengers and a well-televised evening news item. It spelt the end of the traditional-type Sydney ferry, and the end of the large wooden inner harbour ferries. It also generated a spate of media interest, political buckpassing, and wisdom after the event that did very little good for anyone, most particularly the old wooden Sydney ferries.

MV Karrabee was built as a steamer in 1913. She was converted into a motor vessel in 1936, her old steam engines (formerly *Pheasant*, 1887) being given to the (then) Museum of Technology. On 18 January 1981, *Karrabee* 'won' the first Great Ferry Boat Race, stage managed on Port Jackson as part of the Australia Day period festivities. Under Captain Ron Archer, she came third in the race in 1984, but sank soon after the race ended.

During the event *Karrabee* had steering and other mechanical problems and had lagged behind. The well-primed 'crew' of paying passengers crowded forward as the old boat surged after the other ferries, her blunt bow and bulwarks forcing through the stern wash of the leading ferries. Photographs show that the ferry was running bow down under the weight of the passengers all crowding forward and that her actual hull was below the average sea level.

At the finish of the race, Captain Archer reported concern at the amount of water in the 71-year-old ferry. He was instructed to return to the Quay. Water continued to come in, and all passengers were unloaded at the Quay. There were no injuries, but the old ferry then sank at the wharf.

Two days after she sank, plans had been made to lift the ferry using the large floating crane, 'Titan'. The crane was positioned; divers worked under the ferry's hull, passing slings; and then at about 3.15p.m. *Karrabee* was above the surface once more. After she was pumped out, she was towed to the Urban Transit Authority ferry base at Balmain. After some months laid up while investigations continued, *Karrabee* was given to the buyer of the equally-old *MV Kameruka* in June 1985. She was resold in September 1985 and was towed

to Brisbane Waters by the workboat, *Fergo B*, for conversion to a floating restaurant in May 1986. In 1990, the *Karrabee* was connected to shore by a flexible coupling and in use as a restaurant at Gosford under the ownership of Aldo Katalinic who was planning to restore the old ferry to her former appearance.

One other incident or series of incidents may be used to partly illustrate the degree of difficulty with which masters of large commercial harbour vessels have to work under on the harbour today. Undisciplined behaviour by private boat owners and by gangs of louts on passenger ferries combined to create total chaos from an already difficult situation, and the result was many months of enquiries and litigation although, luckily, there were only a few minor injuries.

As part of the celebrations for the Bi-Centennial, a laser light and sound demonstration had been arranged from a floating platform on the harbour. The intention was for the display to be seen mainly from shore, but some thousands of small craft attended with many anchored, regardless of legality or seamanship, across the harbour channels. This was exacerbated when the southerly wind increased causing many boats to let out much more anchor warp, further restricting the navigable channel. The situation was made even worse, as night fell, by the number of anchored small craft which displayed wrong navigation and anchor lights, making it difficult for masters of harbour ferries and cruise boats which were moving to accurately identify 'Rule of the Road' and crossing situations.

As a result, some Manly ferries found themselves unable to go forward or backward, and were blown downwind into the incorrectly-anchored mass of boats. Other cruise boats and ferries became entangled in anchor lines and could no longer use their propellers. One other ferry, unable to make its way on its normal scheduled run to Sydney was forced to call for police assistance when irate passengers, wishing to continue their journey, demanded that the master of the *Freshwater* push through the anchored throng. They started attacking the ferry crew when this was rejected as dangerous and impossible even with an escort.

Marine Services Board information officer, Mike Donnelly, explained:

> 'People on the water were officially restricted to an area north of a line between Milsons Point, the Kirribilli Dolphins and Bradleys Head but from there they could see only the fireworks and they wanted to see the whole show', he said. Hundreds of boats broke this line and anchored in the harbour opposite Farm Cove in shipping channels.[19]

Masters of several small ferries were boarded and attacked by yachtsmen whose yachts they were entangled with and at least two such sailors were thrown back over the side.

It was indeed, a memorable night for the ferries and cruise boats of Sydney; one the masters and crew involved will long remember. If in some

way it encourages the harbour authorities to exercise crowd control or to educate operators of recreational craft, it will not have been the disaster it so nearly was.

NOTES

1 Carruthers, Steven L. 1982, *Australia Under Siege*, Sydney, provides details of this attack and the demise of *HMAS Kuttabul*.
2 Register of Army Small Craft, 1945.
3 Hanna, Don, map, photographs and recollections of *Kalang*'s war service. Engineer *Kalang*, AB97.
4 Bastock, John 1975, *Australia's Ships of War*, Sydney, gives date as July 1947.
5 Rhys, Lloyd 1946, *My Ship is so Small*, Sydney, provides details of *Seeka*'s war service and that of other requisitioned small craft.
6 *Sydney Morning Herald* (*SMH*), 4 November 1927 and other periodicals of that approximate date.
7 Phillips, Valmai 1978, 'Thirty Seconds Difference', *Journal of Royal Australian Historical Society*, No.17, March, p.5; *Daily Mirror*, 18 March 1988, p.76. Mead, Tom 1988, *Manly Ferries*, Sydney, pp.65–73. A fine fictional account based on fact is given in the novel *Waterway* by Eleanor Dark, 1979, Sydney, pp.311–329.
8 *The Sun*, 2 May 1974.
9 *SMH*, 25 March 1938.
10 Torrance, William 1986, *Steamers on the River*, Brisbane, p.15.
11 *Daily Telegraph*, 8 & 9 August 1900.
12 *Ibid.*, 15 May 1913.
13 *Ibid.*, 18 May 1923.
14 *SMH*, 17 November 1936.
15 *Ibid.*, 14 March 1937.
16 *Ibid.*, 27 December 1927.
17 *Ibid.*, 28 May 1955.
18 Mead, Tom 1986, *Manly Ferries*, Sydney.
19 *SMH*, 9 November 1988.

CHAPTER 8

TOURIST AND MAJOR
CHARTER VESSELS

Carrying regular passengers or commuters around Port Jackson has long been the bread and butter of the ferry service. The cake, cream and soft drinks came from the excursion trade and the quote attributed to Numa Joubert that: 'regular passengers were only an excuse to put into the Quay: it was the tourists that make the service pay',[1] applied just as well in the 1920s, 1930s and after the war. However, it was not until the tourist boom of the 1980s that Sydney saw purpose-built vessels which were intended for tourist work and had no secondary or primary role as ferries.

Excursion trips around Port Jackson were a weekend and public holiday mainstay of the early ferries and tugs. *Sophia Jane*'s first harbour trip on 17 June 1831 was an excursion. From then on, new real estate and recreational areas provided a reason for day tripping: Watsons Bay, Parsely Bay, Nielson Park, Shark Island, Clark Island, Bennelong Point, Rodd Island, Five Dock Bay, Fairyland, Cremorne Gardens, Clifton Gardens, The Spit, Clontarf, Roseville, Killarney, Castlecrag and others — the list of picnic areas and tourist venues served by steamers and motor vessels during more than 150 years seems almost endless.

Following aquatic sports and watching harbour activities has long been popular on Port Jackson. Back in 1841, one newspaper enthused: 'The harbour presented a splendid spectacle. The steamers *Maitland, Kangaroo, Rapid* and *Sophia Jane* plied about the harbour crowded with passengers ... '.

From 1893 until 1935, the main event of the Sydney Schools Rowing Regatta on the Parramatta River was the Head of the River for eight-oared

boats. The course was from Ryde Bridge to Searles Monument and chartered ferries and small craft lined the route. In 1936, because of river congestion, the event was moved to the Nepean River where it is still run.

It is difficult to identify any steamer designed for excursion work or, perhaps, converted for that role, before *Lady Rawson*. Built as a ferry, *Lady Rawson* seems to have gradually evolved before and after World War I to allow her to become the 'Picnic Boat'.

Lady Rawson was considered to be the flagship of the Balmain New Ferry Company and often ran cruises along the Lane Cove River. When Sydney Ferries Ltd. took control of the inner harbour routes, there was a vast fleet of vessels available for a range of uses without depleting the scheduled services. In 1924, there were 57 passenger ferries in the combined Sydney Ferries Fleet Ltd. and Port Jackson and Manly Steamship Company fleets with a total gross tonnage of 8272.[2]

Sydney Ferries Ltd. combined ownership of various shore facilities such as the Clifton Gardens Hotel and its adjacent swimming pool with ferry tourist steamers. During the 1920s, the steamers *Kookooburra*, *Kirrule*, *Kubu* and *Kiandra* regularly toured the harbour with the words 'TOURIST STEAMER' displayed along their sides.

Kiandra passes through the Spit Bridge construction site in 1923. The bridge didn't improve in appearance when completed.
[State Archives No. 3960]

The forced redundancy of the Sydney Ferries Ltd's biggest and newest steamers by the opening of the Harbour Bridge gave the company the opportunity to try a new approach to ferry tours. In 1934–5, *Koompartoo* and *Kuttabul* were modified for excursion work. *Koompartoo* was given high wheelhouses and her upper deck seems to have been extended full length. *Kuttabul* was given extensions to her wheelhouse controls to allow the master to see over the crowds when following the sailing races.

The success of these two big ferries inspired a full reconstruction of the laid-up vehicular ferry *Koondooloo*. She emerged as a broad-beamed and capacious Showboat with an enclosed deck and large open spaces at either end of the old car deck. She too was a success and her sistership *Kalang* was taken in hand for a similar but extended conversion. *Kalang* was given two enclosed decks with that on the main deck being full length and that above it being fully enclosed. The boat deck provided open seating between the wheelhouses. *Koondooloo* was then given an extra enclosed deck with an open top deck.

After the war, *Kalang* was once again rebuilt with a passenger capacity of 1925 and a crew of 25 (including catering staff). She was given a dance floor of tallow-wood and on the right night with the right dance-band music, *Kalang*'s triple-expansion steam plant often synchronised with the beat of a

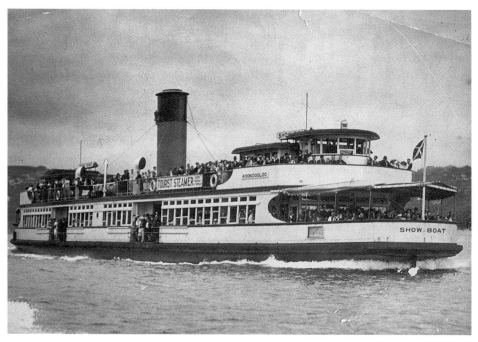

It's 1938 and World War II is looming as *Koondooloo* cruises Port Jackson. [Author]

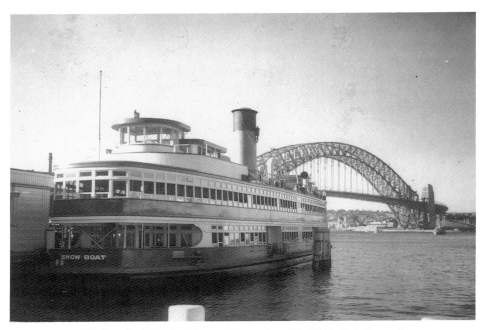

Kalang in Circular Quay, December 22, 1940. [Eric Stevens]

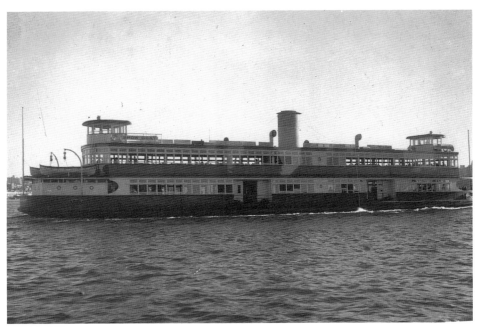

Koondooloo with added top deck. December 22, 1940. [Fred Saxon]

Kalang converting to Showboat; from left: **G. Harkness, F. Fletcher, J.McCormack, Bob Reto, Bill Brooks.** [Ossie Roderick]

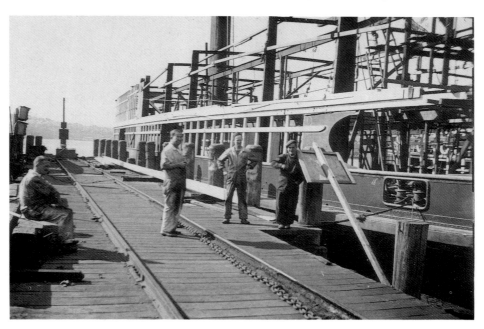

Kalang **conversion.** [Ossie Roderick]

waltz. *Kalang* ran morning and afternoon cruises on Wednesdays with passengers able to stay on board all day to see most of the harbour in the 50 mile cruise for a cost of seven shillings in 1954. Saturday and Sunday night concert cruises were five shillings, following the weekend afternoon runs.

Kalang became the first Sydney Harbour ferry steamer to be fitted with radar when she was used as a mobile display. On 9 December 1948:

> Passengers on Sydney ferries' Showboat *Kalang* saw the latest marine radar equipment operating during a cruise on the harbour. On a screen similar to that of a television set the outline of the harbour, ships and floating objects could be clearly seen. The equipment was installed by the Institute of Radar Engineers of Australia as the main feature of the annual commemoration of Radio Foundation Day.[3]

Kalang might have had radar aboard for a short while, but neither *Kalang* nor *Koondooloo* ever managed to get a full liquor licence, although this was first mooted by the Minister in Charge of the New South Wales 150th Anniversary celebrations, Mr. Dunningham MP. He thought it was a good idea in view of the large number of tourists expected for the Sesqui-Centenary celebrations.

One excellent idea to encourage tourists afloat was the Freedom of Sydney Harbour Pass. This was issued before World War II and cost five shillings; with this pass the holder was allowed to travel to Manly return, to the Zoo and return (with zoo admission included), one morning or afternoon Showboat cruise, and seven days free unlimited travel on all Sydney Ferries Ltd. ferry services. It's an idea that might well be copied in the 1990s.

Kalang's career began to lag at about the time the State Government took over the ferries. *Kalang*'s owners, Harbour Lighterage and Showboat Ltd, faced economic competition from the surfing beaches which were accessible by tram, train and bus, and from the increase in the number of cars which allowed greater flexibility of weekend recreation.

Sydney was no longer looking to its harbour for fun and *Kalang*'s owners began to regret their retention of the big ferry. In January 1958, they offered her for sale to the Government and were rebuffed. It was announced that the Showboat's owners would be forced to retire her and the Government reaction to this was that they would run cruises (presumably with 'K' class ferries) if this happened.[4]

Kalang was sold to a syndicate of Sydney businessmen, Harold Monroe and Maurice Bern, who gave her the imaginative name of *Sydney Queen*, converted her to oil-firing, and painted her white all over which did not suit her. She was back in service in 1960. The *Queen* ran dances and strip shows and tried hard to stay in business, but her time was past and her re-entry to the harbour coincided with the 1961 economic squeeze. By 1963, she was laid up again, sometimes at Long Nose Point and more often in front of the Nicholson ferry base. Her owners tried over several years to gain permission to establish her as a

floating restaurant (off Milsons Point) but were refused permission.[5] There were plans to built a 'Boatel' around her; one 'stomach-churning' suggestion was to steam her outside the three mile limit for gambling trips! *Sydney Queen*, formerly *Kalang* was eventually sold as part of a plan to work her and her one-time sisters in the Philippines. There was next to no chance of the tow making it safely to Manilla, and by 11 January 1972 all three car-ferries (*Lurgerena*, *Koondooloo* and *Koorongabba*) were sunk or wrecked with *Sydney Queen* beached off shore at Trial Bay, New South Wales.[6]

In 1960, there appears to have been only two privately-run, legal charter boats other than the range of ferries which were both Government and privately owned. The former Royal Australian Air Force crash boat, *Bataan*, and the small motor launch, *Carolyn*, eked out a precarious existence, along with a few party fishing launches, some of which were legitimate. People wishing to spend a day under sail could use a range of sailing craft under the control of Griffin's Yachts of McMahons Point. More than a dozen sailing craft, ranging from unique antiques to relatively modern 50-ft. schooners, provided the only low-cost means by which Sydneysiders without boats could get to the waterside areas and beaches of the harbour. Ownership of one's own boat really was necessary to take a detailed look at Sydney's harbour in the 1960s.

A description of the origins of Port Jackson's large charter boat industry was written in 1969 — much has changed:

> For some years some nefarious characters have evaded the very strict chartering laws and have run small numbers of people around the harbour. The visitor who did not know how to contact these casual operators had to be content with a ferry trip. For the tourist who was well heeled or who wanted to go around the harbour in more style there was the licenced M.V.Bataan and the small licenced cruiser Carolyn. The Vietnam War's American Rest and Recreation programme burst upon Sydney like a bombshell. Many boat owners, feeling that here was a quick way to get easy money, were quick to jump onto the dollar trail. Large and hopelessly unsafe yachts were given exotic names and loaded with paying hopefuls, chugged or sailed around the harbour. Others, equipped with girls who were no better than they had to be tried a new approach to an old institution until at least one small and dangerously overloaded cruiser made history by scoring front page on several newspapers [with a topless female crew scattered about].
>
> Quietly and in the background, other organisations were setting up a permanent tour programme. These groups came in two categories. Both groups had boats that were able to pass the Maritime Services Board survey. One group [worked] under a direct contract to the American authorities and the others work on a catch-as-catch-can hiring basis. Probably the best-known and the only official 'R and R line' on the harbour is the Proscenia group. Using two boats on the harbour and one game fishing boat operating out of Pittwater ...
>
> The unofficial boats are under no control as to charges and often run to produce as big a profit margin as quickly as possible. The official group with

their boats, 60 ft. cruiser Honey Hush and motor sailer Stella Maris are under strict controls. All prices are vetted by the Americans and profits are not allowed to rise over a set figure. Prices of all purchases such as foodstuffs, must be made known to the US Army and a subsidy is paid by the US Government to cut the price to the serviceman. Cruises are divided into three main types. There is the all-day cruise under sail or by the cruiser, the moonlight cruise by sail or power and a photographer's three-hour run. With the exception of the short run, all cruises include meals of a mouth-watering standard on board or on one of the small islands in the harbour. Competition for the job of hostess on these legal cruises is keen and the girls must be of high intelligence and moral character and be prepared to prove it. The Americans are more than a little annoyed over the antics of a few of the illegal boats and their girls, and while agreeing that not all of the visitors want fire-side chats, they do their best to tune this rollicking bawdy image down.

Most of the cruise outfits are not looking past the Vietnam War, but the Proscenia people (director John Hudson) intend that they will be able to show off the harbour in style to the flood of tourists that we are told will be coming in the next decade.

At present there are about eight large boats doing the 'Showboat run' around the bays and points of the harbour. Best known of them, apart from 41 ton Queensland-built Honey Hush, is the cruising cutter Stella Maris. Both of these boats are chartered by their owners to the Proscenia group. Another well known boat was the old timer Zane Grey. Named after the great old sportsman because of his alleged use of her, she was recently gutted by fire. A most impressive boat is the one-time Army Fairmile launch, Mizama. This boat operates from the Whiskey Au Go Go nightclub and can be seen on the harbour nearly every day of the week. Latest newcomer to the lists is the old time ketch Nautilus. This elderly boat, one-time Kurrewa II, runs mostly as a power boat and advertises barbecues on 'Hideaway Island'. The map of the harbour does not show this island …

The Vietnam War has been the means of opening up the beauties of Sydney's harbour to those that have a yen to see them and a trip by day or night will be a must on the agenda of many overseas visitors in future. Despite this, harbour men feel that a limit must soon be reached in the number of large boats that can run the charter system safely. Some of the boats now running will fall by the wayside, but the charter boat system on the harbour is here to stay.[7]

This article was published two months before the first voyage from Captain Cook Cruises began and appears to be the only summary published on the beginning of the modern industry. I was the author of this article and worked on the harbour in this period photographing most of the legal and illegal party boats.

Sydney's charter boat industry peaked in the period one year either side of the nation's (and Sydney's) Bi-Centennial celebrations on 26 January 1988. In this period, a considerable number of large and expensive vessels came into the port, many of them having been built to carry the crowds of people to

Fremantle for Western Australia's unhappy defence of the America's Cup. The crowds did not eventuate. There were over ten times the number of these craft that had worked in the 'Rest and Recreation' period of the 1970s, and harbour congestion, particularly when loading or unloading, was exacerbated by the few and declining numbers of accessible public wharves.

Some of these very large and opulent craft were obviously taxation deductions for large companies, yet their owners and operators did not have them surveyed as commercial vessels because they were 'not commercial'. As an inspector for the Maritime Services Board of new South Wales during this period, I was amazed and then angered by the attitudes to local regulations displayed by people who seemed to believe that being wealthy meant laws could be ignored. That no-one was seriously injured as a result of the careless and arrogant handling of these craft, some almost as big as the Sydney ferries, was a minor miracle.

During this period, Sydneysiders and visitors could travel on local and visiting square-riggers — the publicity industry gave these small sailers the title of 'tall ships'; they could steam on a wooden replica paddle steamer, dine afloat in a dozen cruising restaurants, browse on a barbecue boat, sluice on a luxury floating bar, dance to live and tinned music, or travel by ferry. Towards the end of the period, they could see theatre on a pseudo Mississippi paddler, or go Chinese on a multi-hulled Chinese temple replica that almost defied description.

Following the Bi-Centennial, the Port Jackson excursion trade fell back somewhat with itinerant cruise vessels moving on searching for trade. The business assumed a variety of market levels with the exclusive executive motor and sailing yachts catering for the very wealthy and for the upper echelons of big business, often not advertising in the public media. The next level comprised vessels operated by Captain Cook Cruises and Matilda Cruises. Both these companies invested in up-to-date and expensive large charter vessels. Captain Cook Cruises provided a scheduled range of cruises from Circular Quay. These ranged from Coffee Cruises of an hour or so duration, to fully catered cruising restaurant meals and special cruises. Captain Cook Cruise ships show the evolution of single-ended cruise ships of increasing size and capacity with the more recent showing some extreme design features, the purposes of which are obscure. Matilda Cruises, based in Darling Harbour, has a similar total passenger capacity, but mainly uses modern catamarans to provide maximum loading in minimum overall length. The company also operates a reconditioned sailing ship on day trips of varying duration. The only other charter boat fleet (other than dedicated ferries doing tourist trips) is that of Vagabond Cruises. Vagabond operates a mixed fleet of timber mono-hulls, mainly former Queensland coastal ferries displaced by the faster modern catamarans.

In 1992, a combination of a national economic downturn and the effects of a national pilot's strike have left many charter companies in either financial

trouble or under new ownership. Typical of businesses to change hands or close down in 1989–1990 was Vagabond Cruises, sold to a combination of local and Japanese interests in 1990. The Chinese restaurant and catamaran cruise vessel, *Tai Pan*, went to auction after little more than a year on the harbour.

The next tier of charter boat operators comprise those with just one vessel, often mainly crewed by the owner and his or her family. Some of these rely on a particular niche in the market — cruise boat *Eve* appears to concentrate advertising on the wedding afloat market — others offer scuba diving, parasailing, historical tours, strip shows, 'ladies' nights and, reportedly, gambling nights.

Many of the single boat or two-boat operators have to compete in a level of the market which sees football and other sporting clubs, university and other young groups, having nights or days on the harbour. Very bad behaviour is not uncommon on these trips and, in early 1990, some operators were refusing to carry live Rock and Roll bands and were demanding very large deposits against damage to crew and vessel.

Many charter boat operators belong to an organisation formed to promote their particular interests on the harbour. Perhaps this may be thought of as a 'trade union' for charter boat operators. Some idea of the size of the industry can be gained from the Sydney phone book yellow pages for 1990, in which 14 pages are devoted to charter boats.

CAPTAIN COOK CRUISES

This company commenced working on Australia Day, 26 January 1970, using a chartered, modified World War II Fairmile Launch. Cruise vessel, *Captain Cook*, (formerly *Daydream* and *Point Cloates*), was built in 1943 and chartered by Captain Trevor Howarth to run a scheduled coffee cruise on Port Jackson. This was a new idea as competitors generally sailed only when a paying load was aboard. *Captain Cook* started with several cruises a week from Circular Quay, carrying a maximum of 102 passengers and often running almost empty, but always leaving on time. This regularity allowed the company to come to terms with other tourist-oriented businesses and, by 1974, *Captain Cook* was too small for the demand. Carrington Slipways, near Newcastle, launched the purpose-built *Captain Cook II* in January 1975 with a capacity of 250 and the ability to provide meals when underway. The following year, the company bought a 14m cruiser, *Corsair*, to cater for groups of up to 40. The company expanded its role with the arrival of the Millkraft-built (Brisbane) timber *Lady Geraldine* in 1978. She could handle 150 passengers. With her arrival, the old *Captain Cook* was returned to her owners and was later wrecked in Fiji under the name, *Star Mist*.

Sims Engineering, Dunedin, New Zealand, built the next vessel in the fleet. It seems the new ship was intended to be named *Matthew Flinders*, but went

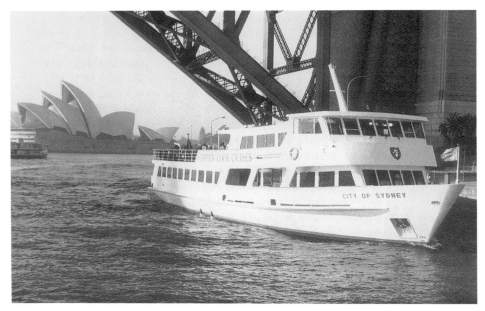

City Of Sydney was a **New Zealand-built bigger version of**
Captain Cook II. [Author]

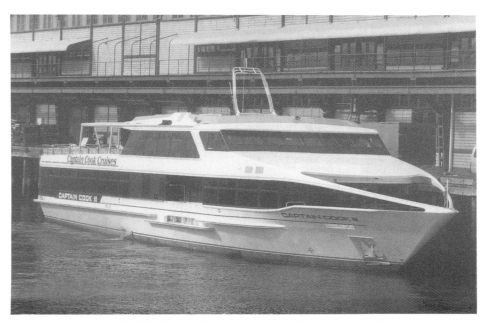

Captain Cook III shows the design trend of the company's newer
cruise ships. [Author]

into service as *City of Sydney*. She arrived in Sydney under the command of Captain Howarth and entered service on 28 November 1981.

The first passenger catamaran built for the Sydney passenger trade was Stannard's *Port Jackson Explorer*. She began work for Stannards in 1981, but within a year or so had been sold to Captain Cook Cruises and began a Sydney Harbour Explorer run, providing a somewhat exclusive ferry service.

Working the harbour from D'albora Marine for several years was the cruising restaurant *John Cadman*, built on the 1914 hull of the one-time Sydney ferry *Lady Scott*. She joined Captain Cook Cruises in 1984 and became more popular than she had ever been — the Circular Quay location and fleet bookings probably helping. In July 1988, *Corsair* was sold and was replaced by the newer *Australia Fair* which fitted in more easily with the upmarket image of some of Captain Cook Cruises' fleet. *John Cadman II* joined the fleet in 1986, following the success of the older vessel.

John Cadman III was built by Carringtons and went into service in June 1989. She has three passenger decks and can cater for a variety of separate functions simultaneously. In January 1990, the ultra-modern *Captain Cook III* arrived from Fremantle under her own power.

Captain Cook Cruises also owns and operates the small ferry company N.D. Hegarty and Son, which runs scheduled ferry services and some charter trips. Acquisition of this three-ferry group in 1988 gave Captain Cook Cruises unlimited access to both sides of Number Six Wharf, Circular Quay — a great asset in the competition for the tourist dollar. The company also operates the large passenger ship *Hawkesbury Explorer II*, working two and five-day cruises on the Hawkesbury River. *MV Lady Hawkesbury* instigated this service in 1987, but was transferred to the Great Barrier Reef area under the name *Reef Escape* in 1991.

Table 8 *Captain Cook Cruises Fleet List — 1992.*

vessel	date	gross tons	length m	pass.
John Cadman	1914/74	193	33.5	246
Captain Cook II	1975	301	33.4	250
Lady Geraldine	1978	177	24.3	170
Australia Fair	1981	67	12.75	50
Port Jackson Explorer	1981	133	19.8	200
City of Sydney	1981	340	37.0	300
John Cadman II	1986	366	38.6	450
John Cadman III	1989		38.0	450
Captain Cook III	1990	399	39.6	500
The company also operates the Hegarty ferry fleet and has used the following ships on the Hawkesbury River:				
Lady Hawkesbury	1987	1815	68.9	138
Murray Explorer	1979	1115	52.0	132
Renamed Hawkesbury Explorer II				

THE UPPER LANE COVE RIVER FERRY SERVICE

Truly, it seems that ferry services have been attempted almost 'anywhere a duck can float'. No better example of this can be found than the small ferry and cruise service along the upper Lane Cove River of more than 80 years ago. This service is included in this section because of its early concentration on tourist aspects.

A unique ferry service was pioneered by local residents. Thomas Ashcroft of Joubert St. Hunters Hill, told the Commissioners of the Sydney Harbour Trust (SHT) on 13 May 1908 of a move to open up the Lane Cove River by means of a motor launch service.

This may well have been the first use of the marine internal combustion engine in an Australian scheduled ferry service.

The formation of the company with 1000 One Pound shares was announced in June, 1908.[8] The directors were C.E. Lodowici, T. Ashcroft and J.F. Burley. Initially two launches, *Killara* and *Native Rose*, were used, with a third added later. The service ran from a wharf near the Fig Tree terminus of the Lane Cove ferries, up the Lane Cove River as far as Killara. Regular skippers were Fred Rose and Harry Ovens. About a dozen small wharves, some of them private, were built along the river. Regular wharves were at Fig Tree, launch depot, Penrose Street, Cumberland Paper Mills, North Ryde (flour mill), Strawberry Gardens, Fairyland, Fullers Bridge (Killara), Redbank and Comerford's Orchard. These small ferries gave the isolated rural dwellers the chance of weekday services to the city. On weekends and holidays, the ferries served the local picnic spots, predominantly Swans Picnic Ground, more usually known as 'Fairyland'.

The company paid its first dividend in 1912 but was already experiencing the problems of shallow water navigation. By 1913, the company was complaining to the Sydney Harbour Trust that silting was general and was causing great difficulties. The company struggled on through the War. In 1915, a Sydney Harbour Trust report noted that there were six return services a day between Fig Tree and Magdala (Ryde) near Mowbray Road. Only spasmodically did they run to Killara (bottom of Fiddens Wharf Road), depending upon the tide. The service seems to have died out in about 1918.[9]

A leaflet issued by the Upper Lane Cove River Ferry Co. in about 1910–11, described the tourist attractions thus:

> This newly-opened tourist trip — seven miles of beautiful scenery. Wild flowers, Ferns, Forrests. Fares One Shilling return, Children half price.
>
> Killara wharf — within 20 minutes walk of the … Killara Golf Home and Links.
>
> Chatswood Wharf — within 30 minutes walk from Chatswood Railway Station and Tramway.
>
> Swans Picnic Grounds 'Fairyland' — Situated in the Field of Mars and within 20 minutes walk of luxuriant vineyards, orchards and poultry farms. Produce in abundant supply at Sydney prices.[10]

Many years later, after a weir was built across the river, another tourist vessel worked the Upper Lane Cove River. Paddle boat, *Turrumburra* went into service on the river above the weir in 1976. Built by Roy and Eunice Reynolds, *Turrumburra* can carry up to 188 passengers at a sedate 4 knots along the river. She splashes her way along, passing swimmers, canoes and water birds. She is 16m long and is powered by two small diesel engines independently driving each paddle wheel. Her base is near the weir in the Lane Cove River Park.

MATILDA CRUISES

The second largest tourist fleet on Port Jackson is owned by Tim and Jillian Lloyd: Matilda Cruises. Based at Pier 26 Darling Harbour, the company has a varied fleet, comprising a large fibreglass catamaran and three steel and aluminium larger versions. A high-speed ferry, a small water taxi, and a restored 1902 square-rigger make up the fleet.

The company began work on the harbour in mid-1981 with the arrival of *Matilda*, a 19.9m fibre-glass catamaran, built by Shark Cat at Labrador, Queensland. *Matilda* could take up to 200 guests on a displacement of about 75 tonnes. Like all the Matilda fleet other than the ferry and the water taxi, *Matilda*'s crew prepare meals on board. The success of *Matilda* and the prospect of the 1988 Australian Bi-Centennial celebrations led to more

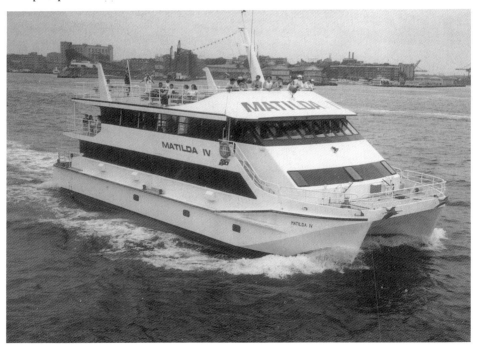

Matilda IV, shows the latest development of the company's fleet. [Author]

Matildas. *Matilda II* was built by Currumbin Engineering, Queensland, in 1986. At 24.9m, she needed a Master Class IV and a marine engineer to carry her 300 passengers around the port. *Matilda III* also came from Queensland, built by Sea Management Corporation, associated with Matilda Cruises. She arrived in 1987, and is of similar dimensions to *Matilda II* but has smoother lines. *Matilda IV* has even neater lines and was built in 1989 by Tamar Steel Boats in Tasmania.

Flagship of the company is probably topsail schooner, *Solway Lass*. This vintage vessel began life in 1902 as the Dutch-built, German sail trader, *Adolf*. She passed through French and British ownership and was sold to Danish owners in the 1930s. She was taken by the Germans in World War II and was sunk and refloated. After the war, she traded in the North Sea before heading for the Pacific where she became a run down island trader. As *Jai Nasavusavu*, she was seen by Tim Lloyd in the Ellis Islands and bought. The old ship arrived in Sydney in 1983 and 'absorbed a fortune' for hull replating, rerigging, rebuilding the interior, and meeting Uniform Shipping Laws survey standards. She was relaunched on 19 May 1985, and was New South Wales official 'tall ship' as host to the visiting square-riggers in Sydney for the Bi-Centennial party.

Smaller and faster than the Matildas is *River Rocket*. This futuristic looking fast ferry was prototype for an abortive fast ferry service along the Parramatta River. She was built by Sea Management Corporation and was launched in November 1988. Of radical hull design and propulsion, *River Rocket* can carry up to 70 passengers at around 26 knots. It was hoped that her wash would not be as damaging along the river banks as other fast ferries, but there were complaints about noise and wash and the one-boat service soon closed.

Smallest of the company's fleet is the 9.9m water taxi, *Cockle Bay*, built by Sea Management in 1989. This 50-passenger tender serves the confined Cockle Bay area of Darling Harbour and is also used to take passengers to and from *Solway Lass* when that vessel is standing off.

Matilda Cruises did not introduce the modern catamaran to Sydney, but the company has made the type its own, considering that the stability and passenger numbers for length ratio make catamarans ideal for their routes.[11]

Table 9 *Matilda Cruises Fleet List — 1992.*

vessel	year	tons	length	pass
Matilda	1981	75disp.	19.9m	200
Matilda II	1985		24.9	300
Matilda III	1987		24.9	300
Matilda IV	1989		24.9	300
River Rocket	1989		17.0	70
Solway Lass	1902/1985	105 gross	—	70
Cockle Bay	1989		9.9	50

VAGABOND CRUISES

Robert McMahon worked the converted Naval Harbour Defence Motor Launch, *Vagabond II*, on Port Stephens before bringing her to Sydney towards the end of the Rest and Recreation program for Vietnam servicemen. *Vagabond II* began life as *HDML 1129*, built by Thornycrofts of Hampton, UK in about 1942-3. She was used mainly as a survey vessel around Papua New Guinea after transfer from the Royal Navy.

Vagabond II worked with Vagabond Cruises until the company went into receivership in 1990. When the company was reconstituted as Keelpact Pty. Ltd, trading as Vagabond Cruises in July 1990, and taking over the assets of Restana Pty. Ltd, *Vagabond II* was soon sold when Keelpact completed conversion of former Queensland charter boat *Minerva* into *Vagabond Star* begun by Restana.

The largest ship in the Vagabond fleet is the triple-decked *Vagabond Majestic*, formerly *Whitsunday Wanderer*. The oldest vessel in the fleet is *Mulgi*, formerly Nicholson's *Prolong* and one of the harbour's classic ferries. Corporate-style charter vessel, *Bennelong*, was built in Brisbane in 1973 to replace the pioneer charter boat *Honey Hush*. Newest vessels on the list are *Vagabond Princess*, formerly *Marena* and *Vagabond Star*, formerly *Minerva*. These ferries were bought from the Cairns-based Great Adventure Holidays

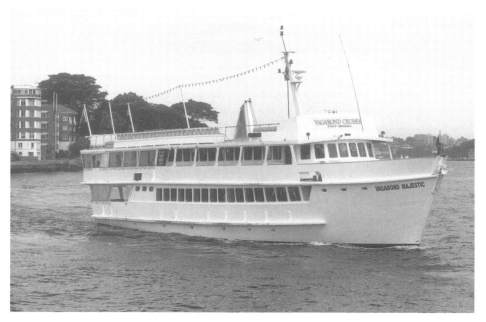

Displaced from the Queensland cruise scene by the fast catamarans, *Whitsunday Wanderer* became *Vagabond Majestic* on Port Jackson.
[Author]

**Vagabond II was the first vessel of the Vagabond Cruises' fleet.
A converted naval vessel, she was sold in 1990.** [Bob McMahon]

early in 1989 after they were replaced by high-speed catamarans. *Marena* was converted in 1989 and was in service by October that year. *Minerva* entered company use in September 1990.

Vagabond Cruises works mainly from the East Circular Quay pontoon, offering three daily scheduled cruises, and picking up charters wherever there is satisfactory wharfage.[12]

Table 10 Vagabond Cruises Fleet List

vessel	built	tons gross	length	passengers.etc
Vagabond II	1942/3	—	22.2m	80
Mulgi	1926	68	74ft	200
ex Prolong				
Vagabond Princess	1958	91*	27m	200
ex Marena				
Vagabond Star	1967	96*	28.9m	200
ex Minerva				
Bennelong	1973	124	80ft	120
Vagabond Majestic	1975	136	106ft	300
ex Whitsunday Wanderer				

** Tonnage gross when in Queensland registry — now greater as enclosed space increased.*

SYDNEY SHOWBOAT

The first passenger stern-wheel paddler to work on Port Jackson is *Sydney Showboat*. Designed on pseudo-Mississippi River paddle-steamer lines by Shiptech of North Sydney for Blue Line Cruises, she was built in Singapore and shipped to Sydney aboard *MV Project Europa*, arriving on 12 December 1987.

Sydney Showboat is a true stern-wheeler, using diesel engines and hydraulic drive to turn the big wheel. As stern-wheelers have little ability to manoeuvre, she is fitted with a directional bow thruster. She has two enclosed decks and considerable open space and offers dining, cabaret shows and floor shows of various types.

Also operated by Blue Line is the twin screw, *Southern Cross*, formerly *Pittwater Princess*. In 1991 this cruising restaurant was being marketed as an Indian restaurant.

Table 11 *Blue Lines Fleet List — 1992*

vessel	year	tons	length m	pass
Sydney Showboat	1987	735 gross	41.45	425
Southern Cross	1981	74 *	19.9	150

** Under deck tonnage — a surveyor's measurement.*

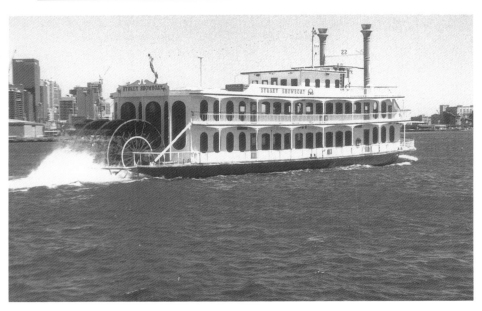

Somewhat jarring in appearance on Sydney Harbour, the 'fake' Mississippi paddler *Sydney Showboat* is a genuine motor paddler with a bow thruster. [Author]

NON-SCHEDULED AND SMALLER COMPANIES

First Fleet Cruises

Robert McMahon, founder of Vagabond Cruises, began a new tourist-passenger service from Manly to Darling Harbour on 17 December 1900. Calls were made both ways at Watsons Bay with an intention to add stops at Balmoral. Traffic was insufficient and the service ceased early in March 1991, apparently then becoming a water taxi service for a short time.

First Fleet Cruises should not be confused with the First Fleet Class of catamaran ferries run by the State Transit Authority. The company used the chartered Queensland catamaran ferry, *Spirit of Redlands*, under the name *Spirit of Manly*. The *Spirit of Redlands* was built by Proctors in Bundaberg for the Burnett Heads-Lady Musgrave Island run, but was bought and used by Golden Mile Ferries of Brisbane. Twin Perkins diesels gave a top speed of 16 knots and a service speed of 12.[13]

The 92-passenger *Spirit of Manly* was built in 1986; is 18 tons disp. and is 15.8m in length.

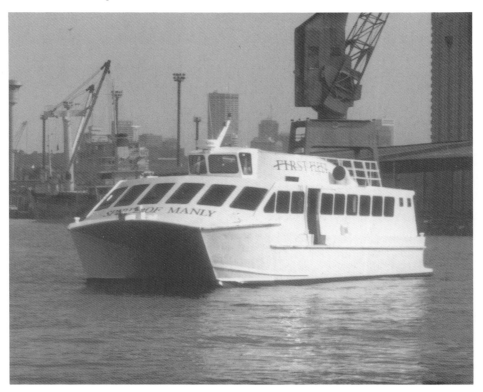

The small, ex Queensland catamaran *Spirit Of Manly* offered Manly to Darling Harbour ferry cruises for a few months late in 1990. [Author]

Three former Tasmanian Ferries

National introduction of the Uniform Shipping Laws code allowed easier and increased transference of commercial craft between States. While each State has its own variations on the Urban Shipping Laws code, interstate movement of working craft is now common.

Three former Tasmanian ferries now work as cruise boats on Sydney's Harbour: *O'Hara Booth*, *Martin Cash* and *James McCabe*. Oddly enough, the one time Port Hacking Sydney ferry *Bundeena*, now works the Tasmanian route instituted by the *O'Hara Booth*.

O'Hara Booth was the first of the trio to arrive in Sydney. She was built in 1974 for Peacock's Carnarvon Cruises and has three passenger decks, a bar and a galley. Her run was from Port Arthur to the Isle of the Dead. She ceased work on 10 April 1985 and was then sold to Greg Smith of Sydney, arriving in May 1985. *O'Hara Booth* had her moment of glory when, with *James McCabe*, car ferry *Mangana*, and antique river ferry *Cartela*, she was needed to maintain contact across the Derwent River when Hobart's bridge collapsed.

O'Hara Booth is one of the most attractive charter vessels in the Sydney area, looking more like a small ship than most.

The 80-passenger *O'Hara Booth* was built in 1974, is 80 tons gross and is 20.4m in length.

Next of the Tasmanian trio to join Sydney's charter fleet was *Martin Cash*. Named after a Tasmanian bushranger, she was built by Bob Clifford's Sullivans Cove Ferry Company to help cope with the split city — Hobart. When the bridge was rebuilt, *Martin Cash* moved on and, before coming to Sydney, worked for many years on the Queensland Low Isles tourist run. She was replaced by a fast catamaran ferry, ironically also a developmental by-product of the bridge collapse. Slow displacement-type ferries need short distance runs to remain viable as ferry or cruise boats, and *Martin Cash* was brought to Sydney by Alan and Barry Riley in September 1987. She retains the distinctive red and white colours of her Hobart days.[14]

The 122-passenger *Martin Cash* was built in 1975, is 94 tons gross and is 21.6m in length.

It was a happy coincidence that *O'Hara Booth* and *James McCabe* were built only a year or so before the Hobart Bridge disaster. Without them, life would have been even more unpleasant for the local people.

James McCabe was the only modern ferry in Hobart's harbour when the bridge fell. People and Government were grateful, but only until the bridge was repaired. Then the ferries moved on, as did *James McCabe*. She worked on the Triabunna run and then tried her hand on Victoria's Westernport Bay without success.

Graham and Christine Littlewood brought her to Sydney in July 1988 and she has since worked as a charter and cruise ferry.[15]

The 100-passenger *James McCabe* was built in 1973, is 43 tons gross and is 19.5m in length.

FERRIES CONVERTED TO CHARTER BOATS

Many Sydney ferries have been converted for tourist work, together with some from other waterways. The better-known are listed here:

Monohulls

Walsh Bay, formerly *Raluana*. Operated by Vic Souter's Pier Charter Services, *Walsh Bay* provides 'Heritage' cruises for special interest groups in addition to conventional tourist work. She was bought from Don McKay in 1981.

The 110-passenger *Walsh Bay* was built in 1969, is 69 tons gross and is 18m in length.

Katika, another former Don McKay ferry, is run by Katika Cruises as a general duty charter ferry.

The 200-passenger *Katika* was built in 1981, is 74 tons (under deck) and is 19.5m in length.

Escapade, formerly *Binburra* of Don McKay, was sold to Jim Dempsey of Avalon in December 1985.

The 100-passenger *Escapade* was built in 1978, is 69 tons gross and is 16.4m in length.

Hawkesbury Star, formerly *Melissa* and *Hawkesbury*, a twin screw ferry, she spent many years on the Hawkesbury River and appeared to be under refit early in 1991.

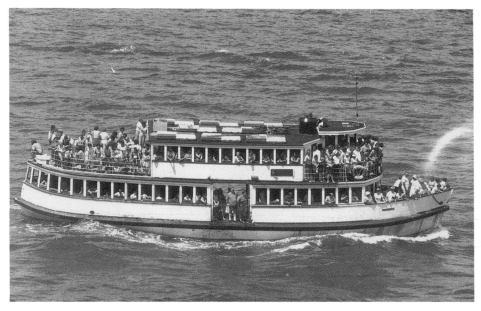

In 1992 *Proclaim* was the oldest ferry running to a schedule on Port Jackson and the last Nicholson ferry working under her original name.
[Author]

The 152-passenger *Hawkesbury Star* was built in 1945, is 34 tons gross and is 17.3m in length.

Annabelle, formerly *Ellen Anne*, *Arthur G. Walter* and *Maheno*. Built by Holmes in Sydney, this old-timer spent most of her working life on the Newcastle-Stockton ferry run. When this service closed in 1976, she went to Peter Verril as *Ellen Anne* (*Verril*). In 1983, she was sold to Amaroo Cruises as *Annabelle*. John Fitzpatrick owned her next, and then the present (1991)owner, David Jeffries bought her in December 1989. Although in survey for up to 108 passengers, she is restricted to about 60 to allow charter parties more room to socialise.

The 60-passenger *Annabelle* was built in 1935, is 25 tons gross and is 13.87m in length.

West Head, one of the few small ferries built for other than smooth waters, *West Head* has had a long and varied career. She was chartered to the (then) Urban Transit Authority for service in Newcastle, pending completion of the new Hunter class catamarans. After several owners, she was for sale once more in 1991.

The 140-passenger *West Head* was built in 1947, is 73 tons gross and is 16.8m in length.

Proclaim, once pride of the Nicholson fleet, is now owned by Ross and Neva Williams' Ablay Pty. Ltd, trading as Cobb Marine. *Proclaim* is now thought to be the oldest ferry still working passenger routes on the harbour. She has been carefully restored after some years of general neglect and works both as a ferry and cruise boat.

The 300-passenger *Proclaim* was built in 1939, is 72 tons gross and is 20.2m in length.

Sunrise Star is one of the oldest passenger vessels working Port Jackson. She was built in 1926 by W.O. Ryan on the Manning River as a milk boat *Sunrise*. She was used to collect milk churns along the river for the Manning River Co-op Dairy Society until about 1938. She arrived in Sydney on 23 August 1940 for Hegarty's ferries. Subsequently *Sunrise* (*Star*) worked for that company in Sydney and on Westernport Bay, Victoria, before returning to Sydney. She took the name 'Lady Bay' when used as a film set in mid 1986.

In 1991, *Sunrise Star* was owned by Jennifer and Peter Magnuson and was in regular charter use.

The 190-passenger *Sunrise Star* was built in 1926, is 47 tons gross and is 21.4m in length.

There are several other converted displacement hull ferries available. Among them are Lloyd Cruises, formerly Keppel Island, Queensland, ferry *Fiesta* (1973, 173 tons gross, 20m in length), *Caprice*, built in 1980 for R. Morton (89 tons gross, 16.76m in length) and *Lithgow*, formerly *Kin-Gro*, a typical and original 1930s small ferry, used by Stannards Launch Services. *Kin-Gro* was built for the Kincumber Growers in 1927 and since World War II has been owned by Stannards (20 tons gross, 13.4m in length).

Two other displacement hulls of unusual background are *Burragi*, formerly *Isis*, and *Eve*. *Burragi* was built for the Sydney Harbour Trust in about 1916 as a steam-powered tug and water boat. In 1957, she was converted to diesel power and rebuilt as a ferry and water boat. *Burragi* was sold in controversial circumstances in July 1987 for conversion to a cruising restaurant. In 1988, she was bought by Paul Maule who has worked her since that time.

The 120-passenger *Burragi* of 1914 is 22m long and was converted to a ferry in 1957.

Eve was built as an unpowered explosives barge in about 1925. The very heavily-built barge was converted to a function boat, specialising in weddings in 1975 by G.S. Chapman. In 1992, she was still working mainly in this field although facing competition from larger, more modern vessels.

The 130-passenger *Eve* was built in about 1925, is 150 tons gross and is 23m in length.

Catamarans

Richmond Riverboat. Several catamarans, other than those already mentioned, were at work in Sydney in 1991. The largest non-fleet catamaran was the *Richmond Riverboat*. This unique-looking function boat was built for use on the New South Wales Richmond River. She was brought to Sydney in November 1986. Along with the now-departed *Tai Pan* and the *Sydney Showboat*, she has been criticised for her appearance.

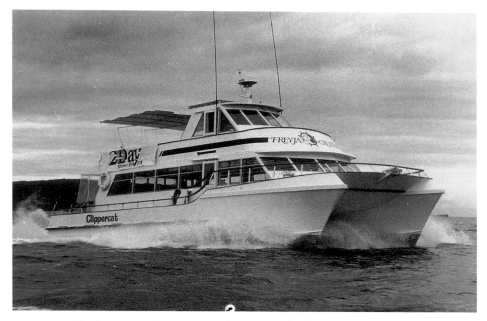

Medium-speed catamaran *Freyja* was the first fast cat working Port Jackson. [Author]

The 150-passenger *Richmond Riverboat* was built in 1986, is 237 gross construction tons and is 20m in length.

Philanderer II was built for the cross Backstairs Passage run to South Australia's Kangaroo Island. She was replaced by a larger version which could carry cars, and came to Sydney in 1987.

The 105-passenger *Philanderer II* was built in 1982, is 151 tons gross and is 20m in length.

Freyja was intended to be named 'Clipper Cat' while being built at Barrenjoey Marine, Oxford Falls, Sydney. She was launched by yachtsman, Sir James Hardy, on 16 June 1982 for R.B. Pile. Her relatively high speed of 18 knots allows rapid positioning of this upmarket cruiser when on corporate charters.

The 100-passenger *Freyja* was built in 1982, is 32 tons under deck tonnage and is 16m in length.

Major Sailing Vessels

Solway Lass is the largest sailing vessel based on Port Jackson, although two large catamarans have much more deck space. The replica 1700s ship, *Bounty II* (1979, 400 t displacement) works the harbour in between overseas voyages. Her owners are Bounty Voyages Pty. Ltd.

Catamarans *Aussie One* and the smaller *Tafua* are the largest modern commercial sailing vessels based on the harbour. *Tafua* can take up to 80 guests and *Aussie One* about 250. The owner is Sail Venture Cruises.

There are, perhaps, another 25–30 legal commercial sailing vessels in the 30–50 passenger class. Some of these are rarely in use and this group is omitted because of space limitations.

NOTES

1 Brodsky, Isadore 1957, *Sydney Looks Back*, Sydney, p.219.
2 Sydney Harbour Trust 1924, *Port of Sydney*, Sydney.
3 *Sydney Morning Herald* (*SMH*), 10 December 1948.
4 *SMH*, 7, 22, 23 January 1958.
5 Millar, J.C., manager, Harbour Restaurants Pty. Ltd.
6 Andrews, G., 'End of a Long Voyage', *SMH*, 22 January 1972.
7 Andrews, G., 'The Yankee $$', *Power Boat and Yachting Magazine*, September, 1969.
8 *Daily Telegraph*, 18 June 1908.
9 Russell, Eric 1970, *Lane Cove*, Sydney, pp.135–40.
10 *UPPER LANE COVE FERRY CO.*, leaflet.
11 Lloyd, Tim, letter to author, March 1991.
12 Stirzaker, Andrew, letter to author, March 1991.
13 McMahon, Robert, details, January 1991.
14 Riley, Barry, details, January1991.
15 Littlewood, Christine, details, January 1991.

CHAPTER 9

OUTER METROPOLITAN AREA
FERRIES AND CRUISE CRAFT

Small, local area ferry services have long been a feature of the waterways on the outskirts of Sydney. Ferry services were particularly well-developed on Brisbane Water to the north of Sydney. Other services crossed from one side of Botany Bay at La Perouse to the other side at Kurnell, from Cronulla to Bundeena and along the Hacking River. They also went to the various islands and small communities of the Hawkesbury River system.

Because of the range and variety of craft plying for hire and reward, it is difficult to list every vessel available. Many are offered on a temporary and casual basis, so I have included only those of basic ferry configuration which are available on a schedule or on a regular basis. Party fishing boats, motor cruisers, sailing yachts and casual vessels available only for charter, have been omitted.

BRISBANE WATER

The Brisbane Water area to the south of Gosford was long home for a range of small commuter ferries, the last of which, *Lady Empire* (1905–1971, 51 pass.), ceased trading on 30 June 1970. *Lady Empire* and the larger *Southern Cross* (1924–1971, 114 pass.) were owned by Stan Smith and provided a civilised waterway connection from Kincumber to Woy Woy for many years until the assault of the motor bus became too much. Smith's ferry service was representative of many of the small services that developed from around the turn of the century.

Before land developers 'invented' Brisbane Water, near Gosford, small ferries like *Lady Empire* carried stores, passengers, schoolkids and mail around the area. [Len Rodney]

The first ferry service in this area was a pulling boat run by the Catholic Orphanage at Kincumber to Woy Woy for passengers and mail from the train. The orphanage itself later owned a motor launch as a ferry and was joined by other operators, including Eric Wilson, Lewis and Fisher, the Murphies, and the Amalgamated Growers, whose ferry carried their fruit, stores and passengers. Frank Smith ran a ferry service between Woy Woy and Saratoga which closed in 1958.

The neat little *Christina* (formerly *Brighton*, 1917–1968, 30 pass.), owned by Mr. Arthur Anthony, ran on enclosed Woy Woy Bay, picking up commuters from waterfront homes for the train station. She was earlier owned by Frank Smith and served Berowra Waters from 1958 to 1963 before moving to Woy Woy where she ran until burned in the Spring of 1968.

A new Brisbane Water ferry service, combining a cruise and scheduled passenger trade, began in September 1985. Alan Draper bought the former Gippsland Lakes cruise boat, *Lennabird* (formerly trading ketch *Lenna*, 1906) and renamed her *Lady Kendall* (130 pass.). *Lady Kendall* runs shopping trips and regular cruises around Brisbane Water.

Early in 1992, two redundant passenger launches from Sydney's Cockatoo Island Dockyard were bought by Glen Davis and partner, Dave Hadson, trading as Brisbane Water Ferries. The launches, *Banksia* and *Corella*, carrying up to 50 passengers, recreated the mid-1900s ferry trade around Woy Woy and Davistown. I worked as a relief master for this company.

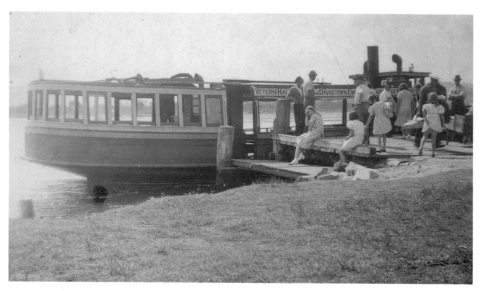

In May 1939 Brisbane Water's ferry *Kin-Gro* loads at Empire Bay Wharf. Compare her later appearance as *Lithgow*.
[Graeme Andrews Collection]

PITTWATER

For several years in the early 1970s, the small Pittwater enclave of Scotland Island and surrounding shoreline homes was served by two ferry services. The Church Point Ferry service, then owned by Chris Cowper and Laurie Duff, ran *Curlew, Elvina* and *Wagstaff* around the circuit. Competing with them was the Pittwater Ferry Company with the *Grower* (1922, 38 pass., a former Brisbane Water ferry) and the former Nicholson ferry, *Promote* (formerly *Nambucca*, 1915, 120 pass.) more recently called *Macquarie Princess* on Berowra Waters.

The Church Point ferry service in 1990 was run by Bill Edwards who in 1983 bought the run and the ferries from Graham Hart, who had earlier bought the service from Laurie Duff. In 1990, Church Point Ferries used the small *Elvina* (1934, 30 pass.), *Curlew* (formerly *Gloria*, 1922, 60 pass.) and *Church Point* (formerly *Tropicana* and *Golden Petrel*, 1944, 48 pass.).

Don McKay began work with the old well-decker *Swanhilda* (formerly *Ena*). *Swanhilda* started in 1910 as an explosives barge tug and had many duties including ferry work for Goddards and Windebanks before World War II. Don McKay took over the Basin and Mackeral Beach Ferry Company in 1964 and built it up into a viable service. The run was started by Goddards in the 1930s, passed to a Mr. Emery, and later to the Port Jackson and Manly Steamship Co. It was then sold to a Mr. Buel who passed it on to Don McKay. McKay's fleet later included at various times the seaworthy *Merinda* (formerly *James Matra*) which was built for the La Perouse-Kurnell service on Botany

Church Point ferry *Curlew* is slipped for a clean-up and for repairs to her stern. [Graeme Andrews Collection]

Bay, and larger ferries *Raluana* (later *Walsh Bay*), *Mirigini* (later sold to Verrils), *Binburra* (later *Escapade*), and *Katika*. When Don McKay retired, all of his fleet, except for *Mirigini*, left Pittwater and the ferry run was then catered for by Peter Verrill.

BASIN AND MACKERAL BEACH FERRIES

Trading under the names 'Basin and Mackeral Beach Ferries' and 'Palm Beach Ferry Services' is the modern small fleet run by Peter Verrill.

The Palm Beach Ferry service was originally owned and run by the Port Jackson and Manly Steamship Company as part of that body's efforts to diversify its operations. The two main ferries were the seaworthy, purpose-built *West Head* (1947, 158 pass.) and the older well-decker *Barrenjoey* (formerly *Regent Bird* and *Kilcare Star* 1920–1974, 85 pass.) *Seeka* was also used by the company for many years, particularly on the Juno Head National Park run. (See Hawkesbury River Ferries.) *West Head* was unusual in that she was designed to handle the sometimes unsettled conditions off West Head at the mouth of Pittwater. She is one of three small ferries I know of to be built to carry passengers in partially smooth conditions (the others are *Currunulla* and *Bundeena*).

Late in 1990, Verrills' fleet comprised *Mirigini* (1973, 180 pass.), *Myra* (1985, 126 pass.), *Merinda II* (1983, 112 pass.) and *Mia* (formerly *Golden Gull*, 1965, 80 pass.).

Verrill's *Merinda II* takes a load of day-trippers across the Hawkesbury River. [Author]

PITTWATER BOAT CRUISES

The only cruising restaurant based on Pittwater in 1990 was the *Stockton* (formerly Newcastle ferry *Stockton* 1939). *Stockton* was bought by Gordon Davey in 1976 as a unit of Newcastle ferries. She was seriously damaged hitting a wharf on 10 March 1977 and was laid up. She was sold to David Letts and B. Gray as Boatshed Cruises and was rebuilt as a cruising restaurant. Her master was Ted Steck. Graham Hart was involved in the company until it was sold to Ross Stiffe in November 1988.

Stockton carried out a regular program of tourist cruise-lunches, coffee cruises and jazz nights, and was available for general charter. However, she suffered a major setback when, after taking water, she sank in shallow water in Pittwater on 27 April 1991. According to a television news report, a party of American tourists climbed out of the windows 'without their lunch' but no-one was hurt.

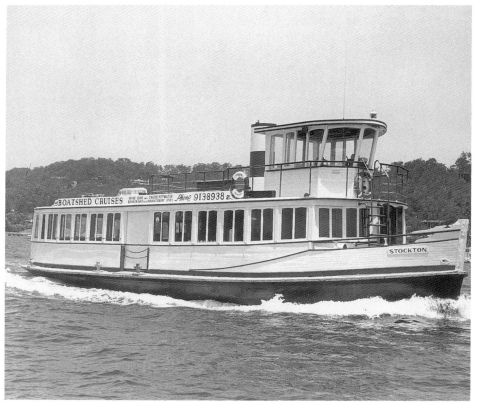

Pittwater cruising restaurant *Stockton* sank in shallow water on 27 April 1991 and was then offered for sale.
[Graeme Andrews Collection]

HAWKESBURY AND NEPEAN RIVERS

Hawkesbury River Tourist Service

Working from Brooklyn is the ferry and tourist run of Hawkesbury River Ferries. The largest ferry operated is the 1981-built *Hawkesbury* (2) (225 pass.) supported by the *Hawkesbury Explorer* (formerly *Birkenhead* and *J.H. Walter*). Owners Gordon and Sue Davey have bought and sold many ferries in the 17 years since the company began trading. Among well-known ferries to have worked for them are *Hawkesbury* (1) (1945), later *Melissa* and *Hawkesbury Star*, *Juno Head* (formerly *Protend*, *Messenger II* and *Unit 1* (1932)), *Challenger Head* (formerly *Nowra* and *Regent Star* (1947, 158 pass.), later *Kangaroo* in Hobart, 1981), *Ku-ring-gai II* (formerly *Provide* and *Wangi Wangi* (1924–1980, 266 pass.)) and *Seeka Star*.

The largest vessel to be operated by the company is the 1981-built, *Hawkesbury* which is set up for use as a function boat and a ferry.

The Daveys bought Palm Beach and Bobbin Head Ferries from the Port Jackson and Manly Steamship Co. on 28 November 1974. The older company also used the name Hawkesbury River Ferries. This name was used by the new owners as their services were based at Brooklyn. Well-deck ferry *Barrenjoey* was quickly sold but *West Head* and *Hawkesbury* (1) were used for many years. In 1982, *West Head* was exchanged for the Hegarty ferries,

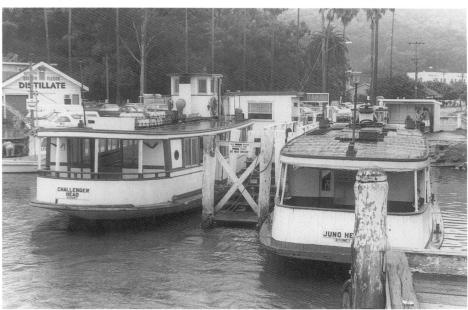

Two of Gordon Davey's early ferries lie at Brooklyn. *Challenger Head*, ex *Nowra*, was *Emma Lisa* of Hobart in 1991. *Juno Head* was *Cockatoo* in Sydney. [Author]

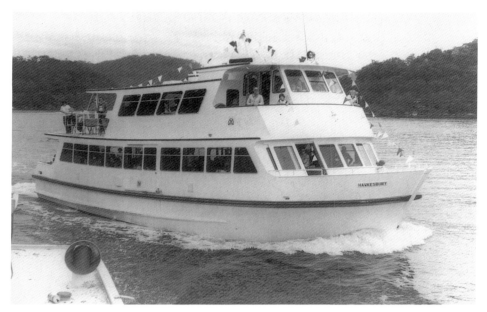

Hawkesbury (2), joins the Davey fleet in December 1981. [Author]

Sunrise Star (1926, 190 pass.) and *Seeka Star* (1940, 92 pass.) For *Seeka* it was a return to the river that she had worked for many years.

Best known of the Davey services is the famous *Riverboat Postman* which carries mail and parcels upstream along the Hawkesbury River to isolated riverside houses and hamlets. The run has been marketed as a tourist trip for a number of years with some success. The company also services Dangar Island, offshore from the railway terminal of Brooklyn, the National Fitness camps on the northern banks of the river, and sundry adjacent hamlets. Ferry services are run as far afield as Patonga and Palm Beach, with spasmodic cruises to Brisbane Water.

In 1981, Gordon and Sue Davey began a ferry service from Circular Quay to the Birkenhead Shopping Centre, using *Birkenhead* (formerly *John H. Walter*, 1966, 187 pass.). After several years, she was replaced on the run with *Birkenhead Explorer* (formerly *Newcastle-On-Hunter*, 1946, 164 pass.). Insufficient custom and lack of a subsidy from the shopping complex caused the service to be abandoned in March 1988. *Birkenhead* had already been converted to a cruise ferry under the name *Hawkesbury Explorer*. *Birkenhead Explorer* was sold to Laurie Duff for use on the Clarence River.

In 1987, with the Bi-Centennial celebrations approaching, the company added charter boat *Barbie A* (1982, 100 pass.) to the fleet as the *Hawkesbury Wanderer*. She was sold in 1989 (as *Australis*) as was *Seeka Star*, back to Hegartys (Captain Cook Cruises).

Dangar Island Ferry Services *(previously Terry's Ferries)*

Like many private ferry companies, Hawkesbury River Ferries has competition in its area. Terry's Ferry, long operated by Terry Hodgson, began in opposition in about 1980, using the small, 10.7m well-deck launch, *Protex* (formerly *Waikare*, 1909, 34 pass.), now preserved by the Sydney Maritime Museum. Price cutting and other forms of competition began with residents supporting one company or the other. As so often happens with communities served by and dependant upon ferries, complaints were made, both about the quality and frequency of the service, and about the cost of it. The two problems are mutually combative.

In 1990, both companies were still serving the area, with the now Dangar Island Ferry Service, then owned by Garth Cameron, using *MV Sun* (formerly *Sunshine II*, 1950, 62 pass.), a roomy and handy small former milkboat from the Manning River of New South Wales and the Daveys' service, using *Hawkesbury* and *Hawkesbury Explorer*.

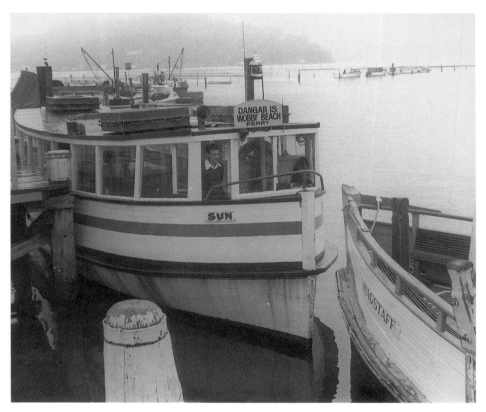

Terry's little ferry *Sun* loads for Dangar Island while the elderly *Wagstaff* waits for her tourist group. [Author]

Captain Cook Cruises

The passenger liner, *Lady Hawkesbury*, was the largest vessel ever to work the Hawkesbury River system. A beamy, shallow-draught craft, she had to handle river currents, low bridges and river shallows; aspects which caused her unusual 'boxy' shape.

Lady Hawkesbury was built by Carrington's shipyard at Tomago and was launched in January 1987. She carried up to 138 passengers with a crew of 29 on two, three and five-day cruises around the Hawkesbury River. She was replaced in 1991 by the former *Murray Explorer*, which for sometime was known as the *Brisbane Explorer* and is now known as *Hawkesbury Explorer II* (not to be confused with the longer-established and smaller *Hawkesbury Explorer*). The vessel offers cruises between Pittwater, where she anchors while passengers watch the many sailing craft, to the wharf at up-river Windsor, more than 60 nautical miles from the sea. *Lady Hawkesbury*'s first master was Ralph Langham, and her second was Hamish Patenall. *Hawkesbury Explorer II*'s master from commencement of duty on the river was Ms Manon Wathier, a former Canadian Coastguard. The 132-passenger, *Hawkesbury Explorer II*, is based at Kangaroo Point, near Brooklyn. Passengers are brought to her by bus or train or have security parking provided.

The largest vessel ever to work the Hawkesbury River was *Lady Hawkesbury*, seen here leaving the up-river town of Windsor for the down-river run. [Author]

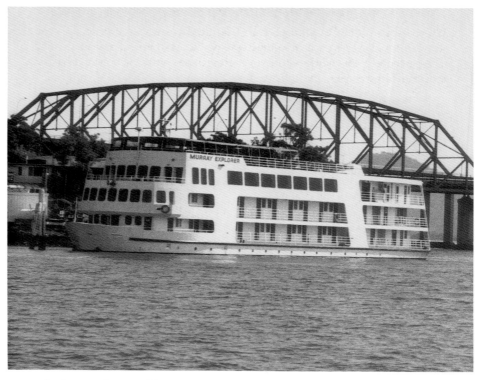

A river cruiser seeking a new home — *Murray Explorer* moved from the
Murray River to Southport's Broadwater as *Brisbane Explorer* and
thence to the Hawkesbury River to replace *Lady Hawkesbury*. [Author]

WINDSOR RIVER CRUISES

Windsor River Cruises was started by Ian Clayton in 1984, using the small,
one-time Noosa River ferry, *Miss Tewantin* (1950). This lovely little shallow-
draught launch soon became too small and was sold to a Mr. Dick in Port
Macquarie in 1985. She was renamed *Pelican*.

Replacing *Miss Teewantin* was the *Deerubbun* (formerly *Snowy*, *Wandella*
and *TRV3*, about 1944, 94 pass.). This vessel had worked on Lake Eucumbene
in the Snowy Mountains.

Windsor River Cruises runs on Wednesdays, Sundays and Public Holidays
over a set route on the upper reaches of the Hawkesbury River from Windsor
to Port Erringhi. Once a month, a full river length cruise is undertaken each
way, taking about six hours overall. Night cruises and special charters to local
wineries are also on offer.

The company is considering a shallow-draught, medium-speed multi-hull
for the early 1990s.

BEROWRA WATERS

Owned and operated by Gordon and Joan Mandin, the classic small harbour ferry, *Macquarie Princess* is based at Berowra Waters Marina. Rated in 1990 at 120-passengers, she works exclusively as a charter boat offering a range of scheduled cruises from one hour to all day.

NEPEAN RIVER
(UPPER REACHES OF THE HAWKESBURY RIVER)

An unorthodox but genuine paddle vessel is the *Nepean Belle* (1982, 150 pass.). A Yanmar diesel on each paddle shaft gives *Nepean Belle* remarkable manoeuvrability on the narrow and winding Nepean River at Penrith, downstream from Warragamba Dam.

The two-deck catamaran's owner is John Wakeling's Depagi Pty. Ltd, trading as *Nepean Belle*. The vessel runs scheduled coffee and dinner cruises on the lower Nepean and longer day cruises into the lower waters of the Blue Mountains National Park.

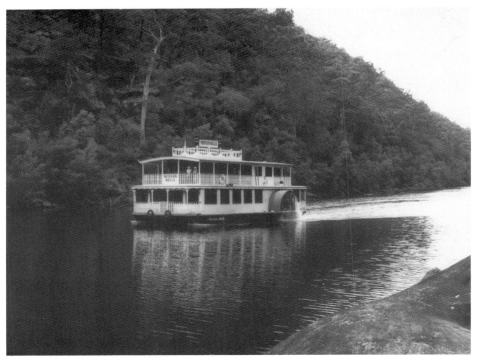

A most unusual paddle-boat: *Nepean Belle* is a catamaran with one engine for each paddle. She works the headwaters of the Nepean/Hawkesbury River. [Author]

GEORGES RIVER, BOTANY BAY, PORT HACKING

Georges River Ferry Co.

Mr. G. Hamming started the Georges River Ferry Company in 1979, using the former Brisbane River ferry, *Mirabel* (1937, 110 pass.). *Mingela* provided a program of day and evening cruises along the Georges River and on Botany Bay.

Laurie Hardie bought the company on 13 February 1981 and has continued the program. *Mingela* is unusual in that, because of limited deck space, she has a platform built over the stern. This is used for the band and a company joke is that the area has a trapdoor for bands considered to be inadequate.

A second classic Brisbane ferry (formerly Hayles Cruises' *Mingela* (1951)) was bought in November 1990. In early 1991, she was undergoing conversion to New South Wales survey standards.

Botany Bay Cruises

One of the more interesting small ferries in the Sydney area is *Lady Eucumbene*. She started life in 1946 as the *C.A.M. Fisher* on a ferry service from La Perouse to Kurnell across the heads at Botany Bay. It was a run that required a seaworthy ferry, and *C.A.M. Fisher* was built as a well-decker with canoe stern to the order of M.V. and J. Fisher.

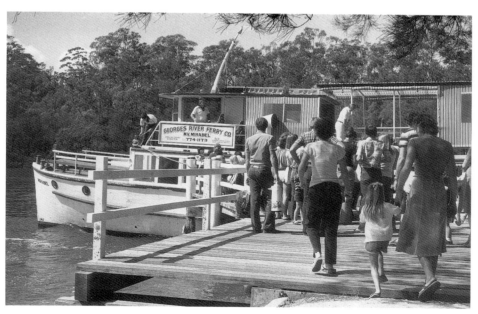

The traditional-style Queensland ferry *Mirabel* takes on day-trippers for a Georges River cruise. [Author]

C.A.M. Fisher was sold to the Snowy Mountains Authority for use on Lake Eucumbene in about 1958 and, after about ten years, was sold to Paddy Kerrigan for use as a commercial cruiseboat on that lake.

Lady Eucumbene returned to Botany Bay in 1979 under the ownership of Don Finn and Bob Williams. She was refurbished as a luxury cruise-boat, but suffered a setback when she hit the Taren Point Bridge and sank nearby in shallow water on 25 October 1980. She participated in several ferry boat races on Botany Bay, and was sold to W. 'Bill' Boffinger on 19 January 1986. Re-engined with a 70hp Gardiner, she has continued running a charter and cruising program.

Georges River and Botany Bay Cruise Information Centre
(incorporating Riverboat Cruises, Bass and Flinders Cruising Restaurant and the information centre)

This charter boat and cruise business began in 1979 with the purchase of the old 16m ferry *Protector*. The former Rosmans 19m ferry *Regalia* was bought in 1980, and the 20m cruising catamaran *Bass and Flinders* was purpose-built in 1985.

Scheduled and charter cruises for up to 200 passengers can be arranged and the owners, Jan and Ian Ford, have developed a central booking area cruise and charter boat base on Kogarah Bay from which a variety of party-fishing, game fishing and cruise boats can service passengers.

PORT HACKING AND THE HACKING RIVER

Port Hacking and the Hacking River to the south of Sydney is home for several small ferries and cruise vessels. The area is largely residential with aquatic recreational activities on the north bank, and national park and residential hamlets on the south bank. The largest 'village' on the south bank is Bundeena near the mouth of the river.

Bundeena has been served by a regular ferry service since 1915 when master mariner Captain R. Ryall retired from the sea and began a ferry run to the isolated homes of Bundeena from Cronulla. His first ferry was the well-decked launch, *Myambla* (8m, 25 pass.). There was no road to Bundeena and Ryall and his son Eric were often to claim that they 'built Bundeena'. *Myambla* carried all sorts of building materials and what she could not carry she towed on a punt. She lasted until about 1947; by then worn out and far too small. Many other launches worked the route over the years. Among them were *Audley* (8.5m, 35 pass.), *Eclipse* (9m, 42 pass.), *Pioneer* (12m, 48 pass.), *Gunnamatta* (1) and (2) (11.5m, 60 pass.), *Macquarie* (9m, 50 pass.) and *Burraneer* (12m, 77 pass.). *Macquarie* was the second boat on the run and was taken over by the Army in World War II as was *Burraneer*. After the war, *Audley* went to Pittwater and *Gunnamatta* (2) worked on the Cooks River.

After the war, the company's vessels included *Conqueror*, which came from Woy Woy and was then sold to Lake Macquarie in about 1950, *Myambla*, which was sold when *Bundeena* was building and the first purpose-built ferry, *Curranulla*. *Curranulla* was built by Morrison and Sinclair of Balmain, Sydney, and was the first real ferry on the service. She is a double-ended, seaworthy small ferry, one of the few such craft built for partly-smooth passenger work in the Sydney area. She was the last vessel ordered by Ryalls and was intended to be able to serve Bundeena's exposed wharf in almost any weather. *Curranulla* entered service on 12 May 1939, with the Ryalls taking a load of press and local VIPs for a river cruise.

Mr. H.C. Mallam bought the ferry service from Captain Ryall upon his retirement soon after World War II and ordered completion of a bigger *Curranulla* — MV *Bundeena*. The new boat was nearly twice the mass of the older boat and was designed along similar lines. She could carry almost 200 passengers, against 135. Both ferries used Kelvin hand-start diesels, which provided passengers with visual interest as the crews 'wound them up' with the big fly-wheel. Long term ferry masters such as Hector Eagling (25 years), Hec Monroe (20 plus years) and Ron McMaster (a 'mere' four years), kept fit swinging the big wheel.

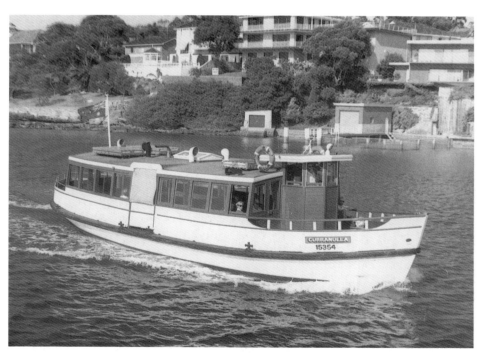

Travelling to Bundeena from Cronulla aboard *Curranulla* is one of the few exposed water ferry runs in the Sydney area. [Author]

Mallam sold the ferry service and the ferries which then included *Gymea* (1949, 70 pass., formerly *Alma G* of Forster) to Jack Gowland in the late 1960s. *Gymea* was a shallow-draught ferry, ideal for the run up the shallow Hacking River to the wharf at Audley in the Royal National Park.

Problems with river siltation, new ferry regulations, and the demolition of the Audley Wharf, plagued the Gowland period, and *Bundeena* was sold to become part of the ferry 'rescue fleet' which went to Hobart after the bridge fell down. Her loss is still regretted by locals, ferrymen and passengers alike.

More recent owners have included Harry Brain and Les Whitehead who upgraded the two ferries and rearranged *Gymea*'s superstructure. Others were Andrew Cureton and Richard Patchett, then Cureton alone, followed, in 1989, by Carl Rogan who started with the company as a deckhand. In 1991, the company was known as Cronulla and National Park Ferry Cruises Pty. Ltd., with two ferries, *Curranulla* and *Tom Thumb III* (formerly *Gymea* and *Alma G*). Longest-running master was Geoff McLenehan whose tales of trying to maintain a ferry service in big seas and shallow waters would daunt most passengers other than Bundeena residents.

In 1991, the only other regular scheduled passenger service on the Hacking River was provided by the aluminium catamaran *Gunnamatta* (3). Owned and

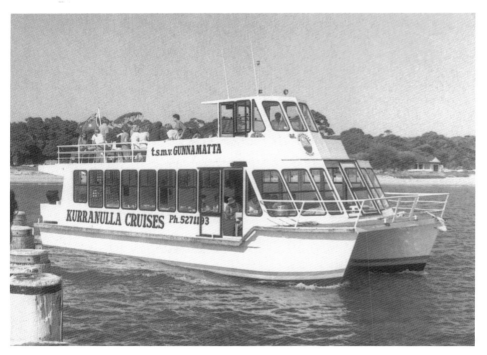

The modern shallow-draught catamaran *Gunnamatta* (3) is a recent arrival on the Hacking River. [Author]

run by Greg Forrest, this 120-passenger 15m function ferry provides modern cuisine and comfort for many groups seeking to tour the area. Her shallow draft and twin diesel-powered stern-drives allow her to work in the Hacking's shoaling waters. *Gunnamatta* (3) was built in Queensland in 1990 and took just 50 hours steaming time to reach Port Hacking from Southport, via Ballina.

AN OVERVIEW

The ferry and excursion boat services of Port Jackson show some signs of strain. This may be an indicator for the future. The divergence of design between the 'ferry' and the purpose-built charter vessel that became apparent during the mid-1980s in the lead-up to the Bi-Centennial continues. It is this divergence which is producing a dedicated cruise boat that may become so specialised it will be unviable in any other role.

As economic conditions worsen in the 1990s, the Government ferries (State Transit Authority(STA)) are required to not only pay their way, but also to make money for the State. This is bringing the STA into increasing competition with private commercial companies. It is also, perhaps, a return to the days when Sydney Ferries Ltd. and the Port Jackson & Manly Steamship Ferry Co. ran the major tours and cruises.

The STA's actions have already changed the ferry services. A number of 'tourist-oriented' ferry routes have been added to the commuter routes. The veteran of the Hobart Bridge ferry relief fleet, *Lady Wakehurst*, has been over-hauled and modernised for duty as both ferry and cruise vessel, and new fast catamarans are in service to Manly. Four new low-wash medium speed cata-maran ferries were built in 1991–1993 for the Parramatta River run as part of Sydney's Olympic 2000 bid. They are *Dawn Fraser*, *Betty Cuthbert*, *Marlene Matthews* and *Shane Gould*.

Evidence of a clash of interests on the harbour came when Captain Cook Cruises pioneered a ferry route from Sydney Cove to the new Darling Harbour Tourist attraction. During 1988 and early 1989 this service used *Seeka Star* and *Port Jackson Explorer*. Permission to operate this run seems to have been withdrawn and, in late 1990, the only ferries on this service were vessels of the State Transit Authority's First Fleet Class running from the Quay to Darling Harbour and back, via Darling Street Wharf, Balmain. Early in 1992, the low-profile *River Rocket* was running a service from the Quay to The Rocks to Darling Harbour and return, apparently on charter to the STA. *River Rocket* was able to pass under the historic Pyrmont Bridge when it was closed.

Some contraction in charter vessel numbers became apparent soon after the end of the 1988 Bi-Centennial celebrations as 'craft of opportunity' from other States returned to their normal runs or moved on in search of business.

Among their number, were vessels built in anticipation of riches from the (unsuccessful) defence in Fremantle of the America's Cup. Some tried to survive in the crowded Sydney scene, and others moved to Queensland for Brisbane's Exposition. Among the former was the extravagant *Captain's Lady*, a large Glass Reinforced Plastic (GRP) cruising restaurant complete with two-deck solarium and palm tree! Competition was too much for her in Sydney so she sailed to Auckland, New Zealand, but seems not to have done well there as she was reported in the middle of 1990 as having returned to her origins on the Swan River, via Darwin — perhaps something of a record voyage for a cruising restaurant?

As part of the Wran/Unsworth Labor Government's plans for the Bi-Centennial, a rundown and little used area of small wharves and a railway yard in the south of Darling Harbour were rushed into construction as a tourist attraction. Charter boat wharves and administrative offices were provided there in expectation that tourists would 'spill over' to the nearby aquarium and to the variety of charter boats on offer. To some extent this happened, and at this location Matilda Cruises became the major operator among a range of varying cruise services.

Major companies/vessels working from Sydney Cove (in addition to the State Transit Authority) are Captain Cook Cruises and its subsidiary, Hegarty's ferries. The Number Six ferry wharf is used and is not generally available for others. Vagabond Cruises operates on a semi-regular basis from a small pontoon on the now wharfless east side of the Cove, while pseudo Mississippi paddler, *Sydney Showboat*, works from a pontoon in Campbells Cove on the west side of the Cove. Blue Line Cruises, the paddler's owners had hoped to use Number Two Wharf at the head of the Cove, but found this to be impossible while gaining, perhaps, some understanding why stern-wheelers were not used locally on the port in the era of the paddle-steamer. Cruising Chinese restaurant, *Tai Pan*, also worked from Campbells Cove and the handling problems of these two unwieldy craft brought them into contact more than once.

It may perhaps be appropriate here to give a brief explanation of the major rules and regulations of the port as they apply to local commercial vessels.

For more than 50 years, the New South Wales *Navigation Act*, with various amendments, was administered by officers of the Maritime Services Board's Survey branch, and by other officers appointed by the Harbour Master. Similar Acts applied in other States, but all differed in important items and this precluded commercial vessels and even their operators from quickly changing location to work in another State. While such a situation could be criticised, it allowed States control over aspects of their marine scene which differed from those of other States, and it allowed some control of the numbers of vessels and operators.

This situation changed when all States agreed, after many years of discussion, to share common rules and regulations concerning commercial vessels.

The means by which this could be done was through 'Uniform Shipping Laws (USL) Code'. Each State was required to introduce an Act based upon USL. In New South Wales, this became the *Commercial Vessels Act* of 1979 which was introduced gradually from about 1984 and Gazetted (No.109 of 26 June 1987) law with other States passing similar Acts at varying times.

The intention of USL was to ensure a common standard for commercial vessels and their crews, and to some degree this has happened. Students of its effects may well find much to comment upon.

The combination of the Bi-Centennial and the USL Code brought new people into the industry. During our 200th birthday, there were also many people operating vessels commercially in Sydney who had no legal right to do so. Many of these vessels were not in commercial survey, nor were they equipped to even a minimal safe standard. As one of the few Maritime Services Board officers assigned to this job, I boarded scores of craft during this period.

Perhaps the arrival in Sydney of the cruising Chinese restaurant, *Tai Pan*, may illustrate some of the difficulties faced by both operators and marine authorities in the 1980s. Built in Beechmere, Queensland, to the order of a group of Sydney investors including Margaret Shen, and trading as Tai Pan

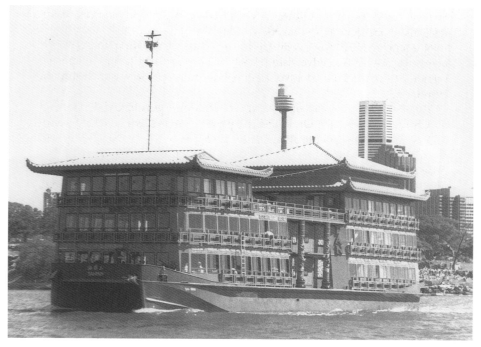

A short and unhappy career was ahead of cruising restaurant *Tai Pan* when this photo was taken. [Author]

Cruises Pty. Ltd, *Tai Pan* was launched on 14 April 1988, and arrived in Sydney under its own power just one month and two days later on 16 May. It was intended to go into immediate service but mechanical troubles intervened. So did the Maritime Services Board, whose surveyors were dubious about the fire resistance of certain parts of the ship. The *Tai Pan* was allowed to work with a reduced passenger certificate initially (200 people) and eventually gained approval for about 500 diners, although it rarely seemed to have a full load.[1]

The *Tai Pan* quickly became public property. It was either liked or loathed. *Tai Pan* was called the 'Tai-Panic', the 'Floating Dim Sim', and names even less attractive. *Tai Pan*'s appearance was attacked on aesthetic grounds at all levels.[2] Paul Reid, Professor of Architecture at the University of New South Wales, was quoted: 'I think we ought to resist the trend. Operations like this are exploiting the beauty of the harbour and at the same time destroying it'.[3]

Two months later in the *Sunday Telegraph* of 13 November 1980, Margaret Shen raised the issue of racism: 'I think racism will become worse if people's homes are threatened ... ' Margaret Shen seemed to consider that any attack on her vessel was inspired by racist ideas. I doubt that Australia's many Chinese restaurants, and a less pretentious version afloat in Sydney's Rose Bay, had the same problems. Similar criticisms were levelled at the paddle boat, *Sydney Showboat*, and the catamaran function boat, *Richmond Riverboat*. Racism did not seem to have any bearing with these two craft.

Not long after *Tai Pan*'s arrival, other plans were made for a prism-shaped neon covered mobile advertising 'boat.' This vessel was to be the marine version of the truck-based advertising hoardings on the roadway. It did not eventuate.

Tai Pan lasted about 18 months in service. Mortgagees forced the last run on Christmas Eve, 1989. On 26 February 1990, it was auctioned for a paltry $1.5m and reported sold to Albert Lau who has interests in Hong Kong and Macau.[4]

Margaret Shen, obviously hurt, made a last comment: 'I thought Sydney was a cosmopolitan city ... obviously I was wrong'. She then went on to blame journalists for the demise of her venture.[5]

In 1990, while the Government was announcing that the State Transit Authority would soon cease to lose money or would even trade in the black, some private companies were in difficulty. *Sydney Showboat*'s owners, Blue Line Cruises, were reported to have sold her to Asian interests; Vagabond Cruises likewise, and perhaps one third of the charter boats of Sydney (and Australia) seemed to feature in the classified advertisements.

Compounding the problem for these operators was (in December 1990), the number of non-ferry route public wharves damaged or closed off as unsafe. Provision of wharves safe enough for large numbers of boat patrons was insufficient for the numbers waiting. Those with adjacent car parking were fewer.

This situation followed the reduction of the Maritime Services Board's trained bridge and wharf carpenter teams, and an apparent Government decision to reduce the MSB's role in the port. The Maritime Services Board no longer had the obligation to maintain most public wharves, nor did it have the men and plant to do so as a result of the Greiner Government's reduction in the MSB's outdoor workforce numbers. Private enterprise was expected to fix the wharves, but private enterprise had been unable to run major ferry services on the inner harbour or to Manly or along the Parramatta River. At the end of 1992, cruise boats battling for business were still queuing and jockeying for wharf space, while Yeend Street and Dawes Point Wharves were closed, McMahons Point Wharf was dangerous at low tide, and the private Luna Park Wharf closed and locked when it could have had a vital role to play. History tours to Goat Island were cancelled because no wharf on that base was considered to be safe for public use.

New ideas in catering for a public need have always found quick acceptance among the harbour's ferrymen and women. With new ideas and new designs, the ferries of Sydney have always been quick to show new influences. Throughout the history of ferries, examples have been illustrated which show forward thinking, yet two of the most interesting ideas had to wait until the 1980s to appear on the harbour.

I have already suggested it is possible that the horse-boat, *Experiment*, of 1831, was a multi-hull — a catamaran. I offer no evidence for this theory, but there is some deductional evidence to suggest, at the least, the possibility.

The question will probably remain unanswered and, this being so, the first official passenger-carrying catamaran on Port Jackson was the Stannard-built, Phil Hercus-designed, *Port Jackson Explorer* of 1981. *Port Jackson Explorer*, more recently carrying the sign 'Sydney Harbour Explorer' along her sides, is still in service on the harbour (1990). Her designer has gone on to change the face of the world's ferry services with his designs, generally built under the aegis of International Catamarans.

Another new idea for Port Jackson was that of an overnight cruise 'liner' carrying passengers around the harbour on tours of several days. It was a good idea, and it could have and, perhaps, should have worked, but unfortunately it did not.

Inspired by the success of overnight cruises on the Murray River during the last 30 years, shipping companies have considered other similar types of locations, among them the Gold Coast to Brisbane area, the Hawkesbury River area, and the New South Wales Myall Lakes.

The owners of the Murray cruise liner, *Proud Mary*, tried their hand with a similar idea on Port Jackson. It was initially intended to work the Hawkesbury River area, but this location was abandoned for Port Jackson.

Proud Australia Cruises bought the 1972 Suva built *Taleianda* from Fiji's Blue Lagoon Cruises for conversion to an Australian cruise ship. On Sydney waterways (after modification in South Australia), *Proud Sydney* carried a

maximum of 52 passengers in 26 cabins on cruises that usually spanned two nights and three days, anchoring in the most visually attractive parts of the harbour when the day's cruise was done. *Proud Sydney* started cruising the port on 28 February 1988 and after also trying a stint as a function boat, gave up and sailed for South Australia in December 1990.

Following *Port Jackson Explorer* were a number of others of differing styles and roles. The high initial stability of a multi-hull and its great deck area compared to overall length, makes it popular for cruise boats and ferries. Manoeuvrability in confined quarters was a bonus and Matilda Cruises was quickly into the catamaran club with *Matilda*, and *Matilda II, III* and *IV*. The Urban Transit Authority (UTA) and later State Transit Authority, ordered nine First Fleet class medium speed catamarans to be designed originally by Alan Payne, but later modifications produced vessels that did not do exactly what had been intended. Regardless, they have been fine ferries, although constrained by their being able to travel in only one direction. The State Transit Authority continued its interest in fast cats with the Phil Hercus-designed Jet catamarans for the Manly run — *Blue Fin*, *Sir David Martin* and *Sea Eagle*. It had been intended to name them all after creatures found in the sea around Sydney, but the death of a very popular State Governor inspired the gracious tribute of naming a new Manly ferry after him.

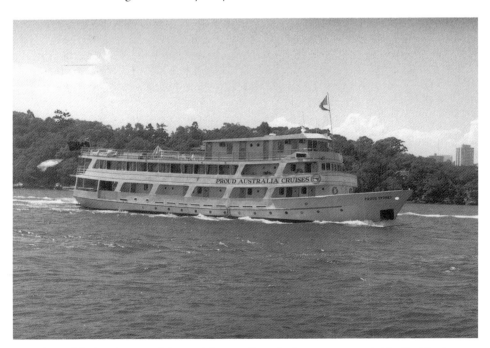

Proud Sydney's overnight cruising on Port Jackson was a notable first but attracted insufficient trade. [Author]

The Blue Fin class Jet cats represent a second attempt at providing a fast, upmarket commuter service for Manly. The rise and fall of the hydrofoils is discussed in Chapter Four. In several articles over the last two decades, I queried both the real value of hydrofoils on a short run and the wash damage caused by them. My doubts were based mainly on the short distances involved locally for hydrofoil use. Great engine power and strain is needed to make a hydrofoil 'fly'. The seven nautical mile run to Manly represents about 10–12 minutes hydrofoil time, and then the vessel must come back to displacement state. Time taken to reverse out of berths and turn around reduces the time benefit of a hydrofoil over conventional double-ended ferries. On a run of (say) 20 nautical miles, the fast ferry, hydrofoil or Jet cat, has a time benefit which can cancel out any manoeuvering deficiencies.

The Jet cats, with their long and narrow hulls, do not plane but slice through the water, needing, it is claimed, much less power and fuel than a comparable hydrofoil for a similar speed.[6] The distance between the hulls has caused some stress problems in other areas in which they have worked, and it remains to be seen how well they will withstand the wracking and twisting forces of a high-speed passage diagonally across the big swells of Sydney's Heads.

The arrival of this new class, and the arrival of a new class of low-wash river cats, illustrates the continued interest in innovation in ferry work now well established in the responsible Government agencies since the arrival of *Kooleen* in 1956.

CABLE FERRIES IN GREATER SYDNEY

In addition to the cable ferries crossing the Parramatta River and at The Spit, they have crossed the Georges River in several other places, notably Taren Point, Lugarno and Tom Uglys. These ferries have all been replaced by bridges.

At the end of 1990, cable ferries or punts, described in the International Regulations of the Sea as 'vessels working in chains', could be found in five locations in and around Sydney. The maritime equivalent of the railway level crossing, but not as dangerous, punts are always at risk from the bridge builders even when, in some cases, there is no economic reason for building a bridge.

Five crossings served the Hawkesbury River system and one could still be found on Sydney Harbour, crossing the Parramatta River.

The Berowra Waters ferry may well be one of the most visually attractive vehicular ferry services. Using the 1963 built *DMR 1*, this punt can take about 15 cars. It makes a short crossing across the almost 'Fiord'-like Berowra waters connecting both sides of the village. The punt is busy at weekends but at other times there is little demand for its service.

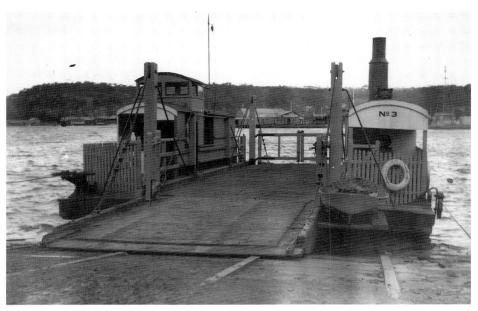

This steam-powered cable ferry, No.3, worked at The Spit, until replaced by the first bridge in 1924. [Auckland Institute Museum]

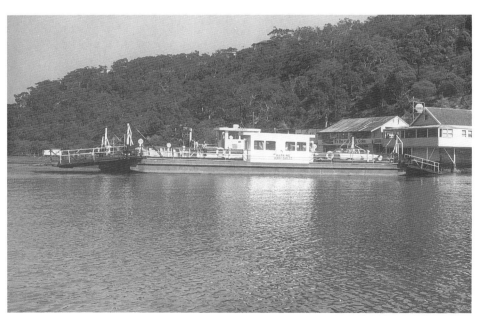

The Lugarno ferry across the Georges River, was replaced by a bridge in the mid-1970s. [Author]

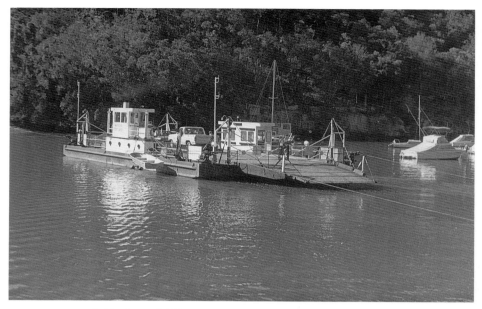

**Cable ferry *DMR 1* (RTA 1) doesn't go far but enhances
the Berowra Waters area.** [Author]

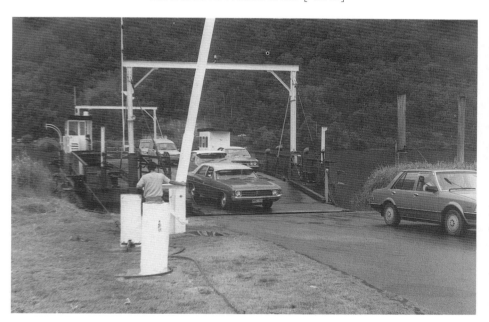

**The large car punt at Wisemans Ferry, *DMR 8*, originally worked
on the Clarence River at Harwood.** [Author]

The main body of the Hawkesbury River has four other punt sites. The best-known and largest is at Wisemans Ferry. The Wisemans Ferry is the oldest continuous public transport service in Australia, dating back to the very early days of the colony when the Great Northern Road was the only land route heading north from Sydney. The large, main, Wisemans ferry punt is *DMR 8 (RTA 8)* and dates from 1928 when, as a steam punt, it crossed the Clarence River at Harwood. Replaced by a main highway bridge, this rivetted steel punt still does good work, carrying loads of up to 154 tonnes (equal to 24 standard motor cars). When *DMR 8* is out of service, the replacement punt is *DMR 55* (1920–8 cars.)

Just upriver from the Wisemans ferry and serving the same community, is the Webbs Creek ferry, *DMR 26* (1961–15 cars). This punt serves farms and homes on the north bank of the Macdonald River.

Further upriver there are two cable ferries. The small punts at Sackville and Lower Portland were under discussion in the mid-1980s as being able to be replaced by one road bridge.[7]

Crossing the harbour between Putney and Mortlake is the 'Putney Punt', *DMR 28* (1962–15 cars). This is the last harbour car ferry, and dates from 1935 when the cable ferry upriver at Ryde was replaced by a road bridge. The existing ferry was then established a mile or so downstream to serve the factory areas of Mortlake.

The service is not well known and gets mainly local traffic, yet it offers a visual delight and an unusual way of crossing the harbour — car and all. In February 1980, the night service was restricted and, more recently, the Greiner Coalition Government introduced fares because of falling traffic. This had the effect of reducing traffic further and a local outcry caused the fares to be removed. The punt is certainly under threat of removal without replacement, and in 1992 there appeared no sign of action on a suggestion that the Government would include it in an advertised 'tourist drive'.

NOTES

1 I discussed the ship's problems with various members of the *Tai Pan* during several visits.

2 *Sydney Morning Herald*, 1 September 1988, 'Floating Dim Sim' is not to everyone's taste.

3 *Ibid.*

4 *The Log*, May 1990, also reported as Atlas Shipping Service Ltd.

5 *Daily Mirror*, 2 February 1990.

6 Weekly fuel consumption for two Jet cats = 31 840 litres versus 24 875 litres for two large hydrofoils. *Daily Telegraph*, 9 September 1990.

7 DMR Planning Minutes, 1983, Department of Main Roads (more recently Road Traffic Authority).

CHAPTER 10

ANECDOTES AND

REMINISCENCES

TO MANLY BY FERRY IN THE '30s

'In the 1920s and 1930s, morning and afternoon teas were served in a lower deck saloon (on *Dee Why* and *Curl Curl*). This idea was renewed in the 1950s. The Manly end of the ferry was always the Gents Saloon and the Ladies Saloon was at the Sydney end.

On the business hours ferries there were often twenty or more men balanced along the lower rail as the ferry eased to her (Sydney) berth. A whole 'boarding party' made the leap from ferry to wharf. Occasionally someone 'went in the drink'.

'Jumping for it' was less popular when the ferry was leaving Sydney. The 'Five minute bell' clanged, and deckhands cried out, 'Hurry on please' as the upper gang plank was removed. The lines were taken away as the bottom planks were removed — telegraphs tinkled and the screw frothed — then a whirr of turnstyle, running feet, a flying leap and success — or not! Sometimes a briefcase went to Manly and back in the care of the deckhand while its owner waited, sheepishly, for that ferry to return — having baulked at the last second.

Clearing the wharf and into the sudden sunlight: the clang as the heavy steel gangway gates are pulled in and secured and we are, already, starting to turn towards Fort Macquarie as the speed increases. With one or two Sydney ferries also heading out, we keep over to starboard to give incoming Sydney and Manly ferries clear room in the Quay. The incoming Manly boat will be the 'Ten past six'.

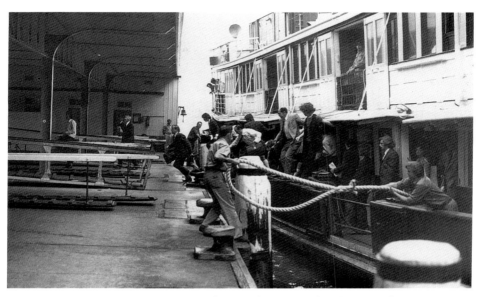

The mooring lines go over as *Baragoola* eases to her berth in Sydney. The over-anxious are readying for their moment of truth. [Author]

In the Quay there might well be *SS Mariposa* berthed during the day with a P and O liner, one of the 'Straths' on the western side. Passing Bennelong Point and Fort Macquarie, we will probably see the new RAN seaplane carrier *HMAS Albatross* and one of the heavy cruisers, *Australia* or *Canberra* with the sunset bugle calls coming across the water.

Rounding the turn marker at Bradleys Head, we can see North Head and Manly in the distance. If the wind is in a certain quarter, our own thick brown smoke will roll along the surface of the harbour in front of us. Those sitting on the port side will be able to study a small collier as we overtake and pass her.

There's a steady increase in swell as we near The Heads — past Dobroyd Head and the bombora — Forty Baskets Beach, and then easing back off Smedleys Point and into the calm of Manly Cove.

The engine telegraph rings to 'slow', then 'stop' as we head towards the right hand berth which was the preferred one. Halfway along the berth at 5 knots and drifting — the telegraph rings 'astern', the engine builds up vibrations and we have stopped. It was always interesting to compare the seamanship of different masters when coming alongside — some reversing much later than others and some, sometimes, leaving it too late or misjudging the line, resulting in a collision with the fender at the wharf end.

Coming alongside at the Manly end was often a problem in bad weather, especially with a cross current — sometimes the ferry had to back out and make another approach.

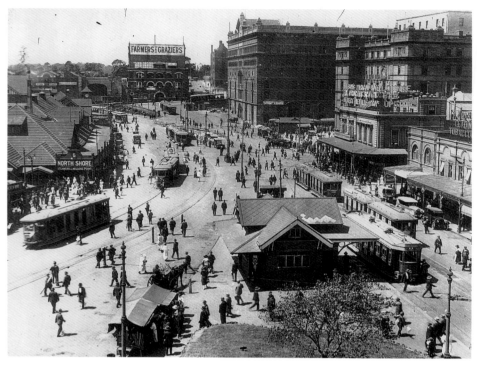

Transport Interchange, 1920s style. This view from the Sydney Harbour Trust building shows how well the busy tram services related to the busy ferries. [Graeme Andrews Collection]

The siren was used sparingly except for navigational needs. It was sometimes used to call for police or ambulance with a series of short blasts, and help was usually in attendance by the time the ferry berthed.

During World War II, the ferries were painted grey, and interior lights were blacked out at night between Manly and the anti-submarine net barrier.

In the Quay, the road frontages of the wharves were all similar — olive green with wooden awnings and a conglomeration of upstairs architecture of slates and shingles — Sargents had a café upstairs in the wharf nearest to George Street. The Manly wharf had a clock tower, a fruit shop, and a bookstall.

At Manly there was a wide, rambling frontage to the wharf with a large café on the right. There was also a clock tower, and a red-tiled roof. Two large wagons with cast iron wheels were used for carrying coke in bags to the ferries. The stokers (firemen) were dressed in big boots, worn serge trousers, and grey woollen sweat shirts. When lumping bags of coke, they wore a cut-out sugar bag over their heads, covering their necks and upper backs.'

(*Kel Woodside, Forbes, 1969.*)

AN OCEAN VOYAGE FOR STAY-AT-HOMES?

'During the early 1930s, a man was ordered by his doctor to take a sea trip for several months for the good of his health. He bought a season ticket on the Manly ferry and travelled all day every-day. Well.....?'

(*Gil Hayman, Sydney, 1974.*)

DEE WHY MEMORIES

'*Dee Why* rolled so heavily on one crossing that her top-deck piano broke free and smashed through the sides of the superstructure.

At another time, *Dee Why* smashed through the wooden barrier at the Quay and embedded her bow in the Quay footpath. Passengers were disembarked by gangplank from the bow direct to the path. Here one of the company's directors quickly took station with a coin box to collect the tokens.'

(*A.E. Bailey, 1969.*)

SELLING SWEETS ON THE FERRIES

'In 1915, Bill White was one of eight boys who answered an advertisement for a 'chocolate boy'. Selling sweets on a ferry, while wearing a posh naval uniform, seemed a great idea to 14 year-old-Bill.

Bill and six others were chosen after their fingernails and hair were checked for cleanliness. They were each given a winter and summer uniform and promised a wage of 20 shillings a week plus 2d. in the £ commission.

Hoping to work on the more glamorous Manly ferries, Bill was sent to the inner harbour ferries. He carried his sweets tray on the Mosman and Neutral Bay run, but never on the Watsons Bay run which was a closed shop. After six months of intensive ferry travel, Bill White reached his dream. He was transferred to the Manly run onto the magnificent *Barrenjoey* (later *North Head*) — now he really was part of that exciting ferry trip across The Heads.'

(*Interview in the 'Manly Daily', April, 1982.*)

FERRY MUSICIANS

'My uncles, Jack and Morris Rosen, were musicians on the Manly ferry. Uncle Jack played the violin and Morrie played the piano and shook the coin box. The third member of the trio, Archie Jackson, played the cornet. The Rosen brothers were well-known in racing circles and at one time won a large flitch of HAM which amused them more than a little.'

(*Isaac Goldstein, Brunswick, Victoria, 1968.*)

NOBBING AND LUGGING

"It doesn't matter how bad a band is on the ferries … it's how good you are at nobbing. Some blokes wouldn't get a penny the way they go on … "

He took the wooden box from the top of the piano: "You must keep it in close — like this — and just jiggle it gently".

"It's a real art, this nobbing."

"And when you see a boy and a girl holding hands you go over and stand in front of them. Not on their toes but just in front. Then you play those love songs like 'You made me love you … ' you know, that gets them right in."

He put the box on a seat, pulled the violin from under his arm and stroked it delicately with the balding bow. There was a screech, even he grimaced; yet he didn't bother to adjust the tuning.

"It's no use trying to adjust it," he laughed, "the pianos are all out of tune. It wouldn't matter if I had only one string. Besides the folks want it as corny as you can make it and boy, do we make it corny."

Despite his experience in nobbing and his knowledge of the public's taste in music, the business is slipping. Forty years ago these travelling players could earn £3 on a good summer Sunday. Before World War II they could average £18 a week. Today, they claim, a good week is about £40.

"Once the boat begins to pitch, they are more interested in keeping their breakfast down than in coughing up money … " A flourish of the bow and he was off......'

(*Norman White, Manly ferry musician, interviewed by Ron Tarrant, 'The Sun Herald', 11 March 1956.*)

CAUGHT BY THE ANTI-SUBMARINE NET

'I was 10 years old when my family caught the 4.10p.m. New Year's Day Manly ferry to Sydney. We had travelled about half way across The Heads when we stopped. The ferry bobbed around there for an hour or more with most of the passengers including me, getting sick. There were other ferries also floating around.

We later found out that the authorities had closed the boom as there were suggestions that a Japanese submarine might try to enter the harbour again. We got home to Gordon at 9 p.m. after our longer than normal Manly trip and I still feel an odd feeling when boarding the Manly ferry.'

(*Janice R. Timmins, Turramurra, 1990.*)

VAUCKY VERSUS BURRA BRA.

'The races between the Manly steamer *Burra Bra* and the Watsons Bay run's flier *Vaucluse* were really good contests. *Vaucluse* was a little older and smaller than *Burra Bra* and was wooden built against steel for the Manly ferry. On her trials over the measured mile, *Vaucluse* proved to be slightly faster than the bigger *Burra Bra* and to mark the dignity of the position, had two brooms mounted on the fore and aft steering poles. *Burra Bra* never conceded the position due to the 'Vaucky' — and many mornings she would contest the honour on the run up the harbour from Chowder Bay to the Quay entrance

… On the night trip, the discerning passengers would note a dull glow around the top of *Vaucluse*'s funnel, showing that the forced draught was on. As Fort Macquarie was rounded, this glow increased, until, by Fort Denison, it would be some yards long.'

('*On the Harbour 50 years ago … *', O. Barnaby Bolton, article about 1950 and reproduced in part from 'The Log', 30 September 1972.)

WHEN THE SEAS REALLY GET UP

'The *Burra Bra* was lifting to the swell before she was half way to Smedleys Point. Passengers could see the huge rollers sweeping in through The Heads and breaking heavily on the rocks … *Burra Bra* was dipping and rising, then burying her nose into the swells, spray flying over the bridge and water running all over the lower deck. She was halfway across The Heads when one mighty sea slammed into her on the port quarter, a massive wall of solid water, disintegrating with an explosive roar … Dozens of windows were broken, seats with passengers on them, were wrenched from their fastenings and slid across the rolling decks, the sliding doors on the port side were stove in and shattered, leaving the sea to pour into the lower decks … four people were injured, one badly … 26 June 1923.'

(*Tom Mead, 'Manly Ferries', 1988, Sydney, pp.32–33.*)

The artist may have been just a little extravagant in this impression of *Burra Bra*'s rough night on 26 June 1923. [E. Abercrombie]

BUILDING A MANLY FERRY

'I was an apprentice at Morts Dock in 1922 and I did most of my apprentice-
ship working on *Baragoola*. She cost £44 000 to build and apprentices then
were paid 7/6d. in the first year, 11/9d. in the second year and 31/- in the
third year. To get to work I had to catch the ferry from Bay Street to
Woolwich Dock. From there we would travel on the Morts Dock steamers
Atlas or *Clyde* to Cove Street, Balmain from where we would walk up and
over Long Nose Point to Morts dockyard.

The storeman in the boiler shop was Bill McKell who ran that shop with
his brother. Bill did his apprenticeship at Morts Dockyard 10 years or so
before me.'

(*Eric Stephens, Palm Beach, 1990.*)

BUILDING *BELLUBERA*

'The late Sir William McKell told me of his work as an apprentice building
Bellubera. He remembered the 'Pretty Lady' jamming on the slipway during
her launching and of a hard hat diver named Roderick* being injured while
trying to get the ferry moving. Strangely there was no apparent mention of
the incident in contemporary press reports.'

(*Conversation with Sir William McKell in January, 1981,
following the scuttling of 'Bellubera'.*)

MANLY FERRY OR SOCIALITE'S SALON?

'A contemporary description of the Manly paddler *Brighton*:

The main saloon of the steamer is handsomely fitted out with stained glass
panels representing well-known Scottish, English and Irish views; and these
are set in panels and mouldings composed of polished plain [sic] tree, ash
and walnut wood relieved with gilt cornices and trusses. This, with an elabo-
rate use of white and gold in the ceiling, suitable mirrors, crimson or green
velvet for the sofas and lounges, and corresponding carpeting and runners on
the floor makes an altogether splendid apartment.

The first class deck saloon is quite equal in fittings and furniture, having
large plate glass windows all around, shaded by silk curtains to match the
sofas and lounges. The Ladies Cabin which enters from this saloon but has a
separate entrance from the deck, is similarly fitted out. The ceiling is panelled
and moulded. The floor is carpeted, sofas and lounges in green and crimson

[* 'Ossie' Roderick of Ballina, New South Wales, whose father was interviewed by
Isadore Brodsky for the book, *Sydney Looks Back*, confirms that his grandfather, A.
Roderick, was killed by a flying wooden wedge during the launching of a ship at Morts
Dock.]

velvet, curtains to match, gilt framed mirrors, a silver fountain with cold water for allaying the thirst of passengers.

The forward deck saloon and cabin under it are of similar size but plainer design to the First Class cabins. The sponsons in the main deck are occupied by the galley, WCs, store rooms, etc. The saloon deck gives a promenade of 160ft. length, by the width between paddle-boxes and is fitted with plenty of sparred seats; access to this deck is by four good staircases. A large smoke room is also provided on the deck amidships with the ship's bridge immediately above.'

(From the 'Rutherglen Reformer' of 20 April 1883, before 'Brighton' sailed for Australia. Perhaps the next Manly ferry might be fitted out in that style?)

WHEN THE WEATHER CHANGES AT MANLY

'Early in 1980 I worked as relief master on the Manly ferry run. On a summer Sunday I had the temporary Manly ferry, *Lady Northcott*, at Manly wharf a little after mid-day.

It had been a wonderful morning and the ferries had taken full loads to Manly. Then the weather suddenly changed and everybody who came by ferry wanted to go home — right away and at once.

As the rain began, a vast crowd headed towards the *Lady Northcott*. She was allowed only to carry 722 on this run, against more than 1300 for the 'real' Manly ferries.

The crowd forced its way past the wire gates, brushing aside the wharf and ship's staff trying to control it. Two gangways were pulled down to reduce the flow, but people climbed onto the ferry directly from the wharf.

It seemed to me that if I refused to leave the wharf with the obvious overload the crowd would keep climbing aboard until the ferry rolled over. If I did leave, we'd surely be overloaded, facing a good swell running at The Heads.

We pulled away, with people abusing us as the last line dropped away. There were people standing, packed like sardines, on every section of deckspace, including the internal companionways. Two women were slightly injured in the mêlée and both presented themselves to me in the wheelhouse for first aid. I refused to allow the canteen manager to announce the opening of his shop as I didn't want any alteration in the trim of the ship.

Lady Northcott rolled and lolled her way across The Heads, staggering under the load, but we made it safely — and to my great relief there was no MSB inspector counting passengers at the Quay. How many did *Lady Northcott* have on board on that run? I don't know, but it may well have been around 1000, and it was a case of damned if you do and damned if you don't. It's a tale that can be, without doubt, told by many of the other Manly ferry captains.'

(Graeme Andrews, relief master, Manly ferries, 1980.)

THE GERDES FAMILY — FERRYMEN

'Henry Charles Gerdes (1883–1965) served his apprenticeship on sea-going tugs and on the Bald Rock ferries. His Master's certificate was issued by the long-defunct Department of Navigation on 24 July 1906.

Gerdes was, perhaps, best-known on the Lane Cove River run; famous for running to time, even in fogs. Passengers were known to miss an earlier ferry so as to travel with Herman Gerdes. As ferry master, he ran on corrected compass courses, using his stop-watch and timing (mentally) the reflection time of sound echoes from the ferry whistle.

Gerdes was a ferrymaster. His brother, waterman* Herman Gerdes (Jnr.) was employed as night watchman and fireman on those company ferries laid up overnight in Tarban Creek. Herman slept on the ferries and, early in the morning, fired the boilers and then rowed ashore to pick up the ferry crews to take them to their nominated vessels. His brother, George, was a ferrymaster on the Watsons Bay and Sydney Ferry's services.

The Gerdes brother's father, Herman.G. Anton Gerdes, jumped his ship in Sydney in about 1840 and worked on the pioneer ferry, *Ferry Queen*.

Henry Charles Gerdes was, on 11 January 1911, awarded a Royal Shipwreck and Humane Society of New South Wales certificate and a silver watch for diving from the ferry *Drummoyne* to rescue a small boy.'

<div style="text-align: right">(Edna Callaby, nee Gerdes, St. Ives, 1990.)</div>

WORKING ON THE FERRIES IN THE '30s

'The ferry base at Blues Point/McMahons Point was known to the ferry crews as 'Gibralter'. In the early 1940s, *Kara Kara*, *Kameruka*, *Koompartoo* and *Kuttabul* were among the floating plant berthed or laid up at 'Gibralter'.

One of the out-of-hours problems of the area involved uninvited visitors. Some were fishermen with hand lines; others were children off on a voyage of discovery using homemade, galvanised iron canoes. Some were drunks, looking for a place to sleep, and others were lovers with a somewhat similar problem. There was no vandalism.

Patrols of the area during the night were maintained by the steam tugs, *Victor* and *Langdon*, often with Jack Lewin firing in the cramped boiler room. The hulls of these small harbour tugs were so low that fireman Lewin's back was often wet from salt spray while his front was heated from the furnace.

Ferry *Karabella*, did not have steam-powered steering. She was 40 years old or more, and she needed considerable muscle-power to make tight turns. On weekend trips to Clifton Gardens, deckhand Bill Geary was called to the wheelhouse to help Captain Green put on enough 'wheel' to come tightly around the headland at Chowder Bay. The spokes of the big steering wheel

[*Waterman's License, No. 4, issued by the Marine Board of NSW, limited to eight passengers and only from Erskine St. Wharf. Issued August 24, 1875.]

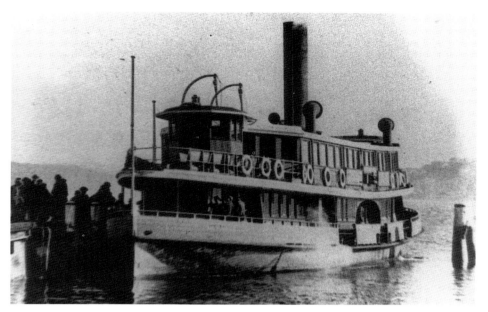

Kookooburra collects medically-cleared passengers released from the North Head Quarantine Station. [National Parks Wildlife Service]

were all worn from the boots of her crew standing on them to turn the wheel.

Early in 1941, the early morning staff trip to McMahons Point for ferry crews was taken by *Kookooburra*, often with Captain Shultz — *Kookooburra* was usually used as a cruise ferry to service the Quarantine Station and for any run that needed a fair turn of speed.

One day, in 1941, *Kulgoa* was required to go from Gibralter to the Morts Bay ferry base for survey. The master was Captain Johnson. *Kulgoa* was low on bunkers (coal) and her water tanks were empty, causing her to sit high in the water, reducing the grip of her propeller. As she neared the laid-up *Kara Kara*, *Kulgoa*'s senior deckhand threw his rope's eye and missed. Bill Geary had a second throw — if he missed, *Kulgoa* would smash into something hard.

Senior master, Captain Dick Weldon, had insisted that Geary learn to handle a rope the hard way — by practice — and the throw was good. As the rope burned its way around the staghorn bollard, slowing *Kulgoa* and burning off rust and paint, the fireman ran over and jammed his heavy boot on the rope to increase the friction. *Kulgoa* was secure and the senior deckhand ignored Bill Geary from then on!

In 1941, the senior base Captain was Dick Weldon. He was often master of the showboats, *Koondooloo* or *Kalang*. When *Kalang* began service as a showboat, Weldon stopped her under the Harbour Bridge, had a full hoist of flags run up the masts, and then let fly with a series of siren blasts. Weldon's son,

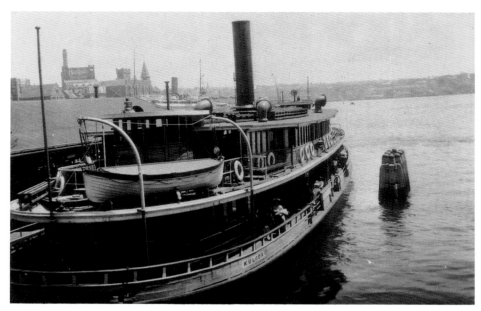

Few detailed photographs of *Kulgoa* survive. Note exposed steering position used when following sailing regatta. [Ray Estrada]

Well preserved after more than 70 years is this sad tribute to a dead son. The ferry is *S.S. Lady Ferguson*. Crewman George William Robertson drowned while working aboard her. [Author]

Sydney, was master of the steam tug *Hero* when she was rammed and sunk near the Bridge in 1941.

The foreman of the coal trimmers was an unpleasant man. He had a little trick of tipping a barrow load of coke onto an old coal-trimmer, I knew only as 'Old Bill'. When Old Bill bent down to shovel coke, the foreman would upend a barrow of coke over him — very funny — there was nothing we could do about it. Old Bill often shared his lunch with me as well as the leatherjackets (fish) which entered his fish traps.

'Long Tack Sam' was taller than Chips Rafferty. His pet hate was passengers entering the unused ferry wheelhouse and fiddling with the controls. This could be very dangerous if an engine-room telegraph gave a wrong signal. Long Tack warned them once: the next time, the police were waiting at the wharf. A series of blasts as we passed the water police base always brought help. Sam was well liked by the passengers, particularly those who, wet through, were dried off by him in the stokehold.'

(*W.H. Geary, Leichhardt, 1990.*)

THE FERRY ON THE TOMBSTONE

One of the more unusual mementos of a Sydney ferry can be found in Sydney's Rookwood Cemetery. The Robertson family's only child, George 'Tib' William Robertson, was drowned while working as a fireman on *Lady Ferguson* on 30 October 1918.

The grave displays a beautifully carved relief of the ferry as it appeared as a steamer, together with carved anchors and a small steering wheel. The grave and tombstone can be inspected at Section AAAA, 2046/7, Anglican section.

A CHILD ON THE LANE COVE RUN

'My father often talked of a deckhand or an engineer named Albert who used to let me go into the stokehold and shovel coal. He was also taught to throw a rope's eye over a bollard. At least once Albert dried him off in the stokehold after Dad fell in.

My father told of a Tarpaulin Muster on one ferry in aid of the wife of a deckhand who had been killed. The ferry passengers raised £5 which was given to his widow to buy a mangle so that she could take in washing. There was no workers compensation in those days.

When I went to Sydney Grammar School, I usually went both ways by ferry. My favourite was *Karingal* under Captain Stagg. The steam 'K' class sometimes ran the river but mostly it was the diesel Lady boats and 'K' boats. Sometimes the waterbus *Pelican* would fill in, but these vibrating and noisy ferries were usually run in non-peak hours. The showboat, *Koondooloo*, changed ends in Woodford Bay, right in front of our house.

In business hours, the ferries ran to Tamborine Bay, Alexandra, and Mornington Street wharves. Gale Street was not in use when I lived in the

area. Day-time ferries terminated at Longueville but there were weekend runs to Fig Tree Bridge.

Our annual treat was to Fairyland, upstream from Figtree Bridge. I think we used a Rosmans launch which often stuck in the shallows. On these trips I discovered what girls were interested in while my mother was forward with the Ladies of the Church Guild.

In 1945 some of us pinched some rockets from *Kameruka* and fired them off to celebrate VE Day — "Ya wadna judge a child?"'

(Richard Davies, Wynyard, Tasmania, 1990.)

THE BOY WHO SKIPPERED THE FERRY

'I was living at Neutral Bay and boarded my usual ferry at the Quay for the way home. The Neutral Bay wharf was next to the Manly wharf. Two ferries left together. As we neared Fort Macquarie, we came closer and closer until we seemed only four or five feet apart. My school friend, Russel Gillies, who was upstairs, realised there was no Captain in the wheelhouse. Russel knew a lot about ferries, having become friendly with many ferry masters. He took the wheel, released the rudder pin and steered away from the Manly ferry. On board also was Colonel Spain, Manager of Sydney Ferries Ltd. He took over and berthed the ferry at Kirribilli.'

(Fred Gibbons, Narabeen, 1990. Report in 'Daily Telegraph',
15 November 1926.)

THE WHARFINGER'S WHARFCREW

My father, E. S. Gordon Oliver, was a wharfinger for Sydney Ferries Ltd. His job was to control arrivals and departures of the ferries and to deal with the public's problems. His staff took the fares and worked the turnstyles. When the Harbour Bridge opened, Sydney Ferries Ltd. sacked dozens of staff, including my father. Dad was unemployed from 1932–1936; it wasn't a good time for us.

Gordon Oliver's work nick-name was 'Patsy' but no-one knew why; there were some very odd nicknames. 'Longun' had a fine appetite and would bring in a whole cake or a large jam tart. There were no plastic bags, only brown paper and 'Longun' would always share half his meal.

'Jazza' Brown was a very flash dresser and was smitten with a new girl. He wanted the afternoon off to go home and get ready to take her out, but the wharfinger refused. As a ferry came in and Jazza tied it up he 'overbalanced' and fell in — he HAD to be sent home to change his clothes.

Another good trick was for wharf crews to nail a purse to the deck and quietly watch people try to pick it up. Simple days — simple fun.'

(Nesta R. McLelland, South Strathfield, 1990.)

GOING UP THE LANE COVE BEFORE
WORLD WAR II

'The *Lady Chelmsford* could always be recognised by her skinny funnel; *Lady Edeline*, *Denman*, *Scott* and *Ferguson* could also be recognised if you studied them carefully. *Karingal* was the fastest on the run and the *'Chellie'* was the slowest, so we tried to catch the *Lady Chelmsford* of a morning to school and the *Karingal* of an afternoon. Sometimes steamer *Kookooburra* was on the run and then we fairly flew along. There were usually three or four buses at Valentia Street for each ferry ... it seems to me we picked up a couple of hundred passengers from each wharf on the river.

An old ferry makes her last run. *Lady Scott* with Captain 'Jackie' Gray in charge heads home on February 16, 1969. [Fred Saxon]

Getting a ferry alongside at Greenwich Wharf was often difficult. The ebb tide and current would force the ferry out from the wharf with the deckhand straining to keep the line on, but sometimes having to let his end go. Passengers on the wharf would pull it in while the ferry tried again.

The deckhand really was the passenger's contact with the ferry company. The Captain was remote in his wheelhouse; the engineer was mainly concerned with his machinery. For us, the deckhand was help and friend and the company's 'front' man.'

(*Clem Holdsworth, Mandurang, Victoria, 1990.*)

IRVING'S 'FRIENDSHIP'

'Commuters on catamaran ferry, *Friendship*, on the Meadowbank run, were informed over the speakers that 'Irving' the rat who pedal-powers the ship's generators had returned to work and would be grateful for copies of the *Sydney Morning Herald* to read.'

(*Sydney Morning Herald, 3 May 1990.*)

A CHANGE COMES TO PORT JACKSON

'Conversion from steam to diesel machinery:
"... the ferry steamer *Lady Chelmsford*, which runs on the Lane Cove River service, had her steam machinery removed and Diesel Engines installed ..."
"The steam machinery gave the vessel a speed of 9.3 knots and in order that

a greater speed could be obtained it was decided to install higher power. A British Gardner Diesel Engine of the direct air reversing type was supplied ... The engine is of the two-stroke 5-cylinder, crank case scavenging, solid injection type, giving 190bhp ... the new machinery gives the vessel an average of 10.3 knots ... the complete absence of vibration in the vessel is remarkable...'"

('*The Power Boat and Aquatic Monthly*', *December, 1933.*)

[Perhaps the magazine was quoting from Sydney Ferries Ltd's publicity spokesperson when commenting on the lack of vibration — steam engines make very little vibration or noise when compared with a diesel engine.]

THE DEATH OF GEORGE WILLIAM BONSALL

'Half mast'

'Manly and Sydney Harbour ferries flew their flags at half mast yesterday as a tribute to the late Mr. George Bonsall ... who died of a heart attack on Saturday, aged 66. He was manager of Sydney Harbour Ferries Pty. Ltd and had been with the company since 1926.'

DOB July 7, 1897; DOD July 27, 1963.

(*From family records: Helen Neville, Nambour, Queensland 1990.*)

BORN ON A FERRY

'On Saturday night 26 August 1905, my mother Frances Margaret Casey and her friend Helene de Grey Egerton were playing cards with her father, Michael Joseph Casey, at Casey's Hotel at the corner of Liverpool and George Streets, Sydney. Mother knew she had to get to a mid-wife at North Sydney, but she stayed late and caught the midnight ferry *Wallaby* to Milsons Point.

Just before Milsons Point, mother told her friend Helene to not make much fuss but she had just had a baby! The deckhand ran to tell the Captain and the ferry fairly raced across the harbour. A Hansom cab was brought right down to the ferry and Helene wrapped mother's floor-length dress around her and baby as both were carried to the cab.

The baby was christened 'Florence Cecily Casey' and her place and date of birth were given as Sunday, 27 August 1905 at North Sydney.'

(*Cecily Stringer, nee Casey, Hunters Hill, 1975.*)

... AND THE FERRY LEFT US!

'Charles Rosman's Lane Cove River service called at four or five wharves along the river in the morning peak hour trips. For some time, certain self-important members of the legal profession had been making the ferry wait — ever longer. This caused everyone else to be late.

The skipper used to blow his whistle as a warning for the tardy, but still they would not stir themselves to hurry for a mere ferry. One memorable

morning, Charles Rosman blew his whistle, waited one minute, and then left — on time.

All passengers were punctual next day.'

<div align="right">(Charles Rosman, interview, 1990.)</div>

AND SIXTY YEARS EARLIER

'There was always a five minute whistle to hurry the stragglers. When the whistle blew, we grabbed everything and almost flew across the bridge. One wet morning, we were on our usual marathon when the bridge was opened to allow a boat through. Our case looked hopeless and we were heading home again for shelter when we saw the deckhand coming across in the ferry's dinghy. We were hauled aboard like two dripping rats to the cheers of those aboard.

We usually did our best to be early, but I'll not forget one attractive young lass who made a practice of coming last. She just loved to catch the looks of the young lads at Longueville. One morning the ferry left her. She stamped her dainty foot in a way that would have put a young filly to shame, but she was early next morning.'

<div align="right">(Miss King, 1968.)</div>

THE PENNY FERRY

'About 70 years ago (1896), when a schoolboy at the Annandale Public School, I was often aboard the local ferries to Sydney. *Annie* and *Lilac* carried passengers for many years on a run which started at Rozelle Bay, calling at Annandale, Glebe Point and Pyrmont en route to Erskine Street. The fare for me was one penny, and I also paid that small sum during my early working years. I think adults on full pay paid two pence for the trip. Both vessels were steamers, of course, the *Lilac* having an oblong and ugly appearance all fully-enclosed, while *Annie* had open seats on her outer decks along the front or forward area. She had a ladies saloon at the after end. Both ferries were fully-patronised competing well with the one-penny steam trams and horse buses running in opposition.'

<div align="right">(Journalist, the late A. Gray, c1967.)</div>

PERC COWAN — FERRYMAN

'Perc Cowan of Balmain was master of the waterbus *Swan* (III) in the late 1930s. Bringing her into the Quay from the Lane Cove River one day, he backed off to allow the liner *Nieuw Holland* to depart. As he did so, a small plane which was over-flying the liner crashed into Sydney Cove. Both aircrew were pulled aboard *Swan* and deposited at the Quay almost before the fuss started.

Perc Cowan served many years aboard the Parramatta River ferries. On one occasion, he was aboard the big *Bronzewing* when a passenger attempted suicide by jumping overboard as the ferry passed Silverwater. Deckhand, Charlie McVea, dived after him, punched him on the chin, and dragged the inert man back aboard the waiting ferry. McVea, known as 'Porky', often slept aboard *Bronzewing* and was aboard one night in 1927 in Five Dock Bay rafted up to *Rose* and *Una,* when the other two ferries were gutted by fire. McVea coaxed *Bronzewing*'s fires into life, let the ship go, and steered her to Chiswick. Running the ship's pump, he doused the fires and saved the ferry.

On the river ferries, many passengers considered that they 'owned' their seats. Foremost among these were Judges Manning and Windeyer of Hunters Hill. Schoolboys reckoned it a good joke to settle a new boy into one of the Judges' seats and wait for the 'explosion' at Hunters Hill.

While destination boards were plainly shown it was easy to get a wrong ferry. If you were running late at the Erskine Street terminal you could hurl yourself aboard a ferry going to any one of these destinations: Annandale, Leichhardt, Pyrmont, Balmain, Bald Rock, Cockatoo Dock, Darling Street, Yeend Street, Stephens Street, Thames Street, Morts Dock, Goat Island and Long Nose Point. In peak hours, you might also catch a ferry to Punch Street, Elliot Street, Cove Street, and Birchgrove.

At least 500 men were employed by Sydney Ferries Ltd. at the peak of its services and many of them were ex RN or ex RAN; they made sure the ferries looked just right. To get a job on the ferries you had to join a waiting list. While you were waiting, you were advised to row or sail around the harbour, to commit to memory the names of all inlets, bays, reefs, buoys, hazards and currents; you would be questioned on them. Having passed that problem, you would then be asked the distances from Sydney Cove of just about every place on the harbour, travelling times, fares, ferry loadings, wharves with gang-planks and those without, and so on. Proficiency with a rope was a must and you were told that if you broke a rope, you paid for it. You had to have a natural aptitude to work up to being a master.

On the Milsons Point run, the big ferries came in at two-minute intervals and that required split second timing. Direct ferries like those to Milsons Point had no margin for error, and they came in at speed, berthing with the screws at each end 'walking' them sideways to the berth. The whistle signals were important and watching the steam could give an indication a split second before the sound came over the water. With each boat (of 50) having its own handling characteristics, some with screws at both ends, and others at one end only, it was said that good ferry masters were not conceived — their keels were laid!'

(Perc Cowan, Balmain, c1966.)

MANY FERRIES — MANY MORE DIFFERENT HANDLING WAYS

'In the early 1980s I was a new relief master with the Public Transport Commission. There were the *Karingal, Karrabee, Kameruka, Kanangra* and *Lady Edeline* of the old-style ferries, and *Lady Cutler, Lady McKell, Lady Woodward, Lady Street, Lady Herron, Lady Northcott* and *Lady Wakehurst.* Little *Kooleen* was odd-boat out. All were diesel-powered.

Kanangra had screws each end, as did the small *Kooleen. Kameruka, Karingal* and *Karrabee* had left-handed single screws, and *Lady Edeline* had a right-handed single screw. The handling of the single screw boats was much different when the propeller was pushing to that when the propeller was pulling. One had to remember to do everything different in *Lady Edeline.* When the propeller in a single screw ferry was pulling, the ferry had almost no steering until it built up speed. Because of this, it was sometimes necessary to use a rope spring at Mosman Wharf and at Hay Street, to force the ferry around into the right direction, against the torque of the propeller BEFORE leaving the wharf. Failure to do this or to remember which ferry went which way, would have the ferry cruising into the packed private moorings — with great effect.

All the older ferries used compressed air to start the engine. Approaching a wharf, the engineer stopped the engine — completely. At the signal, he used the air to restart the engine in the opposite direction of rotation. If the master needed too many engine movements to berth, the air would run out and the ferry would be dead in the water until the compressor built up pressure again — gearboxes were not used.'

(Graeme Andrews, 1991.)

APPENDIX ONE

HARBOUR STEAMERS 1831–1860 — ALL HARBOUR AREAS (All paddle steamers)

vessel	date	o/n	loa	tons	pass.	disposal
Surprise	1831	—	58ft	18*	—	
Experiment	1832	—	80ft	38*	100+	b/u 1849
Australia	1834	32656	83ft	45*	?	wk 1863
Rapid	1838	—	80ft	44*	?	hulk c1850
Kangaroo	1840	31697	89ft	82*	?	b/u Melb '91
Princess	1841	—	?	?	?	hulk 1844
Emu (1)	1841	32274	94ft	72	c150	wk 1884
Comet	1843	36956	92ft	87	?	sank to NZ
Waterman	1844	59514	49ft	17	50	b/u 1874
Native	1844	—	60ft	—	—	—
Ferry Queen	1844	—	—	8	—	—
Alma	1855	59516	62ft	28	—	—
Gipsy Queen	1845	—	—	6	—	—
Agenoria	1850	40906	52ft	22	—	?
Star	1852	32360	73ft	44	—	wk. 1857
Pelican (1)	1854	32480	90ft	42	—	sank 1888
Black Swan	1854	32481	90ft	40	—	wk. 1868
Herald	1855	59510	75ft	41	—	sank 1884
Premier	1856	32601	72ft	35	—	b/u 1891
Pyrmont	1856	32522	50ft	10	—	b/u1876
Nautilus (1)	1856	32523	56ft	11	—	1891?
Pearl (1)	1856	32552	56ft	11	—	1891?
Peri	1856	32587	56ft	11	—	b/u 1886

Note: * tonnage burden (burthen). Old measure of capacity.

Ferries and Ferry Companies by Area

Vessels are listed once, in the area in which they were best-known or longest-lived.
MANLY: H. Smith, S. Skinner, T. Parker, T. Hesselton, J. Watson, Port Jackson Steam
Boat Co. Ltd, Port Jackson Steamship Co. Ltd., Manly Co-Operative Steam Ferry Co.
Ltd., Port Jackson Co-Operative SS Co. Ltd., Port Jackson & Manly SS Co. Ltd., Public
Transport Commission (PTC), Urban Transit Authority (UTA), State Transit Authority
(STA).

vessel	date	o/n	loa	tons	pass.	disposal
Brothers	1847	59513	67ft	23	c50	b/u c1890
Cobre	1849	32206	83ft	67	60	b/u c1917
Mystery	1842	27244	96ft	105	—	barge 1899
Huntress	1854	32617	89ft	86	—	wk. NZ 1872
Breadalbane	1853	16250	140ft	144	530	b/u 1883
Black Swan	1854	32481	90ft	40	c160	wk. 1868
Phantom	1858	41100	119ft	64	166	b/u 1885
Goolwa	1864	48675	130ft	191	c600	1919
Emu (2)	1865	52221	171ft	270	800	b/u 1909
Renamed Brightside *September 1887.*						
Royal Alfred	1868	57781	132ft	141	c700	b/u 1893
Manly (1)	1874	71794	101ft	89	c300	b/u 1906
Glenelg	1874	70695	136ft	210	210	sank 1900
Fairlight (1)	1878	74996	171ft	315	950	hulk 1914
Commodore	1878	74986	121ft	187		scutt.1931
Port Jackson	1883	83769	104ft	108		wk 1910
Irresistible	1883	87172	109ft	136		scutt.1931
Admiral	1883	83757	102ft	121		b/u 1926
Brighton	1883	83729	220ft	417	1137	hulk 1916
Largest and last Manly paddle steamer.						
Marramarra	1884	89256	84ft	66		wk 1896
Cygnet (3)	1885	91893	120ft	124		b/u 1933
Narrabeen (1)	1886	93554	160ft	239	850	hulk 1917
Fearless	1895	94121	112ft	104		b/u c1852
Conqueror	1893	101109	81ft	92		hulk 1932
Manly (2)	1896	106127	147ft	229	820	b/u 1926
Kuring-Gai	1901	112524	171ft	497	1221	hulk c1930
Binngarra	1905	121108	191ft	442	1372	scutt.1946
Burra Bra	1908	125175	195ft	458	1437	scutt.1946
Commissioned HMAS Burra Bra *1942/1944.*						
Bellubera	1910	125244	210ft	499	1490	scutt.1980
Diesel-electric conversion 1935.						
Balgowlah	1912	131538	210ft	499	1528	b/u c1953
Barrenjoey	1913	131567	210ft	500	1509	
Renamed North Head *1951*						
Baragoola	1922	150182	199ft	498	1523	laid up
Curl Curl (1)	1928	155335	220ft	799	1574	scutt.1969
Dee Why (1)	1928	155336	220ft	799	1574	scutt.1976
South Steyne	1938	171240	217ft	1203	1781	N'Castle, 1991
North Head	1951	131567	210ft	466	1295	Hobart, 1987
Manly (3)	1964	317480	63ft	60	72	laid up
To Rosslyn Bay, Qld. 1978 as Enterprise.						

vessel	date	o/n	loa	tons	pass.	disposal
Fairlight (2)	1966	317902	89ft	140	140	b/u 1986
Dee Why (2)	1970	343631	88ft	129	140	b/u 1986
Curl Curl (2)	1972	355207	88ft	140	140	sold '91
Operated final hydrofoil service on Port Jackson, 18.3.1991.						
Long Reef	1969	—	87ft	140	140	sold '91
Ex Freccia di Mergellina.						
Palm Beach	1969	—	87ft	129	140	b/u 1986
Ex Patane						
Lady Wakehurst	1974	—	38.92m	366	718	relief Manly
Lady Northcott	1975	—	38.92m	366	718	relief Manly
Manly (4)	1984	—	31.2m	91!	239	sold 1991
Freshwater	1982	—	70.4m	1184	1100	
Queenscliff	1983	—	70.4m	1184	1100	
Narrabeen (4)	1984	—	70.4m	1184	1100	
Sydney	1985	—	31.2m	91!	239	sold 1991
Collaroy	1988	—	70.4m	1184?	1100?	
Blue Fin	1990	18244	32.09m	108!	250	jet cat
Sir David Martin	1990	18394	32.84m	108!	279	jet cat
Sea Eagle	1991	18436	32.84m	108!	279	jet cat

Note: *PJ & MSSC operated several ferries on the Hawkesbury River area, of which West Head was later to work as a ferry on Port Jackson and Port Hunter (Newcastle).*

PARRAMATTA RIVER FERRY SERVICES
Major services and vessels.
See text for owners: Manning, ASC C, PRSC, C. Jeanneret, PRS&TC.

vessel	date	o/n	loa	tons	pass.	disposal
Surprise						
Experiment						
Kangaroo						
Australia						
Rapid						
Emu						
Comet						
Native						
Star						
Pelican						
Black Swan						
Nautilus						
Pearl						
Peri						
Courier	1865	59517	72ft	19	—	b/u 1886
Cygnet	1866	38818	89ft	30	—	hulk 1890
Ysobel	c1860	—	—	—	—	?
Adelaide	1866	38795	112ft	131	—	b/u 1900
Renamed Swan *1879*						
Platypus	1867	38856	—	33	—	sunk c1884
Alchymist	1869	59523	82ft	54	—	wk 1878

vessel	date	o/n	loa	tons	pass.	disposal
Nautilus (2)	1873	64415	46ft	11	75	b/u 1919
Eclipse	1873	64442	64ft	16		b/u 1925
Wareember	1877	74947	56ft	28		b/u 1924
Katie	1878	75018	53ft	20	c100	?
Osprey	1879	75028	66ft	34	200	?
Renamed Lilac *1892*						
Florrie	1879	75037	56ft	32	c150	?
Pacific	1879	83631	61ft	19	—	?
Aleathea	1881	83629	110ft	79	428	hulk 1913
Defiance	1881	83635	83ft	64	c370	b/u 1930
Eagle	1882	83760	78ft	74	240	
Lengthened, renamed Cygnet *1898*						hulk 1931
Petrel	1883	89234	61ft	26	—	?
Gannet (T)	1883	89235	65ft	48	213	extant1937
Albatross	1883	89306	84ft	84	c500	Qld.?
Halcyon	1884	89392	84ft	82	290	b/u 1933
Kestrel	1885	89393	79ft	61	—	
Renamed Clyde *1899*						
Pheasant	1889	93622	110ft	138	459	lighter 1928
Engines now in Powerhouse Museum, Sydney						
Bronzewing	1899	106216	110ft	149	500	b/u 1931
Blue Dolphin	1973	—	51ft	20disp	62	
First commercial hovercraft in Aust.						In NZ 1991
River Rocket	1989	18062	17m	—	72	
Matilda Cruises, prototype fast river ferry = 26 knots.						

Various Stannards and PTC/UTA/STA ferries have worked the river as required. See also J.Rosman.

LANE COVE RIVER FERRIES
JOUBERT FAMILY FERRIES

vessel	date	o/n	loa	tons	pass.	disposal
Kirribilli	1860	59518	46ft	11	c60	b/u c1889
Womerah	1871	64365	78ft	34	—	b/u 1887
Aegeria	1877	74932	58ft	25	—	sold 1887
Rose (1)	1881	83636	67ft	43	—	burnt 1916
Waratah (1)	1882	83666	49ft	17	—	sold 1901
Lily	1882	83724	76ft	66	—	burnt 1911
Pearl (2)	1883	83758	59ft	41	—	sunk 1896
Pearl (3)	1884	89266	79ft	76	—	burnt 1911
Daphne	1886	89389	76ft	65	c290	burnt 1916
Lotus	1886	93512	74ft	70	268	1939
Used as harbour cargo boat 1918–1939						
Lobelia	1886	93528	75ft	50	—	1932?
Rose (2)	1898	106187	84ft	80	—	burnt 1927
Shamrock	1901	112544	83ft	82	400+	
Renamed Wattle, *to Newcastle.*						

UPPER LANE COVE FERRY COMPANY

vessel	date	o/n	loa	tons	pass.	disposal
Killara (1)	?	—	30ft	—	33	?
Native Rose	?	—	—	—	—	extant 1991
Twilight	?	—	—	—	—	?

Recent Rosman and BNFC/SFL vessels inc. under Small Ferry Companies 1900–1990.

INNER HARBOUR SERVICES
NORTH SHORE and GENERAL
Major ferries of:
J.Milson and partners, North Shore Ferry Co., North Shore Ferry Co. Ltd., Sydney Ferries Ltd. (inc. other companies), Sydney Harbour Transport Board/Public Transport Commission of NSW (PTC)/Urban Transit Authority of NSW (UTA), State Transit Authority (STA).

vessel	date	o/n	loa	tons	pass.	disposal
Kirribilli						
Alexandra	1864	69767	68ft	27	75	sank 1883
Transit	1866	93577	81ft	69	—	b/u 1900
Florence	1872	64411	49ft	15	—	hulk 1900
Coombra	1872	64412	78ft	45	—	b/u 1913
Bungaree	1872	69736	78ft	62	—	hulk 1900
Darra	1875	73305	82ft	57	—	b/u 1883
Nell	1878	74970	83ft	71	—	wk 1883
Telephone	1878	75001	105ft	85	300+	hulk 1920s
Victor	1878	74999	52ft	24	—	?
Zeus	1878	75000	54ft	16	—	wk 1892
Wallaby	1879	75011	109ft	163	329	b/u 1926
St Leonards	1881	83650	110ft	110	—	hulk 1902
Warrane	1882	83737	99ft	109	14v/144p	hulk 1921
Victoria (2)	1883	83777	112ft	119	430	Melb.1910
Possum	1884	89229	60ft	32	—	sank 1911
Cammeray	1884	89285	130ft	197	671	hulk 1914
Waratah (2)	1885	89355	120ft	197	695	b/u 1911
Bunya Bunya	1885	89372	121ft	202	671	b/u 1914
Benelon	1885	89390	120ft	204	28v/84p	sold 1932
Barangaroo	1889	93625	119ft	205	26v/86p	sank 1933
Benelon/Barangaroo *last passenger paddlers on harbour.*						
Kangaroo (2)	1890	93650	112ft	158	632	b/u 1926
(The) Lady Mary	1892	101083	83ft	79	393	houseboat '28
Lady Napier	1892	101084	98ft	89	448	hulk 1928
Lady Manning	1894	101110	109ft	97	475	b/u 1928
Waringa	1894	101115	106ft	125	588	RAN 12/43
Renamed Karaga *1913*						
Lady Hampden	1896	106137	116ft	135	636	target 1943
Wallaroo	1896	106135	106ft	122	574	RAN 11/43
Renamed Kiamala *1914*						

vessel	date	o/n	loa	tons	pass.	disposal
Carabella	1897	106151	106ft	129	574	RAN 1943
Renamed Karabella *and rebuilt 1919*				151	595	
Kurraba	1899	112471	134ft	195	890	sold 1934
Neutral Bay	1885	89385	69ft	50	—	b/u 1920s
Renamed Thelma *1897*						
Kirribilli (2)	1900	112489	130ft	198	896	b/u 1934
Kamilaroi	1901	112528	128ft	328	28v/109p	b/u 1933
Koree	1902	112589	141ft	276	1080	b/u 1934
Kailoa	1902	117618	97ft	124	—	tug 1917
Ex tug Greyhound II, *converted 1908 to ferry.*						
Kummulla	1903	112594	119ft	168	795	hulk 1935
Kulgoa	1905	117679	140ft	338	1255	b/u 1952
Kareela	1905	117699	113ft	186	785	b/u 1959
Lady Rawson	1903	117636	117ft	172	760	sold 1934
Renamed AMYS Clubship as a floating yacht clubhouse						
Lady Northcote	1905	121122	116ft	128	602	hulk 1941
Converted to motor vessel 1936						
Lady Linda	1906	121196	44ft	13	70	sold 1934
Lady Carrington	1907	121187	130ft	146	701	sold 1934
Kai Kai	1907	121166	152ft	303	1355	USN 1942
Kookooburra	1907	121169	140ft	180	799	N'castle '47
Kaludah	1909	125190	115ft	137	—	burnt 1911
Rebuilt hull and engines as Kamiri						
Kanimbla	1909	125223	116ft	156	761	b/u 1946
Renamed Kurra-Ba *to free name for new liner*						
Killara (2)	1909	125222	131ft	309	33v/49p	Vic. 1933
Lady Chelmsford	1910	125248	110ft	98	446	
Converted to MV 1933					552	In Melb.1991
Kirrule	1910	125247	140ft	258	1100	b/u 1953
Kiandra	1911	131487	140ft	258	1107	b/u 1953
Kosciusko	1911	131491	116ft	165	790	Hobart 1975
Lady Denman (2)	1912	131510	110ft	96	542	museum 1979
Converted to MV 1936					500	
Kubu	1912	13152	140ft	258	1072	b/u 1960
Last coal-fired ferry and last inner harbour steam ferry						
Kirawa	1912	131534	149ft	295	1075	sold 1953
Kanangra	1912	131544	149ft	295	1075	museum 1987
Converted to motor vessel 1959					951	
Kamiri	1912	131516	112ft	144	592	b/u 1950
Part of Kaludah's *gutted hull and machinery included*						
Lady Edeline	1913	131586	111ft	96	477	
Converted to MV 1936					500	
Last 'old' Lady ferry working the harbour. Hulk awash 1990.						
Karingal	1913	131565	104ft	106	586	
Converted to MV 1937. Sank off Vic. June 1985.					625	
Karrabee	1913	131583	107ft	107	590	
Converted to MV 1936. Floating restaurant 1986.					645	
Kameruka	1913	131560	112ft	144	640	b/u 4/86
Converted to MV 1955.					600	

vessel	date	o/n	loa	tons	pass.	disposal
Lady Scott	1914	136379	110ft	95	486	
Converted to MV 1937. See John Cadman.					486	
Lady Ferguson	1914	136409	110ft	95	490	Hobart 1975
Converted MV 1937					518	
Kuramia	1914	136383	157ft	335	1360	target 1953
Kedumba	1914	131584	132ft	294	33v/–	sank 1932
Sold to Vic. sank en route, see Killara.						
Kooroongabba	1921	150177	137ft	313	45/220p	
To Newcastle 1932. Sank at sea 1972						
Koompartoo	1922	150184	182ft	448	2089	barge 1966
Kuttabul	1922	150185	182ft	448	2089	sunk 1942
Koondooloo	1924	151994	192ft	524	56v/292p	wk 1971
Converted to Showboat 1937–42. Veh. ferry 1951–71.						
Kalang	1926	152025	187ft	525	50v/250p	RAN 1941
As Showboat 1955 registry, 1460 tons, 1560 pass. orig. 2173 pass. wrecked 1971						
Kara Kara	1926	152035	187ft	525	50v/250	RAN '41
Sunk as target January 31, 1973						
Swan III	1934	157644	70ft	39	150	b/u 1950s
Pelican II	1934	157645	70ft	39	150	b/u 1950s
Crane II	1934	171211	70ft	39	150	b/u 1950s
Kooleen	1956	199171	75ft	67	278	h'boat 1985
Lady Cutler	1968	332975	119ft	350	578	laid up '92
Lady Mckell	1968	343913	119ft	329	573	"
Lady Wakehurst	1974	15234#	43.9m	366		811/see also Manly
Lady Northcott	1975	15177#	43.9m	366	811	"
Lady Woodward	1970	343914	119ft	339	573	in use
Lady Street	1979	17336#	38.7m	350	573	"
Lady Herron	1979	15521#	38.7m	350	573	"
Sirius	1984	15622#	24.8m	88!	393	"
Supply	1984	16496#	24.8m	88!	393	"
Alexander (2)	1985	15517#	24.8m	88!	393	"
Borrowdale	1985	16852#	24.8m	88!	393	"
Charlotte	1985	17256#	24.8m	88!	393	"
Fishburn	1985	15519#	24.8m	88!	400	"
Golden Grove	1985	16497#	24.8m	88!	400	"
Scarborough	1986	16814#	24.8m	88!	400	"
Friendship	1986	17458#	24.8m	88!	400	"
Dawn Frazer	1992	—	36.35m	51!	150	Rivercat
Betty Cuthbert	1992		"	"	"	"
Marlene Matthews	1993		"	"	"	"
Shane Gould	1993		"	"	"	"

** # indicates MSB survey registration number used to this point.*
! indicates full load displacement tonnage.

SOUTH EASTERN SERVICES

Eventually incorporated into Sydney Ferries Ltd (SFL). W. Harmer and family, (Sir) John Robertson, Watsons Bay & South Shore Steam Ferry Co. Ltd., Watsons Bay & South Shore Ferry Co., Sydney Ferries Ltd.

vessel	date	o/n	loa	tons	pass.	disposal
Golden Rose	1872	73340	39ft	12	58	b/u 1891
Swansea	1877	74909	76ft	60	350	b/u 1922
Renamed Federal						
Bee (2)	1884	88977	70ft	25	—	wk 1901
Oceana	1886	93541	62ft	34	200	wk 1903
Courier (2)	1887	93555	75ft	65	300	hulk 1930
King Edward	1902	112583	102ft	98	540	hulk 1935
Vaucluse (2)	1905	121109	140ft	121	709	N'castle'31
Greycliffe	1911	131478	125ft	133	—	sunk 3.11.27
Woollahra	1913	131577	125ft	152	744	sold 1941

** See also Messengers, Stannards and Government services.*

SOUTH WESTERN SERVICES

Watermen company, J. Entwistle, H.C. Perdriau etc, S. Crook, M. Byrnes, etc, J. Watson etc, Balmain Steam Ferry Co. Ltd., Balmain New Ferry Co. Ltd., Annandale Co-Operative Ferry Co. Ltd., J. Henley, Drummoyne, Leichhardt & West Balmain Steam Ferry Co. Ltd., Sydney Ferries Ltd.
** See also Nicholson, Rosmans, Stannards, SFL/PTC/UTA/STA, Captain Cook Cruises.*

vessel	date	o/n	loa	tons	pass.	disposal
Atalanta	1867	38850	78ft	21	—	wk 187?
Wonga	1870	59556	71ft	25	—	?
Leipoa	1872	64389	90ft	49	—	1938?
Quandong	1874	73350	106ft	101	—	?
Nellie	1877	74926	98ft	69	—	?
Fairy	1879	75027	96ft	86	—	1901
Rebuilt as SS 1883 for BSFC, lengthened.						
Osprey	1879	75028	66ft	35	200	?
Renamed Lilac	1892					
Millie	1880	83613	103ft	81	—	hulk 1902
Excelsior	1880	83615	109ft	101	—	?
Waldemar	1881	83638	108ft	110	—	?
Annie	1882	83726	61ft	24	140	b/u 1934
Balmain	1883	83773	120ft	177	580	b/u 1910
Waterview	1884	89257	127ft	140	580	b/u 1911
Psyche	1884	89301	72ft	42	300	
Renamed The New Era, *1898, r/n Drummoyne 1907*						Bald Rock
	1884	89302	112ft	105		
Renamed Vaucluse *(1) 1900, r/n Bald Rock 1905, to Vic. 1907*						
Alma	1885	59516	62ft	28		
Lincoln	1886	93491	113ft	10	400	?
Genista	1886	93522	80ft	83	—	Vic. c1930
Leichhardt	1886	93495	76ft	68	370	burnt 1916
Daphne	1886	89389	76ft	65	290	burnt 1916

vessel	date	o/n	loa	tons	pass.	disposal
Lobelia	1886	93528	75ft	50	—	cargo 1918?
Me Mel	1888	93572	125ft	174	500	wk 1914
Birkenhead	1888	93590	88ft	115	440	sunk 1913
Guthrey	1899	112478	76ft	50	300	to N'castle

SMALL FERRY COMPANIES—1900–1990

ALL AREAS
CHARLES H. ROSMAN 1916–1987

vessel	date	o/n	loa	tons	pass.	disposal
Regal	1910	—	—	—	35	?
Rex	1914	174729	44ft	18	139	1950s
Renamed Rex Star?						
Regina	1914?	—	40ft	—	99	1940s
Renown	1917	174732	45ft		114	1953
Ex Loonganna *from Tuggerah Lakes c1930*						
Royal	1917	—	45ft	—	156	1947
Rodney	1937	171258	60ft	31	212	sank 1938
Renamed Regis, *then* Regalia *c1942*						
Regalia	1937	171258	60ft	33	140	extant 1991
Regent Star	1947	178356	51ft	33	156	—
Renamed Nowra, *then* Challenger Head, *then* Kangaroo *(in Hobart)*						
Radar	1947	179712	57ft	60	248	extant 1991
Ex La Radar, *ex* Radar.						
Royale	1974	355657	60ft	149	295	extant 1991
Regal II	1981	15846#	18.7m	44	156	extant 1991

* *Rosmans ferries served Garden Island from 1916 to c1980.*
* *Rosmans ran Lane Cove River ferry run from 1950 to date.*
* *Operated charter and picnic/race ferries from 1916 to date.*
MSB registration number.

BRYSTAND PTY. LTD., trading as ROSMAN FERRIES (1987–)
Operated by Steven Matthews.
Radar;
Royale;
Regal II.
Charter services, Goat Island and Cockatoo Dockyard ferry services, peak hour Lane Cove River ferry run.

JAMES DEVENISH ROSMAN (c1932–1949)
Rex;
Regina;
Renown;
Regent *(1), ex* Leura *(1), later* Project.

N.D.HEGARTY & SONS PTY. LTD.

Later owned by Barber and Porter (1949), John Needham (c1960),Stannard Bros. Launch Services, Captain Cook Cruises.

vessel	date	o/n	loa	tons	pass.	disposal
Glen Lyon	?	?	?	?	?	well-decker
Mt Pleasant	?	?	34ft	—	63	"
Aster	?	?	39ft	—	90	ex Newcastle
Kurnell (Star)	1913	171235	44ft	18	87	b/u 1982
Gippsland	1909	120753	113ft	159	—	to Bris. RAN.
Evelyn (Star)	1924	171237	59ft	33	104	b/u 1973
Estelle (Star)	1927	171236	80ft	85	401	burnt at sea
Ettalong (Star)	1927	171231	61ft	44	240	Profound
Eagle (Star)	1936	171230	78ft	74	270	Vic.1950
Sunrise (Star)	1926	172919	71ft	47	190	extant 1991
Emerald (Star)	1943	174701	52ft	38	157	"
Sorrento	1909	101791	104ft	121	—	museum 1991
Seeka (Star)	c1940	196387	48ft	43	92	extant 1991
Twin Star	1972	374694	17.9m	80	158	"
West Head	1947	191365	59ft	73	158	"
Port Jackson Explorer	1981	—	19.8m	133	200	catamaran

* Twin Star *carried this name from completion.*

NICHOLSONS BROTHERS HARBOUR TRANSPORT PTY. LTD (1916–1968)

Previously Nicholsons Bros.
Passenger ferries and launches, excluding tugs, lighters and line handling boats.

vessel	date	o/n	loa	tons	pass.	disposal
Nellie II	1910	—	25ft	—	14	to Nowra
Proceed (1)	1917?	—	32ft	—	35	burnt 1969
Process (1)	c1921	—	?	—	?	r/n Clyde (2)
Process (2)	WW1	—	?	—	?	?
Prominent	1918	—	32ft	10	45	sold c1978
Promise	1911	—	33ft	—	48	sunk 1979
Prospect	1914	—	31ft	—	38	sold ?
Protex	?	—	32ft	8	34	museum
Protector	1917	—	43ft	37	94	extant 1991
Proclaim	1939	172896	66ft	72	347	extant 1991
Produce	1947	179714	55ft	38	148	"
Profound	1922	171231	61ft	44	240	Wangi Queen (2)
Ex Ettalong Star, *ex* Ettalong						
Project	1925	—	—	—	48	ex Wangi Queen (1)
Prolong	1926	174700	75ft	68	297	ex Mulgi
Renamed Mulgai, *then* Mulgi *1977*						
Promote	1915	172892	49ft	24	197	ex Nambucca
Renamed Macquarie Princess						
Protend	1932	196415	44ft	17	92	extant
Ex Messenger II, *ex* Unit 1, *r/n* Juno Head, *then* Lady Patina, *then* Cockatoo.						

vessel	date	o/n	loa	tons	pass.	disposal
Provide	1924	171257	62ft	43	266	ex Wangi Wangi

Renamed Ku-Ring-Gai II, *burnt 1980*

* *Data given as per Nicholsons original details.*
** *Nicholsons and Hegartys jointly operated* Sorrento. *Nicholsons fleet was quickly sold following takeover by Stannards with the exceptions noted in Stannards text.*

CHARLES AMOS MESSENGER (c1925–1940s).
Charter and Picnic Boats.
Contract ferry service from Rushcutters Bay to Garden Island naval base (when still an island) carrying workmen.

vessel	date	o/n	loa	tons	pass.	disposal
Lady Dudley	?	?	34ft	—	41	well-decker
Lily Braton	?	?	43ft	—	100	?

Renamed Patonga, *thence to Noumea in 1961.*

ERNEST MESSENGER (1920s–1953)
Charter and Picnic Boats.
Ferry service from Circular Quay to Watsons Bay (1950s) with Naval men for HMAS Watson and ships at Watsons Bay Wharf. Return run from Watsons Bay with office workers, calling at Central Wharf Vaucluse, Parsely Bay, Neilson Park and Circular Quay. Service lasted about two years and used, mainly, Messenger II *(see* Protend *etc.)*
Ern Messenger and son, E. Charles 'Boy' Messenger, stood in for J.D.Rosman, Hegartys etc, when their ferries were over-worked or unavailable.

vessel	date	o/n	loa	tons	pass.	disposal
Lady Denman (1)	1909	—	39ft	—	99	?
Messenger	?	—	34ft	—	31	c1930s
Lady Marjorie	?	—	36ft	—	50	?
Lady Lynne	?	—	28ft	—	24	?
Susie	?	—	29ft	—	20	?
Messenger II	1932	—	44ft	17	92	ex Unit 1

Renamed Protend *(g.v.)*

STANNARD BROS LAUNCH SERVICES

vessel	date	o/n	loa	tons	pass.	disposal
Promote						
Profound						
Provide						
Project						
Prolong						
Protend						

vessel	date	o/n	loa	tons	pass.	disposal
Proclaim						
Produce						
Lithgow	1927	178332	44ft	20	117	ex Kin-Gro
Leura (2)	1940	172920	56ft	30	135	
Nowra	1947					
Ex Regent Star (g.v.)						

BLUE DOLPHIN FERRIES PTY. LTD. (1973–1974)

vessel	date	o/n	loa	tons	pass.	disposal
Blue Dolphin	1973	—	51ft	20	62	
Renamed Michael Howe *(Hobart) 1975, to Auckland.*						

GORDON AND SUE DAVEY (1980–)

vessel	date	o/n	loa	tons	pass.	disposal
Birkenhead (2)	1965	—	54ft	38	187	
Ex John H. Walter, *renamed* Hawkesbury Explorer.						
Birkenhead Explorer	1946	156166	52ft	43	162	
Ex Newcastle-on-Hunter, *renamed* Harwood.						
West Head						
See Hegartys, Port Jackson SS Co. etc.						

Lengths given in feet are rounded off to nearest foot. Lengths in metres are given to one decimal place.

Caution is advised when comparing lengths. Generally figures indicate registered length (LBP) but some are for length overall (loa).

Caution should also be taken with figures for tonnage. Very early figures are given as 'tons burden (burthen)', meaning the load able to be carried. Most figures given are for Gross tonnage which is a measure of volume—the enclosed volume of the vessel divided by 100 (cubic feet) gives Gross Tons. A more accurate measure of actual weight is the Displacement Tonnage—this can be given in light, full load and in between. For example, Koondooloo—524 tons gross—as punt 862 tons displacement full load. As showboat 991 tons displacement full load.

Similarly, Lady Chelmsford—98 tons gross. Light displacement tonnage 163 tons. Full load displacement tonnage—212 tons.

Displacement can be stated as tonnes after conversion. Gross translates to Cubic Metres.

Under the national USL Code, tonnages are rarely used in vessel's registers. Specific survey data known as Gross Construction Tonnage or Under Deck Tonnage (GCT or U/D) are used. These do not relate to older data.

* *M.S.B. Survey Book*

APPENDIX TWO

CRUISE AND EXCURSION VESSELS AND OUTER AREA FERRIES

Listed in order of mention.

vessel	date	tons	length	pass
Kalang	1926	1460	187ft	1560
Sydney Queen (*ex Kalang*)	1926	1469	187ft	2140
Above included for comparison with later vessels.				
Bataan	WW2	—	14m	34
Honey Hush	—	41	18m	c60
Stella Maris	—	—	c15m	117
Carolyn	c1930	—	11m	10
Mizama	WW2	28	62ft	—
Nautilus	—	—	—	—
Tai Pan	1988	930	34.9m	500
		(330 full load disp.)		*(26 crew)*
Captain Cook	WW2	290	34.1m	104
John Cadman	1914/74	193	33.5m	246
Captain Cook II	1975	301	33.4m	250
Lady Geraldine	1978	177	24.3m	170
Australia Fair	1981	67	12.75m	50
Port Jackson Explorer	1981	133	19.8m	200
City Of Sydney	1981	340	37.0m	300
John Cadman II	1986	366	38.6m	450
John Cadman III	1989	—	38.0m	450
Captain Cook III	1990	399	39.6m	500
Lady Hawkesbury	1987	1815	68.9m	138
Murray Explorer	1979	1115	52.0m	132
Turrumburra	1976	50	16.1m	188
Matilda	1981	75 disp	19.9m	200

vessel	date	tons	length	pass
Matilda II	1985	—	24.9m	300
Matilda III	1987	—	24.9m	300
Matilda IV	1989	—	24.9m	300
River Rocket	1989	—	17.0m	72
Solway Lass s/v	1902/1985	105 gross	—	70?
Cockle Bay	1989	—	9.9m	50
Vagabond II	1942/3	—	22.2m	80
Vagabond Princess	1958	91 ?	27.0m	200
Mulgi	1926	68	74ft	200
Vagabond Star	1967	96 ?	28.9m	200
Bennelong	1973	124	80ft	120
Vagabond Majestic	1975	136	106ft	300
Sydney Showboat	1987	735	41.45m	425
Southern Cross	1981	74 u/d?	19.9m	150
Spirit Of Manly	1986	18 disp	15.8m	92
O'Hara Booth	1974	80	20.4m	80
Martin Cash	1975	94	21.6m	122
James McCabe	1973	43	19.5m	100
Walsh Bay	1969	69	18.0m	110
Katika	1981	74 u/d ?	19.5m	200
Escapade	1978	69	16.4m	100
Hawkesbury Star	1945	34	17.3m	152
Annabelle	1935	25	13.87m	60
West Head	1947	73	16.8m	140
Proclaim	1939	72	20.2m	300
Sunrise Star	1926	47	21.4m	190
Fiesta	1973	173	20.0m	200
Lithgow	1927	20	13.4m	112
Burragi	c1916	57	22.0m	64
Eve	c1925	150	23.0m	130
Richmond Riverboat	1986	237 GCT	20.0m	150
Philanderer II	1982	151	20.0m	105
Freyja	1982	—	16.0m	100
Bounty s/v (sailing vessel)	1979	400 disp	133ft	49
Aussie One s/v	—	—	—	250
Tafua s/v	—	—	—	80

OUTER AREA FERRIES AND CRUISE/CHARTER BOATS

vessel	date	tons	length	pass
Christina	1917	7	7.9m	30
Lady Kendall	1906	45	19.9m	130
Grower	c1922	—	38ft	38
Elvina	1934	6	7.6m	30
NSW' smallest scheduled ferry—1991				
Curlew	1922	12	13m	60
Church Point	1944	15	13.2m	48
Swanhilda	1910	9	43ft	69

vessel	date	tons	length	pass
Merinda	1964	26	14.85m	95
Raluana	1969	69	60ft	175
Mirigini	1973	69	18.1	180
Binburra	1978	69	16.4m	180
Barrenjoey (2)	1920	16	45ft	85
Myra	1985	32 u/d	14.32m	126
Merinda II	1983	30 u/d	14.3m	112
Mia	1965	26	44ft	c80
Stockton	1939	34	—	83
Hawkesbury	1981	—	20.0m	225
Hawkesbury Explorer	1966	38	54ft	187
Hawkesbury Wanderer	1982	—	50ft	100
Sun	1950	12	39ft	62
Miss Teewantin II	1950	—	30ft	30
Deerubbin	c1944	32	57ft	94
Macquarie Princess	1922	24	14.5m	120
Nepean Belle	1982	52 disp	18.3m	150
Mirabel	1937	34	18.0m	110
Mingela	1951	51	—	226
Lady Eucumbene	1946	23	50ft	84
Protector	1917	—	16.0m	50
Regalia	1938	33	19.0m	140
Bass & Flinders	1985	—	19.6m	200
Myambla	—	—	8m	25
Audley	—	—	8.5m	35
Eclipse	—	—	9m	42
Pioneer	—	—	11.5m	60
Macquarie	—	—	9m	50
Burraneer	—	—	12m	77
Gunnamatta (1)	—	—	12m	—
Gunnamatta (2)	—	—	—	—
Conqueror	—	—	—	—
Curranulla	1939	27	16.8m	135
Bundeena	1946	46	59ft	198
Gymea	1949	17	45ft	78
Tom Thumb III	—	—	—	—
Ex Gymea				
Gunnamatta (3)	1990	16 disp	15m	120
Proud Sydney	1972	260 gross	37.4	52
Boonaloo	1981	25 u/d	17.35m	100

APPENDIX THREE

FERRY COLOURS

Manly Service

1800s–1928 — Apparently black hulls, white trim, dark varnished superstructure. White funnel, black cap.

1928–1974 — Bottle green hulls, white trim, medium varnished superstructures, white funnels, black funnel caps. Upperworks later painted brown/cream for economy.

1974–1991 — Pale blue hulls, cream trim, cream superstructure and funnel, pale blue bridge rails, black funnel caps, stylized NSW logo on funnel.

Variations:

c1979 — Pale blue restricted to highlight band over dark blue hull. Funnel logo stylized two-way arrow on funnel etc.

c1982 — Pale blue discarded. Hulls dark blue to sponson line, above sponson line; hull, bows and superstructure off-white or light cream. Dark blue one plate higher on bows of *North Head*.

1983 — *Freshwater* introduced dark blue hull with dark blue 'eyebrow' sponsons which were added after launching. Arrow logo on funnel and bows. Words 'URBAN TRANSIT AUTHORITY' on side of upper deck gangway (soon removed as rapidly defaced by use).

Hull dark blue, sometimes flat fore and aft in line with hull sponson. Other modifications curved blue upward towards stemhead in an attempt to give impression of sheerline. Apparent efforts to integrate 'eyebrow' sponson into lines failed.

1988 — *Collaroy* — hull one colour dark blue, absorbing 'eyebrow' sponsons. Superstructure pale cream, funnel with two-tone arrow logo. Others then re-painted in like manner, later with new circular logo.

1990 — *Queenscliff* — late 1990, mid green hull, cream superstructure, dark cream trim, circular funnel logo.

 * Government ferries have shown three funnel logos in 16 years. This should assist photographic dating in the future:

Hydrofoils

1964–1991 — *Manly* (3), originally lemon green hull and cream upperworks. Then red hull with broad white band and cream cabin, later pale blue band.

 Other hydrofoils — 140 passenger type — generally all-cream/off-white with, at various times, broad red band or broad pale blue band. Variously dark panel aft of exhausts. Name boldly on sides aft of wheelhouse. Final refit of *Curl Curl* and *Long Reef* — names on bow, hull and cabin, cream, dark blue trim lines (to match Sydney/Manly (4)).

Jet catamarans

White hull and superstructure — green and yellow diagonal bands with words `JET CAT' dominant.

Inner Harbour Ferries
SFL/SHTB/PTC/UTA/STA

c1900–c1922 — Probably white hulls and bulwarks, maroon rails, varnished superstructures, black funnel.

c1922–c1934 — Grey hulls on steel hulled ferries (including vehicular ferries), maroon bulwark rails, varnished superstructures, black funnel.

 Wooden vessels, generally as from c1900, but some large wooden `K' class may have had a grey hull with a white(ish) bulwark plank.[1] In 1928, the *Lady Carrington* (or *Northcote*) is shown with two black capped white funnels.[2] Watsons Bay ferries, at the time of *Greycliffe* disaster: grey hulls, white bulwarks, maroon rails, varnished upper works and black funnel.

Balmain New Ferry Co. (original)

Some vessels may have had cream hulls.[3]

c1934–1974 — Ferry livery may have changed as a result of a marketing push following completion of the bridge. It seems that the new fast river ferries of the Water Bus type may have been built with a change of colour. The change may also have started with the return to service of the 'dieselised' *Lady Chelmsford* in 1933. Certainly a photo of the 'Chellie' on motor ship trials shows a change of livery.

 The hull colour was a mid to light green, somewhat lighter than hulls of the Manly ferries. The bulwarks were green with a top plank of cream

topped by a maroon or grey handrail. The superstructure became a lighter shade of varnish of almost a creamy appearance with red piping. The funnel was dark cream with a black top.

The light varnish was replaced late in the 1950s, or early 1960s, by a dark cream, almost yellow paint and the hulls became a brighter green. It did not please everybody.[4] In the late 1960s and early 1970s, the livery was again varied. Pale green panels were added along the sides of the upper saloons and this colour was used for the hulls. When *Kooleen* was built, she had used a similar pale green for the top of the passenger's cabin and the roof of the wheelhouse.

The Public Transport Commission colour modifications from 1974 generally followed those for the Manly ferries. The 1974 cream superstructure seems finally to have been abandoned with the 1991 refit of *Lady Northcott* and *Lady McKell* which showed the 1990 green hull, white names and a creamy-yellow deckhouse. The result reminded me of the late 1950s livery and was designed by noted marine artist, the late Phil Belbin.

Differing from the Manly and larger inner harbour ferries were the First Fleet class catamarans. Group one (the first five) were originally given dark blue hulls and cream deckhouse with dark blue trim and funnel caps. The second group were given an extended upper deck house while building and were given light green hulls and light cream upperworks with green trim and funnel caps. As Group One ferries were refitted from the original 250-passenger configuration to that of the c393 passenger capacity, they were repainted to match the four Group Two ferries' Bi-Centennial colours. The whole class was gradually repainted with a third colour scheme during 1992. The hull became dark green, with yellow names, and the superstructure was lighter cream, picked out in dark green.

NOTES

1 *Sydney Harbour Panorama*, Sydney Ferries Ltd., Sydney, c1935.
2 Cover, *Motor Boat and Yachting Monthly*, 1 January 1928.
3 John Gunter 1978, *Across the Harbour*, Sydney, p. 29.
4 See Chapter 7.

APPENDIX FOUR

GLOSSARY

AIR CUSHION VESSEL/VEHICLE(ACV) — professional term used for hovercraft.

BOOM GATE VESSEL — vessel used to open and shut anti-submarine harbour netting.

B/U — broken up.

BOLLARD — metal deck fitting to hold mooring and other ropes.

BULWARKS — solid rails around vessel's main deck.

CATAMARAN — modern term for vessel with twin hulls.

CKD — completely knocked down i.e., built elsewhere for re-assembly.

DE-PERMING VESSEL — used to reduce the magnetic field of other vessels in time of war.

DOLPHINS — wood or concrete, free-standing harbour structures, used for temporary vessel berths.

DOUBLE-ENDER — vessel of similar shape at either end and often designed to travel in either direction.

GANG-PLANK — small, portable temporary bridge between ship and shore.

HORSE-PUNT — self-propelled vehicular ferry. Known also in Sydney as car ferry/punt/etc.

HULK — old vessel stripped for use as barge or abandoned.

KNOT — measure of so many nautical miles in one hour is stated as 'so many knots'. Not given as knots per hour.

MASTER — person in charge of a vessel.

MONOHULL — vessel with one hull.

PULLING BOAT — seaman's term for large rowing boat.

RIGHT OF WAY — vessel having priority over another within the meaning of the International Collision Rules.

SHEERLINE — side elevation curve of a vessel's lines, fore to aft. If convex, known as reverse sheerline.

SIDE-WHEELER — paddle vessel with paddles on its sides.

SINGLE-ENDER — Vessel with clearly defined bow and stern.

SPONSON — extension of the vessel's main deck beyond the limits of the hull.

STERN-WHEELER — paddle vessel driven by one paddle wheel at the stern.

TONNAGE — Gross (registered) official measurement tonnage — actually a measure of internal volume.

Displacement tonnage — actual weight (mass) of vessel; can be stated as light load/full load/service etc.

Gross construction tonnage — surveyor's measurement.

Under deck tonnage — surveyor's measurement.

WELL-DECKER — small ferry/craft in which main passenger deck is recessed below line of main deck.

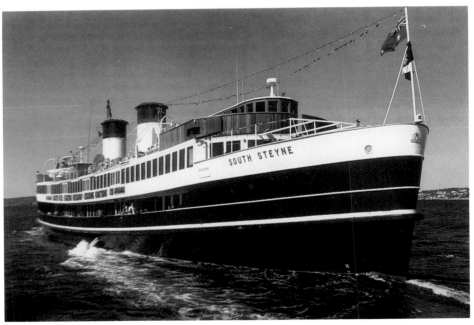

Cruise ship *South Steyne* leaves for Newcastle after a promotional visit to Sydney in January 1991. [Graeme Andrews Collection]

BIBLIOGRAPHY

Ancher, Edward A., 1976, *The Romance of an Old Whaling Station*, Sydney.

Andrews, Graeme,1971, *Australasian Navies*, Sydney.

Andrews, Graeme, 1975, *The Ferries of Sydney*, Sydney, 2nd.ed.

Andrews, Graeme, 1982, *Pictorial History of Ferries*, Sydney.

Andrews, Graeme, 1983, *South Coast Steamers*, Sydney.

Andrews, Graeme, 1986, *Port Jackson 200*, Sydney.

Andrews, G. (ed.), 1977, *Gregorys Waterways Cruising Guide*, Sydney.

Aplin, Graeme & Storey, John, 1984, *Waterfront Sydney 1860–1920*, Sydney.

Bastock, John, 1975, *Australia's Ships of War*, Sydney.

Birch, Alan & McMillan, David S., 1962, *The Sydney Scene 1788–1960*, Sydney.

Bradley, William, 1969, *A Voyage to New South Wales 1786–1792*, Sydney.

Brodsky, Isador, 1957, *Sydney Looks Back*, Sydney.

Brodsky, Isador, 1963, *North Sydney, 1788–1962*, Sydney.

Broxam, Graeme & Nicholson, Ian, 1988, *Shipping Arrivals and Departures, Sydney*, Vol. III, Canberra.

Bull, J.C. & Williams, Peter, 1966, *Gippsland Shipping*, Melbourne.

Burgess, John N., 1955, *Robinsons Cruiseguide to Sydney Harbour*, Sydney.

Carruthers, Steven L., 1982, *Australia Under Seige*, Sydney.

Clarke, L.A., 1976, *North of the Harbour*, Sydney.

Cole, Joyce, 1983, *Parramatta River Note Book*, Sydney.

Collins, David, 1975, *An Account of the English Colony in New South Wales*, ed. B. Fletcher, Sydney.

Cox, G.W., 1971, *Ships in Tasmanian Waters*, Hobart.

Dark, Eleanor, 1988, *Waterway*, Sydney.

Davies, Jann, 1977, *The Story of Nicholson Bros. Harbour Transport Pty. Ltd.*, private compilation, Surfers Paradise.

Duckworth & Longmuir, 1972, *Clyde River and other Steamers*, Glasgow.

Fildes, R.D., 1975, *The Ships that serve Australia and New Zealand*, Vol. 1, Sydney.

Fitchett, T.K., 1973, *Down the Bay*, Adelaide.

Geeves, Phillip, 1970, *A Place of Pioneers*, Sydney.

Gibbs, Shallard & Co., 1882, *An Illustrated Guide to Sydney*, facs. Sydney, 1981.

Goddard, Roy H., 1955, *The Life and Times of James Milson*, Melbourne.

Gunter, John, 1978, *Across the Harbour*, Sydney.

Hardie, Daniel, 1989, *The Rosehill Packet*, Sydney.

Hardie, Daniel, 1990, *Forgotten Fleets*, Sydney.

Howland, Keith & Lee, Stewart, 1985, *Yamba Yesterday 1885–1985*, Yamba.

Joubert, Jules, 1890, *Shavings and Scrapes*, Hobart.

Kelly, Max (ed.), 1978, *Nineteenth Century Sydney*, Sydney.

Kemp, Peter (ed.), 1979, *The Oxford Companion to Ships and the Sea*, London.

Levy, M.C.I., 1947, *Wallumetta*, Sydney.

Lindsay, Rose, 1964, *Ma and Pa*, Sydney.

Loney, Jack, 1982, *Bay Steamers and Coastal Ferries*, Sydney.

Maclehose, James, 1977, *Picture of Sydney and Strangers Guide to NSW for 1839*, facs. Sydney.

Mann, D.D., 1973, *The Present Picture of New South Wales 1844*, facs., Sydney.

Matthews, Michael R., 1982, *Pyrmont & Ultimo, a History*, Sydney.

McCormick, Tim, 1987, *First Views of Australia 1788–1825*, Sydney.

McDonald, Charles E. & Henderson, C.W.T., *The Manly–Warringah Story*, Sydney.

Mead, Tom, 1988, *Manly Ferries of Sydney Harbour*, Sydney.

Meredith, Louisa Anne, 1973, *Notes and Sketches of New South Wales, 1844*, facs. Sydney.

Nicholson, I.H., 1977, *Shipping Arrivals and Departures 1826–1840*, Canberra.

Parsons, R.H., 1973, *Paddle Steamers of Australasia*, Adelaide.

Parsons, R.H., 1958, *Steamships Registered Sydney, 1834–1899*, Adelaide.

Payzant, Jean & Lewis, 1979, *Like a Weaver's Shuttle*, Nova Scotia.

Pike, D. (ed.) 1966–1974, *Australian Dictionary of Biography*, 5 vols., Melb. Univ. Press.

Pollon, Frances, 1988, *The Book of Sydney Suburbs*, Sydney.

Port of Sydney, 1950, *Maritime Yearbook 1950*, Sydney.

Prescott, A.M., 1984, *Sydney Ferry Fleets*, Adelaide.

Public Transport Commission/UTA/STA, *Annual reports*, 1980, onwards.

Rees, Leslie, 1948, *Mates of the Kurlalong*, Sydney.

The Register of Australian and New Zealand Shipping, various from 1880–1937.

Rhys, Lloyd, 1946, *My Ship is so Small*, Sydney.

Richards, Mike, 1987, *Work Horses in Australian Waters*, Sydney.

Russell, Eric, 1987, *A Lane Cove History 1788–1970*, Sydney.

Sekold, Frank, 1991, *Watsons Bay Ferry Passes and Tokens*, private publication.

Sekold, Frank, 1991, *Catalogue of Australian Ferry Tokens and Passes*, private publication, Sydney.

Sharpe, Alan, 1979, *Colonial NSW 1853–1894*, facs, Sydney,.

Shore, Harvey, 1981, *From the Quay*, Sydney.

Spearitt, Peter, 1978, *Sydney Since the Twenties*, Sydney.

Stephenson, P.R., 1980, *The History and Description of Sydney Harbour*, 2nd ed., amended by Brian Kennedy, Sydney.

Sturrock, Rob, 1983, *A Pictorial History of Mosman*, Sydney.

Ships on the Australian, New Zealand & Islands *Register*, various 1950–1960, Sydney.

Sydney Ferries Ltd., 1916, *Articles of Association 1916*, Sydney.

Sydney Ferries Ltd., 1916, *Annual Reports*, various, Sydney.

Sydney Ferries Ltd., c1936, *Sydney Harbour Panorama*, Sydney.

Sydney Australia, 1908, *The Queen of the South Pacific*, Sydney.

Sydney Harbour Trust, *Port of Sydney*, various.

Thorne, Les G., 1968, *North Shore, Sydney*, Sydney.

Toghill, Jeff, 1982, *Sydney Harbour of Yesteryear*, Sydney.

Torrance, William, 1986, *Steamers on the River*, Brisbane.

Woodley, A.E., 1973, *Westernport Ferries*, Melbourne.

Wotherspoon, G., (ed.) 1983, *Sydney's Transport: Studies in Urban Transport*, Sydney.

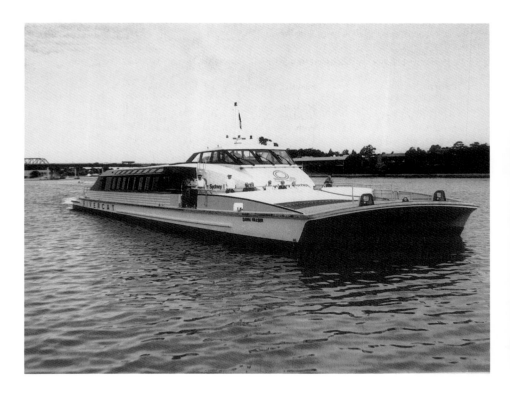

INDEX

This index is divided in two. The first index deals with people and the second with ships and ferries.

Where a subject is discussed in a note a lower case 'n' follows the page reference.

INDEX